Treasured Possessions

OBJECTS/HISTORIES

Critical Perspectives on Art, Material Culture, and Representation

A series edited by Nicholas Thomas

PUBLISHED WITH THE ASSISTANCE
OF THE GETTY FOUNDATION

Haidy
Geismar

Treasured Possessions

INDIGENOUS INTERVENTIONS
INTO CULTURAL AND
INTELLECTUAL PROPERTY

DURHAM AND LONDON 2013

Printed in the United States of America on acid-free paper ∞
Interior design by Bea Jackson. Cover design by Jennifer Hill.
Typeset in Garamond Premier Pro.

Library of Congress Cataloging-in-Publication Data
Geismar, Haidy.
Treasured possessions : indigenous interventions into cultural
and intellectual property / Haidy Geismar.
pages cm — (Objects/histories : critical perspectives on art,
material culture, and representation)
Includes bibliographical references and index.
ISBN 978-0-8223-5412-3 (cloth : alk. paper)
ISBN 978-0-8223-5427-7 (pbk. : alk. paper)
1. Cultural property—Vanuatu. 2. Intellectual property—Vanuatu.
3. Cultural property—New Zealand. 4. Intellectual property—New
Zealand. 5. Ni-Vanuatu. 6. Maori (New Zealand people). I. Title.
II. Series: Objects/histories.
DU760.G455 2013
993'.00499442—dc23 2013004647

Duke University Press gratefully acknowledges the support of the
Humanities Initiative of New York University that provided funds,
through its Grants-in-Aid program, toward the publication of this
book.

Contents

Illustrations

FIGURES

Preface

WHAT HAPPENS WHEN ritual practitioners from a village in a small Pacific archipelago make an intellectual property claim to the origins of bungee jumping? Or when ancestral names are given to plastic children's toys?[1] Globally, the polarizing rhetoric and contestation over indigenous rights that emerges in these cases, and in many others, can be extremely divisive. Locally, positive connections among cultural heritage, intellectual property, and indigeneity in the Pacific region are only gaining strength.[2] Indigenous activists, curators, legislators, lawyers, and scholars are creatively exploring the possibility of genuine alternatives to the global policies and concepts that circumscribe their lives. In this volume, I look at the ways in which intellectual and cultural property provide a framework for claiming economic sovereignty and for forging new national utopias around exchange and entitlement in the Pacific island nations of Vanuatu and Aotearoa New Zealand.[3] The "indigenization" of cultural and intellectual property I discuss here uses these institutional forms as a way to reframe who owns the so-called cultural commons. There has been a reformulation of the colonial commodity inheritance, one both poignant and innovative.

Indigeneity as a discourse and political movement has emerged prominently in settler-colonial nations with minority native populations, such as Australia, New Zealand, Canada, Brazil, and the United States. Additional discourses have emerged in recently independent nation-states like Vanuatu, in which native people make up the majority of the population, and the term *indigenous* occurs most prominently there in relation to the deployment of cultural and natural resources in that strange, unmappable space between village and international arena. The concept of the indigenous is now more than a description or identity; it is increasingly a call to arms and an international political manifesto, a ground for resistance and a way of surmounting radical cultural difference in the face of shared experiences of colonial and postcolonial "development."

It is inadvisable and inappropriate to write about indigenous issues, especially as a nonindigenous person, without explicitly positioning oneself and the contribution one wishes to make. I acknowledge myself as a nonindigenous participant in these discussions and a grateful guest in the places I write about. I do not claim to speak for my interlocutors or to generalize about all Māori or all ni-Vanuatu. What, then, do I bring to the table? My background as a museum practitioner as well as an anthropologist paved the way for this project. In my museum work, I have been committed to extending to communities the opportunities to visit (if on occasion only virtually), comment on, and wield agency over historic collections frequently held in faraway museums (see, e.g., Geismar 2003b, 2009; Geismar and Herle 2010). This work has necessitated a rethinking of the historical and continuing social and political dynamic of anthropological and museum research and practice. It is this humility regarding the history of ownership and exchange of cultural artifacts that I bring to my study. In particular, this view has been inculcated by my collaborations with people in communities who are pleased to enter metropolitan museums but who also quietly and confidently assert rights of connection that transcend the bald circulation of museum collections in commodity networks of trade, political donation, and so on. This kind of museum work made me instantly aware of the fact that single artifacts may inhabit several different registers of value and ownership simultaneously and that ultimately we must never lose sight of where they come from.

Working in both Vanuatu and Aotearoa New Zealand, I have often felt that there was much to be gained from bringing into focus the divergent ways in which people were working to similar ends. This book is therefore an attempt to bridge divides within the Pacific, raising awareness for Pacific islanders, as well as for anthropologists and cultural policy makers, about the interesting projects that are taking place across this region and

encouraging all of these people to develop a shared framework for understanding the ways in which traditional knowledge, customary practices, and national property regimes are inflected by both the history of colonialism and current patterns of globalization. Despite the general perception of the Western Pacific region as an "arc of instability," there are in fact many reasons why Māori might look to Melanesia in developing models of indigenous governance, resource management, and so on. Vanuatu is grappling with independence from its colonial past, but issues of postcolonial development still curtail the place of indigenous worldviews within national governance (exemplified by the Say No to WTO movement that failed to stop the country's accession in 2012). What emerges in both Vanuatu and Aotearoa New Zealand are alternative ways of talking about property, resources, and heritage based on nationalized concepts of indigeneity and unique sovereignty that in turn jostle with ideologies of neoliberal economic development, the free market, and the ideals of multicultural democracy. Each nation has different capacities, and intentions, to develop these issues in terms of public policy, practice, and the promulgation of a local discourse about what it means to be indigenous. This book is fundamentally about the imaginative ways in which Māori and ni-Vanuatu absorb intellectual and cultural property as legal categories into their own efforts to constitute indigenous identities and, by extension, sovereignties. I investigate what happens when customary or traditional artifacts are simultaneously commodified internationally and constituted as indigenous resources. Cultural and intellectual property discourse is used as a filter for the production of alternative economic imaginaries that are increasingly affecting policy and practice. The questions I ask here have been asked already by the people I have worked with. The answers also lie with them, although they may not always be given a voice. I hope here to bring these debates, and this regional perspective, to the forefront of international discussions of property and to emphasize their consequences for the implementation of governance and for sovereignty for indigenous peoples in the Pacific.

Acknowledgments

THIS BOOK IS THE PRODUCT of more than ten years of research and a developing collaboration with colleagues in Vanuatu and Aotearoa New Zealand, the United Kingdom, and the United States. During my doctoral fieldwork (2000–2001) in Vanuatu, I was supported by a grant from the Economic and Social Research Council. My research was supported by the Vanuatu Kaljoral Senta, then under the leadership of Ralph Regenvanu. My PhD supervisors, Susanne Küchler and Chris Tilley, and my examiners, Lissant Bolton and Eric Hirsch, provided guidance and invaluable intellectual critique. In 2003, 2006, and 2009 I returned to Vanuatu, with support provided by a British Academy Small Research Grant (38582), the Getty Grant Project at the Cambridge Museum of Archaeology and Anthropology, and the Pacific Alternatives: Cultural Heritage and Political Innovation in Oceania Project (funded by the Research Council of Norway, Grant 185646), respectively. During this time, my work was greatly enriched by my lengthy collaboration with, and mentorship from, Anita Herle at the Cambridge Museum.

Fieldwork in Aotearoa New Zealand started in 2002, when I was invited to the Museum of New Zealand Te Papa Tongarewa to consult on the museum's role in the marketplace for Māori cultural property, and in 2004 I returned to make a larger study that evaluated the possibility of developing a bicultural valuation policy for the museum. This research was funded by a grant from the UK-NZ Link Foundation. My partner in research, Huhana Smith, and the other members of the Māori curatorial team, Arapata Hakiwai, Awhina Tamarapa, Matiu Baker, and Dougal Austin, provided guidance and support during this time, as did my close friends Jade Tangihuia Baker and Rachel Thompson. I returned to New Zealand to complete this research in 2006. In 2009 I was granted a Goddard Fellowship, with relief from teaching, from NYU. During this time, I was a Visiting Scholar at the Mira Szászy Research Centre in the University of Auckland Business School, sponsored by the director, Dr. Manuka Henare. During the final writing period, I benefited greatly from editorial advice and unflagging support in general from Lynn Meskell and Ken Wissoker, from the editorial guidance of Mandy Earley and Jade Brooks, and from the professional support of Duke's wonderful production team. The review process was truly a privilege, and I received constructive, engaged, thoughtful, perceptive, and expert criticism from the two readers for Duke University Press, which greatly improved the book. Rosemary Coombe was a provocative, inspiring, and generous interlocutor who really pushed me to think beyond myself in the final stages of editing the manuscript. The departments of anthropology and museum studies at NYU have proved wonderfully convivial places to work, and in particular I thank Bruce Altshuler and Fred Myers for their personal and professional support and their willingness to be interrupted and to give of their time. Tatiana Kamorina and Dorothy Rangel provided invaluable administrative support from within NYU Museum Studies. Eugenia Kisin created and checked my reference database and sourced the images, saving me an enormous amount of time, and proved an extremely constructive reader of my manuscript. Gerry Krieg of Krieg Mapping created the maps of Vanuatu and New Zealand. Image permissions and indexing were supported by a grant from the NYU Humanities Initiative.

I am enormously grateful to all of these people and institutions for the direct support that they have provided during this time. In addition, there are many others whom I have worked with, stayed with, broken bread with, and discussed ideas with and who deserve my heartfelt appreciation.

In Vanuatu: Marcellin Abong, Richard Abong, Vianney Atpatun, Abel Bong, Miranda Forsyth, Katherine Holmes, Kirk Huffman, Martha Kaltal, Sero and Regina

Kuautonga, Takaronga Kuautonga, Sara Lightner, Numa Fred Longga, Catriona and Armstrong Malau, Chief Willie Bongmatur Maldo, Estelio Maltaus, Jean François and Celine Maltaus, Richard and Esther Maltaus, Jean Mal Varu, Thomas Freddy Nagof, Anna and Anne Naupa, June Norman, Ralph Regenvanu, Veronique Rono, Benedicta Rousseau, Malcolm Sarial, Marie Sisi, Marianne Sokomanu, Monika Stern, Bule Tainmal, Hanghang Tainmal, Jack Taylor, Firmin Teilemb, Matthias Teilemb, Emmanual Watt, Connie Wells, Eric Wittersheim, and Gene Wong.

In Aotearoa New Zealand: Jade Tangihuia Baker, Matiu Baker, Deidre Brown, Mark Busse, Chanel Clarke, Jeanine Clarkin, Sue Crengle, Arapata Hakiwai, Manuka Henare, Te Kaha, Rangi Kipa, Marama Muru Lanning, Aroha Mead, Owen Morgan, Manos Nathan, Roger Neich, Rosanna Raymond, Amiria Salmond, Naomi Singer, Huhana Smith, Michael Graham Stewart, Awhina Tamarapa, Blaine Terito, and Rachel Thompson.

In the United Kingdom: Barbara Bodenhorn, Anita Herle, Susanne Küchler, Danny Miller, Chris Pinney, Simon Schaffer, Nicholas Thomas, and David Wengrow.

In the United States: Bruce Altshuler, Jane Anderson, Miriam Basilio, Joshua Bell, John Comaroff, Rosemary Coombe, Sonia Das, Fernando Rubio Dominguez, Tejaswini Ganti, Ilana Gershon, Bruce Grant, Stuart Kirsch, Tate LeFevre, Lamont Lindstrom, Sally Engle Merry, Lynne Meskell, Fred Myers, Robin Nagle, Anne Rademacher, Jennifer Stampe, Noelle Stout, Glenn Wharton, and Paul Williams.

A special category must be made for special friends: Jane Anderson, Jade Baker, Miriam Basilio, Sue Crengle, Kate Fletcher, Anita Herle, Kate Holmes, and Rachel Thompson. Ladies, thank you so very much for your friendship over the past few years.

Finally, this book could not have been completed without those who helped me at home during my research and writing. Thanks to my mother, Hilary, and my father, Robert, for being there (everywhere) whenever they were needed. To Danielle Vogel, Christie Ann Reynolds, Taryn Andrews (my Poet-Nannies), Khylee Baker, Nicola Jobson, and Rachel Kunde for their fantastic childcare. My deep and loving gratitude to my husband, Stephen Neale, who has encouraged, through his own precise language, a pursuit of clarity I have found invaluable. Thanks to my beloved Calliope, who came with me to both Vanuatu and Aotearoa and was a brilliant sidekick, even in the *nakamal*. This book is dedicated to my grandfathers, Harry Snitcher and Joseph Geismar, each thoughtful scholars in their own way, who both made successful lives in new places out of difficult beginnings.

An earlier version of chapter 4 first appeared as "Copyright in Context: Carvings, Carvers and Commodities in Vanuatu," in *American Ethnologist* 33, no. 3 (2005): 437–459.

An earlier version of chapter 6 first appeared as "Alternative Market Values? Interventions into Auctions in Aotearoa/New Zealand," in *The Contemporary Pacific* 20, no. 2 (2008): 291–327.

A Note on Macrons in Māori

Throughout the book I make use of the orthography provided by the online Māori dictionary, provided by Te Whanake Māori Language Online (www.tewhanake.maori .nz), developed by Auckland University of Technology Te Ara Poutama. All spellings of Māori words not in quotations have been cross-checked at www.maoridictionary.co.nz/, specifically developed for learning and teaching Te Reo Māori.

1 | Introduction

CULTURE, PROPERTY, INDIGENEITY

TREASURED POSSESSIONS EXPLORES THE WAYS in which global forms of cultural and intellectual property are being redefined and altered by everyday people and policy makers in two very different Pacific nations: Vanuatu and Aotearoa New Zealand. Vanuatu is a small Melanesian archipelago formerly under joint management by the French and British, which has been an independent republic since 1980. New Zealand, by contrast, is a settler state, a former British colony that recognizes the national entanglement of Polynesian and British heritage through the ethos of "biculturalism." The indigenous people of Vanuatu make up more than 95 percent of a country of just under a quarter of a million people (who speak more than 111 different languages), recognized by the United Nations as simultaneously having Least Developed status and having the world's greatest cultural and linguistic diversity. Māori, the indigenous people of Aotearoa New Zealand, make up nearly 15 percent of a diverse, multicultural population of nearly 4.5 million in a nation that increasingly sees its "knowledge economy" as at the forefront of national development.[1]

Despite these structural and cultural differences, indigenous communities in both countries use, and conjoin, intellectual and cultural property to frame profound sovereignty claims and assert new forms of national entitlement. In both countries, global concepts of cultural and intellectual property are appropriated and transformed by indigenous people who use them to vibrantly reimagine national polity, economy, and culture from the grass roots up.

The term *cultural property* is commonly used to refer to certain "things," traditionally the kinds of objects housed in the antiquities galleries of the Metropolitan Museum of Art in New York or the British Museum: collections of national patrimony held in trust by these elite institutions for their citizens and for the ultimate benefit of all humankind.[2] It is, in fact, a category defined by the intangibility of culture theory that holistically defines collective identity through a wide array of symbolic expression (see Brown 2003; Appiah 2006; Cuno 2008, 2009) and which acknowledges the dynamic power relations that underscore the value that is culture. Intellectual property, or IP, is commonly understood to apply to the immaterial productions of minds but is practically used to define ownership for resources that are becoming daily more tangible and broadly circulating. It is the distinct genealogy of these concepts within institutions and as instituted practices that has kept them apart: cultural property as the preserve of museums, heritage organizations, and cultural institutions and policies; IP as the preserve of trade, commerce, financial regulation, and industry. However, as will become apparent throughout this volume, there is a growing convergence of these two categories—it is increasingly difficult to tell the difference between intellectual and cultural property when copyright law is used to define ownership of the local carving traditions in Vanuatu, or when patents derived from indigenous flora in New Zealand are claimed as Māori cultural forms. I compare the ways in which cultural and intellectual property are defined, and come together, in these two "ethnographic" contexts to provoke a more nuanced awareness of the increasing complexity of these legal, political, and cultural forms.

The standard reference points for the study of IP are the corporate histories and agenda of Western capitalism (e.g., Coombe 1998a; Vaidhyanathan 2001). For cultural property theory, many people turn to global definitions of heritage, patrimony, and nationalism (e.g., Handler 1988; Coombe 2009). Here, I steer carefully through this literature without meaning to suggest that it is not important or influential. Instead, I undertake a form of "reverse anthropology" (following Kirsch 2006) in which I present an alternative way of understanding intellectual and cultural property from a different regional vantage point to the places in which I live and teach (Europe and North America). In doing so, I ask provocative questions about the power of communities to transform their legal, political,

and economic environments and about the role that cultural difference plays within this process of redefinition. Indigeneity is defined by an understanding of radical cultural difference: native people have claims to the land that predate the nation-state and these are discursively validated by mythic charter as well as by virtue of priority. How then are indigenous rights incorporated into generic legislation and state legal regimes? Is this ultimately empowering for indigenous people or does it merely recreate the existing power relations that so often subordinate them?

In this introduction, I describe the analytic frame, key concepts, and pressing questions I draw on throughout the book. Chapters 2 and 3 introduce the historical and political contexts of Vanuatu and New Zealand and set out in more detail the frames of indigeneity and law in both places. Most accounts of intellectual and cultural property tend to be formulated from one disciplinary vantage point (i.e., law *or* anthropology). I approach the nexus of culture, property, and indigenous peoples by linking perspectives gleaned from Pacific ethnography, legal anthropology, material culture studies, museum studies, and literature on indigenous identity and rights. I argue that intellectual and cultural property must be understood within a rich contextual framework that takes into account not just legal codifications but also popular understandings of law and the complex social and political histories and contexts that inform the production of property rights. In Vanuatu and New Zealand, this contextual framework includes colonial histories, the contemporary conditions of post- and settler-colonial nationhood, the different ways in which indigenous sovereignty is recognized, the experience of development, and the anthropological inscriptions of Melanesia and Polynesia. All of these frames inform how intellectual property and cultural property have become filters for connecting culture and creativity to new kinds of entitlement and processes of claim making. They influence the legal codes, popular understandings, modes of exchange, policy documents, political recognition, and material forms that compose both intellectual and cultural property.

Eliciting this complexity using ethnography provides a better understanding of local transformations of intellectual and cultural property in Vanuatu and New Zealand as processes of *indigenization* that work to redefine political authority, entitlement, and perspectives on property relations locally. My definition of indigenization does not refer only to the assertion of alternative political authority and economic entitlement by ethnically defined indigenous peoples (see Comaroff and Comaroff 2009; Li 2010), nor is it only a way of talking about particular grassroots forms of resistance and transformation (see Miller 1995; Sahlins 1999). I understand the process of indigenization through the lens of *provincialization* (following Chakrabarty 2000)—a concept that speaks to the

ways in which cultural difference may be used to re-center our view of global politics and directly challenge the perception that the global will always be elsewhere, in another "center" in relation to these "marginal" communities. For instance, copyright and trademark regimes in Vanuatu and New Zealand demonstrate how discourses of cultural and intellectual property are being used to challenge the relation between the local and the global and to explore the limits of both state and indigenous sovereignty. The new forms of cultural and intellectual property I discuss throughout this book are being indigenized—remade collaboratively in a local context that increasingly recognizes, and debates, cultural priority and difference as the basis for ownership and entitlement.

The indigenization of intellectual and cultural property in these two countries destabilizes assumptions about how "owners," "authors," "cultures," and indeed "things" are recognized in law and requires a reconsideration of what kinds of law are recognized within communities. This process draws indigenous people into dialogue with the state and challenges us to alter our perspective on both subject positions. The state as well as indigenous people may be understood as indigenized in Vanuatu and New Zealand, although this process occurs in very different ways in each place, inflected with very different power relations.

The commonsense meaning of "provincial" speaks not to the radical potential of the provincializing project but to the reactionary nature of the provinces that look continually to their metropolitan counterparts to show them how to dress, enjoy themselves, build cities, and develop citizenries. It is from this tension within the provinces—between emulation and independence—that new forms of the nation may develop. There is something both radical and reactionary in how Māori and Aboriginal Australian images were domesticated into the settler-colonial tea sets and dinner services in Australia and New Zealand (see Thomas 1999). Here, the British Empire itself was provincialized and its colonies made indigenous (Coombes 2006). Writing of this "Creole Europe," Pinney (2002) uses the idea of the figural or the material to identify the settler-colonial nation as a "reflection of a reflection." Here, I argue that models of intellectual and cultural property present similar refractions.

The forms of intellectual and cultural property that are being developed by the people I work with in Vanuatu and Aotearoa New Zealand use ideals of difference to posit viable alternatives to other, historically more dominant, property forms. Throughout this book I follow my interlocutors in questioning the terms of engagement between indigenous people and global property regimes. The dominant perspective of the global sees it as a kind of generification, a strategy for making the particular general that is inflected with all sorts of power relations (see Errington and Gewertz 2001). However, following Huffer

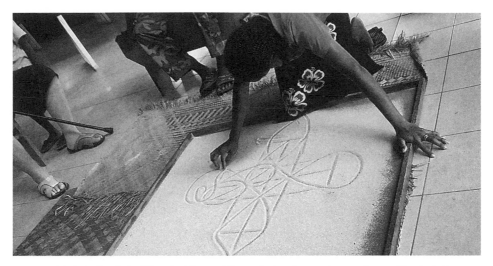

FIGURE 1. Lela Savina, from Lasive Village, North Pentecost, Penama Province, Vanuatu, demonstrating a sand drawing in the Vanuatu Cultural Centre, October 29, 2010. (Tarisi Vunidilo, Pacific Island Museum Association. Reproduced with permission.)

and Qalo (2004), I ask if we have been "thinking upside down" about the constitution of property, power, and culture both in the Pacific and internationally, and I challenge all of us to imagine what cultural and intellectual property might mean to us, if we thought of it as arriving *from* the Pacific, as a priori an "entangled object" (Thomas 1991). Two brief examples will introduce the complexity, interconnection, and comparative perspective on intellectual and cultural property that I track throughout the rest of this book in the specific contexts of Vanuatu and Aotearoa New Zealand.

Property Both Indigenous and Global

A group of tourists visiting the National Museum of Vanuatu notices a square tray filled with sand in the center of the gallery. As the visitors wander around the displays of traditional canoes and archaeological discoveries, a slight man and a young girl come into the space and stare intently at the sand, talking quietly. The young girl crouches, and with her right index finger marks out a grid in the sand. The girl then proceeds to draw out a schematic diagram of a turtle, singing as she draws (see figure 1). The older man explains what is happening to the museum visitors, who videotape the performance (later to be found

on YouTube). After a few moments, she scratches out the image and they both leave. It is as though nothing has happened.

This short performance may seem trivial, but in fact it is the product of a "new" frame for thinking about traditional knowledge in Vanuatu. Sand drawings come from the North Central region of Vanuatu. They are ephemeral linear designs, often depicting animals and birds, traditionally sketched with a finger into sand or dirt. These ancient images are inextricably linked to mythic narratives, children's songs, and ritual knowledge. The drawings embody complex forms of knowledge; for instance, some are necessary for entry into the afterlife, where upon death one will be required to complete a sand drawing in order to enter the spirit world in the fiery volcano on Ambrym Island.

In 2003 sand drawings were proclaimed to be "intangible cultural heritage," spearheading Vanuatu's participation in UNESCO's proclamation and subsequent convention and launching a nationwide grassroots research project, drawing together local fieldworkers, schoolchildren, ritual practitioners, curators, and cultural policy makers (Zagala 2004).[3] Alongside its customary presence in Vanuatu, sand drawing has been bureaucratized, standardized, and elevated into a national icon. This allows practitioners of sand drawing to participate in the circulation of global models of heritage that also map on to the commodity culture of tourism and other forms of international consumption, which have long-standing histories within the spread of colonial powers and the movements of people and resources that they engendered.

Popular and academic discussions of property still too often fall into polarizing language that distinguishes the "West" from the "rest," the alienable from the inalienable, the private from the communal, the colonial from the indigenous. The constitution of sand drawing as a form of intangible cultural heritage forges a new path through these debates, demonstrating what can happen when domains previously conceived as incommensurable come together. Intangible cultural heritage is itself an institutional rethinking of the global category of cultural heritage, defining and categorizing tensions between objects and rights, object and subject, bureaucracy and practice, local and global. In the context of UNESCO, intangible cultural heritage acts as a palliative to other, more rigidly objectifying legislation that in the past has been accused of fossilizing dynamic cultural practices, with lack of attention to the rights and needs of indigenous peoples in its Eurocentric orientation.[4] The official proclamation of sand drawing as intangible cultural heritage describes how it is a mnemonic for exchange and movement rather than a static representation: "Sand drawings often trace the movement of things (rather than their figurative form),

the characteristic flight of an insect, the way in which a flower blooms, or the route taken by people fleeing an enemy" (UNESCO 2000: 5). This draws on a formal understanding of property (and heritage) as a *medium* of exchange rather than a bounded object, a vehicle for relationships rather than a terminus for ownership.

A second example makes more explicit the global geopolitics that define intellectual and cultural property. In 2002 a German company, Media xs, sued the successful Māori singer Moana Maniapoto for damages after she used her name, Moana, on one of her albums (Solomon 2006: 361). Media xs claimed that it had already registered the trademark "Moana" in Germany for a number of its different products and services. After a lengthy suit, the case was settled out of court and the singer agreed to market herself under the name Moana Maniapoto and the Tribe. Several power struggles and inequities emerge here. First, there is the geopolitical context in which a German company can file for a trademark appropriated secondhand from another place without consideration of potential use of the word in that other country. Second, the framework of cultural production—here "world music," of which Germany is a leading consumer—has an unequal circulation, in which cultural difference is celebrated in the form of sound without recognizing relationships of ownership between sound and its creators (see Feld 2000). A "world" musician making her voice heard through the use of her own name on her own album challenges an IP regime in which personal names may be unproblematically translated into trademarks belonging to corporations.

Third, the case raises a provocation to the very idea of traditional knowledge and how it may, or may not, be framed by law. Moana (meaning "sea") is part of the lexicon of all Polynesian languages. Can it be owned at all? Did a German company trademark a personal name or a common Polynesian word? Are the boundaries of entitlement ethnic or national rather than individual or corporate? How can a discourse of cultural rights inflect our understanding of words as trademarks, personal names, or both? In this instance, we witness a victory for a private property regime, facilitated by an understanding of the commons in which property and culture are detached from one another. The legal case that resulted in the protection of the sanctity of German trademark law exposes structural imbalances, political hierarchies, and analytic tensions inherent to the implementation of these forms of property. But it also raises larger questions regarding the inevitability of this outcome and its dependency on being in a particular location on the planet rather than generic principles of law or property.

Even after it was lost, the case was influential in Aotearoa New Zealand, where it

became part of the growing local evaluation of IP from an indigenous perspective. Moana Maniapoto made a documentary film, which was screened on national television, that asked provocative questions about the implications and importance of IP for Māori. There has been growing indigenous activism in New Zealand to assert intellectual and cultural property claims both nationally and internationally. This feeds into one agenda of many indigenous rights movements to connect cultural rights to property rights. The codifications of culture that this conflation requires, which some authors perceive as irrational or even impossible (see, e.g., Brown 1998), are attempts to achieve parity within this global domain and to insist on these cases being heard in different places, where they may have very different outcomes.

Both of these examples show how ni-Vanuatu and Māori have connected to global discourses of intellectual and cultural property and created their own pathways through national, regional, and international efforts to frame traditional culture under these rubrics—in the process creating and circulating dynamic cultural forms that are simultaneously new and traditional. They show us the constraints that surround this process: idiosyncrasies of national law, continued legacies of colonialism, and the impact of international development and the global marketplace. We also see the pivotal role that key individuals, as activists, play in redefining and articulating vibrant manifestos for alternative models of sovereignty and citizenship, inspiring many other indigenous peoples throughout the region and beyond.

Ultimately, this book has been inspired by how people in New Zealand and Vanuatu are developing ways to articulate alternative imaginaries to the utopian templates of the free market, the global cultural commons, and the indigenous as the exception rather than the rule. As I show, these alternatives are more than just pipe dreams or naïve fantasies. They are, like the dream of the free market, global cultural commons, or a state-defined understanding of indigeneity, blueprints for action. These actions increasingly take place on national and international stages, but unlike the placeless free market or cultural commons, they emanate from specific communities and cultural landscapes and are grounded in an awareness of ancestral power and inheritance. Can this "cultural" perspective become the norm rather than the exception? Or must the state ultimately protect its citizens from too much culture in the judiciary? What happens to politics when culture extends out of the marketplace, moving from a form to be owned to a form of governance? All of the political and cultural movements described within this book are poised on the brink of this kind of transformation. They are clarifying what culture is at a time when many commentators challenge its

status as an analytic concept. The projects I explore in the following chapters may never bring closure to these debates, but they provoke a serious challenge to the foundations of sovereign governance for nations modeled on a colonial system, disputing the rationale that assumes the nation-state will retain ultimate mastery over all of a country's resources.

An Ethnographic Trajectory:
Multiple Frames for Thinking about Property

I have worked intensively within specific communities in Vanuatu since 2000, when I first went there to do doctoral research. Since then, my time has been divided between a base in Port Vila and extended periods of research in island villages, mainly on the island of Malakula but also in Ambrym and Pentecost. In Aotearoa New Zealand, I was invited in 2003 to participate in a museum-based project assessing value models within the Museum of New Zealand Te Papa Tongarewa because of my earlier research into the market for Pacific artifacts (Geismar 2001, 2008). Since then I have worked in New Zealand on several shorter projects in museums, galleries, and auction houses. Despite these differences in community engagement and immersion, I worked within a similar research framework in each country. In both places my project was initiated within national museums and extended outward from there to study domains of value formation framed by the marketplace for culture. In both places I investigated the emergence of national discourses around cultural and intellectual property in terms of the perspectives and practices of indigenous people, at the same time working to understand the experiences and rhetoric that compose and conceptualize indigeneity.

The perspective on property I develop here has its roots within anthropology, especially anthropology in the Pacific, which has long examined cultural difference in terms of property relations as a way to question the key values of the "West" or "Euro-America" (see Malinowski's, Firth's, and Strathern's work for three important historical examples). By provincializing ideas about property within my own ethnography, I want to overcome analytic divides that assume plural and often incompatible property relations that map onto different cultures or societies and that separate "cultural property" as an international discourse from local understandings of how "culture" may be owned, created, and transacted.

The Pacific, most particularly the regions of Melanesia and Polynesia, has long been used in the West as a cipher for ways of thinking about property and gift exchange in contrast to European capital and commodity exchange. Mauss's delineation of *The Gift*

([1923–24] 2000) drew on ethnography from Māori and Trobriand Islanders to think through a powerful alternative to the forms of exchange emergent in the industrial West, in which "what imposes obligation in the present received and exchanged, is the fact that the thing received is not inactive. Even when it has been abandoned by the giver, it still possesses something of him" (11–12). A complex body of anthropology, focused particularly on the region of Melanesia, has subsequently emerged to critically evaluate property relations.[5] Within this work, ontological assumptions about the relations between individuals and society, between persons and things, and between artifacts and the allocation of entitlements have been provocatively challenged using ethnographic material primarily from Papua New Guinea (e.g., Strathern and Hirsch 2004).[6]

Outside of the Pacific, there is a vibrant legal and anthropological literature that has greatly expanded the way in which we think about property more generally, moving away from a narrow perspective of commodity exchange and private property to a broader understanding of the many different forms of entitlement, ownership, authority, and creativity that the concept may address (e.g., Radin 1993; Rose 1994; Coombe 1998a; Hann 1998; Strathern 1999; Humphrey and Verdery 2004; Pottage and Mundy 2004; Carpenter et al. 2009). At the same time, many anthropological discussions of intellectual and cultural property (including many focused on the Pacific region) are still limited by analytic distinctions between gifts and commodity in which "indigenous" political economies (where exchanges are socially embedded in communities) are juxtaposed with a placeless, disembedded free market (where social relations are perceived to be sacrificed for an alienating and individuating focus on externally valued commodities) (e.g., Gregory 1982; Battaglia 1995; Strathern 1999). Talk about cultural and intellectual property still often presupposes a fundamental difference in the ways in which exchange relations and property rights are understood in different places such as "the Pacific" and "the West."[7]

When indigenous activists emphasize the lack of fit between Western intellectual and cultural property and their own cultural traditions and practices (see, e.g., Tauli-Corpuz 1998), this dichotomy is as important for them as a kind of political placement and activism as it is for drawing anthropological conclusions about the nature of culture (Carneiro da Cunha 2009). In New Zealand the language of indigenous property rights is intimately entangled in debates about sovereignty and governance. For instance, Māori scholars such as Aroha Te Pareake Mead (2004), Mason Durie (1998, 2003), and Barry Barclay (2005) have criticized the applicability of private property within a system that values principles of guardianship, cultural protocols, and interconnectedness (genealogy).

Maui Solomon, a Moriori/Māori lawyer, distinguishes between intellectual property rights (IPR) and indigenous peoples' rights and responsibilities (IPRR), claiming that there is a "fundamental clash between the ideological underpinnings" of these two domains (2004: 224). In Melanesia, scholars such as Lawrence Kalinoe (Kalinoe and Leach 2001), Jacob Simet (2000), Andrew Moutu (2007, 2009), and Ralph Regenvanu (Regenvanu and Geismar 2011) have highlighted the ways in which *kastom* (glossed as indigenous tradition and practice; see chapter 6) may provide an alternative trajectory for organizing relations of exchange and entitlement. In Vanuatu, intellectual and cultural properties are mobilized as forms of cultural preservation and as commentary on, and resistance to, development (see chapters 4 and 8). Despite the seeming hegemony of global market-places, new property regimes are being developed that accept communal ownership (in the case of the National Copyright Act in Vanuatu; see chapter 4) or the moral categories of indigenous communities as part of the marketplace (as in the case of the New Zealand Trade Marks Act, discussed in chapter 5). The acknowledgment that all property is a priori both cultural and intellectual in many indigenous communities is slowly emerging within the bureaucratic frameworks that institutionalize intellectual property and cultural property regimes (see J. Anderson 2005).

Here, I chart the emergence of attempts in Vanuatu and in Aotearoa New Zealand to seek broader recognition for the fact that struggles for power, a sense of globalization, and an imbalance of agency and authority are built into "property" everywhere, while also recognizing that discourses of alterity (as radical difference) are crucial to the formulation of alternatives (as models for viable change). This comes through very clearly in a rich body of commentary, emerging from activists, lawyers, and other stakeholders who have also theorized the commensurability of property models in relation to indigenous values, promoting new working models.

For instance, in an article charting the inadequacies of IP law for indigenous people, the Aboriginal Australian lawyer Terri Janke tabulates a series of oppositions: nonindigenous IP emphasizes material form unlike indigenous IP, which values oral transmission; nonindigenous IP emphasizes economic rights, while indigenous people emphasize the preservation and maintenance of culture; nonindigenous IP is individually owned, indigenous is communal; and, finally, nonindigenous IPR are generally compartmentalized into categories such as tangible and intangible, arts and cultural expression, whereas indigenous people take a holistic approach in which all aspects of cultural heritage are interrelated (paraphrased from Janke 1998: 58). Her interest, and her work for the World

Intellectual Property Organization (WIPO) (Janke 2003), is not to reify these divides but to renovate existing legal categories and create new (sui generis, or unique) ones, thereby combating the exclusion of Aboriginal Australians from global and national cultural and intellectual property regimes.

Globally, the extensive commentary around indigenous rights takes property rights as key to the struggle for self-determination (e.g., Langton and Council for Aboriginal Reconciliation 1994; Langton 2006; Horse Capture et al. 2007), although with various expectations of what this means. There has been an emergence of what might be called an "indigenous rights" theory of property that unites commentators from many different cultural contexts and that provides a platform for international connection, networking, and activism. This model highlights the vital importance of culture, constructs an ecology of property that connects culture to nature, develops the concepts of custodianship and sustainability, and emphasizes principles of self-determination and the importance of reciprocity, knowledge, and communication as integral to IPR (see Posey and Dutfield 1996; Solomon 2004).

Alongside the emergence of this global body of indigenous property theory, there are a series of other global perspectives from international organizations such as UNESCO and WIPO and instruments such as the Trade Related Aspects of Intellectual Property Rights (TRIPS) agreement of the World Trade Organization (WTO). These institutions have advocated the drafting of generic legislation throughout the world to protect local IP rights internationally and to promote a globally consensual political economy around their exchange and enforcement. This process includes indigenous people as workshop participants, authors of white papers, and consultants in different capacities and at different levels, with an increasingly transformative effect.[8]

There is a growing conceptual and institutional convergence of cultural and intellectual property internationally and an emergence not only of new languages of property but also of new global legal regimes. For instance, the TRIPS definition of IPR as "the rights given to people over the creations of their minds" (World Trade Organization n.d.) emphasizes that IP emerges at the very moment when the links between entitlements and ideas are consolidated (Blakeney 1996). Yet this definition cannot tidily fix the boundaries between persons and things. Recent discussions about genetically modified material, for instance, continually expand understandings of what kind of entities may be patented and of how these patents may be upheld (Boyle 1996; Pottage 2004). The emergence of traditional knowledge (TK) and traditional cultural expressions (TCE) as terms that

span the divide between, for instance, UNESCO and WIPO or between local communities and national legislation indicates the emergence of an expanded field that incorporates cultural into intellectual property and vice versa (J. Anderson 2009b).[9]

In this context, cultural heritage and IP provide divergent frames for the inclusion of indigenous peoples within global markets for culture. As a result of this kind of participation, UNESCO and WIPO now insist that IP rights are human rights (Grosheide and Brinkhof 2004: xii). Both WIPO and UNESCO provide powerful discursive frames and policy environments for navigating cultural rights and the commodification of culture. To an extent they also provide grounds for resistance: some indigenous commentators are wary of the commodity logic of the WTO but find themselves able to observe and participate within the WIPO process (with its investment since 1999 in the Intergovernmental Committee on Intellectual Property and Genetic Resources, Traditional Knowledge and Folklore). Many find the WIPO more sympathetic to grassroots cultural perspectives than UNESCO, whose cultural rights models are often perceived by activists as overdetermined by the governments of member nation-states.

There is therefore an accessible toolkit with which to problematize the exploitation of resources within indigenous communities both drawing on, and moving beyond, the binary of commodity/culture and the reductionist conflation of property and place. Within the Pacific region, there is a diversity of colonial experience (settler- and post-colonial); a diversity of ranking in terms of global wealth, GDP, and other international indices; a unique set of environmental challenges precipitated by both the expansive and limiting nature of island living; and intense cultural diversity in which exceptional linguistic variation jostles against the ubiquity of lingua franca such as Bislama and even English.[10] Vanuatu and Aotearoa New Zealand are unique, even within this region, in the ways in which indigenous people and discourses of indigeneity take center stage in discussions of national development and are incorporated into (and appropriated by) a successful national imaginary. I argue throughout this volume that this very fluidity may also provide an avenue for the assertion of significant grassroots empowerment as well as corporate political agency.

Culture, Property, Indigeneity

The categories "culture," "property," and "indigeneity" come together to provide a critical nexus for understanding the constitution of new economic imaginaries in Vanuatu

and New Zealand. Throughout this book I explore the different ways in which these three terms define and encircle one another. These imaginaries connect utopian visions of indigenous entitlement to models of national development.[11] Many provocations and disheartening policies surround the promulgation of new frontiers within intellectual and cultural regimes for indigenous peoples. In turn there are growing numbers of formal opportunities for indigenous imaginaries to be institutionalized in policy and practice.[12]

In general, anthropological and indigenous accounts (and combinations thereof) help us to think in diverse ways about the genesis of property models and where such models do and do not fit in different cultural contexts. There are many aspects of private property that do not "fit" with other models of property that recognize temporality, spatiality, and collectivity as factors determining ownership in places that have organized relationships of entitlement in various ways with different histories. Many anthropologists emphasize difference in order to privilege indigenous epistemologies and to present an alternative analytic to that of "Western" economics, for example (following Mauss's trajectory, see Graeber 2001). I am, however, critical of the ways in which difference may be magnified within academic debate to the point that "alterity" becomes a romantic charter that removes the possibility of shared conceptual structures, both cognitive and political. (This view is espoused, for instance, in A. Henare et al. 2007.) This reification of difference—perhaps unwitting, perhaps not—in fact supports the hegemony of the (colonial) nation as the only organ that can supersede partisan perspectives and truly legislate and define property relations (e.g., Brown 2004).

The geographical determinism that links property forms to particular locales undermines global indigenous rights movements; diasporic, urban, and unrecognized communities; and desires for inclusion in the context of enforced exclusions. New Zealand, for example, has been an enthusiastic proponent of neoliberal economic policies such as structural adjustment, and models of the corporation are increasingly used as a way to organize the dynamics of tribal organization (see Rata 2000).[13] Goldsmith sums it up eloquently in an article discussing the Waitangi Tribunal claim regarding Māori ownership of the foreshore (the part of the shore between the high-water and low-water marks) and seabed: "The question, then, is not just who owns nature or culture, in part or in whole, but who has the right to define which of these is which and how much of each is ownable. The answers to those questions are partly matters of culture, but the cultural values in question are shaped by a multitude of other factors:

legal traditions, historical changes in production, claims of class allegiance, and (in the case of the New Zealand foreshore and seabed dispute) relations of power in colonial societies" (2009: 336).

Commentators such as Brown (2003) and Kuper (2003) become alarmed when indigenous rights movements attempt to appropriate international remits concerning intellectual (and cultural) property from pluralist democracies. However, generic legislation is able to assimilate, or at the very least recognize, diverse understandings of entitlement. For example, a claim by six Māori tribes before the Waitangi Tribunal in Aotearoa New Zealand (Te Rōpū Whakamana i te Tiriti o Waitang Waitangi Tribunal 2006: 262), demanded recognition and protection of cultural and intellectual heritage rights in relation to indigenous flora and fauna and related traditional knowledge, customs, and practices. The claim reconfigures traditional connections to both indigenous cosmology and the environment and challenges the delineation of a pluralist cultural commons, explicitly using the language of IPR (see Solomon 2001; also see chapter 5 of this book). In Vanuatu, the incorporation of the legal category of copyright into traditional modes of establishing political and economic authority and the extension of this connection back into the international art market has accomplished a similar synthesis (see chapter 4). Many ni-Vanuatu and Māori are as interested in underscoring the crosscultural similarities between systems of entitlement as they are in exploiting their differences. A key question I ask here is to what extent this is possible under the differing conditions of post- and settler-colonial nationhood.

Provincializing the "Culture" of Property

Thinking about intangible cultural heritage in terms of sand drawing or German trademarks in terms of Māori language, rather than the other way around, turns our usual assumptions about the relationship of the global to the local on their head and re-centers the Pacific in a way akin to the "Surrealist Map of the World" (itself an artful representation generated by a metropolitan elite, enthralled by the commodity potential of all things Oceanic) (see figure 2). This contextual entanglement, with its ability to center a powerful discourse of alterity, was the provocation for my study, and it demands an ethnographic engagement above all others—an engagement that uses the trope of provincialization as the filter for understanding how intellectual and cultural property become indigenous.[14]

Despite a rich body of economic philosophy that argues to the contrary, property is

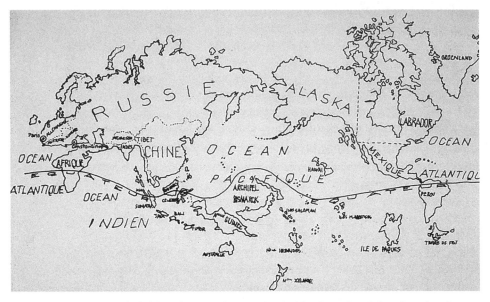

FIGURE 2. The Surrealist Map of the World. (Artist unknown, perhaps Paul Eluard, 1929; *Varietés*. Special Issue: Surrealisme en 1929. Brussels, Belgium)

not a necessary object. It is a contingent artifact, and like all artifacts it contains its history and its context in its form. As Rosemary Coombe notes, property is made up of "flexible nexi of multiple and negotiable relationships between persons and things that continually shift to accommodate historical recognitions of prior inequities and current social needs" (1998b: 208; see also Myers 2004).[15] Another of my starting questions is why is it that some forms of property have left behind their geopolitical markers and their social history, while others are marked as "alternative" or "cultural"?[16] I evaluate "cultural property" by following the long-standing Maussian tradition of dissecting our *own* assumptions about what property is and might be (see Strathern 1999), rather than by being distracted from this by searching for what it is in "culture" that can be owned in a narrow way (see, e.g., Brown 2003; Appiah 2006).

To exemplify, let us return again to the connections between sand drawing and intangible cultural heritage. The connection of these ephemeral marks from the South Pacific to this new form of heritage, via the bureaucracy of UNESCO, marks a local transformation of global understandings of cultural property and provides an entry into my use of the terms "indigenization" and "provincialization." Sand drawing is used by curators, village leaders,

experts in traditional knowledge, and policy makers in Vanuatu to articulate (in images) a theory of owning knowledge (or of cultural/intellectual property) that draws simultaneously on the international language of heritage and understandings of exchange and entitlement that emanate from the particular history and circumstances of the North Central region of Vanuatu. The initial intangible cultural heritage list was devised and approved by a jury drawn from UN member nations. One of the jury members was Ralph Regenvanu, then the director of the Vanuatu Cultural Centre, the head of the Vanuatu National Cultural Council, and currently (in 2013) a member of Parliament for the constituency of Port Vila (Vanuatu's capital), with his own political party, Graon mo Jastis Pati (Land and Justice Party). Regenvanu holds degrees in anthropology and development from the Australian National University and is also a practicing artist and musician. In commenting on the process of making the category of intangible cultural heritage, Regenvanu remarked to me that

> the Vanuatu conception of culture and cultural heritage, as demonstrated by the approach and activities of the VKS [Vanuatu Kaljoral Senta] since the '70s, was instrumental in framing the UNESCO conceptualization of ICH [intangible cultural heritage]. I was involved on almost all "expert meetings" called by UNESCO to define ICH and its scope and how it should be approached. I was also on the first jury of the masterpieces program which finessed the criteria for recognizing what are now called "representative" expressions of ICH by the Convention (rather than masterpieces) and I was also on the drafting committee for the Convention. . . . There is definitely an argument to be made that Vanuatu influenced UNESCO's conception and not the other way around.[17]

The global category of intangible cultural heritage, therefore, comes as much from Vanuatu as it does from anywhere else. This perspective re-centers the "alternative" space of the Pacific. Rather than seeing places that are incommensurably different, I see property regimes emergent in Vanuatu and Aotearoa New Zealand as creating new, potentially mainstream, models of property that draw from the toolkit of global culture and property theory in innovative, and sometimes surprising, ways.

I use the tension within concepts such as provincialization (following Chakrabarty 2002) and reversal (following Kirsch 2006) to elicit a deeper understanding of how cultural and intellectual property might be seen to be undergoing a process of indigenization in Vanuatu and Aotearoa New Zealand. As will become apparent, this process is co-produced

between indigenous people and the state. Both develop a vision of an alternative or transformative "other" that only exists in relation to a powerful overarching norm. In a dialogue about his book *Provincializing Europe*, Chakrabarty acknowledges "the indispensability of European political thought to representations of non-European political modernity, and yet . . . struggles with the problems of representations that this indispensability invariably creates" (2000: 22). Kirsch describes his concept of reverse anthropology in terms of perspective: "whether we should be doing anthropology as it has been done in the past (analyzing how others see our shared world) as opposed to doing reverse anthropology (examining how people analyze their *own* world, and its interaction with other worlds)" (2010: 90). He goes on to admit that this position fails him when examining climate change, the effect of which, whether man-made or natural, transcends any one perspective, linking us all together. Ideas of reversal and of provincialism neatly capture many of the tensions that inform local appropriations and national undertakings around cultural and intellectual property. These forms of property continually oscillate between provoking awareness of their transformative, adaptive, networked potential and how they are implicated in emulations of hegemony as dominance and imperialism (the two meanings of provincialism that I will explore throughout this book). It is for this reason that I see the projects of provincialization and indigenization as mutually constitutive.

Each chapter that follows examines the ways in which global and indigenous discourses about cultural and intellectual property intersect in Vanuatu and Aotearoa New Zealand. Contemporary copyright laws emerged initially out of the struggles between understandings of authors' rights as creators in relation to the entitlement claims of corporate monopolies.[18] Indigenous interventions seek to unite the interests of corporations, of individual authors, and of communities. In Vanuatu, copyright is a mechanism for formulating indigenous entitlement, extending indigenous values and exchange systems into other regimes of transaction, but it is also able to create and employ monopolies over resources in an increasingly competitive marketplace. We need to develop a way of talking about property that describes and understands all of these angles of use, description, and interpretation.

Sovereignty, Indigeneity, Law

Property is an implementation of sovereignty everywhere, whether or not it is acknowledged as such (see Moreton-Robinson 2007).[19] Cultural and intellectual property are at the forefront of struggles by indigenous peoples to claim and frame their identity,

because they wisely perceive that recognition of their identity is mapped onto their power to mobilize and control resources. I explore here how cultural and intellectual property are reworked in the specific postcolonial and settler-colonial contexts of Vanuatu and Aotearoa New Zealand. I approach cultural and intellectual property not simply as legal regimes but as zones of practice and enquiry that permit the organization and participation of settler-colonial and postcolonial subjects in both national and local forms of governance and within vibrant modes of cultural production. In thinking about the ways in which objects and governance intersect, I aim to contribute to legal anthropology and the study of law and society a perspective gleaned from material culture studies, critical museology, and Pacific ethnography.

The entanglement of property and sovereignty extends into the analytic frame. Commentators who criticize indigenous property claims as being strategically conflated with political claims to cultural identities (e.g., Brown 2003; Kuper 2003) often conflate (and naturalize) other kinds of property rights and political authority. These accounts obscure the inequalities—indeed, human rights abuses—that historically underpin indigenous claims. For instance, in a discussion about an influential article, "In Defense of Property" (Carpenter et al. 2009), Brown criticizes the authors' assertion that "the doctrine of sovereignty entitles Native Americans to "legal protection of, and autonomy over, their cultural resources." He argues that "they are trafficking in a slogan rather than a policy that stands a reasonable chance of implementation. No society can accurately be said to enjoy 'autonomy' over its cultural resources, although communities do have a modest ability to encourage and defend elements of culture that they value highly" (2010: 571; see also Brown 2004). For Brown, "sovereignty-thinking . . . hinder[s] the search for creative, pragmatic solutions to the unwanted circulation of traditional cultural expressions" (2010: 573). Carpenter, Katyal, and Riley reply, "We wish to clarify that many of the indigenous property claims we discuss within our article stem not from attempts to control public discussion, but from a desire to restore indigenous cultural properties to a comparable base-line of protections that many other social groups or individual property owners already enjoy" (2010: 584).

They go on to explain that the conflation of property and sovereignty is widespread and promoted not only by indigenous peoples, who tend to be excluded to a far greater degree than almost any other constituency. Brown's discomfort with "sovereignty talk" naturalizes one version of sovereignty as much as it negates another and fails to present a picture of the nuanced way in which sovereignty itself is zoned and might be unequally

applied (see Biolsi 2005).[20] Following Carpenter et al. (2009), we need not restrict ourselves to a vision of property that polarizes between private and other kinds of ownership. Property is a spectrum of necessary enterprise for thinking about sovereignty in contexts that are *always* cultural, where culture itself is shaped by the political process of recognition (see Bodenhorn 2004: 40). I focus on indigenous engagements with cultural and intellectual property to underscore the ways in which culture is a crucial resource in sovereignty talk and to challenge us to develop models of understanding these relationships that underscore their complexity and resist the foreclosures too often presumed by academic analysis.[21]

The complex relationship between property and sovereignty is mediated by the institution of law. Discussions within legal anthropology center on the tension between expanding uniform legal categories into new contexts or promoting legal pluralism as a road to fully extending cultural diversity into the domain of law (Merry 1988; Conway 2009). However, what is striking in evaluating the "indigenization" of cultural and intellectual property in Vanuatu and Aotearoa New Zealand is how much these categories are appropriated in ways that radically open up the nexus of law and governance and draw into question the assumptions of what legal pluralism, for example, even is (see chapter 3).

The models of property I discuss here are built from imaginaries of a different utopian property regime to that currently promoted by the (colonial) nation-state—those in keeping with the agenda of indigenous agents who seek to prioritize their own concerns, property languages, and experiences within a context in which access to money, global exchange, and international support is desirable and necessary yet is difficult to access and is fraught with complications. What would happen if the indigenous became mainstream? Why is this option so often foreclosed by the state? The hegemony of the West in property theory in Aotearoa and Vanuatu seems to be fracturing, and new ideas about cultural and intellectual property are emerging within the cracks. These new ideas are, however, still organized within old languages of ownership. If we return, as I do in chapters 4 and 5, to the emergence of these languages at the time when the state was born, we can see that colonial property relations may not be as inflexible or predetermined as we might assume.

To fully develop this perspective, we need to examine the ways in which indigeneity has emerged as more than a mode of being, but as a key political strategy to enter, expand, and complicate the encounter between local and global concepts of culture and property. Property itself plays a part in constituting indigeneity. Sui generis legal regimes are increasingly promulgated as context-specific solutions to the problem of the inapplicability of

"Western" or "Euro-American" generic property regimes. The ideal of sui generis, which is formulated to fit into a bureaucratized international legal regime while at the same time positioning itself as unprecedented within that body of law, may be seen to mirror tensions that emerge within the very context of the indigenous—a category of personhood and citizenship that is both exceptional and (often involuntarily) included in that which it is defined as apart from. Indeed, in policy documents and public commentary, sui generis law is often used as a shorthand for detailing indigenous interventions into existing legal frameworks.

Outline of the Book

This book compares the expansion and indigenization of ideas about cultural and intellectual property in the Pacific. Though this may sound like a description, it is in fact an argument. The argument is that we must understand the process of indigenization as a kind of provincialization, and that we need to re-center our understanding of the power dynamics, languages of law, and cultural imperatives that inflect the ways in which culture is both a mode of ownership and a form of sovereignty. Traditionally, both indigenous people and cultural and intellectual property have first been recognized and defined by the nation-state. Increasingly, however, the boundaries of state ownership and entitlement and the processes of recognition for indigenous people are being challenged from numerous directions. In the chapters that follow, I explore the ways in which cultural and intellectual property provide a conceptual frame for many of the imaginative enterprises that make up these challenges to, and rethinking of, state authority. To read this book is to undertake a comparative methodology in which one moves continually between divergent understandings of law, and processes of generification and indigenization (standardization and the production of radical difference). This book is intended to be a palimpsest in the same way that cultural and intellectual property is: uniting many different perspectives, arguments, and subject positions and provoking, through comparison, an altered way of understanding.

Chapter 2 explores the colonial and national histories of Vanuatu and Aotearoa New Zealand. It is important to have a sense of the historical trajectories of each country, the unique qualities of each nation, in order to understand how property relations play out in each place. Chapter 3 compares settler-colonial and postcolonial constructions of indigeneity and law and develops both a historical and comparative framework within which to

understand the ethnography of intellectual and cultural property that follows. Chapters 4 and 5 follow the history and contemporary progress of IP rights in Vanuatu and Aotearoa New Zealand, respectively, charting the involvement of copyright and trademarking in discourses of sovereignty, identity, and the ways in which they create different perspectives on value through their convergence with broader understandings of cultural property in each nation. Chapter 4 examines how the emergent national copyright regime in Vanuatu unites kastom copyright—theorized especially in relation to the ritualized hierarchies of ceremonies of status alteration on Ambrym Island, which I define in detail in the chapter—and national law, repositioning kastom practitioners as agents of national business. Chapter 5 discusses how, in Aotearoa New Zealand, the reform of the Trademark and Related Design Act, the development of the toi iho Māori Made trademark, and the increasing discussion of developing Māori brands initiate a similar convergence, but one that in its current form has provoked uncertainty and disappointment, even as it contains new hope for indigenous management of a Māori brand. Divergent legal histories and colonial or postcolonial expectation ensure that these IP regimes differ in their efficacy and in their power as national economic imaginaries.

Chapters 3, 4, and 5, read together, demonstrate the tensions that emerge in different kinds of states when indigenous culture is made to fit into state-sanctioned IP regimes. The second half of the book explores in greater detail the emergence of indigenous models of cultural property that in turn provide new ways to imagine the national economy. These chapters foreground the complicity of the cultural sector, most especially museums, in creating a powerful intervention into previous ways of thinking about national economy and markets. Chapter 6 introduces this framework by discussing some specifically Māori and ni-Vanuatu ways of thinking about the relationship between culture and objects and comparative formulations of indigenous property from the standpoint of local museums. I argue here that we can view Pacific museologies as re-theorizations of property relations from a "cultural" base and that this view should provoke us to expand our understanding of the role that museums play within society. An important theme of this book is the power of cultural institutions, particularly museums, to arbitrate and affect people's relations to the world of objects and thereby to configure property relations. The museums I discuss in Vanuatu and Aotearoa New Zealand are newly expanded and expansive institutions. The "object" world that interests them has also expanded to include the intangibility of ancestral efficacy, community activism, and untouchable artifacts (digital, oral, and ephemeral, such as sand drawing). At the same time, museums have their origins as colonial

institutions, originally founded and funded by agents of imperialism; they continue to function within a rationale that privileges some perspectives on objects and collections over others. Even within the burgeoning field of postcolonial, or indigenous, museums and museology, an uncomfortable sense of negotiation and confinement is experienced by indigenous practitioners—what Mithlo (2004) refers to as the "red man's burden"—who recognize the imbalance of power in the contact zone that is the contemporary museum and are often made responsible for fixing it (see Clifford 1997a).[22] Museums are not often used as lenses into the world of property relations, outside of a narrow formulation of cultural property that focuses on the legitimate ownership and trade of colonial collections and antiquities. Yet they are in fact excellent places in which to address the complex relations among people, objects, rights, and ownership regimes of institutional and other authorities. They are also places in which these issues not only are made visible, but also are increasingly given new form.

The second pairing of chapters charts efforts to reconfigure national cultural markets and promote the possibilities of exchange from an alternative base. Both the activism of Māori in the auction marketplace analyzed in chapter 7 and the Pig Bank Project in Vanuatu discussed in chapter 8 negotiate with commodity exchange and translate commodity value into other registers. In doing so, these projects work through museums to envisage powerful utopias that compete with the rules of the free market to define citizenship, entitlement, and the cultural practice of exchange.

The initiatives described here appropriate intellectual and cultural property and use them as a form of critique to redefine the boundaries of entitlement and self-determination in an environment in which nation-state sovereignty is increasingly compromised by multilateral trade agreements and international conventions. A discourse of treasured possessions, gleaned from museum models of cultural property, is increasingly extended outward to construct a vision of cultured resources, tangibles and intangibles made viable by the entitlements of culture as recognized by the state. The state itself is the ultimate provincial entity: continually emergent and transforming and continually looking back as it moves forward. New Zealand and Vanuatu are both marginal (in global terms) and central (in the Pacific). They are in fact in a privileged position from which to rethink the boundaries of property, sovereignty, and the entitlements of culture.

2 | Mapping the Terrain

CONCEPTUALIZED AS A "SEA OF ISLANDS" (Hau'ofa 1993) interconnected by shared histories of migration, ancestry, and the environmental and cultural concerns of a shared ecosystem, the Pacific has also been carved into a number of discrete divisions: tribal, ethnic, colonial, and national. Despite the lines drawn by national borders and the curtailments of treaties, the region is justly famous for its legacy of interconnection. Alongside long-standing indigenous connections through trade, exchange, and travel, the influence of the British and French (and, to a lesser extent, Spanish and German) as original colonizing forces, the subsequent emergence of Australia and New Zealand as "legacy" powers, and the growing influence of China have forged multiple political, economic, and social connections (Denoon et al. 2000). In New Zealand, most people think of the Pacific Islands in terms of their Polynesian neighbors (Tonga, Samoa, the Cook Islands, Niue). Māori look less to Melanesia as a place to find inspiration or to draw cultural affinities. However, there are many reasons why Māori might look to a place like Vanuatu for

inspiration. It is an independent nation-state where indigenous people have already negotiated national self-determination. Ni-Vanuatu, on the other hand, look eagerly to other Pacific countries in order to connect directly to the international network of indigenous peoples and to assert their identity and share their political struggles on a global stage.

Drawing Comparison

We need to understand the specific histories of place and nation in order to make sense of the ways in which contemporary Pacific islanders, such as ni-Vanuatu and Māori, trace connections and assert themselves as unique. At the same time, we need to recognize the entanglement of place and identity as they emerge from complex encounters and exchanges, colonial, indigenous, and otherwise (see Thomas 1991). It is this unique context that constitutes indigenous identities in the Pacific, and it is the practice of connection *and* boundary marking that inflects the production of property everywhere.

By comparing, throughout this book, different frames of indigenous identity, legal practice, museum culture, and discourses of ownership and property, I build a theoretical framework that juxtaposes and links the ways in which these frames are articulated in a comparative context. A series of "comparative" approaches infused the early ethnology of the Pacific, known as the "Oceanic" phase of social anthropology, in which the region became a laboratory for theoretical and methodological disciplining. The work of early British ethnologists such as C. G. Seligman (1910), W. H. R. Rivers (1914), and A. C. Haddon (1936) used Oceania (with a focus on Melanesia) as a laboratory through which to understand the process of cultural diffusion across large areas of land and ocean. They followed the presence of mythic culture heroes, language terms, and kinship forms between and across islands, tracing the connected ancestry of social forms.

This Oceanic phase of anthropology also mapped onto the so-called museum age, during which there was a convergence of object-based research and anthropological theory (Stocking 1985; M. Henare 2005). Most early anthropological comparison was museological and drew on the juxtaposition and formal analysis of museum collections. This comparative endeavor was for many years lost from an Oceanic anthropology that, prompted by the agenda of Malinowski, retreated into functionalist, symbolic, and structural accounts of village- or tribal-bound societies defined by their own internal logic, and later through negotiation with the (colonial) nation-state.

The anthropological conceit of comparison has primarily been associated by

indigenous peoples of the Pacific with a form of anthropology that imposed its own programmatic ethnic classifications and typologies, often used oppressively to the benefit of colonial authorities. As Strathern notes, "Comparative procedure, investigating variables across societies, normally de-contextualizes local constructs in order to work with context-bound analytic ones" (1988: 8). Here I aim to recuperate the process of comparison in a different manner—to provincialize the very act of comparison and highlight the benefits of understanding local contexts from the perspective of others, rather than from the detached bird's-eye of an imperialist social theory (see Fox and Gingrich 2002). This is a "provincialism," and a reversal, that is a helpful filter to understand intellectual and cultural property in diverse contexts and how we might understand "indigenous" intellectual and cultural property.

The falling away of outmoded classificatory systems based on museum objects was no bad thing, and museum anthropology has transformed itself through this legacy to become prominent in the criticism of colonialism (see Clifford 1997a, 2001). However, a strand of regional analysis in the Pacific that has productively maintained a comparative perspective is the broad study of objects and the development of a "cultural" approach to property relations. Mauss's seminal volume, *The Gift* ([1923–24] 2000), drew Māori concepts of Hau (the spirit of the gift) into conversation with the Kula exchange networks of the Trobriand Islands (and Northwest Coast potlatches), spanning the divides between Melanesia and Polynesia. Weiner's study, *Inalienable Possessions* (1992), drew on her research and that of Malinowski (1922) in the Trobriand Islands and also focused on Samoa, Tonga, and New Zealand. Thomas's influential account of colonial and native histories of exchange, *Entangled Objects* (1991; see also Thomas 1997), traced the history of colonialism in the Pacific through the circulation and exchange of artifacts. Recent collections (Jeudy-Ballini and Juillerat 2002; Bell and Geismar 2009) have developed this comparative perspective and have used the panregional movement and exchange of artifacts as a lens through which to understand the construction of culture and to meditate on the geopolitical and social identities of the Pacific Islands and islanders. This is the comparative perspective I develop here. I use the comparative method not just as a form of description but as a form of argumentation. I do not do so in the style of many of my anthropological predecessors in order to generate cultural (and ethnic) essentialisms; instead I promote a form of ethnography that uses comparison to demonstrate the creative tensions that lie in categories such as property as they span and are shared by different places, with varied histories and meanings.

In this chapter, I briefly discuss in parallel the histories of Vanuatu and Aotearoa New

Zealand. In chapter 3, I go on to trace points of convergence and dissonance in the ways in which indigenous identity and law frame the perspective on cultural and intellectual properties I uncover in the rest of this book. By comparing visions of cultural and intellectual property, national and local economies, participation in global markets, and the resistance and commentary of indigenous peoples with one another, we may complicate the received bifurcations that are at the heart of much academic and other analyses: indigenous and state, local and global, national and international (Strang 2006). This nuanced perspective can only be made within a comparative frame, which in turn alters the subjects that it purportedly only surrounds. The very idea of provincialization is itself, in this way, a comparative project.

Vanuatu

> *WE, the people of Vanuatu,*
> *PROUD of our struggle for freedom,*
> *DETERMINED to safeguard the achievements of this struggle,*
> *CHERISHING our ethnic, linguistic and cultural diversity,*
> *MINDFUL at the same time of our common destiny,*
> *HEREBY proclaim the establishment of the united and free*
> *Republic of Vanuatu founded on traditional Melanesian values,*
> *faith in God, and Christian principles,*
> *AND for this purpose give ourselves this Constitution.*
> PREAMBLE TO THE CONSTITUTION OF VANUATU

A group of more than seventy diverse, inhabited islands set in the western Pacific Ocean was first "discovered" in 1606 by the Spanish explorer Pedro Fernández de Quirós, although the area had seen waves of Melanesian migration going back at least three thousand years, with the arrival of the seafaring "Lapita" people (Gorecki 1996: 63; Bedford et al. 2007). The disparate islands were named the Great Cyclades by De Bougainville in 1768 and were more comprehensively charted in 1774 by Cook, who renamed them the New Hebrides.[1] The nascent archipelago nation united island clusters that had already formed discrete cultural groups through the passage of people on seafaring canoes; these people formed these bonds through trading pigs, turmeric, yam, taro, songs, stories, and ceremonies.

The first traders came for the trees on sandalwood-rich islands such as Erromango and

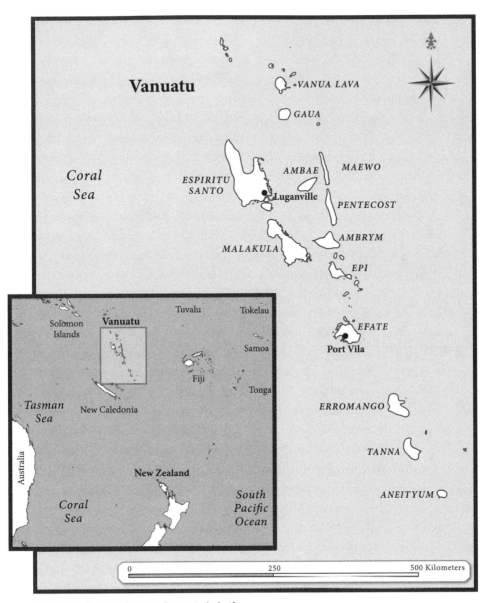

MAP 1. Map of Vanuatu, showing its location in the Pacific.

for sea cucumbers (*bêches-de-mer*) for export to China. At the same time (ca. 1863–1904), the labor trade moved significant numbers of ni-Vanuatu back and forth between home, Fiji, New Caledonia, and the Queensland sugar plantations (see Shineberg 1967; Jolly 1994b). Even before the arrival of plantation owners and labor traders, missionaries arrived to convert the islanders to Christianity. Despite the high-profile murder of an Evangelical minister, John Williams, on Erromango in November 1839, the islands were slowly colonized by waves of Presbyterians, Anglicans (predominantly Anglophile), and Marist Catholics (Francophile). Subsequently, a proliferation of newer (largely Anglophile) Christian churches arrived, and continue to arrive, in the archipelago—first Seventh Day Adventism and Church of Christ, and later Assembly of God, Jehovah's Witness, and Neil Thomas Ministry, to name but a few contemporary denominations. Pentecostal Christianity thrives as an indigenous and global medium that unites the performative efficacy of charismatic Christianity with traditional practices, bringing a local sense of international participation, redemption, and a national forum through which to excavate local authority in the face of external development (see A. Eriksen 2009). Christianity also exists in a problematic, yet creative, tension with the precolonial past and the celebration, and reinvigoration, of indigenous tradition, kastom (see chapters 3 and 6).[2]

From 1906 to 1980 the New Hebrides was governed by the Joint Anglo-French Condominium, an enterprise established out of the wrangle for control over trade and colonial domination in the Pacific. This system, better known as "pandemonium" (Lini 1980), comprised two post offices, two residencies, two commissioners, and two languages, and encouraged two broad kinds of Christianity, Anglo-Protestant and Franco-Catholic. Jurisdiction over the archipelago was divided into districts, each managed by a French and a British district agent, along with indigenous "assessors" and newly made "chiefs."[3] As Vanuatu was never technically a colony but a "region of joint influence," indigenes—the name "ni-Vanuatu" was taken upon independence—were denied citizenship by both Britain and France. They could, in theory, choose their jurisdiction but in practice were tried by a native court established to deal with "customary law." Unity consisted only in a joint court in which disputes over the thorny issue of land ownership were heard. The court was run by both French and British judges, presided over by a Spanish president and a Belgian public prosecutor, and proceedings often took place in four languages (French, English, Spanish, and Bislama—the developing national pidgin, now a creole). After independence both French and British legal systems were inherited in a curious mixture of pre-independence convention and postcolonial constitutional law (Corrin-Care and Paterson 2007: chap. 3).

During the period of Condominium governance, copra (dried coconut) became Vanuatu's main export alongside cocoa and cattle, and international shipping companies such as Burns Philps (now Unilever) established themselves in the burgeoning urban center of Port Vila, linking islands by running trading ships between plantations. During World War II, Vanuatu was a staging ground for thousands of American troops waiting to engage with the Japanese. The Americans kick-started urbanization in Vanuatu; they brought Coca-Cola, electricity, airports, and better roads to the country and impressed ni-Vanuatu with easier interethnic relations than those they had been used to from the British and the French (see Lindstrom and Gwero 1998). Encounters with the resplendence of American material culture and the wastage of war matériel also precipitated the emergence of quasi-religious political movements, coined by colonial administrators and other outside observers as cargo cults. Groups such as the John Frum movement on Tanna, started by the supposed clandestine movements of a mythic white man (Frum himself) who promised material plenty, a release from want, and a promised land of consumables, began to radically reject the past and to develop quasi-militaristic rituals. Cargo cults have been analyzed as performances of Melanesian encounters with modernity, protonationalist anticolonial movements, and emblems of a Western primitivism (see chapter 7). For certain, these social and political movements perform some of the tensions around different modes of production, consumption, representation, and ritual that continue to inflect contemporary life in Vanuatu and which inflect the ongoing indigenization of national property relations.

The period of rapid development that started during World War II peaked in the 1970s with a growth of ni-Vanuatu dissatisfaction with the Condominium government. Several pro-independence movements developed the desire for autonomous governance, land restitution, and the promotion of indigenous culture, galvanized by the recent independence of the Solomon Islands and Papua New Guinea. The Anglophone New Hebrides National Party (formed from the New Hebrides Cultural Association, and later to become the Vanua'aku Party) was led by an Anglican pastor, Father Walter Lini. The Francophone opposition party, the Union de la Population des Nouvelles-Hebrides, was supported by grassroots (often secessionist) movements such as Nagriamel, and was led by Jimmy Stevens on Santo and the John Frum movement (see Van Trease 1987; Lindstrom 1993; MacClancy 2002; Abong 2008; Tabani 2008). These two sides fractured a sense of potential national identity—the Vanua'aku Party modeled citizenship on its colonial predecessors who filtered business interests through the infrastructure of the nation-state

(promoting a strong national culture). The Nagriamel movement, sponsored by the U.S.-based Phoenix Foundation[4] and a loose consortium of French politicians and businessmen, drew on models of private enterprise as a foundation for "private" citizenship that provided space for a broader activation of indigeneity (promoting a weak national culture in favor of grassroots multiculturalism). While the Vanua'aku Party envisaged a postcolonial nation modeled on colonial order, Nagriamel imagined a charismatic nation that drew on multiple indigeneities as a basis for cooperation or "unity" rather than encompassment by a higher order of the state. These two models of citizenship and development continue to resonate and engage within local imaginings of the nation in the present day.

In 1975 the election of a Representative Assembly began a process of devolution toward internal autonomy. By 1980, just before the date set for independence (July 31), rebellions on Santo and Tanna had to be contained by Condominium police, eventually aided by the Papua New Guinea Kumul Defence Force (MacClancy 1984, 2002). Several people died. Many more, including Jimmy Stevens, were arrested, and the Francophone political opposition was suppressed, with much (continuing) resentment (Abong 2008).

The Anglophone party that was elected with a two-thirds majority chose the name Vanuatu, meaning "the country that stands up," out of an amalgam of indigenous languages for the independent nation. The new constitution returned all alienated land unequivocally back to its customary landowners. To this day, all land in the hands of the government or expatriates is rented on long-term negotiated lease (Regenvanu 2008). Following the basic tenets of the Vanua'aku Party, the modern nation considers its roots to lie equally in Christianity and kastom, exemplified by the coat of arms: a traditional chief presiding over the logo *Long God yumi stanap* (In God we stand). Despite the Anglophone origins of the contemporary nation, French policy and law continue to inflect the nation in varying degrees (Miles 1998), in particular as Paris continues to promote "cultural" development and offer financial support no longer provided by London.

The establishment of the Malvatumauri (National Council of Chiefs) and of the island councils of chiefs created a formal structure for implementing customary law within both national and local governance, as equal to the French and British legal systems, all of which were adopted as sources of law upon independence. The establishment of the Malvatumauri, which first met prior to independence in 1977, created a space for theorizing and codifying traditional governance and customary law at a national level, for instance, with the passage of the Chiefs Act (2006), which lays out the powers and responsibilities of chiefs throughout the archipelago.

At present, Vanuatu is divided administratively into five regions: TAFEA (comprising the islands of Tanna, Futuna, Erromango, and Aneityum), SHEFA (the Shepherd Islands and Efate), MALAMPA (Malakula, Ambrym, and Paama), PENAMA (Pentecost, Ambae, and Maewo), SANMA (Santo and Malo), and TORBA (the Torres and Banks islands). The current population is approximately 240,000, out of which roughly 113 different languages (not including dialects) are from the Austronesian language group (Tryon 1996). Vanuatu remains, linguistically, one of the most diverse parts of the world. The colonial inheritance of national, district, and village divisions continues to inform the organization of juridical, political, and economic domains. With the emergence of a younger generation of university-trained parliamentarians, the still-growing power of the chiefs, and the growing formalization of the National Council of Chiefs, the devolution of authority is currently being rearticulated in surprising ways with moves to decentralize government and increase the recognition of customary authority in the judiciary (Regenvanu and Geismar 2011).

Despite the reliance of roughly 70 percent of the country on subsistence horticulture (Vanuatu National Statistics Office 2000a: 35), the country is increasingly focused on the two urban centers: the capital city Port Vila, on the island of Efate (population 45,694 in 2009), and Luganville (population 13,484 in 2009), also known as Canal or Santo, on the island of Espiritu Santo. Since independence, there has been an increased effort to reduce the dependency of Vanuatu on foreign aid (Philibert 1981: 323), which today comes primarily from Australia, New Zealand, France, and China. (The UK officially withdrew its funding from the Pacific, closing its High Commission in Port Vila in 2005.) This was partially achieved in 1970 through the establishment of Vanuatu as an offshore tax haven and the subsequent development of a financial sector relatively large for a country of Vanuatu's size, accounting for 7.5 percent of the GDP and employing over four hundred ni-Vanuatu (de Fontenay 2000: 17, 22; see also Rawlings 1999a). Despite a recent growth in the tourist sector, it remains a fact that most people live without access to regular wages and are unable to afford rising school and medical fees.

Urban experience has developed its own mélange of commercial kava bars, kung fu movies, pornography, slot machines, luxury resorts, duty-free shopping, reggae, hip-hop, multiple Christianities, and political flux. The nation provides incentives and support for local businesses through the National Credit Union and Cooperative Society. The National Bank of Vanuatu (NBV), Telecom Vanuatu, and the new arrival, the private corporation Digicel, are spreading through the islands as they gradually gain electricity and cellular

coverage. Schools, hospitals, and cultural centers are slowly being built on other islands, but the ideal of development in the islands remains for many utopic; empty cooperative centers are due to failed business enterprises subject to the fluctuation of global markets and intemperate tropical weather conditions. Church and kastom are the primary organizational frames within which people manage their social, political, and economic lives and imagine themselves as part of the nation, but these two domains do not always sit comfortably together.

Village life is increasingly defined in relation to this dynamic—many people position themselves as aspirant urbanites, working in cash cropping and tourism in order to make money to send their children to school or with a view to gaining employment elsewhere. Or they celebrate their independence from these global circuits and champion self-reliance and the maintenance of their customary base. These are polarized imaginaries and both inform life for most people. With the frustrations of fluctuating global markets for kava, copra, vanilla beans, and coffee and the dependency of tourism on other countries' economic well-being, people increasingly have to think in terms of maximizing their local situation. The establishment in 2007 of a recognized seasonal employment (RSE) arrangement with New Zealand (and, in 2011, Australia) has had perhaps the greatest economic impact on ni-Vanuatu in recent years. At the end of the third season in 2010, 2,600 ni-Vanuatu were working in New Zealand on short-term visas, primarily in rural areas picking fruit, working in canneries, and so forth. This is thought to have brought over two billion Vatu per season into the country (Cullwick 2012).[5] These sums of money filter throughout the archipelago, bringing previously unknown levels of affluence to many families. The ni-Vanuatu population in New Zealand is, however, largely invisible, at best subject to resentment that they are undercutting local laborers and thus taking money away from the predominantly Māori and Pacific Island workforce in the regions where the scheme is strongest. Part of the aim of this book is to link ni-Vanuatu to Māori and raise awareness of parallel interests and cultural connections that may at first glance not be apparent.

Within this context the Vanuatu Cultural Centre and National Museum (known in Bislama as the Vanuatu Kaljoral Senta [hereafter VKS]) is perhaps the most influential national institution in terms of grassroots impact throughout the archipelago. Through its network of volunteer fieldworkers, the VKS has an explicit program to develop self-reliance through the promotion and strengthening of kastom—a category that it has been instrumental in shaping in the postindependence period. It increasingly works with NGOs and the government to develop strategic policies aimed at maximizing indigenous resources.

Through the media of radio and television programs, cultural festivals, and workshops, the VKS expands the newly national cultural sector into a strategy for governance and re-articulates the state's remit with regards to indigenous tradition. This is timely and necessary, as the flux and cronyism of Vanuatu's political parties, the frequent motions of no confidence and crisis of the parliamentary system, and the tense relationship between chiefs and parliamentarians frequently require mediation from national ombudsmen or even external agencies. The VKS provides a cultural "alternative," which is politically active without being contingent on party politics. It is engaged in the process of provincializing a number of key national frames, including cultural and intellectual property. Its work will be discussed in much greater depth throughout this book.

Aotearoa New Zealand

ARTICLE THE SECOND

Her Majesty the Queen of England confirms and guarantees to the Chiefs and Tribes of New Zealand and to the respective families and individuals thereof the full exclusive and undisturbed possession of their Lands and Estates Forests Fisheries and other properties which they may collectively or individually possess so long as it is their wish and desire to retain the same in their possession; but the Chiefs of the United Tribes and the individual Chiefs yield to Her Majesty the exclusive right of Preemption over such lands as the proprietors thereof may be disposed to alienate at such prices as may be agreed upon between the respective Proprietors and persons appointed by Her Majesty to treat with them in that behalf.

KO TE TUARUA

Ko te Kuini o Ingarani ka wakarite ka wakaae ki nga Rangitira ki nga hapu—ki nga tangata katoa o Nu Tirani te tino rangatiratanga o o ratou wenua o ratou kainga me o ratou taonga katoa. Otiia ko nga Rangatira o te wakaminenga me nga Rangatira katoa atu ka tuku ki te Kuini te hokonga o era wahi wenua e pai ai te tangata nona te Wenua—ki te ritenga o te utu e wakaritea ai e ratou ko te kai hoko e meatia nei e te Kuini hei kai hoko mona.

ARTICLE II OF THE TREATY OF WAITANGI[6]

Māori trace the origins of the islands to the time of the gods, when Maui and his four brothers fished up Te Ika a Maui, the North Island of Aotearoa. Te Waka a Maui, the South

Island, is Maui's canoe. Māori trace their physical arrival to Aotearoa through a number of voyaging canoes from the ancestral home of Hawaiki in Eastern Polynesia. The canoes (and in particular those included in the theory of the Great Fleet [S. Smith 1904]: Aotea, Arawa, Tainui, Kurahaupo, Takitimu, Horouta, Tokomaru, and Mataatua) carried people, *kūmara* (sweet potato), animals, and tools. These voyaging people established *iwi* (tribes) and *hapū* (subtribes and extended kin networks) that made up the social units of Māori society. Archaeological evidence shows the Māori settlers came most recently from the eastern Pacific (probably Tahiti or the Marquesas Islands) about one thousand years ago, and while the Great Fleet theory has become discredited, it has provided a founding charter and symbolic resonance for both the unity and diversity of Māori people (see map 2).

Until the arrival of Captain Cook in 1769, Māori (meaning normal people) lived as the *tangata whenua*, the people of the land. They referred to themselves not as Māori but according to their hapū affiliation, and at times in reference to their iwi or *waka* (canoe). They lived as agriculturalists and fishers, in dense settlements in a sparsely populated land-scape, and marked their boundaries with each other through intertribal marriage, alliance, and warfare. Cook's arrival heralded a lengthy process of negotiation between the Crown and Māori and, despite early efforts by the Dutch, kick-started British colonization.

There is a lengthy history of Māori investing in more generic or national discourses of rights as specifically indigenous peoples (united with a pantribal identity, not just as groups of people organized by iwi, hapū, or *whānau*, family). In this way Māori have been constituted as a people, not just by the visions of the colonial Crown but also as a result of their own engagements with the process of colonization. In October 1835 a group of Māori *rangatira* (chiefs/leaders) met James Busby at his house in order to discuss their Declaration of Independence, signed by thirty-four northern chiefs on October 28, 1835 (see M. Henare 2003: chap. 3). Busby sent it to the king, and it was formally acknowledged by the Crown in 1836. Signings continued until July 22, 1839. By then, fifty-two names were on the Declaration. Whereas Busby was concerned to protect the fledgling colony from the colonial interests of the French, the rangatira considered the Declaration of Independence a necessary step toward establishing the confederacy they felt was vital for them to be taken seriously as a sovereign nation. Manuka Henare (2003) argues that a sense of sovereign nationhood was a natural result of the expansion of trade and political authority necessitated by the globalizing forces of imperialism in the nineteenth century.

Historical memory of the Declaration of Independence has been largely over-

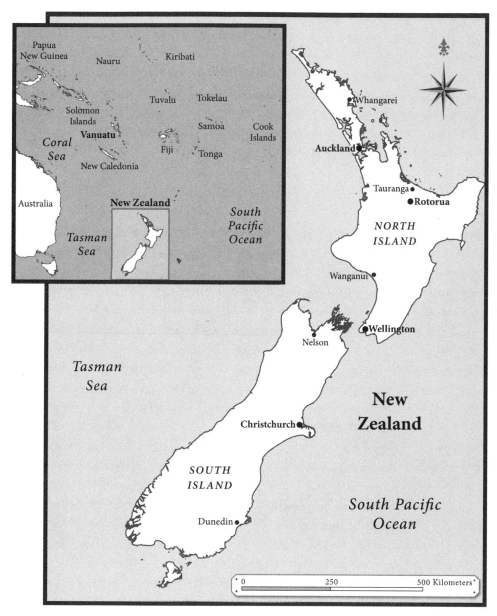

MAP 2. Map of New Zealand, showing its location in the Pacific.

shadowed by the Treaty of Waitangi, signed on February 6, 1840, by more than five hundred Māori chiefs and representatives of the British nation, which rendered the Declaration void. However, the Declaration illuminates many of the key debates surrounding the interpretation of the Treaty in the present day—most of which focus on how the Treaty made a distinction between governance (*kāwanatanga*) and sovereignty (*tino rangatiratanga*). Unlike the Treaty, which exists in two languages, the Declaration was written first in Māori. The Declaration of Independence was an unequivocal affirmation of indigenous sovereignty within a native idiom. Translation into other registers (of power as well as language), rather than being simultaneous, was subsequent.[7]

This specific history, a complement to the more widely known story of the signing of the Treaty at Waitangi, provides us with an important reading to the constitution of indigenous property rights in the present day. From the start of the settler state, indigenous identity has been constituted not only as a tribally based alternative to the model of citizenship provided by the British Crown but also as an alternative vision of the nation.[8]

However, these nuanced engagements have been historically overshadowed by the Treaty of Waitangi. There were two versions of the Treaty (in English and Māori) and several circulating copies have differed on crucial points of translation and interpretation. The version of the Treaty that is most consistently considered "correct" consists of a preamble and three articles. Article I of the English version signs the rights of "sovereignty" in New Zealand over to the British Crown. In the Māori version, something quite different (kāwanatanga, or governorship) was granted to the Crown. Article II reserved Māori tino rangatiratanga—full sovereign authority—over their lands, forests, fisheries, and "me o rātau taonga katoa" (everything they valued). Article III states, in English, that everyone in New Zealand would have the rights and privileges of British subjects. (This overview and translation is drawn from Williams 2005a: 95.) The complexities of Māori/Pākehā (white settler, of European, primarily British, extraction) relations, later to be theorized as biculturalism, were thus enshrined within this document in 1840, even though the Treaty was not formally recognized until 1975 by the New Zealand government. Since 1840, issues over governance versus sovereignty, the definition of *taonga* (what is to be treasured), and the status of Māori as governable citizens in relation to an alternate view of more independent indigenous sovereignty have continuously been debated. In particular, the separation of governance and sovereignty continues to dictate the power relations of the contemporary settler-colonial state. However, unlike the case of the New Hebrides, the Treaty made Māori citizens of the British Empire, and this expectation of inclusivity

has also colored debate about the exceptional status of indigenous rights in New Zealand.

Almost immediately, the promises of the Treaty were neglected and negated as Māori and settlers entered into a series of violent conflicts over land. The Land Wars of the nineteenth century eventually alienated twenty-two million of the country's twenty-six million hectares (Sinclair 2003: 2) and resulted in a decimation of Māori communities through fighting, disease, and dispossession. Established in 1865, the Native Land Court "proved to be an effective mechanism of subtle conquest" (Belich 1997: 94), supposedly providing an avenue for hearings around unsatisfactory land dealings but in fact making land much easier to alienate and disempowering Māori within many of these transactions (Banner 2000).[9] Governor George Grey conceived of confiscation as a strategy of making Māori pay for the war, in turn seizing many of the best properties and the most fertile land. The majority of Māori now live in urban areas.

Despite the entwined anthropological and colonial narratives of a disappearing people common throughout the "fourth world" (Wolfe 1999), Māori developed cultural and political tools of survival.[10] Cultural renaissances occurred at the start of the twentieth century with government-driven development of the geothermal area around Rotorua as a center for tourism and traditional arts (Neich 2001). Religious renaissances occurred with the prophetic movements of Te Ua Haumēne, Te Kooti, Te Whiti, and Rua Kēnana (Binney 1997; Sinclair 2003: 1), faith-based resistance movements focused on self-determination and the protection of sovereignty using the Bible (especially the Old Testament) as a founding charter. Political movements such as The King Movement and The Young Māori Party organized and negotiated on a local and national stage for Māori rights, drawing on the global languages of monarchy and parliamentary government. Significant numbers of Māori enlisted in both World Wars, demanding equality and recognition as citizens of New Zealand and of the Commonwealth. Key figures such as Sir Apirana Ngata and Maui Pomare became prominent in government and influential in the administration of Māori affairs.

The formation of the New Zealand state inculcated themes of governance that also persist into the present. In the nineteenth century, New Zealand "became one of the most self-consciously democratic societies in the world" (Hamer 1997: 131), establishing universal adult suffrage years before the United Kingdom or the United States. The nation was dominated by the Liberal Party with strong socialist leanings for much of the late nineteenth and early twentieth centuries. However, the worldwide depression in the 1930s and the global impact of World War II drew New Zealand into a worldwide theater

of concern for national development. The postwar period, as the country moved away from British influence, was marked by an increasing move toward neoliberal economic policies and development.

In the 1970s, in response to the continued suppression of Māori rights and bald statistics indicating that Māori continued to suffer in terms of general well-being (see Pomare et al. 1988; Harris and Robson 2007), a second Māori "renaissance" emerged once more on all fronts. Culturally, Māori literature, music, and art were increasingly celebrated internationally, exemplified by the *Te Māori* exhibition that opened at New York's Metropolitan Museum of Art in 1984 (see chapters 5 and 6). Socially, Māori activists campaigned for welfare issues around health care, social security, and education, and a new generation of Māori began attending universities, graduating as doctors, lawyers, and other professionals. Māori Studies emerged within the universities as a discipline that asserted representational control over Māori issues (rejecting anthropology as the academic domain that spoke for Māori). In particular, the Māori Education Movement forged a profound critique of the politics of knowledge, advocating for Māori language to be taught from preschool (through the development of Kōhanga Reo, Māori language nests for infants) through to the tertiary level of indigenous universities (Wānanga) and for Kaupapa Māori (Māori philosophy and perspective as the framework or set of principles for education, political engagement, development, research, and so on) to become the basis of a Māori epistemology that would inform both academic analysis and public policy (see Linda Smith 1999; G. Smith 2003).

Politically, intense activism, such as the massive Māori Land March of 1975, precipitated a reexamination of the Treaty of Waitangi and a public acknowledgment of the Crown's failure to hold up to its end of the contract. The Waitangi Tribunal, founded in 1975 by the Treaty of Waitangi Act, is an advisory body implemented to address wrongdoings under both the provision and spirit of the Treaty, primarily in the domain of land/property rights and asset management. In 1985 the Treaty of Waitangi Amendment Act backdated claims to 1840. The cutoff for raising historical claims was set at September 2, 2008, with the aspiration that all historical claims will have been heard and reported on by 2020. This new juridico-political infrastructure implemented a broader discourse of biculturalism. However, the framing of biculturalism rather than, for instance, binationalism, and the advisory rather than juridical capacity of the Waitangi Tribunal meant that this reconfiguration has been primarily one of cultural framing and a reimagined being-in-the-state, rather than a specific implementation of real power sharing by the government. The

Tribunal establishes a moral framework for the recognition of indigenous rights, which is then translated into governance through the infrastructure of the settler state (see Coates, McHugh, and Durie 1998).

In turn, biculturalism has superseded the multicultural facts of a country that has, since 1945, seen successive waves of migrants from the Pacific Islands (primarily Tonga, Samoa, the Cook Islands, Nuie, Fiji, Tokelau, and Tuvalu) and Asia (primarily from China, India, Korea, the Philippines, Japan, Sri Lanka, and Cambodia). Māori currently comprise about 15 percent of the total population (as of the 2006 census).[11] Statistics New Zealand projects that they will make up 17 percent of the total population by 2021 (Harris and Robson 2007: 15), but with rising birth rates, some projections estimate that they may make up close to 50 percent in the next one hundred years.

The Waitangi Tribunal describes biculturalism as "an integral part of the overall Treaty partnership. It involves both cultures existing side-by-side in New Zealand, each enriching and informing the other" (O'Sullivan 2007: 21). Biculturalism provided a platform for policy and practice to open a new space for Māori people and to recognize the founding charter of the nation-state. But from the start, the relationship between the two cultures has been different and uneasy, and the tensions in the Treaty of Waitangi have made it hard to bridge universal and particular models of citizenship. As Rata notes, the stereotype of Pākehā as "a perceived Western culture of alienated and fragmented individuals" is countered by a bucolic view of Māori as "communal, spiritual with emotional and spiritual links to the land," with community identity trumping any sense of possessive individualism (2000: 26–27). The paradoxes of biculturalism—that the inclusion of indigenous peoples in the formulation of the state threatens to undermine both the idea of indigeneity and the structure and authority of the liberal democratic state—have been increasingly recognized. So much so that biculturalism, despite remaining a supposed mandate for state practice, is increasingly viewed as an ideology of the 1980s and 1990s (Durie 1998; Rata 2005; O'Sullivan 2007). In the present, commentators prefer to focus on indigeneity and multiculturalism as guiding tropes for understanding Māori relationships with the state, drawing on models of indigenous rights in Australia, Canada, and the United States. Perhaps it is no coincidence that this discursive shift mirrors the recent political shift from Left to Right in the New Zealand government. O'Sullivan comments that "the defining character of contemporary Māori policy debate became the clash between self-determination, which gives theoretical articulation to the politics of indigeneity, and the reemergence of assimilation [through the ideology of multiculturalism] as a

subtle although not explicit policy objective" (2007: 1). In turn, Māori commentators have begun to contrast biculturalism as a state-led ideology with tino rangatiratanga (translated as "absolute authority, self determination, sovereignty, independence" [Melbourne 1995: glossary]), one of the fundamental rights guaranteed by Article II of the Treaty.[12]

Māori have benefited from some of the official policies of biculturalism. They have gained funding for language and culture, reasserted property rights to valued resources, and positioned themselves in unique ways within government and in relation to the physical space of New Zealand—recognized as both owners and custodians of key resources like greenstone and Aoraki/Mount Cook. However, recent controversies over ownership of fisheries and the foreshore and seabed show how biculturalism is limited by the government's view of its own sovereignty as defined by the ability to mobilize and exploit natural resources. The question is how much biculturalism in fact furthers the power and agenda of the Crown-led nation or genuinely opens a space for indigenous participation as equals. Metge (2010) describes how this tension is inflected in the ways in which Māori language has been adopted into New Zealand English. Even as the numbers of fluent speakers of Māori has diminished, key words have been brought into the mainstream to be used by all New Zealanders. The everyday presence of words such as *taonga, mana, tapu, marae,* and *hui* extends the representational authority of Māori but also indicates a broader process of co-option, appropriation, and nation building. In the 1980s the government embarked on a structural adjustment program that ushered in a period of neoliberal reform marked by privatization and a market approach to such public services as education, health, and so on (Bargh 2007). In the context of neoliberal policies of economic development and global expansion, with New Zealand moving directly from an agrarian to an information-based economy (sidestepping the industrial age, more common to the progressive development of capitalist nations, as the charter myth of the nation argues), it can be argued that biculturalism has also paved the way to theorize Māori as citizen-consumers, providing a branding and image for the state (Williams 2006; also, see chapter 5).

It is important to realize that even in the present day, Māori life expectancy is lower and mortality higher than for most other New Zealanders. Rates of cardiovascular disease, heart failure, premature birth, SIDS, some cancers, and diabetes are all significantly higher than in non-Māori New Zealand populations (Harris and Robson 2007: 33). Māori are more likely to go to prison and are more likely to commit suicide (33). They earn less and are less involved in higher education; their unemployment rates are three times higher than that of Pākehā aged fifteen and over (23). In short, despite the supposed egalitarianism

of neoliberal reform and despite a discursive commitment of government toward the ideology of biculturalism, the effects of colonialism are still marked on the bodies and well-being of Aotearoa's indigenous people. This is the stark reality that lies behind many of the initiatives and debates that I will go on to chronicle here.

These two brief historical accounts highlight the ways in which Māori and ni-Vanuatu are positioned in relation to distinct national cultures with very different lifestyles. The comparative effort I make in this volume was triggered by a conversation I had at the Ministry of Economic Development in New Zealand, where I had been invited to talk to attendees of their Indigenous Knowledge Seminar Series about copyright in Vanuatu. After presenting some recent developments in copyright (recounted here in chapter 4), a prominent Māori lawyer commented that she felt the emergence of sorcery in Port Vila as a strategy to enforce customary entitlement was something that ni-Vanuatu would surely "grow out of, as Māori have." The perception of sorcery as primitive and backward speaks to how Melanesians are often perceived by Polynesians to be less developed. This internalizes a colonial model of progress that uses global indices of development to evaluate cultural difference. Sorcery in the present day, which has emerged globally as a strategy of grassroots agency, cannot be explained through a progressive model, but only through a comparative lens (see Comaroff and Comaroff 1993). In the following chapter, I describe the emergence of ideas about indigenous peoples and law to highlight the ways in which these specific histories play out in the indigenization of intellectual and cultural property and to emphasize that intellectual and cultural property in Vanuatu and New Zealand are the outcomes of the interplay of colonial and postcolonial engagement, the politics of recognition, and the nature of indigenous culture. The rest of this volume explores the ways in which forms of intellectual and cultural property have emerged within these local histories of colonial power sharing, indigenous resistance, and cultural production.

3 Indigeneity and Law in the Pacific

IN THE PREVIOUS CHAPTER, I gave a condensed outline of the parallel histories of governance, colonialism, and development in Vanuatu and New Zealand, setting the stage for a comparative project that will follow the pathways of intellectual and cultural property in each country. In this chapter, I introduce the way in which key discourses of the indigenous and law are constituted in Vanuatu and Aotearoa New Zealand. Now that the historical facts have been established, I can resist the presentation of Vanuatu and New Zealand as discrete island nations and highlight the ways in which they share and alter ideas and ideologies that circulate internationally. By shifting between local, global, and indigenous frames, I develop a comparative perspective for understanding how intellectual and cultural properties are constituted and consolidated. These property forms develop in relation to the perceived standardization of global instruments (such as the Trade Related Intellectual Property System [TRIPS]); in the context of an ongoing and thoughtful consideration of regional interests, efforts, and differences; and in relation to local ways

of articulating relations of entitlement and sovereignty over property. Throughout this book I identify these local ways as both indigenous (unique and alternative) and provincial (re-centered in relation to a colonial dynamic).

The Constitution of the Indigenous in Vanuatu and Aotearoa New Zealand

The term *indigenous* is generally used in relation to people defined "in terms of collective aboriginal occupation prior to colonial settlement" (Trask 1999: 33). Globally, it is principally used either to refer to the marginalized aboriginal peoples of land still colonized by others—the inhabitants of "fourth worlds"—or to refer to a specific national identity for (postcolonial) citizens who define themselves through common discourses of race, ethnicity, and culture that transcend all other identities by virtue of ancestral priority and mythic charter.

Settler-colonial indigeneity is at the forefront of a global image of indigenous peoples as dispossessed minorities within their own lands who struggle to maintain spiritual, political, and economic sovereignty and achieve self-determination (Niezen 2003; Coombes 2006; de la Cadena and Starn 2007).[1] The long struggle to pass the United Nations Declaration of Indigenous Rights and the reluctance for many years of the settler colonies Canada, New Zealand, Australia, and the United States to endorse the draft Declaration highlights the tensions that arise from the co-production of indigenous people and the state (Oldham and Frank 2008). Yet despite the dependence on indigenous identity on the invasive infrastructure of the nation-state, the United Nations Permanent Forum on Indigenous Issues emphasizes self-definition as intrinsic to the delineation of indigenous identity, maintaining a decentralized flexibility to the category (Corntassel and Primeau 1995).

The recognition provided by institutions such as law, government, and cultural policy not only impact indigenous peoples on the ground—they also forge the ways in which they are allowed to "be" (see Clifford 1988a; Coombes 2006) As Povinelli points out, this often entails a "necessary failure" of indigenous identity in which a focus on incommensurability forces indigenous people to always be outside that which in fact brings them into being as political subjects (2002: 56; see also Cattelino 2005: 196; Cattelino 2010). Many analysts perceive the very concept of "indigenous" to emerge from the global system whose authority it rejects and emphasize how the transnational forces that give the indigenous

rights movement power also diminish its authenticity (Tilley 2002; Kuper 2003).[2] Being indigenous thus signifies a state of subjectivity in relation to the state and a political position as well as the personal, domestic, social, and cultural worlds of marked communities.

Alongside this global ecumene of indigeneity, indigenous rights movements have emerged around the world in different ways as constituted by the specificities of colonial experience, contemporary formulations of ethnicity and culture, contemporary political economies, and so on. It would be a mistake to map the definitions of indigenous in African countries onto Latin America. Here, I focus on the specific ways in which understandings of the indigenous emerge in the Pacific Island region, highlighting the ways in which being indigenous is both highly specific to local context and also generic in terms of constituting a shared discourse and political position.

In Vanuatu, even though it is populated by an indigenous majority, being a ni-Vanuatu citizen does not ensure that one is indigenous.[3] The term *kastom*, a gloss for indigenous tradition (see chapter 6), refers to that which comes from the islands, authenticated by ancestry and by fundamental connections to place (in Bislama, *ples*) by birth and inheritance. *Ples* is a more complex concept than land or territory—evoking symbolic, metaphorical, and poetic as well as material and ancestral connection (see Rodman and Rodman 1985; Bolton 1997). It evokes indigeneity in a provincial way, referring as much to the conservative politics of recognition and community consensus as to physical landscape. The continual movement of people throughout the archipelago, most especially to its urban centers, has expanded this place-based model of indigeneity as islands and villages are re-manifested within communities of people residing in town. Kastom as a philosophy of the indigenous is therefore explicitly not aligned with citizenship but, rather, with a prevailing ethos of social experience and connection to place based on ongoing cultural practice and sentiment.

There is a regional flavor to the articulation of kastom in Vanuatu, mirroring the emergence of similar words in other Melanesian pidgins and creoles. The Melanesian Way (Tjibaou et al. 1978; Narokobi 1980) was an indigenous philosophy and political movement that strove to define a regional sense of exceptionalism by provocatively connecting to other movements aiming to resist the spread of global capitalism (e.g., the movement Melanesian Socialism, which was inspired by the export of Soviet Communism to countries like Tanzania; see Regenvanu 1993). *Kastom* is a local term that provincializes the concept of the traditional by reframing ideas about native tradition within a specifically Melanesian nation-building project. When people in the Highlands of Papua New

Guinea or on the island of Pentecost in Vanuatu specifically call themselves indigenous, they not only refer to a priority relationship to land, to their ancestry, *and* to a colonized sense of marginalization, but also use the term to claim a current state of empowerment, to bypass the machinery of the (post)colonial nation, to continue to think of themselves as apart from the state.[4]

In Vanuatu, *indigeneity* as a specific term has been configured primarily in response to the successes of the global indigenous rights movement. While the colonial state constituted the subjectivity of the "native," the use of the term *indigenous* has specific currency in Vanuatu, resonating particularly within debates about economic sovereignty, the environment, traditional knowledge, and ni-Vanuatu participation within these conversations. The term is used explicitly as a way to connect to other groups faced with colonial legacies and striving to use their entitlements to exceptionalism as an alternative model or imaginary—not just of governance but of development, environmentalism, social organization, and value. For example, Motarilavoa Hilda Lini, the first female M.P. in Vanuatu, the sister of Father Walter Lini, and current chief in the Turaga Nation on the island of Pentecost (discussed more in chapter 8), has been active in using the language of the global indigenous rights movement as a strategy to inflect her challenges to development in Vanuatu and indeed throughout the Pacific. Lini is an ardent supporter of independence in New Caledonia, East Timor, and West Papua and is a champion of the Pacific antinuclear movement. The Turaga Nation, and its affiliated organization, the Vanuatu Indigenous People's (VIP) Forum, recognizes an inherent neocolonialism in the ways in which countries such as Vanuatu negotiate with outside, especially corporate, interests (Turaga Nation n.d.). The Nation uses the term *indigenous* explicitly alongside kastom to connect these two modes of articulating oppositional ways of being in the state.

In Aotearoa New Zealand, the marking of Pākehā as the other half of the bicultural state provincializes understandings of indigenous identity (as opposed to the ni-Vanuatu majority). Māori are different, in relation to their colonial counterparts. Biculturalism permits Māori to be more than just a minority, acknowledging the cultural (if not fully sovereign) primacy of first peoples in their own land. Yet the balancing of Māori with Pākehā equally legitimates the Crown and its descendants as partners in the land, potentially undermining the principles of indigeneity that presume priority and exception. The constitution of Pākehā as "the other half" generates a notion of settler-colonial indigeneity, exemplified by the neologism Ngāti Pākehā—the Pākehā tribe.[5] This suggests the multiple levels on which indigenous identity can be constituted and that it is a mistake to

read indigenous identity only in terms of political discourse. Indigeneity is also defined in relation to cosmology. Māori have maintained the key principles of *whakapapa* (an organizing cosmology based on genealogy), developing and formalizing their knowledge system and principles (Mātauranga Māori) of kinship, cosmology, and geographic lineage and interconnection as key indicators of identity. In addition, Māori (and by extension the New Zealand state) resist the mapping of these cosmologies onto models of blood and race by rejecting the quantification of identity (the U.S. model for recognition), instead emphasizing self-identification and community recognition (for instance by an urban Māori authority or iwi and hapū elders) as primary criteria for the formal (state-recognized) definition of indigenous identity.

The ongoing settler-colonial and the postcolonial legacies position Māori and ni-Vanuatu in relation to a discourse of indigeneity in ways both similar and different. In Vanuatu, articulating oneself as indigenous unites a political position on globalization and the state with a set of values around practice, community, and belonging. In Aotearoa, being Māori is defined through self-ascription and the tracing of geneaological links by recognition of both one's community and by the forms of recognition devised by the state. In both countries, indigeneity also becomes a filter for communities to articulate a sense of belonging that resists encompassment by processes of state recognition—refuting the national in favor of community-led values and subject positions.

Indigenous intellectual property (IP) has been made in both nations through a desire to mimetically absorb and participate in generic legislation; to express ideas about the public and about free markets; and to reframe those ideas within local epistemologies and colonial histories. Within these complex fields the indigenous is often used as a position of alterity to develop this provincial position. In order to best elicit the complex circularity in which concepts such as IP come from somewhere else, are remade locally, and reimagined as radically different, I develop here a comparative project that moves continually between the frames of the local and global, between Vanuatu and New Zealand, between ideas about intellectual and cultural property, between culture and economy. The diverse policy initiatives and projects I describe throughout this volume emphasize the ways in which law and power intersect in Vanuatu and New Zealand not only to produce the idea of indigenous rights but also to constitute an active and effective indigenous rights movement.

By juxtaposing the ways in which people think, talk, and use the concepts of intellectual and cultural property in Vanuatu and New Zealand, I ask how postcolonial and

settler-colonial experiences in the Pacific inform one another and question what this comparative angle contributes to our understanding of the very category of the indigenous itself. The tensions around the category of the indigenous lie in the ways in which indigenous people must use tropes and institutions from the colonial authorities that circumscribe them to constitute their identities *and* resist this co-option (see Hamilton 2009). If, however, indigeneity is defined by the paradoxical and unworkable space of radical alterity (which depends on a majority consensus on what difference is), how is it implemented in practice and how does it constitute policy? Vanuatu and New Zealand are both countries in which indigenous persons are moving from being defined as a reified alternative, or minority, within the state toward being used to define a more mainstream model of state governance. As we shall see in the case of the kastom economy becoming a charter for national economy in Vanuatu, in the case of Māori values affecting the workings of the free market at auction, or with the ways in which ni-Vanuatu and Māori models of entitlement are infiltrating formal IP regimes, the indigenous is increasingly a model for national governance and policy.

The Constitution of Law

If we define indigeneity as a series of discourses and experiences that create subject positions both in relation to, and outside of, the confines of the state, law at first glance would seem to be the institutional inversion of the indigenous. If we imagine the indigenous as a subject position within the state, we might imagine law to be an objective position taken by the state. In this final section, I unpack the framework that brings law into being in Vanuatu and Aotearoa New Zealand, developing an analytic that recognizes law and indigeneity as co-produced but also as complementary frames for the provincial process of making indigenous intellectual and cultural property. I also briefly summarize the formal legal frameworks in both countries in order to give a contextual framework for the more specific ethnography that follows.

Law, like ideas about the indigenous, is an imagined force for structuring cultural rights, an object of sovereignty, and a mode of organizing people's relationships to objects and places. Law both brings social facts into being (facts such as persons and property) and is itself contingent upon its own social milieu. It is discourse and practice, code and interpretation, structured and structuring. It is both informed by and seemingly transcends (or protects one from) cultural imperatives. It is both generic and specific, practice and

policy, personified and abstract, object and performance. For instance, in Vanuatu the National Copyright Act that I describe in greater detail in chapter 4 has codified copyright in both generic (global) and specific (kastom) ways. However, the law was only gazetted in February 2011 (eleven years after being passed). During the time between passage and implementation, copyright had significant power as a legal category—but this power was enforced through popular imagination, community discourse, and dialogue rather than by law courts, lawyers, and judges. In this way, law may be defined as much by what people perceive "the law" to be on an everyday basis as much it is defined by written codes and elite authorities.[6]

The constitution of law in Vanuatu and New Zealand mirrors the constitution of the indigenous (see C. Allen 2002: 17). In both places, what is indigenous within intellectual and cultural property is recognized not only in relation to local knowledge systems but also in relation to global models (such as intangible cultural heritage), regional efforts (such as the Pacific Model Law), and national charters for recognition (the Vanuatu National Constitution and the New Zealand Treaty of Waitangi). The "frame" for intellectual and cultural property for ni-Vanuatu and Māori is more than just law—it is an imaginary that permits these people to connect to global markets and negotiate their relationship with the state. In this way, law provides a discursive and conceptual frame subject to continual translation into other registers. It is the engagement between these registers, between formal and informal, national and customary legal regimes that frames the ways in which intellectual and cultural property have been appropriated, and in turn provincialized, in Vanuatu and Aotearoa New Zealand.

LOCAL

Vanuatu and Aotearoa New Zealand have unique legal environments that mediate their colonial legacies (see Merry and Brenneis 2004).[7] In both Vanuatu and New Zealand, the Westminster parliamentary system dominates, although the de facto plurality of legal possibility and voice, not all of which are equal, presents us with a blueprint for understanding the ways in which different domains of experience and practice may intersect in the promulgation of organizing regimes of entitlement (see Merry 1988, 2000).

In Vanuatu, independence enshrined a constitutional commitment to recognizing customary law through the framework of state courts.[8] The legal system is presented and practiced as a parallel, or pluralist, system: just as the country is divided into smaller and smaller juridical units (the Court of Appeals, the Supreme Court, Magistrate Courts, and

Island Courts), chiefly authority is recognized by the state to begin in the *nasara* (tribe or extended family) and village and move through the area council of chiefs; ward or district councils of chiefs; and provincial councils to the Malvatumauri, the National Council of Chiefs. In Port Vila, each island or area has its own chiefly representatives to mediate when issues arise within the urban community (Forsyth 2009a: 97).[9]

Despite this lively legal infrastructure and a certain amount of choice that people have in selecting which juridical-political system to participate in, "customary law" is still highly mediated and framed by the state legal system. Since the constitution is recognized as the supreme law of the country, customary law must also recognize the bill of rights that is constitutionally enshrined, even if these rights conflict with customary practice (e.g., kastom and nonkastom legal discourses can take very different views on adultery, custody battles, and domestic violence [see Jolly 2005; Taylor 2008]). Despite the fact that Vanuatu is an "indigenous" nation, its customary law is defined by a parliamentary system imported from Westminster and by a constitutional authority that also draws its integrity from the imperatives of the global human and civil rights movements of the late twentieth century. Even as Vanuatu is a postcolonial nation, its legal system is in part a settler-colonial system that perpetuates many of the paradoxes of recognition experienced by indigenous people living in settler colonies.

However, the tension within these competing views of "classic" juristic pluralism (Merry 1988: 873) and the understanding that the recognition of more than one legal "system" in fact depends on the power to recognize by a dominant national legal frame is complicated due to the weak nature of the Vanuatu state in much of the archipelago.[10] In many places, state law is relatively ineffectual, and the authority of kastom chiefs and other leaders is much more palpable. Recourse to the ways of kastom guides people in their normative activities and provides a vital regulatory framework that is not always defined in opposition to the state but is sometimes a genuine alternative (see Rousseau 2004; Hviding and Rio 2011). For instance, as Rio (2010: 185) points out, the prevalence of sorcery (technically illegal under Vanuatu state law) proves a conundrum for legislators who are as likely to believe in its legitimacy as the people over which they are presiding. Sorcery is recognized ambivalently as Vanuatu "kastom," but while it is a recognized mechanism for asserting social authority (as in the case of copyright in Ambrym, discussed in chapter 4), it cannot be recognized as customary law within the legal system.[11] There are therefore a number of powerful paradoxes within the Vanuatu legal and political system that inform the ways in which global instruments and discourses such as intellectual

property and cultural property are provincialized. The category of rights or, in Bislama, *raet,* exemplifies the kind of conceptual provincialization that infuses the Vanuatu legal system. Whilst the term *raet* riffs in Bislama from the international language of human rights and an international Christian framework, it also provokes profound anxiety as to the applicability of these universal rights, particularly in the context of kastom, which is traditionally constituted as the opposite of the modern or global (Taylor 2008: 170). As Taylor notes, in addition to this moral and global political meaning, the concept of raet is "related . . . to privileges of status that are acquired through ritual and other social mechanisms . . . is primarily understood to be relational and hierarchical. To have *raet* is to hold the power to *'overem'* ('to go over') others; the power to assert one's dominance and impose one's will over others" (176). Raet denotes how ni-Vanuatu provincialize the notion of rights, linking the applicability of courts of law, codified law, and parliamentary political authority to this historical sense of hierarchy and entitlement. There is both a sense of parallelism and a long-standing practice of translation that underlies the provincialization of rights, including IP rights, as I explore in chapter 4 in relation to the emergence of copyright regimes in the archipelago.

In Aotearoa New Zealand, British common law and its written statutes provide the primary framework of contemporary codified law. Māori law has been traditionally recognized by the state as "customary," meaning noncodified, and there is a discourse of parallel cultures of "law" and "lore" (see Wicliffe et al. 2002; Tapsell 2005). *Tikanga* (Māori customary values and practices), *tapu* (sacred or restricted activities), *whakataukī* (proverbs and sayings), *rāhui* (a mark indicating a taboo, or a public ban—on resource extraction, for instance), whakapapa, and Kaupapa Māori (knowledge) are just some of the conceptual frames by which Māori "lore" is imagined and used within communities as an alternative framework for arbitration and for structuring morally correct practice. Often, the implementation of such "lore" is very much at the consensus of individual communities led by *kaumātua* (knowledgeable elders) whose knowledge is also increasingly institutionalized in the form of reports, rulings, and other formal documents.

However, in institutional terms, the political model of biculturalism demands that Māori be integrated into the legal system as equal partners, resulting in the ongoing inquiry into the applicability of state law to Māori. For instance, the Waitangi Tribunal was founded in 1975 to assess the ways in which the Treaty of Waitangi was, and is, upheld (or not), and to provide recommendations to the government for the redress of treaty injustices and the overall obligation of the state system to adequately recognize Māori as

equal partners on all levels (often referred to as the spirit of the Treaty). The Tribunal deals with both historical and contemporary claims, evaluating the ways in which the Treaty has been upheld in the past and the present. The Tribunal itself encapsulates many of the tensions and paradoxes of bicultural ideology. It is itself an artifact of biculturalism, representing the government's responsibility to Māori as outlined in the Treaty document and consisting of members of whom half are Māori and half are Pākehā. However, it is technically a nonjudiciary body, with the power only to make recommendations via reports, and this skews the balance of bicultural obligation away from two parties, toward one: the state. Ultimately, it is the Ministry of Justice, the legal arm of the government and the courts, that decides what to uphold and what forms of redress are suitable. The government therefore decides the framework of its own accountability and demands that iwi conform to specific forms themselves as participants and recipients. As in the case of Vanuatu state law, this is a settler-colonial form of legal pluralism.

But we also have to understand the Tribunal to be a commentary on the settler colony as much as an artifact produced by it. The field of treaty claims is focused around the idea of compensation: restitutive payment for past injustices and recognition of the rights and entitlements that have been negated by the process of colonization and which have also been created out of the colonial encounter. It is also focused on recognition: of historical injustice, colonial repression, and violence. The detailed findings of reports are translated into either dollar settlements for claimants (for example, the Ngāi Tahu settlement case was decided for NZ$170,000,000) or resource ownership (Ngāi Tahu also achieved official recognition of traditional ownership over Mount Cook [or Aoraki, which by prior arrangement the claimants immediately gifted back to the nation]) and ownership of *pounamu* (greenstone) reserves on the South Island.[12] Bargh (2007: 28, 35) criticizes the ways in which the settlement process, rather than exemplifying commitment to bicultural values, in fact promotes the agendas of neoliberal economics by commoditizing historical and contemporary experiences of colonialism. The Tribunal has also been accused of reifying the iwi (over hapū, or whānau) as a unit of negotiation—a political reification that itself stems from the nineteenth century (M. Henare 2003: 127)—and in turn of promoting a corporate structure for iwi in order to receive settlement payments.[13]

But the Tribunal does more than reproduce the hegemonies of the neoliberal settler colony. Its meetings are forms of restorative justice, and its documents and reports are increasingly viewed as cultural resources and as indigenous and public histories (see Johnson 2008). The Waitangi Tribunal makes extensive use of bodies of Māori knowledge,

Mātauranga Māori, and custom/tikanga, initially disseminated orally or via historical documents and the work of researchers, now co-opted into multiple documents, many of which may be found online. It has become a respected, and sometimes controversial, artifact of the state, embodying multiple cultural values and aspirations and imaginings of ideal Māori and Pākehā relationships.

Current discourses about Māori cultural and intellectual property are at the present time almost completely dominated in the public imaginary by claims to the Waitangi Tribunal, including WAI 1071, which challenged state authority over the "foreshore and seabed" and WAI 262, brought by members of six iwi[14] in 1991, and asserting self-determination (te tino rangatiratanga) with regards to flora and fauna and all knowledge associated with them, as protected by Article II of the Treaty. Both of these claims incited public imaginaries, with many Pākehā fearing an indigenous form of enclosure and many Māori imagining an indigenous national property regime (see chapter 5). The Tribunal thus became the location for a sustained critique and evaluation of the nation and its obligation not only to Māori, but also to its own environment and natural resources.

In turn, biculturalism has produced a series of practical and policy results within the political and legal system. The institutionalization of Rūnanga (tribal councils) has provided a local infrastructure for legal implementation and negotiation with the government. For instance, the Te Rūnanga Ngāi Tahu Act of 1996 in New Zealand formalized a collective of eighteen regional bodies on South Island, which act to represent Ngāi Tahu's interests. Rūnanga were developed in the nineteenth century around traditional marae and function as institutional bridges between Maori and the Crown in ways similar to how chiefs governed in Vanuatu. Ngāi Tahu (the predominant iwi of South Island) successfully used the national legal system to establish itself as a corporate entity that became a major economic force in New Zealand. Only after this were they successful in their treaty claim, winning—alongside a number of cash payments—perpetual rights to fisheries, greenstone, forestry rentals, rights of first refusal on the sale of Crown properties as well as forms of apology and restitution known as "cultural redress" (see Belgrave et al. 2005).

In both New Zealand and Vanuatu, colonial state law has created the bureaucratic and conceptual space for an understanding of indigenous lore that is in turn slowly being turned into a hybrid national law, both provincial and indigenous. The discussion that emerges, both in law courts and outside of them, about the applicability of law, the development of legal alternatives, and the possibilities and nature of legal pluralism creates a lively legal environment that encourages critique and exploration. However, in both places

the very real power of police, judges, and magistrates affects indigenous people's experience of law—to the extent that both ni-Vanuatu and Māori have suffered greatly in their national prisons—often out of scale for their offenses. For instance, in 2008 a group of prisoners escaped the Port Vila prison and sought sanctuary at the house of the National Council of Chiefs, claiming maltreatment. Ralph Regenvanu and Moana Carcasses, both progressive members of Parliament at the time, were arrested for aiding and abetting the escapees (the charges were eventually dropped). The VKS's Juvenile Justice Project has been investigating mistreatment of young offenders by police for some time. One of the reasons why customary or community authorities are embraced by people in Vanuatu is because of the widespread fear and mistrust of the police (see Rousseau 2003).

Similarly, in 2007 the New Zealand government passed the Terrorism Suppression Amendment Act, "seeking to correct inconsistencies of that Act with New Zealand's obligations under the Charter of the United Nations and the United Nations Security Council resolutions on terrorism" (Terrorism Suppression Amendment Act, 2007).[15] It then used that law as a justification to mount a series of "anti-terror" raids in which seventeen people were arrested, including many Māori activists, including the prominent activist and artist Tama Iti, who were kept in prison for a month before being bailed. The government claimed that there was a terrorist training camp in the Urewera mountain range, and many of the arrestees were charged with illegal possession of firearms. The arrests prompted bitter protest concerning human rights issues, with many arguing that the rubric of terrorism was used as an excuse to suppress indigenous rights and claims. As a result, the Treaty of Waitangi settlement negotiation between the Crown and Ngāi Tūhoe collapsed at a very late stage, apparently over Tūhoe's claim to the Urewera National Park.

I do not judge the innocence or guilt of participants in both of these cases; I merely show how law and its political authority are tied in with a discourse of what we might understand as indigenous rights and governance. Law is a problematic epistemological framework with which to navigate indigenous identity because of the unequal, colonial, power relationships that determine, for the most part, the state as a legal authority.

GLOBAL

Understandings of indigenous or customary law are not just encircled by national and state law but by international laws and conventions. In May 2011 Vanuatu, until that point only an observer, had its accession package accepted by the World Trade Organization, and it had already drawn much of its legislation into line with the requirements of TRIPS,

for instance, by generating new standardized and compliant legislation on copyrights, trademarks, and patents. In August 2012, Vanuatu, along with Russia, became a full member of the WTO, despite a significant grassroots movement that said "No to WTO." New Zealand's first copyright law was enacted in 1842. New Zealand became a signatory to the Berne Convention in 1928 and joined the WTO in 1995, meaning that it has a long legacy of engagement with global IP regimes. This is a fertile point of comparison—Vanuatu is a country with only a nascent state IP regime, while New Zealand has long included IP within its national legal framework. Yet the issues arising around indigenous intellectual and cultural property rights transcend these histories, cross-cutting the deep time of (colonial) law in New Zealand and raising similar points about inclusion, recognition, and sovereignty.

Despite its hesitation in signing up to many multilateral trade agreements, Vanuatu has been, like New Zealand, an enthusiastic participant in the international movement to quantify and protect cultural heritage. New Zealand and Vanuatu have both ratified the UNESCO Conventions on the Means of Prohibiting and Preventing the Illicit Import, Export and Transfer of Ownership of Cultural Property (1970), on World Cultural and Natural Heritage (1972), and on Intangible Cultural Heritage (2003).

In turn, the Convention on Biological Diversity (CBD), adopted by both Vanuatu and New Zealand at its original signing in 1992, has also had tremendous impact on how traditional knowledge and indigenous rights are recognized internationally, with WIPO working through that framework to evaluate the interconnection between IP and traditional knowledge (see Halbert 2005: 143; Halliburton 2011). The emphasis on biodiversity and on indigenous peoples explicitly recognizes the connections among property rights, development, and sovereignty and the connection between traditional knowledge and custodianship of the environment. The frame of biodiversity is increasingly used as a meta-narrative to link rights to resources and to promote indigenous claims to land and other resources. While the CBD does not explicitly attend to nonbiological entities, its implications reach far into practice and policy, and it is used increasingly as a charter for indigenous IP rights in relation to patents and other knowledge drawn from the natural environment.[16]

Both nations therefore participate within an international legal framework that has for several decades worked to constitute generic understandings of heritage, traditional cultural expressions, and traditional knowledge. These international categories increasingly impact the ways in which ideas about customary or indigenous entitlement are

framed and are connected to IP regimes. This will be seen clearly in later chapters that explore how international trademark legislation has been negotiated in Aotearoa (chapter 5) and how intangible cultural heritage has affected the changing frames for economic development in Vanuatu (chapter 7).

INDIGENOUS IN BETWEEN THE LOCAL AND GLOBAL

Legal processes of both generification and codification provide a constant source of tension for activists and parliamentarians keen to promote and implement indigenous law at a national level in both countries. Throughout the Pacific region, the concept of sui generis law is increasingly used as a discourse with which to generically connect indigenous entitlement to legal regimes. Sui generis laws are by definition unique laws that have been developed in circumstances where existing bodies of law are deemed inapplicable.[17] However, activists and indigenous scholars increasingly refer to sui generis law when conceptualizing indigenous law (see J. Anderson 2010). Sui generis thus has the promise of alterity but also works with the legal frames it aims to set itself apart from.

The growing imaginary of sui generis law balances the promise of absolute uniqueness, on the one hand, and, on the other, the need for such uniqueness to be presented in a language and form recognizable by national and international legal communities (using preexisting legal languages, frames, and expectations of what law is and what law can do; see McNeil 1997). As such, it contains many of the same issues that the concept of the indigenous raises—the currency of exceptionalism within a generic framework, given credibility by an external, rather than internal, authority. Both New Zealand and Vanuatu have been active in generating sui generis law, in the process connecting ideas about indigenous lore to generic legal frames to constitute new "indigenous" legal regimes.

Vanuatu played an important role in developing the 2002 Pacific Regional Framework for the Protection of Traditional Knowledge and Expressions of Culture (also known as the Pacific Model Law).[18] This law, focused on the Pacific Islands with prominent input from Melanesian countries, is explicitly conceived as a sui generis response to the expansion of IP law into the domains of traditional knowledge (TK) and traditional cultural expression (TCE), aiming to provide a platform that is context-sensitive yet regionally applicable (see Secretariat of the Pacific Community 2002).[19]

However, like other multinational initiatives, national law is still the arbiter and framework for defining and implementing the Model Law, and despite the openness of clauses that define customary law as "in accordance with the customary laws and practices

of the traditional owners," there is also a certain amount of generic codification. For instance, the Model Law focuses on the kinds of things that most conventionally fit into contemporary discussions of copyright—music, dance, art and craft, oral literature, and poetry. Ultimately, the Model Law provides a moral rights framework and establishes protocols and rights for the broader dissemination of state-sanctioned TCE but does not concern itself with the specific codification of these practices (J. Anderson 2010). In this way it uses an understanding of what is generic within law to open a space of individual nations to delineate and define TK and TCE in relation to indigenous values.

New Zealand has also been active in regional and global initiatives to provincialize and indigenize generic legal frameworks dealing with indigenous intellectual and cultural property rights. In 1993 a group of indigenous scholars, politicians, and activists, led by the Māori Congress and hosted by the nine tribes of Mātaatua, convened the First International Conference on the Cultural and Intellectual Property Rights of Indigenous Peoples at Whakatāne, on the east coast of the North Island. The Mātaatua Declaration that emerged from this meeting was signed by more than 150 indigenous representatives and nations from 60 UN member states and was ratified by the Māori Congress and signed by individual iwi members (A. Mead 2004: 6).[20] The Declaration, which asserts indigenous people's formation of their own bill of rights, was a foundational document for the global indigenous rights movement, greatly influencing the UN Draft Declaration on the Rights of Indigenous Peoples.[21] Ironically, it was better recognized in New York than it was in New Zealand, where the government did not formally acknowledge its existence (6). The principles of the Mātaatua Declaration and the subsequent UN Declaration are now used as a framework for the international delineation of indigenous intellectual and cultural property rights. Among them are an emphasis on including issues within the basic framework of universal human rights (e.g., the right to self-determination and the freedom of cultural, religious, and political expression and transmission), with an emphasis on the rights to pursue sustainable livelihoods, to have access to land, and to maintain control over traditional territories.[22]

This expanded sense of rights has local origins that may, in part, be traced to the resistance of Māori to colonization and efforts to determine their own sense of national sovereignty. These efforts by indigenous activists have been extremely effective internationally. Much as Vanuatu sand drawing, discussed in chapter 1, played a vital role in constituting the concept of intangible cultural heritage, the Mātaatua Declaration has informed and co-produced (along with the work of many other indigenous activists and organizations)

an international ideal of indigenous cultural and intellectual property rights (see Halliburton 2011).

The local and the global are mutually constituted and discursively entangled in the ways in which they are mediated by indigenous people and ideas about indigeneity. There is a politics of recognition and colonial authority that inflect all of these categories and boundaries. Intellectual and cultural property emerge in Vanuatu and New Zealand as instantiations of, and commentaries on, the particular histories of each nation. They are also increasingly used as practices that articulate understandings of indigeneity and which bring indigenous rights into being. In the following two chapters, I trace more specifically the emergence of indigenous intellectual and cultural property in the Pacific, focusing on copyright in Vanuatu and trademarking in Aotearoa New Zealand and the constitution of cultural markets in both countries. By paying close attention to the epistemology, politics, and discourses, and the power relations that comprise these property forms, I demonstrate the ways in which IP has been absorbed and subverted creating new indigenous forms of national property and entitlement.

4 | Copyright in Context

CARVINGS, CARVERS,
AND COMMODITIES IN VANUATU

> We have made a special provision in the Copyright Act so that
> even if you don't produce anything in the present day, everything
> will still be passed down to you through your clan. The Act will
> protect your clan, and your family. The Copyright Act covers
> all kastom, we made sure that everything would be covered. . . .
> In the past we couldn't always protect kastom because there was
> no law to protect us. Now, we have a law to invoke, we can get
> lawyers and go to court. We had the laws of the chiefs before, but
> now we have the law of the white people as well.
>
> RALPH REGENVANU, speaking on Vanuatu Radio, January 24, 2001
> *(my translation from Bislama, the national Creole of Vanuatu)*

IN THE SPEECH from which the above remarks are taken, Ralph Regenvanu, then
director of the Vanuatu Cultural Centre/Vanuatu Kaljoral Senta (VKS), explained the
importance of the newly passed Vanuatu Copyright and Related Rights Act (hereafter
Copyright Act) to a group of carvers invited to the VKS to discuss the potential effects
of national copyright legislation on their work. As well as stressing the power of the new
Copyright Act to restrict the production and circulation of specified traditional imagery,
Regenvanu emphasized the potential of national legislation to extend endlessly the domain
of kastom into the realm of the nation-state and beyond, into the global domain of "white
people." This moment provides the starting point for my analysis of how copyright has devel-
oped in Vanuatu. As we shall see, a number of competing understandings of copyright are
conjoined in efforts to create a newly national regime. Rather than viewing these competing
understandings as fundamentally incompatible, I aim to show here how copyright in
Vanuatu opens a space to consolidate multiple discussions of rights, allowing participation

in wider spheres of exchange, while at the same time limiting the terms of their engagement. This captures the spirit of provincialization that I am using as a filter with which to better understand the constitution of indigenous intellectual property in the Pacific.

Intellectual Property in Cultural Context

Thinking about copyright as a specific form of intellectual property (IP) necessitates an understanding of who gets to decide which meanings are upheld by law and which entities get to become commodities. Following Coombe, I define context here "not [as] reified social totality, like traditional anthropological 'cultures' but contingent social fields of agency emergent from specific political trajectories" (1998a: 230). It is in the nature of IP to break down some of the conceptual divides between what can and cannot be owned, transacted, and commoditized. As discussed in chapter 1, "the strangeness of all intellectual property" (Boyle 1996: 18) may also be read as a provocative critique of understandings of property more generally.

Despite the primary reference points of the British printer's monopoly, The Statute of Ann, and Mark Twain's assertion of artistic moral rights (see Vaidhyanathan 2001 for a good history), "copyright" as an international legal concept has a long history of entanglement with diverse understandings of entitlement, and it is therefore instructive to chronicle its emergence in a place far removed from the authoritative "centers" of Europe and the United States. In 1999 the Vanuatu State Law Office began drafting a copyright bill that, once passed by the Vanuatu Parliament, would partially fulfill the requirements necessary for the country to join the WTO (see Wright 2001).[1] The bill was modeled in part on the acts already in existence in Australia and New Zealand, using generic UNESCO and World Intellectual Property Organization (WIPO) guidelines. The standard provisions assign exclusive rights to carry out or authorize the reproduction, publication, performance, broadcasting, and adaptation (and other transformations) of the work. In addition, the Act asserts a moral rights framework that exists independently of economic rights and which asserts that authors have the right to remain associated with a work and control distortion, mutilation, or other modifications that might be damaging to their reputation (Wright 2001: 59).

The Act also has sections pertaining to "indigenous knowledge and expressions."[2] Indigenous knowledge is defined in Section 1 in relation to three requirements: it must be created for traditional, spiritual, ritual, or related purposes; it must be transmitted

from generation to generation; and it must pertain to an indigenous person or a group of indigenous people in Vanuatu. The definition of indigenous knowledge was intentionally as broad as possible to accommodate the diversity of Vanuatu. Kastom entitlement in Vanuatu has long been enforced in local contexts by traditional structures of hierarchy and through the medium of village meetings and local councils of chiefs—local judiciaries that function with variable levels of state sanction (see below; cf. Lipset 2004: 65–66; also see Rousseau 2004: chaps. 6, 8; Forsyth 2009b). As well as bringing international legislative expectations into Vanuatu and opening the door for Vanuatu's potential participation in a global economic forum (the World Trade Organization), the Copyright Act marks one of the few times the state has acknowledged traditional entitlement within an internationally recognized framework. This move has also been influenced by other areas of legislation and international convention, which have drawn the rhetoric of biodiversity and traditional knowledge, for example, into dialogue with the usual "property speak" of IP rights.[3] However, as I shall discuss, the actual ways in which copyright facilitates participation in international markets is very different from the expectations and constraints provided through the guidelines emanating from Geneva. Rather than bolstering international trade at its most abstract level, the passing of the Copyright Act facilitated the extension of noted individuals' power and kastom rights directly into national and international exchanges. This is a window into the idiosyncratic form of the nation within Vanuatu in which its marginal global status and small size in fact provide an avenue for making grassroots perspectives national, if not global. It is a good example of how the state creates a frame for a legal system that is then implemented in reference to very different structures of power and authority.

In December 2000 the Copyright Bill was made, without major change, an Act of Parliament (Republic of Vanuatu 2000). It was gazetted in February 2011, paving the way to the anticipated implementation of TRIPS in December 2012. Since being passed, the language of copyright legislation has increasingly been incorporated into disputes outside of the formal justice system around the ownership of kastom imagery and the rights to profit from it.[4] The national law courts are a spectral presence within such disputes, as kastom law is itself to national law. In addition to the legally sanctioned threat of a hefty fine and a year in prison, the mention of the "rules of custom" within the Copyright Act legally validates alternative mechanisms for enforcing copyright (which in practice range from the strictures of traditional ritual hierarchies to the threat of sorcery and even violence).[5] Alongside the National Cultural Council and National Council of Chiefs as

upholders of kastom law, the Act (Section 42) also provides for civil remedies that permit people or groups to take action instead of the state. The intention is to make the legal process as accessible as possible and to devolve courtroom activity as much as is feasible. Individuals can raise suit or, if they feel unable to, they can appeal to the National Cultural Council and Council of Chiefs to institute proceedings on their behalf.[6]

In this chapter, I scrutinize copyright in Vanuatu in the context of these multiple perspectives, moving from the village to the nation and from the nation, passing through the domain of generic legislation, back into the village. Ni-Vanuatu have, over a lengthy period of time, strategically drawn an analogy between highly specific local entitlements and more international notions of copyright to assert significant economic and political agency in local, national, and international domains of exchange.[7] Contrary to popular thinking, which tends to assume a monolithic hegemony to the category, the case of copyright in Vanuatu demonstrates how IPR legislation may be understood as a zone in which the relations between rights, resources, and political authority may be configured to accommodate diverse systems of reproductive entitlement under the unifying rubric of law, in turn, creating a space that may affirm local difference and extend local agency. This is borne out powerfully in the ways in which chiefs from North Ambrym in Vanuatu successfully connect their own mechanisms of enforcing reproductive entitlement to the concept of copyright. This perspective is increasingly influencing international policy and may be seen, for example, in the attempts of legal analysts and scholars to make international IPR regulations crossculturally applicable by promoting the concept of sui generis (unique) copyright systems and their integration into highly generic legislative orders. Terri Janke comments that incorporating sui generis systems into copyright legislation means "not only recognizing the uniqueness of Indigenous culture but also respecting it and understanding that Indigenous knowledge and Western knowledge are two parallel systems of innovation. Furthermore, it must be recognized that Indigenous customary laws and the existing Australian legal system are two parallel systems of law, both of which need to be given proper weight and recognition" (2003: 4). I want to take this further and ask how these two parallel systems in fact influence and alter one another and increasingly form a synthetic legal sector.

The British Commission on Intellectual Property Rights (2002), set up to investigate "the ways that intellectual property rules need to develop in the future in order to take greater account of the interests of developing countries and poor people," advocates the development of sui generis systems of global IPR legislation.[8] Within this document,

sui generis in law is defined as "a distinct system tailored or modified to accommodate the special characteristics of traditional knowledge or folklore" (Commission on Intellectual Property Rights 2002: 102n14):

> Whether these national systems as they evolve will have sufficient common characteristics to enable the development of an international *sui generis* system remains to be seen. We recognise that there is continuing pressure for the establishment of an international *sui generis* system, as recently articulated by the G15 Group of developing countries. With such a wide range of material to protect and such diverse reasons for "protecting it," it may be that a single all-encompassing *sui generis* system of protection for traditional knowledge may be too specific and not flexible enough to accommodate local needs. (Commission on Intellectual Property Rights 2002: 89–90)

Herein lies the paradox of the sui generis (a similar paradox lies in the nature of the indigenous, as I observed in the introduction to this volume). A category based on a notion of uniqueness is, in fact, constituted out of a highly generic version of difference—the alternative becomes the rule rather than the exception. The South Pacific Commission's Model Law for the Protection of Traditional Knowledge and Expressions of Culture (first announced in 2002) aims to present a generic frame that Pacific Island nations can adapt according to their own understandings of traditional knowledge protection (see chapter 3). In avoiding the expression "intellectual property," the Model Law makes no differentiation between the tangible and intangible, makes no provision for time limitation in its protections, provides for notions of collective ownership, and uses contract law as a framework for protecting traditional knowledge and expressions of culture. It also aims to establish a regional cultural authority that can arbitrate, mediate, and in some instances represent customary owners (see Forsyth 2003). However, in turn, the Model Law relies heavily on many of the assumptions built into international IPR regimes (that culture and creativity need to be owned and protected as much as exploited economically and that legal frameworks are required to do this). The prime focus of legislators and policy analysts has been to promote a flexible frame for indigenous IP that can incorporate culture and cultural difference. Here I ask a set of different questions, following on from the perspective on indigeneity and law I outlined in chapter 3: How does this idea of unique context create a generic role for culture? Can sui generis law be read as a provincializing project or does it in fact normalize mainstream legal conventions, especially around IP, by reifying

a particular view of traditional culture? Despite these paradoxes it is clear that the sui generis framework is creating new avenues for the assertion of indigenous agency in a context heavily mediated by international law.

Analogies between Generic Copyrights and Specific Entitlement in Vanuatu

I define copyright very broadly here as "official injunctions and restrictions that establish legitimate entitlement for individual or incorporated entities to circulate and profit at any particular moment from the material reproduction of specified forms." The success of ni-Vanuatu in using "copyright" to control the marketplace for their customary material (a pragmatic aim of establishing broad IP regulations) lies in the success of a longstanding analogy between different understandings of rights that, I argue, over time has become self-fulfilling. I am not interested here in evaluating whether or not legal systems can be purified (separated out neatly into precolonial, colonial, indigenous, national, and so forth). Rather, my ethnographic focus and analytic position expose how IP has become a frame through which people link together multiple understandings of law and a filter through which everyday people perceive the opportunity to attain power and authority, or at least to participate in various legal structures with impact and effect.

Although the term *copyright* may have originally entered Vanuatu from afar, the analogy between ceremonially sanctioned entitlement and copyright (or its Bislama transliteration, kopiraet) is drawn as much by locals as it is by outside observers.[9] During my initial fieldwork in Vanuatu (2000–2001), the drafting and passing of the Copyright Act provoked a great deal of general discussion about the market and economic entitlement. Contemporary artists wondered if they could be penalized for depicting kastom events or images in acrylic paint or tapestry, as just a couple of examples of media perceived as nontraditional that they were working in. Other people talked about copyright as a way to consolidate their ownership of diverse forms of practice, for example, to control the performance of the Pentecost Land Dive ceremony, a ritual precursor to bungee jumping, outside of its prescribed time and location (a long-standing issue of contention; see, e.g., Jolly 1994a).[10] At the same time, nearly everyone I talked to, from representatives of the State Law Office and the National Museum to dealers, carvers, and contemporary artists drew an analogy between copyright and the ritual injunctions concerning making and circulating kastom carvings from the region of North Ambrym, in North Central

Vanuatu. In the following section, I unpack the conceptual foundations of this analogy, arguing that it has enabled a profound assimilation of the language of IPR into local discussions of entitlement. One effect of the process of analogy, I argue, is to continue the work of IPR in shifting conceptual boundaries. Thus, one might ask what happens to a system conceived as sui generis when its participants start to conceptualize local entitlements explicitly as copyright? And what happens to an understanding of copyright when one increasingly thinks about it in the context of indigenous cosmologies and assertions of entitlement? And, in turn, what happens when this indigenous value system is repackaged and internationally recognized as sui generis?

The Graded Societies of North Central Vanuatu: A Copyright System?

> Often, I have a new idea for a drum and I carve a small one first and show it to my father before I carve a big one. When I carve a new face for a drum, one that I can't buy from another man, I still have to make a *kastom* payment to my [maternal] uncle out of respect. In the absence of another man who owns the rights, you pay your uncles [mother's brothers], in respect of where you come from [your mother]. Then it becomes official. I also pay two chiefs from Fanla to claim the rights to the new drum. I had to kill two pigs whose tusks had gone through their jaws and three more that had almost gone round again, plus four small pigs and 40,000 vatu.
>
> BULE TAINMAL, FANLA VILLAGE, NORTH AMBRYM, JUNE 2001

The analogy between IPR and kastom reproductive control in Vanuatu is seemingly straightforward: a mapping of the entitlements apportioned within a diverse series of male rituals of status acquisition in the northern and north central regions onto the idea of copyright (and vice versa). In Vanuatu these ceremonial systems are conceived as a coherent regional complex, generally called *nimangki* in Bislama and "graded societies" by anthropologists (e.g., M. Allen 1981a).[11] Both analysts and participants have long used ethnographic information about the male graded societies to exemplify a more generic indigenous discourse of entitlement to what might be called cultural property. This discourse is increasingly configured in reference to intellectual property—copyright—and is having a growing effect on lawmakers, cultural advocates, and artifact traders, indigenous or other.

A rich history of ethnographic investigation into the graded societies exposes a series of local exchange systems that have often defied rigid documentation.[12] Despite intense local diversity, Michael Allen highlights some general characteristics of the graded societies common to each location: each hierarchical complex consists of a number of ranked grades achieved by men and, occasionally, women, through the ritual sacrifice or exchange of tusked boars, the purchase of insignia and services, and the public performance of elaborate ceremonies.[13] Members of grades are marked by sets of rights publicly represented by emblems, figures, apparel, and eating and sleeping proscriptions (M. Allen 1981a: 24). The circulation of pigs, yams, images, songs, dances, and titles between persons, villages, and islands through broad networks of ceremonial exchange collectively enhances the status of individuals, bringing them progressively closer to the spirit world of the ancestors by the acquisition of ranked names.[14] Most prominently, the tree-fern and wooden figurative carvings that can be found in the sacred dancing grounds of many villages present and maintain the status and power of individuals, both past and present.

Kirk Huffman has described this as a " 'copyright' system [that] recognizes certain individuals, groups or areas as the proper owners of cultural items, the rights to which can be purchased, sold and resold over large areas in the perpetual spiritual and material drive upwards and outwards towards increased social height, prestige, power and influence in the world of the living and the world of ancestral spirits" (1996: 182–183). Through such exchanges between the ancestral world of the spirits and the hierarchical world of mortals, the graded societies are a prime mechanism for the distribution of entitlement, creating a political economy that allocates control over local resources—which range from the prime ritual currency of pigs to yams; knowledge; and, increasingly, cash—to the highest-ranking men. Access to all of these resources, whether tangible or intangible, is embodied profoundly in the material culture of the graded societies, most especially that of the Maghe of North Ambrym (see figure 3). The anthropomorphic carvings that publicly manifest each man's individual grade, the vertical slit-drums associated with a wide variety of rituals, and smaller models of both, made primarily for the market, produced by men from North Ambrym (and now others as well), have come to be archetypal referents when talking about copyright in Vanuatu.[15]

The analogy that links these particular artifacts to the rules of copyright stems from the relationship between the carver and the owner of the right to reproduce designs that, in turn, embody such entitlement. A carver must pay, through various types of

FIGURE 3. Chief Gilbert Bongtur, from Melbera village, North Ambrym, June 2001, alongside a tree-fern carving embodying his graded society rank of Maghenehewul. (Photograph: Haidy Geismar)

ritual practice and, increasingly, with money, for the rights to both produce (carve) and circulate (sell) kastom images. Owners of designs may commission carvers to reproduce them, retaining ownership nonetheless, and skillful carvers may pay for the rights to carve and even sell designs but do not necessarily gain the stature that such designs embody. Complex relations of patronage, hierarchy, and customary authority, therefore, are embodied both in the social form of the ritual complex and materially within the very form of the carvings themselves. This unity of material and social reproduction also facilitates the analogy between kastom entitlement and copyright, the most material form of IP in that it focuses on the specific manifestation, or production, of ideas rather than the ideas themselves. While the division between idea and output is highly problematic, the historical emphasis of copyright law on external manifestation has given the term *copyright* great resonance with communities that are interested in protecting the circulation of their cultural knowledge and recognize that the complex relationship between knowledge and its materialization is crucial to their own self-determination. While some may argue that the ways in which copyright is being discussed in Vanuatu are akin to the moral, or neighboring, rights framework developed in many countries, the reason that the term *copyright* itself is used reflects the power of copyright to curtail material circulation.[16] The recognition of materiality is a double recognition—not only of the way in which form embodies knowledge but of the very real consequences (monetary profit, broad recognition, and so on) that the circulation of form presents. It is this recognition that links copyright specifically to indigenous understandings of entitlement and its curtailment.

In North Ambrym, and increasingly throughout Vanuatu, copyright has passed into local parlance, as kopiraet, to describe the form of such entitlement within the graded societies. When asked to define copyright more specifically, North Ambrym chiefs explicitly elaborated the concept as being about maintaining the hierarchies of rank and title within the graded society and as a method of consolidating local definitions and uses of kastom rights in both local and nonlocal contexts.[17] Chief James Tainmal of Fanla described the purpose of kopiraet as "blong traem meksua se ol man oli go stret blong rank" (to ensure that all men stick to their graded society rank) (author interview, Fanla village, June 19, 2001). Rather than being "like" or merely analogous to copyright in the Euroamerican sense, copyright in Vanuatu has been incorporated into the ways in which rights from the graded society are discussed and implemented. North Ambrym carvings have come to be archetypal embodiments of ideas about kastom and

copyright, and their customary owners have become authorities on both the allocation and enforcement of these kastom copyrights nationally.

A Case in Point:
Chief Willie Bongmatur Maldo and His Five-Faced Drum

The case of Chief Willie Bongmatur Maldo's copyright claim is a clear example of how copyright is used locally as an overarching idiom to link indigenous and (inter)national entitlements, a way to expand local prestige into wider spheres of influences, and a method of consolidating the customary authority needed, in turn, to gain such broad political and economic entitlement.[18] Chief Willie's claim is based on the analogy between copyright and local entitlement that I outlined above. In building his case, Chief Willie showed the potential of copyright to extend local agency outward and illustrates how men and kastom from North Ambrym have emerged as crucial arbiters of the meanings of copyright in Vanuatu.

Chief Willie, who passed away in June 2009, was one of the most famous chiefs in Vanuatu. He was born in 1939 in the Presbyterian village of Likon, West Ambrym (Bolton 1999c: 4). His family moved to North Ambrym after the destructive eruption of the volcano Mount Benbow in 1913. Despite his western origins, Chief Willie claimed an allegiance to the north—a famed place of kastom leaders. Bolstered by this regional grounding, Chief Willie's life was one of political engagement with processes of nationalization and external development. Such mediation lies at the heart of his family history: his grandfather, Wurwurnaim, was a returnee from the Queensland sugar plantations and while there had converted to Christianity; his father, Simon Solip, was a Presbyterian evangelist and teacher (Bolton 1999c; author interview, Port Vila, November 7, 2001). Whereas many villagers in the interior of North Ambrym held on to a "pagan" identity and resisted converting to Christianity well into the 1970s, Chief Willie was well equipped to become a part of the newly nationalized culture of Vanuatu—which held both kastom and Christianity in high regard. A leading member of the Presbyterian diocese, he began his political career as district assessor under the Anglo-French Condominium government. In 1972 he founded the North Ambrym Local Council, then a mediator between village and colonial government, now a body exercising the chiefly power of kastom as the North Ambrym Council of Chiefs. Subsequently, he became a member of the New Hebrides National Party (later the Vanua'aku Party), which, headed by Father Walter Lini, led the

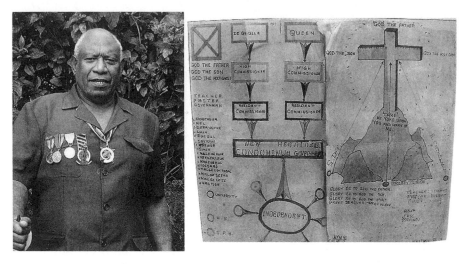

FIGURE 4. (Left) Chief Willie Bongmatur Maldo wearing his five medals, Port Vila, July 11, 2001, and (right) a drawing by him, which visually links the structure of authority in the graded society (Maghe titles are listed in the lower left-hand side of the drawing) to the political structure of the colonial nation-state. (Photograph: Haidy Geismar; drawing reproduced with permission)

country to independence in 1980. Chief Willie was also a founder and the first president of the Malvatumauri (National Council of Chiefs, an advisory body that may be consulted by the government on kastom issues) in 1977.

When I met Chief Willie in 2001, he was preoccupied with a dispute that had emerged over a material gesture that he had made to reauthenticate not only his own status but also that of the nation: some years earlier, as then leader of the Malvatumauri, he had commissioned the carving of a North Ambrym drum, extravagantly decorated with five faces, as a gift to the UN commemorating the incorporation of Vanuatu into that organization.

Schooled in the protocols of the Maghe (the graded society of Ambrym), Chief Willie was aware that strict copyright rules governed the production and use of this drum. He publicly invoked an image of five faces that his grandfather had carved into a coconut tree, representing the five times his ancestor had paid for the right to his Maghe title, Mal. He also approached the family in North Ambrym that possessed the right to carve a five-faced drum and asked its members if he could purchase the copyright from them to make such a drum. They agreed, for a fee of 80,000 Vatu ($860) and some full-circle tusked pigs (this account is drawn from Rio [2000: 7] as well as from Chief Willie himself).

Despite a seemingly harmonious payment and transference of rights and a public ceremony with an exchange of mats, pigs, and money in Port Vila (in the auspicious presence of the prime minister), the legitimacy of the drum was soon called into dispute. Eventually, the man to whom the payment for rights had been made—as a member of the line originally in possession of the right to carve five-faced drums—initiated a court case challenging Chief Willie's genealogical entitlements and, in turn, his political authority. The drum was never sent to the UN, remaining in the storeroom of the VKS. The repercussions of this dispute were still preoccupying Chief Willie in 2001 when I interviewed him at his home next to the Central Presbyterian Church in Port Vila. With the passage of the Copyright Act, he was preparing for the passing of the dispute from kastom to national courtroom, where he would be able to consolidate his claims in front of the highest legal authority in the country.

During one of our meetings, Chief Willie dictated his genealogy to me so that I could transcribe it and print out a document for him to use as evidence in any legal case.[19] The document also incorporated drawings of the drum made by a relative of Chief Willie. Although Chief Willie may not have used the word *copyright* within his genealogy, his narrative was delivered as a lengthy copyright claim and explicitly was made using the idioms and language of entitlement emanating from the Maghe graded society. I reproduce it here to highlight the power of the locally drawn analogy between these two zones of entitlement:

My name is Chief Willie Bongmatur. I want to tell you the history of my family, alongside my own history. This history goes back a long way, and it concerns the history of our kastom, as well as the history of the nation of Vanuatu to the present day.

. . . Now I will tell you my laen [line, genealogy]:

Maltantanu (another name for him is Malrangumo, Malbongnoun), he was a great Abu [ancestor] of ours. Maltantanu took Mal five times. The first time he was Maltantanu, then he became Malkiki (which means the mother of all Mals), then he was Malametu (which means old Mal), after that he was Malten (a Mal from Malakula), then he was Malsanavuhul (which means that he had taken Mal ten times, although he had really only taken Mal five times). All of these rights meant that he had the right to carve a big drum with five faces. The son of Mal was Wuruwuruneim, and he had three brothers. Their names were Wigimal, Ragaragamal (whose son was Joel, and his two sons were Alili and Pipir) and Bongwakon who was the straight Abu [grandfather] of me, Chief Willie.

I too have killed pigs five times. The first time, I took the name Mosari (a name that my uncle Ramel from Likon gave to me), for this I paid twenty full circle tusker pigs and two turtles, because he is a chief of the ocean. Then I took the name Molbaru (which means twice Mol that I bought from a tawien [cousin or in-law] from Ranon), for this I had to pay two pigs. Next I took the name of an Abu [grandfather or elder] from Fonah village, Rahemol. I had to pay twenty pigs together and take one dead pig, one live pig, red mats, and food to the ceremony. Then I took the name of a younger Abu from Lingol, Ramelbong, and I had to pay one dead pig and one live pig. This was the kastom for the drum with five faces. I followed these old men from the past. After this, I took the name Molban, which means a chief who carries title. And when my father died, I killed pigs again and took the name Rahetwip, which means the mother of all chiefs, because at this time, I was the leader of all the kastom chiefs of Vanuatu. The 1979 census said that there were 2,200 chiefs in Vanuatu, and this was the time that I was writing the constitution.

My Abu was Mal five times. I, too, have killed pigs five times, and I also have five medals: the Queen's medal, Independence Medal, First Class Medal (tenth anniversary of the country), the Constitutional Medal, and the Twentieth Anniversary medal.

This entire narrative must, following Chief Willie's explicit intentions, be read as a copyright claim. Chief Willie went on to assert that because of his genealogical connection to men with high ranks in the graded society and his own national stature (which he gained as well as—some say in lieu of—his own active participation in the Maghe), he did not need to buy the right to commission the drum to be carved; the payments he had made were "soemaot respek nomo" (simply to pay due respect) to an older relative. His own series of names in the Maghe consolidate his legitimacy within both a local and a national context: Each of his five names is matched by a national title; each emblem of Maghe (and face on the drum) matched by a medal, which may be hung around his neck like a pig's tusk, highlighting the vital materiality of title and entitlement (see figure 4). For Chief Willie, copyright was about staking multiple claims using the most powerful tools available, balancing both his national responsibilities with the hierarchical conventions of the graded society and the villagers to which he was (almost) equally answerable.

I propose following Chief Willie's own logic to start to understand the ways in which copyright is understood and defined in Vanuatu. That the dispute involving Chief Willie's drum was explicitly described by all concerned as a "copyright" dispute highlights that sui generis understandings of entitlement, emanating from North Ambrym, may be framed

with more national understandings of political authority and economic entitlement in mind. The link between Maghe entitlement and copyright is not, therefore, a superficial convergence. In the following section, I describe how an analogy or convergence has developed over many decades between the entitlements afforded by the Maghe society and exchanges in international and national marketplaces, which in the present has come to be known as "copyright."

A Brief History of an Analogy: The Graded Society and the Market in Fanla Village

I have so far unpacked the conceptual underpinnings of the analogy between copyright and indigenous entitlement within the graded societies in Vanuatu, focusing on the Maghe of North Ambrym. A long-standing pragmatism underpins this analogy, one rooted in market interest, the negotiation of authority, and the emergence of a national political economy based on the relationship between the two. IPR play a vital role in mediating between political authority and economic entitlement within intercultural spheres of engagement. The analogy and the jostling for political authority and economic entitlement that it engenders have a lengthy history, one that has emerged most publicly within one North Ambrym village, Fanla. Today, Fanla villagers underscore their dominance in copyright claims using their genealogical connections to some of the highest-ranking men in the region, legitimating access to the richest material fruits of the Maghe and, thus, the greatest access to the profits of the international art market.

Fanla (population ca. 200) is situated a little inland from the sea on the steep hills of North Ambrym. It is one of the most feared places in Vanuatu, primarily because of its strong continuing association with magic and sorcery—in short, with the most feared and powerful forms of kastom—that it holds in the minds of ni-Vanuatu from other islands (see Patterson 1976; Tonkinson 1981; Rio 2002). Fanla village is also internationally renowned for its production of carvings. Figurative drums from Fanla are on display in the Metropolitan Museum of Art in New York City, Le Musée du Quai Branly in Paris, and the University of Cambridge Museum of Archaeology and Anthropology as well as in the Vanuatu National Museum. The use of their image on the 500-Vatu note also suggests that slit-drums, large and small, are considered both highly lucrative commodities and important markers of local and national identity (see figure 5). For many years, villagers from North Ambrym have exported their carvings both nationally and internationally,

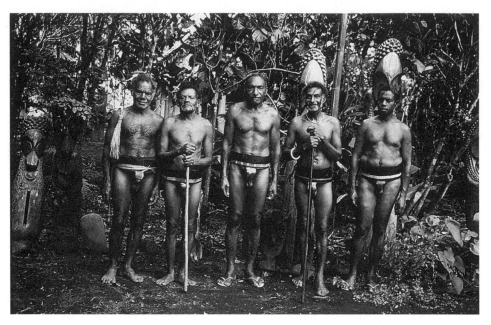

FIGURE 5. Chiefs in Fanla village, dressed in full customary regalia, standing in front of vertical drums in the dancing ground, Fanla, North Ambrym, June 2001. Left to right: Letung, Adil, Hanghang Tainmal, Bongmeleun, Magekon. (Photograph: Haidy Geismar)

selling directly to dealers working in Port Vila, New Caledonia, and as far away as the United States. During my fieldwork large drums currently fetch 100,000 to 200,000 Vatu (approx. $1,075 to $2,150) and are popular with dealers and collectors around the world. Small model drums sold for 500 to 1,500 Vatu (approx. $5 to $15), depending on innovations in design and their sizes. Models of Maghe carvings sold for 3,000 to 6,000 Vatu (approx. $33 to $66), again depending on their complexity of form and size. As Mary Patterson (1996: 261) has commented, even full-size drums are increasingly "decorative" rather than "functional," their visual aesthetic dominating their acoustic capabilities (see figure 6).

Chief Tainmal and his son Tofor (both now deceased) are legendary village characters, famed throughout the archipelago for their lavish grade-taking ceremonies, high rank, and insubordination to the Condominium authorities and feared for their status as powerful *klevas*, or "sorcerers." Within the diverse documentary history of North Ambrym, Tainmal of Fanla emerges as a prominent figure in the development of the public face of

FIGURE 6. Vertical slit-drums standing in the dancing ground of Fanla village, July 2001. (Photograph: Haidy Geismar)

kastom in North Ambrym and as a savvy developer of a locally based international market for carvings. Today, two of his sons are village chiefs and are concerned with maintaining the viability of local cultural resources, ranging from the sporadic performance of dances for tourists to the almost continuous cottage industry of carving.

Rio (2000: 3) comments that he finds no record of the commercialization of carving in North Ambrym before the 1960s, a period that marked the beginning of increased air travel and the more systematic development of tourism in Vanuatu.[20] Patterson (1976: 31) reports that by the time of her fieldwork (the early 1970s), a large proportion of the wealth of the North Ambrymese had been acquired through the sale of artifacts to Europeans. The money raised by the sale of artifacts, she reports, was usually invested straight away in Maghe rites. Charlene Gourguechon, who spent more than two years in the archipelago in the early 1970s in the company of the photojournalist Kal Muller and the photographer and filmmaker Jacques Gourguechon, describes the artifact business in Fanla village. Her account of the most powerful chief in the region, Chief Tofor, highlights how his

ascendance was partially contingent on the profit he made by selling "imitation traditional objects: miniature statues and drums, mass produced masks" (1977: 236):

> A large part of his revenue comes from "custom." . . . As a highly graded man, he also received a good bit of money from ceremonies such as the nimangki. He has discovered, moreover, that he has a product to sell to the Europeans: art objects. . . . Gone are the days, he declared, when you could buy a statue from him for a bottle of rum and a scrap of calico! Now he knows what things are worth. Operating like a professional, he even offered a large drum as a present to the Queen of England and to General de Gaulle, and ever since, he's been able to sell his drums at unthinkable prices to international art collectors. (273)[21]

In addition to reports by anthropologists and tourists, the burgeoning market for kastom artifacts was also much commented on by visiting officials of the Anglo-French Condominium. All accounts highlight a close correlation between profiting from the market and the status achieved through the grade-taking ceremonies. The issue of copyright (which, as it has come to be conceptualized in Vanuatu, is defined as legitimate access to profit and attendant political authority by the assertion of stratified indigeneity and reproductive entitlement) started to infiltrate public discourse during the late 1960s and 1970s. On February 2, 1967, Vanuatu national radio broadcast the following report:

> In North Ambrym, the custom chiefs have now agreed that the local craftsmen may make only those artefacts which are appropriate to their grade in the custom society. The chiefs have found that with the increased business in artefacts, some of which are being exported, some local craftsmen have been making masks, images and slit gongs of a type which should only be made by people of a higher rank. Now, anyone breaking the new regulation will be fined. The senior custom chief in North Ambrym is Chief Tainmal of Fanla village whose duty it is to levy these fines. (M. Leach 1967)

From as early as 1967, Fanla villagers dominated the carving market on the basis of their claims to kastom authority, which, in turn, restricted who could make and sell particular objects. The word *copyright* was not often used at that time, but as international market interest grew, ni-Vanuatu found there was an easy convergence between this long-standing understanding of restriction and the concepts increasingly promoted by the WTO,

WIPO, and UNESCO within their generic models for national legislation. From the start, Condominium officers felt it their responsibility to maintain the "free" aspects of the market as well as the "integrity" of the "art" tradition without releasing political authority into the locality. In a letter dated March 1967, the British district agent wrote:

> I have been following with much interest the developments with regard to the making of artifacts in the North Ambrym area which first came to our notice with the report broadcast by Vila Radio that the custom chiefs had laid down certain rules regarding manufacture of handicrafts. When Tom Layng [a British government agent] visited Fanla recently he was told by Chiefs Tainmal and Tofor that the French District Agent had told them that the arrangement whereby people would be fined if they made an artifact of a higher degree than the rank to which either they or their fathers are entitled in the Namangge [*sic*] was illegal. No doubt Boileau [the French district agent] was technically speaking right since the chiefs of North Ambrym have no authority to exercise control in these matters and particularly to levy fines. (Wilkins 1967)

Such remarks intimate that both British and French authorities accepted the legitimacy of connecting customary to market entitlement but were more deeply concerned about the infiltration of local political power and entitlement into the domain of Condominium authority. Despite the coherent legislative initiative that had emerged clearly on Ambrym, both the French and British district agents were reluctant to accept it in Port Vila. They both concluded that some sort of protective system was needed to maintain quality control and "artistic integrity" (rather than to merely enhance economic profit) but that such jurisdiction should not be in the hands of locals—even though by all accounts it evidently was. This signals some of the complex politics underscoring the development of the economy in Vanuatu in which market exchange and colonial power were intimately entwined. Similar fears relegated indigenous enterprise to the punishable status of cargo cults (see chapter 5).

During the period of the Anglo-French Condominium (1906–1980), some high-ranking men gradually developed national identities as "chiefs" and were viewed by the colonial authorities as useful mediators between the government and the locality (Bolton 1999c: 3–4; see also Lindstrom 1997). Although many commentators have noted that high rank in the graded society does not necessarily give the bearer broader political power (e.g., M. Allen 1981a: 107–108; M. Allen 1984; Blackwood 1981: 39; Bonnemaison 1996: 203;

Jolly 1991), having a high rank was and is useful for becoming a "chief" and vice versa, rank itself being an exploitable resource. The evolving commentaries on reproductive and market entitlement in North Ambrym demonstrate the ways in which ideas about (intellectual) property rights, which in the present day have come to be called "copyright," emerged as a negotiation of political and economic authority among chiefs and between chiefs and the nascent nation-state. Within the growing tension between local and national ideas about how copyrights should be implemented, the mechanisms and authority of the graded society proved the most effective means of controlling the marketplace. Despite Condominium efforts, fierce competition over access to the limited market for carvings resulted in the local implementation of a system of indigenous controls that put economic profit in the hands of the highest-ranking and, hence, most powerful men. It is this system, in turn, that wields great influence on understandings of copyright legislation in the present day.

At the time of my stay in Fanla village (2001), the passage of the Copyright Act and the increasing awareness of the economic potential of the legitimate production of artifacts had led to an escalation of tensions related to making and selling of kastom carvings that highlighted the resonance of copyright within the local political economy. According to Fanla villagers, any man can make a business carving and selling drums by paying a pig and 6,000–8,000 Vatu (approx. $65–$86) to a family member who already holds such a right. This entitles one to sell one- or two-faced drums (Knut M. Rio, personal communication, July 5, 2002). More complex designs fall under stricter rules that hinge on the tracing of customary entitlements like those of Chief Willie through a mixture of personal practice and family inheritance. During my stay, two competing men were engaged in a dispute over rights to carve Maghe figures. One man, whom I will call Sam, and his family had embarked on a frenzied production of carvings to fill a container that was to be shipped directly from North Ambrym to Nouméa at the instigation of a French dealer. Other villagers were concerned about the monopoly of such a lucrative enterprise and charged that Sam did not have the right to carve and profit from the small drums and figures because he had no genealogical rights to the images he was making. Moreover, the fact that he had recently converted from Presbyterianism to Seventh Day Adventism (which overtly rejects all forms of kastom and, most important, forbids the eating of pork and the drinking of kava, thus, excluding all church members from the *bisnis pig* of the Maghe) was an even clearer indication that he had no personal right to use kastom for economic gain.[22] At a public meeting of the region's council of chiefs to ascertain the legitimacy of his copyright claims, Sam had sworn rudely at council members.

They wanted to put a halt to the shipment of artifacts until the matter could be resolved and Sam punished by the local kastom court, probably by being made to pay a compensatory fine. A man from the opposing side dictated a letter to me and asked me to carry it back to the VKS in the hope that the director would intervene and stop the shipment of objects before it left port for Nouméa. Seemingly in response, two of this man's pigs were killed in his gardens.[23]

As far as I am aware, the chiefs of Fanla were unable to block this particular shipment from setting sail. As a result of this dispute and others, however, the North Ambrym Council of Chiefs called a meeting at which all of the "chiefs" (in this instance explicitly calling themselves "high-ranking men") of the region convened and transcribed the Maghe genealogies of their families. Thus, the rights that specific ancestors had paid for in the past could be profitable to those who could trace descent from those ancestors, even if the descendants were no longer active members of the Maghe. The council intended its document to ensure that each individual's family rights to carve became public knowledge and also to serve as the basis for an enforceable form of copyright legislation. The meeting of chiefs was much discussed on Radio Vanuatu, and at the time of my visit to the island, Marie Ange Osea, the manager of the only ni-Vanuatu-run handicraft store in Port Vila at the time, Handicraft Blong Vanuatu, was waiting for a copy of the document to be sent to her so that she could adjust her buying policies accordingly by crosschecking vendors with the names on the list. She commented,

> Copyright will give people back their sense of kastom. I really want every island to write down what belongs to them, and give me a copy so that I can know what is right to buy and what is wrong, what their kastom rights are, what children have the rights to make, what family line has this right or that. It is no good if I buy something and afterwards someone says, they don't have the right to make this. I am waiting for this to arrive—a black and white letter to tell me who has the right to carve what designs. . . . Each decoration belongs to someone. . . . Copyright will stop people from making things haphazardly, by only letting people with the right to carve, carve. (author interview, Port Vila, April 4, 2001)

In establishing through dispute and discussion a consensual legitimacy for carvers, the high-ranking men of North Ambrym were pleased to extend their ideas about the local graded society of both past and present outward into the national, and even international, domain—cutting out those without proper customary legitimacy. In May 2004 a wholesale

store selling North Ambrym carvings opened in Port Vila. Set up following the drafting of the document at the 2001 meeting of chiefs, the store was run by one of the families that had been awarded sole ownership rights to the production of particular kinds of drums (see Toa 2004). The development of grassroots copyright legislation has finally succeeded in fusing the political authority of the Maghe with almost total economic control of the national market for North Ambrym carvings, especially that for vertical slit-drums.

The wholesale store is one of the few formal dealerships of Ambrym artifacts in Port Vila controlled completely by people from Ambrym. Previous dealers have either been expatriates (mainly Australians and French) or ni-Vanuatu working for initiatives of the Vanuatu Cultural Centre. Through their development of a mini-industry in the production of drums and figures for the tourist market, North Ambrym men have redefined the parameters of both market and kastom. In contrast to the seeming possessive individualism of commodity market exchange and the internationalist views of IP legislators (Chapman 2001), Fanla villagers have managed to assert their own forms of entitlement on the basis of a local gerontocratic political economy. The market here has been propagated by the simultaneous stringency and flexibility of local narratives about entitlement, of which copyrights have long been a part. Expatriate collectors and dealers are increasingly affected by the stringent terms of North Ambrym men, who both restrict the pool of producers and control the pool of consumers, whether dealers or tourists.

The Efficacy of Analogies: The Sorry Story of Another Many-Faced Drum

During the course of my research, I quickly found that a local conception of copyright that I had initially aimed to track from Port Vila into the island had developed on Ambrym itself over many decades and that processes of establishing legitimacy and entitlement were evolving as much from the bottom up as from the top down. Also evident, perhaps unsurprisingly, was that ideas about indigenous copyright had developed in tandem with the growth of international commercial interest in customary artifacts and that this interest was a primary motivation for drawing the initial analogy between the entitlements of copyright and the kastom entitlements of the graded society. In this final section, I focus on the profound efficacy of this analogy in Vanuatu—an efficacy that I believe will extend into the national courtrooms once the Copyright Act becomes fully enforceable.

The proliferation of North Ambrym–style artifacts for sale in Port Vila, made by men

without appropriate status or even ties to the island, is of great concern to carvers from North Ambrym who frequently travel between village and town. Intra-indigenous tensions are also precipitated by the dealer stores in Port Vila, spaces that encompass some of the most confrontational social and political relations between foreigners and ni-Vanuatu. As in the case of the tensions between chiefs and Condominium officials on Ambrym described above, ideas about copyright have been consolidated by the wrangling for economic control that takes place within dealers' stores. Copyright in Vanuatu is more than just a legalistic consolidation of customary entitlement using the language of international IPR; it is a crucial political tool—a powerful device in the manifestation of an indigenous political economy and of indigenous agency, more generally. This emerged explicitly in the confrontation that arose in Port Vila between high-ranking men from North Ambrym and an expatriate dealer.

In 2000 the "art" stores fringing the main high street of Port Vila were primarily run by long-term expatriate residents of Vanuatu, predominantly French and Australian women. All of these women entered the artifact business through personal interests in "tribal art" and artistic practice. Within all of these Port Vila stores, carvings of various kinds by men from North Ambrym dominate the stock. By the end of my first stay in Vanuatu (August 2001), many of the established expatriate dealers were talking about closing down. By 2010 almost all of the stores were run by ni-Vanuatu. Each dealer had personal reasons for withdrawal, but a general disaffection with the trade had also arisen, primarily related to the growing cultural politics of the marketplace that made it difficult for expatriate women to trade, especially in kastom artifacts made by men. Once more, carvers, carvings, and copyrights from North Ambrym have been at the forefront of this problem.

Tensions had come to a dramatic head in 1996, when an Australian dealer received a commission to have carvers in her workshop produce several large, four-faced Ambrym slit-drums, to be used as posts for a new bridge at the Le Meridien Hotel in Port Vila.[24] The local newspaper, the *Trading Post* (now the *Vanuatu Daily Post*), reported on the conflict that arose over the hotel drums, which had been carved by two men from Fanla village, one of whom regularly worked in the dealer's workshop, producing North Ambrym artifacts as well as stylized furniture, mirrors, and other decorations incorporating traditional motifs: "[The dealer] was reportedly ready to close down her business and leave Vanuatu following threats made to her by [an Ambrym chief] to 'pay a custom fine' of vt140,000 or have black magic custom put on her" (*Trading Post* 1996c). The newspaper reported the chief's threat: "We will use old custom on you if you refuse to pay. Wherever you go and whatever you do in business it will fail if we do this" (1996c).

The dispute had arisen over the dealer's right to commission the four-faced drums and to sell them to the hotel. Describing the Fanla carvers to the *Trading Post* as her "advisors on Ambrym custom," the dealer related having been assured by them that they had the right to carve the faces on the drums. As soon as the images had, in fact, been created, the carvers, under pressure from the chief, told the dealer that they had broken customary law and demanded 190,000 Vatu (approx. $1,670) from her—the exact value of the contract with the hotel. The Malvatumauri ruled that the dealer should pay only a third of that amount, but she was still threatened by North Ambrym chiefs, who wanted her to pay them the full amount. The newspaper reported that the carvers were dissatisfied by the amount of money that the dealer had paid them out of the original contract with the hotel because, as a woman and a foreigner, she had no business profiting from their kastom. They subsequently approached the Department of Labor, eventually changing their demand for "customary compensation" to one for "severance pay" after their dismissal from the dealer's employ as a direct result of this conflict.

The *Trading Post* article concludes that "expatriates are becoming increasingly more concerned over heavy custom fines in Vatu often exceeding vt100,000 slapped on them for breaching custom laws they know nothing about" (1996c). The Malvatumauri officially stated that it was in the process of drafting the kastom copyright laws and fines that would eventually be presented in Parliament—an initiative that subsequently fed into the local and national copyright legislations I have been describing.

The following week, the *Trading Post* printed a response from the chief whom the paper had previously reported to be responsible for the threats to the dealer. The chief denied threatening her with magic or demanding a custom fine; instead, he asserted that the money owed to the carvers was merely payment for carving the drums and compensation for their dismissal. The chief commented that "to travel to Ambrym and buy a carved tamtam [Bislama for vertical slit-drum] is one thing but to get a carver from the island to carve tamtams outside Ambrym is quite another. . . . Our tamtam carving techniques are sacred to us from Ambrym and carving a tamtam in public for public viewing outside our island in the name of commercialisation is reducing our cultural values and a threat to our identity" (*Trading Post* 1996a).

In the newspaper's final installment of the story, the front-page headline read: "Govt Say Ambrym Chiefs Must Pay Back the 140,000" (*Trading Post* 1996c). The dealer, angry at hearing the chief's denial on the radio, contacted the minister for public works and transport, also from Ambrym, who sent in an official investigator. The investigator concluded that the

carvers had transgressed the rules of copyright and had given the wrong advice to the dealer regarding the customary rules for carving the drums. In fact, the investigator concluded that if the dealer wanted to take the carvers to court, the government would support her case. The Malvatumauri apologized, claiming that it had been given the wrong information by the North Ambrym chiefs and that the dealer need not pay the fine. The government investigator concluded that "vt140,000 is a lot of money, that represents 8 pigs in our custom. Vatu cash is not a custom fine" (1996c).[25]

The rubric of copyright, as it emerged within this conflict, had several meanings that arose in the movement of four-faced drums from North Ambrym to town. From beginning to end it is unclear whether the issue involved carving the drums per se, carving them inside or outside Ambrym, the commissioning per se of such drums, the commissioning and circulation of the drums by someone who was *tabu* and low status in local terms, the sale of such items, or the presentation of such items in a nonindigenous context. None of the parties involved made statements that were clear or consistent, and the story changed ground from week to week.

What is clear, however, is that the rubric of copyright, rather than being a definitive assertion of a static conception of property and entitlement, was an instrument for the assertion of indigenous political and economic authority at the highest level. Despite the findings of the government's investigation, the Ambrym chiefs won out in the end—although the dealer may have succeeded in negotiating the contract with the hotel and in winning her dispute about the legitimacy of her activities, she has since ceased trading in North Ambrym artifacts. When I interviewed all parties concerned in 2001, the dealer claimed that she had been given misinformation at every level and that she was genuinely frightened of North Ambrym sorcery; she carried a magical protective amulet from the island of Maewo on her person at all times. Chiefs from North Ambrym now control the market for their carvings.

Conclusion: Sui Generis Copyright?

Copyright in Vanuatu is an arena within which political and economic entitlements are increasingly extended and contested, most importantly crosscutting divides between exchange strategies and understandings of property and entitlement. We may use it as a provocative critique of anthropological understandings of property and global accounts of the colonial spread of IP. In the case of the Australian dealer, copyright figures both as a trope to articulate various kinds of political and economic tensions and as a manifestation

of indigenous political and economic agency. The analogy between the power of copyrights and of kastom entitlement was supported by the role of another kind of kastom—sorcery—in enforcing copyright through threats and fear. A carver from Paama Island, who also worked with the dealer in the case recounted above, told me that he was ill in the hospital for a number of years after infringing copyright by carving images from North Ambrym, thereby becoming a victim of serious North Ambrym sorcery. The dealer I have been discussing is by no means the last to have been threatened by high-ranking men from North Ambrym who explicitly equate the rights to (re)produce and circulate their carvings with their own political authority.

A long-standing analogy has linked international and indigenous reproductive entitlement to the extent that they are no longer two systems but one ever-expanding domain of reproductive control, entitlement, and authority whose boundaries are negotiated alongside the power structures of the state. A usable written version of copyright legislation modeled primarily on the reproductive entitlements within the graded society of North Ambrym has been available to the nation-state for several decades, and such initiatives have been salient to the drafting of national legislation. At the same time, the Ambrym villagers' conceptions of kopiraet have long been galvanized in explicit interaction with growing international market interest in their wooden carvings. The movements of images and artifacts between, and within, graded societies exemplify this contextual symbiosis: the spirit of the ceremony is also the spirit of exchange is also the spirit of copyright. These spirited transactions are extended into exchanges of objects between graded society members (as well as aspirant or fraudulent members) and foreign dealers. Contrary to the criticisms that many make about the tendency of market interests to greedily objectify and alienate culture, my study of the reproduction and transaction of North Ambrym carvings shows how an indigenous social and moral order may be extended through the commoditization of kastom material. This extension is apparent in the ways in which titled men in Ambrym explicitly claim that kastom rights gives them the right to market touristic objects and to restrict their production by others. The complex ways in which entitlement itself is transacted (e.g., a man of standing may give a better carver the rights to produce his images for him) in kastom creates grounds for potential anxiety in the proliferation of a market outside of the graded system. The solution is to expand the graded system.

This survey of the development of diverse forms of copyright legislation in relation to the commodity market for carvings in North Ambrym forces scholars to confront the

presumptions we make about international IPR legislation and attendant global commodity interest and its relationship to indigenous persons and about the processes by which people participate in these so-called global property regimes. The incorporation of Maghe rank and, by extension, political-economic entitlements into the international marketplace has resulted in the extension of an indigenous political economy, incorporating Australian dealers as well as ni-Vanuatu carvers from throughout the archipelago into a legitimate hierarchy. In this way, Fanla men provide a positive case study for the assertion of indigenous rights and concepts within the marketplace and within the domain of legislation to which the marketplace is so intricately connected. Rather than viewing the process of commoditization, and the attendant forging of IPR, as an alienating transition from immaterial to material, we might focus on "the ways in which relationships to objects can organize boundaries" of entitlement (Myers 2004: 6) and how property relations are able to embody divergent concepts of entitlement and redefine the borders between ideas, places, and regions of political authority.

All the copyright cases discussed above concern many-faced drums from North Ambrym, and, indeed, as far as I know the highest-profile national disputes and local prosecutions of copyright violation have involved these artifacts. Indeed, carved images are the salient reference point within the national legislation. These examples are having repercussions in other domains of production in Vanuatu, and people producing drums and masks on Malakula, dances in the Banks Islands, and the land dive ceremony on Pentecost have also begun to use copyright as a way to think about the control and profit of these manifestations of kastom. The entangled nature of understandings of copyright in Vanuatu demonstrates that copyright legislation has the potential to affect any system of entitlement as much as it may protect or be produced by it.

This in turn has the potential to reinflect our thinking about the interface between international and sui generis IP regimes and the ability of nation-states to mediate between the two. WIPO assumes that the concept of IP is universal to all culture and nations and that even traditional knowledge can be subject to some kind of property regime. Recognizing some of the existing legislative limitations, WIPO aims to investigate and develop a sui generis IP regime for traditional knowledge that will be documented with community collaboration (World Intellectual Property Organization 2006; Anderson and Torsen 2010). As it has been described, the attempts of North Ambrym men to fix the definitions of copyright may be called a sui generis legal regime, but it is very different from what was imagined by WIPO. However, it is not recognized as such by the state. Rather, the National Copyright Act

is a law modeled on generic copyright legislation that frames the efforts of implementation that Ambrym men have taken upon themselves to provide. There is much controversy, both within the realm of indigenous activism and academic commentary, about the applicability of generic IP to traditional knowledge.

This case provides a good example of the complex mediations between law and grassroots agency, and it exposes the limitations and expansive nature of generic legislation. The artifice of sui generis is that it demands even more codification than the generic preexisting IP laws, which at least, in their being context-unspecific, allow for the possibility of translation, mediation, and interpretation. The widespread adoption of sui generis regimes would require a codification that, while by no means inappropriate, would remove the creative tenor of analogy making from the connection between IP and traditional knowledge or cultural expressions. As my survey of the market demonstrates, Ambrym men are already in the world system—they have been managing the market for carvings and, by extension, political entitlement and spiritual rights, long before rubrics of copyright entered into their discussions and into the marketplace. However, copyright is now both an efficacious alternative to Maghe entitlement—and Maghe entitlement may yet be the grounds for a sui generis template with which to understand the connection between kastom and copyright. The copyright complex in Vanuatu demonstrates that the provincialization of ideas about copyright takes place around codified law to such an extent that it affects the understanding of how such laws may be implemented and has been taking place over many decades. In this way, a powerful indigenous imaginary is constructed for IP, which in turn provincializes both the codification of new law and opens the possibility for the recognition of a new kind of "legal" regime. The view of the graded society, seen through the eyes of Condominium colonial administrators, is in turn mirrored back onto the ways in which a kastom or indigenous copyright system is imagined in the present day. This captures the dual sense of the province—which looks always to an authority perceived to be elsewhere but, at the same time, runs its society without the full constraint of those external conventions. It is this kind of provincialization that allows for indigenous copyright, indigenous leaders, and indigenous ideas about law to govern the ways in which drums from Ambrym are made and transacted in the island, in Port Vila, and beyond. In the following chapter, I survey the ways in which trademark law has emerged in a similar frame—that of indigenous value and colonial law. However, the exigencies of the settler state, the power of a more "developed" national economy, and the intensive bureaucratization of indigenous cultural production have created a very different provincial form of IP in Aotearoa New Zealand.

5 Trademarking Māori

AESTHETICS AND APPROPRIATION
IN AOTEAROA NEW ZEALAND

THE DEVELOPMENT OF national and indigenous copyright regimes in Vanuatu builds on a pluralist discourse in which kastom law and "Western" law are conceived as parallel systems that also have the potential to incorporate one another. This pluralism is qualified by a number of factors—all legal systems in Vanuatu are ultimately defined by the state legal system *but* the state is relatively weak. Indigenous copyright is therefore more than a legal category. It is also a provincializing form of power that has been appropriated to the ends of North Ambrym chiefs, privileging indigenous hierarchies as the ultimate arbiters of entitlement by using the global rubrics of intellectual property (IP) legislation and discourse. IP regimes in New Zealand, modeled on first British and then international templates, are more firmly established in the state's legal tool kit and are more successfully bureaucratized in New Zealand than in Vanuatu. They are provincial in the second sense of the term, emulating imperial law in the settler colony. In this chapter, I enquire into the indigenizing project in this kind of province, asking, "What is

indigenous intellectual property in Aotearoa New Zealand?" I follow the same pathway as in my discussion of copyright in Vanuatu by placing new legal initiatives, particularly focused on trademarks, in the context of the state management of indigenous cultural production as an asset or commodity. As with copyright in Vanuatu, which is as much a discourse about kastom entitlement as it is a commentary on the ownership of culture in a global frame, Māori trademarks in New Zealand constitute an aesthetic framework for recognizing indigenous culture and forging communities of practice, as well as appropriating indigenous art to create a national brand.

To understand why IP, and most particularly trademarks and brands, have become such fertile grounds for the production and negotiation of Māori identity in Aotearoa and beyond, we need to trace a brief history of the entanglement of aesthetics, appropriation, and indigenous rights in New Zealand. As with Vanuatu copyright, the power relations condensed within New Zealand trademarks are enacted within the aesthetic domain. Intellectual property is *made* indigenous by the mobilization of visual and other sensory media, epitomized by the aesthetic agency of trademarks and brands. The working definition of aesthetics I draw on is not simply the conventional definition of those principles concerned with what is beautiful and therefore valuable, especially in art. Rather, I draw on the lengthy discussion of aesthetics within the anthropology of art (e.g., Morphy 1991; Coote 1992; Gell 1992, 1998) and define aesthetics more broadly as an affective domain (which might be painful, pleasurable, and powerful as well as beautiful) that is constituted through sensory experience (Buck-Morss 1992). In this opening section, I explore the ways in which trademarks and brands are made effective as IP via the agency and exhibition of sensuous forms.

In New Zealand the language of intellectual and cultural property has for a long time been used to frame indigenous cultural production. In chapter 4 I traced the lengthy history of copyright in Vanuatu, highlighting the ways in which the graded societies of the North Central region have long provided a template for the imagination of indigenous IP rights. I described this analogy as a provincializing process, one that draws together indigenous and generic understandings of copyright to create a new subject position and center for IP. I also highlighted the fact that the generic is itself constituted within a provincial context, destabilizing the boundaries of that which is indigenous, national, and international. Similarly, the history of appropriation of Māori cultural production is also the history of the production of the New Zealand settler state. This can be clearly seen within New Zealand art of the twentieth century in which Māori and Pākehā worked

within the canon of modernism to produce an image of themselves as the other (see Green 1992; Panoho 1992; Thomas 1999). The constitution of the *toi iho* trademark for Māori cultural production likewise rests on a complex history of appropriation and aestheticization that marks the nation itself as indigenous. In the rest of this chapter, given the paradoxical foundations of indigenous entitlement as both resistant to, and encompassed by, the British modeled nation-state, I connect the entanglement of indigenous rights and aesthetic production to the constitution of Māori trademarks and brands. In the broad context of the struggle to constitute intellectual and cultural property rights that are recognizable and acceptable to Māori as well as to the New Zealand state, trademarks and brands occupy a liminal space between these two parties of interest. In the following sections, I outline the dual context of the provincialization of IP and the colonial history of aesthetic appropriation, both of which link image and identity to forge understandings of entitlement and of sovereignty and out of which the toi iho trademark emerged.

Colonial History and the Aesthetics of Circulation

The history of nations is also a history of the generation of particular forms (B. Anderson 1991); national signs and symbols are aesthetic indices of the very tensions that constitute the nation itself (Mookherjee and Pinney 2011). Amiria Henare describes how writing and signing is part of an underlying cultural system in Aotearoa in which marks on paper are equated with marks on skin—both as objectifications of people's ancestral power (mana). She uses the example of nineteenth-century Māori signing of treaties and contracts (including the Treaty of Waitangi) with renditions of their facial tattoos and, in reverse, the use of pages of books as valued ornamentation (A. Henare 2007: 52 53; cf. Gell 1993). The Treaty of Waitangi's authority is material and aesthetic—it literally embodies the ancestors by their marks on paper and presents a visual form of the sociality of contract.[1] By this logic a Māori trademark or brand would be similarly invested with the affective agency of the people that lie behind it—it signifies more than just a commodity relation but a social group and in turn a social contract to publicize the value and relations of entitlement and ownership.

The ways in which the practice and form of marking evoke tensions within the settler colony is drawn out profoundly in the following anecdote, which also highlights the importance of cultural representation, such as museum display, within the provincializing project. In a documentary created to mark the opening of the Te Papa, in 1998,

FIGURE 7. Te Papa Plinth, exterior of the museum. (Courtesy of The Museum of New Zealand Te Papa Tongarewa, Wellington, New Zealand. Reproduced with permission.)

the filmmakers interviewed the advertising executives from Saatchi and Saatchi who were hired to create the museum's brand. Two executives sit in front of the camera, surrounded by sheaves of paper that contain the many images they developed during the process of generating the thumbprint which became the museum's mark. Their talking heads are interspersed with shots of high-level museum management and trustees discussing specific suggestions. These discussions are superficially amusing, for instance, the viewer witnesses the conservative trustees railing against abstraction while drinking tea around the boardroom table. But this surface humor masked a deeper underlying tension. The two (non-Māori) executives spent some time discussing the failure of one of their ideas, a cross-like mark in a typeface taken directly from the Treaty of Waitangi, which was supposed to indicate an "x-marks-the-spot" affirmation of place. Both account executives and museum trustees expressed great enthusiasm for the mark. They were surprised at the response of one of the Māori cultural advisors. It was, he said angrily, a "humiliation to Māori." Māori would associate the cross with failure (the crosses they received at school). The association with the Treaty made this even worse—the cross was the mark made by some of the Māori signatories who were unable to write their names. There was a double failure here, he said: the failure of the Treaty to protect Māori rights and lands and the failure of these chiefs to participate on equal terms because they were illiterate. The executives and non-Māori members of the board, seduced by the treasure-map exuberance of the mark, were baffled by this. The understanding of how marks and inscription resonate in settler-colonial and indigenous frames needs to be counterbalanced by an understanding of how these two frames constitute one another (see figure 7).

The resonance of marking and image making has a lengthy history not just in the domain of political economy, where tattooed skin and its replica on paper became a signifier of Māori political authority, but more generally in the domain of "art" production. An aesthetics of appropriation, responding not only to indigenous experience in the settler colony but also to the mutual constitution of appreciation and appropriation marked out by the consumption of indigenous culture on a global market, has long infused contemporary art in New Zealand. Thomas's influential art history of indigenous modernism in Australia and New Zealand (1999) contains many accounts of the co-production of indigenous and national signs, symbols, and visual styles. Art in the settler state is itself a provincializing activity; it produces the indigenous through the appropriation of canonical styles and institutions (see Myers 2002). The institutionalization of "traditional" Māori art took place in Rotorua, at the center of the New Zealand tourism industry, or in the painted

churches of Te Kooti, among the charismatic leaders of indigenous Christian and colonial resistance movements.

The production of a twentieth-century indigenous New Zealand modernism reflects these dual processes. Take for instance two iconic images by two of New Zealand's most important twentieth-century artists (see plates 2 and 3 of the color insert). Both Hotere and Walters have been at the center of lengthy discussions about the connections between cultural appropriation and modernist aesthetics in the settler colony (e.g., Thomas 1995). Gordon Walters (1919–1995) was a Pākehā artist who incorporated Māori symbols such as the *koru* and *kōwhaiwhai* into his abstract imagery. Commenting on his use of the koru, Walters in 1996 commented, "My work is an investigation of positive/negative relationships within a deliberately limited range of forms; the forms I use have no descriptive value in themselves and are used solely to demonstrate relations. I believe that dynamic relations are most clearly expressed by the repetition of a few simple elements" (quoted in Thomas 1999: 149).

Ralph Hotere (1931–) is a Māori artist who, influenced by American minimalism, particularly the work of Ad Reinhardt, went through a famous "black period." Like Walters, Hotere frequently used Māori language in his paintings and their titles. Throughout his career, Hotere repeatedly refused to acknowledge his artistic identity within a Māori framework, claiming that his indigenous identity was "coincidental" to his identity as an artist (K. Baker 2009: 104). However, his use of black, his fascination with circles, and his later use of Māori poetry have placed Hotere firmly in New Zealand art history canon as a Māori artist (Wedde 2000).

Both Hotere and Walters are painters who could be defined as abstract and minimalist, but they also indigenized these styles, as Thomas notes, "injecting something peculiarly local into their art" (1999: 182). They provincialized the mainstream aesthetics of both global modernism and indigenous culture in similar ways, influenced by the peculiar dynamics of the settler colony, a provincial space shared between indigenous and national cultures, marked by an aesthetics of appropriation that mediates between the generic and the indigenous specific (see also Thomas 1995: 96). Indeed, one might go even further to argue that the settler colony makes explicit the power relations that remain implicit elsewhere—for instance, in underlying appropriations that permit appreciations, such as the inherent primitivism and aesthetic imperialism of high modernism (e.g., in Rubin 1984; see also Clifford 1988b; Miller 1991; Chave 1992).

In the twenty-first century this aesthetic doubling continues in the work of many

contemporary Māori artists who have developed a visual repertoire referring back to troubled histories of colonization: images culled from stamps, coins, or land deeds, from the material culture of colonialism (e.g., the jewelry of Matthew McIntyre Wilson; the typographic images and installations of Robert Jahnke; the clothing, bedding, and quilts produced under the label Native Agent; the sepia historical paintings by Shane Cotton; the photographs taken of museum specimens and in museum storerooms by Fiona Pardington and Neil Pardington, and the installation of embroidered poi by Ngaahina Hohaia) (see plate 5 on the color insert). There is an underlying aesthetic in the work of all of these well-known artists that ironically appropriates the colonial image bank (which itself relied on a series of appropriations of Māori images) to make important statements about indigenous identity in the settler colony. It is no coincidence that the graphic inheritance of colonial images looms strong and is almost viral in moving between artists.[2]

The double effect of contemporary indigenous art in New Zealand, in which strong claims about indigenous identity are made through a visual language that draws on colonial images, which in turn depended on the appropriation of indigenous imagery, maps onto the complex ways in which I have been describing IP as a palimpsest that articulates and produces local/global relations.

Brands and Trademarks as Aestheticizations of Indigenous Identity

Brands can be understood to be semiotic personifications of corporate energy, romantic producers, happy consumers, and global exchanges (Manning 2010), as ontological assemblages (Lury 2009), as materializations of value, and as co-produced cultural indices that negotiate the complex political economy of commodity consumption, personal and corporate status, and economic imagination (Foster 2007). Contra to much of the sociology of brands (e.g., Arvidsson 2007; Moor 2007) Bevan and Wengrow (2010) argue that brands must be viewed in a context that transcends the logic of capitalism and (post) modern globalization (see also Wengrow 2008). Their edited volume reaches far back into (pre-capitalist) history and across the globe into the diverse cultural contexts of appropriation. In these accounts, brands and branded goods are not solely defined by conditions of modernity and modern globalization, but are more broadly "understood as mediators of social relationships; relationships grounded in wider notions of trust and authenticity, and distinction that vary between cultural and historical contexts" (Bevan and Wengrow 2010: 21–22).

Working in Melanesia, both Simon Harrison (2007) and James Leach (2008) focus on brands as particular methods for constituting proprietary identities and identify them as consonant with practices of Melanesian identity constitution. The very idea of "branding" Māori exemplifies the historical relationship between Māori and the state in New Zealand and highlights how indigenous culture (and cultural production) gives aesthetic form to IP rights (and vice versa). This process of aestheticization is in fact an instantiation of power relations and ideas about sovereignty via a process of "affect management: the ongoing attempt to harness a volatile, often explosive, oscillation between affect-intensive images and their discursive elaboration" (Mazzarella 2003: 35).

Over the past decade, the appropriation of Māori words, names, and styles has been avidly contested by Māori people on the global stage. In 2004 singer Moana Maniapoto was sued by a German company for using her own name as the title of her latest album. The name Moana had already been trademarked and associated with a number of different products in Germany. Maniapoto lost her case and had to change her performance handle to Moana Maniapoto and The Tribe (see chapter 1). In recent years Lego marked a series of Bionicle toys with Māori names; the Ford Motor Company used a Māori *moko* (tattoo) design for its F-150 Lightning Brand;[3] Sony Playstation used Māori weapons and customary dress for the character in its game *Mark of Kri*; and a Hollywood film, *The Hangover 2* (2011), appropriated a facial moko from the boxer Mike Tyson—this second-order appropriation causing much dissent amongst Māori *ta moko* practitioners (Strickland 2011). These appropriations were all used in popular media accounts to highlight the diabolical nature of corporate appropriation of indigenous designs and the ferocity of Māori claims to their culture as a form of IP (see van Meijl 2009a). Such critiques have been remarkably effective, with products withdrawn from circulation and public apologies by corporations and individuals. Yet how much does this alter or influence the IP regime (e.g., the legal rather than moral framework in which rights are recognized)? Apologies and modified behavior do not always translate into dollar sums of compensation and the recognition of commodity ownership.

In New Zealand the appropriations continue. There is contestation about the production of greenstone carving and the copying of Māori motifs by both high-end non-Māori artists and Chinese factories. There is contestation about the ways in which the Treaty of Waitangi, and Māori more generally, is imaged and imagined in the media.[4] As in the case of the interventions into auctions that I discuss in chapter 7, the constitution of Māori culture as an object to be appropriately owned and represented works in different

ways. This perspective both sacralizes indigenous culture and commodifies it. The blurring of the boundaries between ownership and accountability exploits a divide between image and object, aesthetics and product: brands and trademarks have become key media through which identity is brought into national sight. In 2009 the New Zealand government invested over $10 million into the Māori Economic Taskforce, which works in seven key areas: tribal asset development, the primary sector, economic development, education and training, small to medium enterprise, economic growth, and infrastructure. Alongside the mission to develop Māori economic activities and support Māori enterprise, the taskforce is committed to the application of Kaupapa Māori principles in business and economic practice and as "drivers of Māori prosperity." The taskforce has dedicated significant energy to discussion of the trademarking and creation of a concept Māori as a global brand. Models for the brand are the All Blacks Haka, which has created a powerful image for the national rugby team, drawing in significant sponsorship, and the exhibition, *Te Māori*, which is widely recognized as a key event in the formation of a positive image for Māori internationally.

TE MĀORI

To underscore my argument that exhibitionary aesthetics and national values meet in the constitution of indigenous IP, in a meeting hosted by Te Puni Kokiri (Ministry of Māori Development) in October 2009, the brand Te Māori.com was suggested as a holistic brand that encapsulated the best of Māori business.[5] The rationale for this was the global success of the *Te Māori* exhibition, which traveled internationally and in New Zealand in 1984–1986, one of the first aesthetic platforms in the postwar period that empowered Māori people internationally and which promoted the idea of Māori museology (the exhibition and its aftereffects in the context of an emergent Māori museology are discussed in detail in chapter 6).

David Butts views the *Te Māori* exhibition as a material site of resistance that explicitly changed the relationships between Māori and museums and altered the museum practices in the places the exhibition traveled to (2003: 86; McCarthy 2011). For my purposes here, I emphasize its importance in consolidating Māori principles of entitlement and rights through the aesthetics of exhibitions. In a discussion between the Māori artist Robert Jahnke and Piri Sciascia, at the MĀORI ART MARKet, a forum for the sale of Māori art (modeled after the Santa Fe Indian Market), Jahnke commented that he believed the strength of *Te Māori* was in the way it created a new public space for Māori art,

reconfiguring the exhibition of artifacts and presenting the pieces not just as "objects of gaze, but objects of culture."[6] Wherever the exhibition went as it moved across the United States, Māori people also went, and they placed their own mark on the museum, revivifying the collections. The Meeting House, Ruatepupuke II, at the Field Museum has since the exhibition become known as Chicago's marae. Despite the infusion of primitivist as well as Māori aesthetics (the presentation, and affirmation, of taonga as fine art, spotlit in darkened rooms from above; an emphasis on the muscular traditions of wood, greenstone, and bone carving), the exhibition also led to an enhanced awareness and acknowledgment of Māori people and their rights as cultural custodians and cultural property owners.

In a speech given at the twenty-fifth anniversary commemorating the exhibition, Hirini Moko Mead, who was its cultural liaison and co-curator, identified a primary contribution of the exhibition as introducing the notion of cultural ownership as an alternative to legal ownership of museum collections. The provincialization of primitivist museum display was effected by the incorporation of extensive consultation, the cultural notion of "keeping our taonga warm" through appropriate protocols, and the accompaniment of elders as the objects traveled. The overseas success of the exhibition prompted a revaluing of Māori culture back at home in the face of such overwhelming international acclaim and resulted in the introduction of more Māori people as museum workers in Aotearoa New Zealand. The national and international power of display and value of exhibition makes *Te Māori* a natural "home" for a discussion of "branding" Māori in Aotearoa.

Exhibition tactics and visual arts are important for the constitution of brands as signifiers of both national and indigenous identity. The aesthetic forms gleaned both from the settler state, from the international array of modernist signage, and from indigenous culture work together to produce a settler-colonial image bank, one that literally invests value in images as a particular kind of resource. In the rest of this chapter, I turn more specifically to the ways in which Māori trademarks are used to generate discussion, policy, and practice around indigenous IP.

Trademarks in New Zealand

I argue here that it is only a short jump from the broader climate of authoritative signification within the settler colony to the constitution of the signifying practices of IP (namely, trademarks and brands). Trademarks were initially established to protect the signs and markings of manufacturers by ensuring that their products would be associated with

their "good names" without any confusion being brought about through copying by their competitors (Bently 2008). The Merchandise Marks Act of the United Kingdom (1852) defined trademarks as "any Name, Signature, Word, Letter, Device, Emblem, Figure, Sign, Seal, Stamp, Diagram, Label, Ticket or any other Mark of other description, lawfully used by any person to denote any chattel, to be the Manufacture, Workmanship, Production or Merchandise or such Person" (10). Conventionally, trademarks establish an origin for a product, guarantee the promises of this origin point (to quality, consistency, and so on), and create an identity for a product, which through the mark becomes an extension of the company that produces it. Most trademarks are visual: words, images, or a combination of the two, but the materiality of the trademark is expanding. Sound marks (such as the closing bell of the New York Stock Exchange) are proliferating, and there are growing numbers of attempts to trademark colors (such as the orange of the telecommunications company Orange; see Lury 2009) and smells (most "scent marks" have been denied, but a few have been upheld such as the EU recognition of the smell of fresh-cut grass as a trademark for tennis balls). In the most successful instances, now delineated as "love marks" (K. Roberts 2005), the connection between mark and product becomes a brand so strong it evokes powerful emotional responses, demanding fierce loyalty with sensuous affect.

Rosemary Coombe (1996) argues, following Taussig (1993), that trademarks operate by a process of mimesis—the visual form gains power from the contact it evokes with its referent and creator. Product, mark, and consumer are in a symbiotic relationship:

> A mark must attract the consumer to a particular source, that, in mass markets, is often unknown and distant . . . it registers a real contact, a making, a moment of imprinting by one for whom it acts as a kind of fingerprint—branding. But if the mark figures a fidelity, it also inspires fidelity in the form of brand loyalty. The consumer seeks it out, domesticates it, and provides it with protective shelter; he makes a form of bodily contact with it. The mark distinguishes the copy by connecting it to an originator and connecting the originator with a moment of consumption. (1996: 205)

Trademarks and brands are therefore intimately linked within a value system constituted by the indexicality of aesthetic form. As Simon Harrison notes, issues of trademark ownership hinge on a form of "proprietary identity" in which the mark may seem to be detached from its referent but in fact stands in for the person—individual or corporate—and can therefore cause harm, offense, and so forth if used inappropriately (2007: 34). In the

case of the connection of indigenous values to trademarks in New Zealand, the prevalent aesthetic value is of appropriateness as well as beauty. Trademark law delineates the domain by which specific aesthetic forms may become the legal, and exclusive, bearers of communal or corporate identities and rights. The discourse on trademarking, in New Zealand especially, has focused explicitly on the nature and politics of appropriation and the ethics of appropriateness rather than on the boundaries of property, private or otherwise. Culture has become a moral ground of indigenous intervention into trademarking regimes. Trademarks are therefore instructive as legal forms through which government can control the circulation of indigenous culture and the language of property as well as propriety.

Trademarking Māori

In 2009, during the last period of my fieldwork for this book, Creative New Zealand, the national arts council, announced that it was withdrawing support for the toi iho group of trademarks—a government-sponsored project to support and protect Māori expressive culture. From the outside, the mark had seemed to be a successful enfranchisement of indigenous cultural production, and the bundling of three marks—toi iho Māori Made, toi iho Mainly Māori, and toi iho Māori Co-Production—seemed to suggest a productive self-consciousness about the nature of indigenous identity in the settler colony. This trio of marks signifies a range of collaborative creative practices and defines indigenous identity within a spectrum of collaboration and co-production—a very different approach than other indigenous trademarks in which the marks are used to authenticate a form of essentialized indigeneity (see Hollowell 2004).[7]

Instead of investigating the successes of the mark as I had anticipated, I was forced to address why the mark was considered a failure by the New Zealand government. The principal argument used by Creative New Zealand to justify "disinvestment" was that the mark had failed to generate notable revenue for participating artists or to capture the attention of enough artists: "Although there are artists who actively use *toi iho*™ to leverage their work, many more Māori artists are making successful careers without the need for the *toi iho*™ trademark."[8] The mark was closed, its Web site disappeared, and Creative New Zealand's toi iho office stopped answering its telephones overnight. Although this was not entirely unexpected, the sudden nature of the closure came as a shock to many participating artists. Many of them felt that the government had not taken its commitment to

support the mark seriously from the start. After all, the mark was supposed to promote the work of hundreds of artists, both nationally and internationally, yet it ran on a yearly budget of only NZ$320,000. The mark is currently in the process of being relaunched by an indigenous-run agency, Toi Iho Kaitiaki Incorporated (TIKI). No doubt its meaning and national resonance will shift again as this organization develops.[9] Given this current state of flux, I focus here primarily on the period during which the mark was operated by the government.

Only a few months before the disinvestment was announced, the Minister of Māori Affairs, Dr. Pita Sharples, appointed a Māori Economic Taskforce charged with, among other things, developing a Māori brand that could be used to signify the Māori economy. This process was to be guided in upcoming months by Te Puni Kokiri, the Ministry of Māori Development. These government initiatives—one that failed, and the other in a state of hopeful development—capture some of the tensions that exist in the state's evaluation and promotion of Māori culture in terms of its economic viability using the aesthetic framework of IP: trademarks and brands.[10] The indigenization of trademarks and brands is a process of national aestheticization of Māori cultural production that fails or is promoted depending on the effect achieved.

Trademarks are aestheticizations of property that promote, via sensual form, ways to apprehend the ownership of identity and the profits it can garner in the marketplace. In the case of the New Zealand state, the indigenous aesthetic domain is both deliberately disempowered by the government and re-empowered by Māori struggling to find an aesthetic form of recognition that is economically effective, for example, to create a brand (cf. Bendix 2008). Māori trademarks emerge into a rich national context alive to the polyvalent significance of indigenous culture, uniting a historic discourse of indigenous rights and negotiation of sovereignty with a circular aesthetic of appropriation, incorporation, and resistance. The social life of indigenous images as trademarks, when they circulate within the framework of a nationalist aesthetics, shows us the ways in which aesthetics are constructed via a strategic appropriation masking itself as appreciation (see Thomas 1997). The case of toi iho demonstrates that the "branding" of culture may provide an expansive moment for the state and its incorporation or acceptance of indigenous rights. The domain of trademarking—the visible use or appropriation of cultural signs, symbols, and words to promote commercial or noncommercial activities or products—has become a space in which indigenous entitlement is increasingly framed in terms of moral responsibility. Rather than focusing on cultural ownership per se, the New Zealand Trademarks

Act (2002) includes a clause that assesses marks in terms of their potential "appropriateness" and "offense." These two instances of trademarking in New Zealand reveal how the domain of trademarking is, like that of copyright in Vanuatu, a pragmatic space that speaks to the tensions between delineating indigeneity as a space of alterity and one of a space of viable national cultural production.

THE TRADE MARKS ACT OF 2002

Within the growing uncertainty of the boundaries of indigenous entitlement and the growth of bicultural governance and administration, the New Zealand government has shown some commitment to incorporating Māori into its IP regimes. In response to concerns about the continual use and appropriation of Māori words, symbols, sounds, and even smells, a Māori Trade Marks Focus Group was established in the late 1990s as part of a reevaluation of existing legislation dating from 1953. The focus group was adamant from the start that Māori would benefit from more comprehensive protection from within the state's IP regime, in particular by asserting what was and was not appropriate to trademark (Māori Trade Mark Focus Group 1997: 19).

The current New Zealand Trade Marks Act of 2002 (replacing the Act of 1953) has attempted to make provision for "Māori Traditional Cultural Expressions" by adding additional checks to the registration process (Morgan 2004). The Māori Trade Mark Advisory Committee was given the authority to evaluate relevant applications for registration and to make recommendations to the commissioner according to Māori protocols, drawing on Section 17 of the Act that evaluates the likelihood of marks to cause offense. In this way, indigenous values are linked to the most generic governance of trademarks; almost every country (including the United States) has a provision that allows for a mark to be evaluated in terms of potential offense caused. By opening up the idea of offense to indigenous definition, the new Trade Marks Act both internalizes and co-opts indigenous values.

The current function of the committee is to "advise the Commissioner whether the proposed use or registration of a trademark that is, or appears to be, derivative of a Māori sign, including text and imagery, is, or is likely to be, offensive to Māori."[11] The committee's work is advisory rather than binding, like the recommendations of the Waitangi Tribunal to government. However, so far the commissioner has not failed to accept their opinions (Simon Pope, Intellectual Property Office of New Zealand [IPONZ], personal communication, October 19, 2009).

The committee developed the categories of *tapu* (restricted, prohibited, or sacred)

and *noa* (profane, or free from tapu) as guiding rulers to make their decisions and to frame the concept of offense from a Māori perspective. Most of the marks that have been abandoned during the registration (often because of awareness of this new process) have been marks that seek to link Māori words and images (considered tapu) to categories of life deemed noa—eating, drinking alcohol, manufacturing certain kinds of clothing, cigarettes, and so on. Problematic marks that have been abandoned during the registration process have included Roto Jet (lawnmower equipment), Toru and Te Whare Ra (as wine labels), Waitemata Gastroenterology (self-evident), and Koru Spring (a mineral water proposed by Air New Zealand).[12]

Indigenous identity is usually discussed in relation to trademarks with regard to the unauthorized appropriation of indigenous signs and symbols as marks of national corporations (see Brown 2003: chap. 3). Less is made of the ways in which the incorporation of indigenous values might actually indigenize IP law. Debates in all settler colonies, including New Zealand, over the definition of common national culture, the compatability of indigenous rights and values and state property regimes, and the sanctity of the public commons as a cultural space that is not bound by too much culture, depend on this bifurcation in which indigenous values are the subject of law rather than its authors. Toi iho exposes a different interpenetration of IP and indigeneity where indigeneity is constitutive of rather than subjected to the trademark.

TOI IHO

The toi iho Māori Made, toi iho Mainly Māori, and toi iho Māori Co-Production marks locate themselves as trademarks by indicating a hierarchy of entitlement to profit from authentically Māori cultural production.[13] The Māori cultural producers who aligned themselves with the toi iho group of marks have no single united style, medium, history, or background. The quality control is one of legitimate indigeneity and an assessment of quality (a set of aesthetic judgments), based on particular values of indigenous practice, which in turn are also expected to mold and control a very specific kind of national marketplace for indigenous culture. The mark therefore aims to coproduce a commodity market and a set of cultural values.

The toi iho group of marks, launched in 2002, guarantees cultural affiliation and quality. They were originally conceived as a way to assist Māori in protecting their work from exploitation and to ensure quality standards based on Māori values (Oliver and Wehipeihana 2006: iii; Tahana 2009). Until 2009 the mark was operated by the Māori

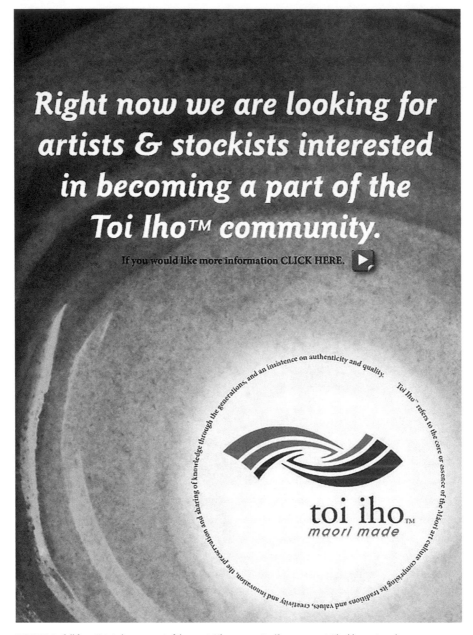

FIGURE 8. Call for artists to become part of the new toi iho community. (Source: www.toiiho.blogspot.com)

Arts Services Division of Creative New Zealand, with a governance role by Te Waka Toi, the Māori arts board.[14] In October 2009, Creative New Zealand announced that it was withdrawing funding and support for toi iho, which cost NZ$320,000 a year to administer. The agency cited the fact that the mark had not really been a success in terms of being picked up by most Māori art practitioners: at the MĀORI ART MARKet mentioned earlier, only fifteen out of two hundred artists were licensed.[15] In the context of a resurgence of corporate and governmental interest in branding Māori, in institutionalizing indigenous entitlement, why did the mark "fail"? Or, rather, why was a "failure" recognized by government and used as an excuse for disinvestment? As I discuss, the problem lay in the very terms through which the mark's success was evaluated. Government interest lay primarily in the market, while the Māori artists were also interested in mentoring, leadership, and an affirmation of respect and recognition. The mark may have been devised to limit cultural appropriation—but under the leadership of Creative New Zealand it was itself an appropriation—of Māori cultural production as a brand for national and international markets.

In their 2009 statement of disinvestment, Creative New Zealand claimed that its reviews indicated that the mark was not a success, that the mark had failed to inspire market growth and consumer recognition (see figure 8).[16] While some artists I spoke to felt uncomfortable with the premise that a government certification would give their work legitimacy, many of the participating artists felt that it gave them a sense of community and support. However, most gallerists felt that the mark was not of particular interest to consumers, that is, a mark without a market. Indeed, even the Vancouver-based Spirit Wrestler gallery, one of the biggest international promoters of Māori art, does not limit its stock to artists who hold the mark. While the mark was a success (fraught with some complications) for many artists, its success in the marketplace, or lack thereof, was the framework for government evaluation, even though it had been developed as part of an initiative to support cultural revitalization for Māori.

A BRIEF HISTORY OF TOI IHO

The need for some kind of protection in order to promote and support Māori artists, especially in the face of ongoing cultural appropriation, has a lengthy history. Sir Apirana Ngata, the noted supporter of Māori culture and arts, initially devised the idea of a mark of authenticity in 1936. In the 1960s Ngā Puna Waihanga, the senior Māori artists' organization, was instrumental in organizing a series of meetings in which the artists

discussed the potential of different mechanisms of protection. It was decided that some kind of mark of authenticity was needed to protect those working within Māori traditions from being copied and to promote a Māori-led market. In the 1990s Te Waka Toi, under the directorship of Elizabeth Ellis, empaneled a small group of distinguished artists, led by Dr. Paki Harrison, which began formulating the rationale and subsequently the design of an indigenous certification mark. At this early stage, the group decided that it was important to have a mark that not only denoted authentic indigenous cultural producers but also was a mark of quality. The perceived failure of attempts to create the Label of Authenticity and Collaboration Mark for Aboriginal people in Australia in the 1990s was seen to lie in the ways in which the mark "externally" authenticated indigenous people (via a potentially problematic construction of race-based ethnicity) without attending to the quality of their work (see Janke 2003: case study 8; J. Anderson 2009b: 205–209).[17] From the start, the participating Māori artists wanted to ensure that the mark ensured the quality of the artwork as well as the identity of the artist.[18]

The right to use the toi iho mark was authorized through a licensing process, in which applicants were assessed in terms of their status as artists and as Māori people.[19] Work was assessed in terms of

> the Māori component of the Work, the design and media, the process and technique, the expertise and skill, and the aesthetics of the Work of the applicant, that Work is (i) Work which is distinguishable as a work of Māori art or craft being a work which comprises an implicit or explicit reference to something Māori; and (ii) Work of quality. (The Arts Council of New Zealand Toi Aotearoa 2002: 4)

The mark required an application fee of NZ$100 and the completion of a form in which an applicant must outline his or her whakapapa (providing a list of marae, hapū, and iwi and the iwi affiliations of parents and four grandparents), which in the Creative New Zealand registry was stored in terms of iwi affiliation, and a justification of what the applicant considers to be the Māori component of his or her work. The applicants' (or groups') whakapapa had to be verified by an upstanding member of their community or official representative of an Urban Māori Authority or Rūnanga, and their standing as artists corroborated with exhibition reviews, comments by peers and elders, and others in the art world. Identity was thus evaluated by family connections and by community recognition (by peers, institutions, and elders).

Robert Jahnke and Huia Tomlins Jahnke, who were instrumental in setting up the qualitative framework for the evaluation of work by the toi iho committee, argued in an early position paper that trademarks are culturally appropriate as they may be co-opted into a historical tradition of Māori formal and qualitative evaluation of cultural production. They felt strongly that "the development of a Māori Mark that recognizes both authenticity and quality is imperative for the maintenance of mana Māori" (2003: 23). They went on, in the same paper, to develop a qualitative frame to assess Māori creative practices and expressions, based on customary practice (6). Their framework comprises six indices of quality assessment: Whakapapa Māori (Māori genealogy); Mātauranga Māori (implicit Māori referent); Āhua Māori (explicit Māori referent); Waihanga Māori (Māori art process); Wāhi Māori (Māori site); and Wairua Māori (Māori ritual practices) (6). However, this evaluative process was not explicitly formulated or made apparent to applicants, many of whom perceived the process as a peer judgment of their authenticity as Māori, via the personal network and preferences of those on the committee.[20]

The toi iho committee assessed works in relation to artists' Māori identity and in relation to the materials the works are made from but also, circuitously, in relation to their accreditation by the mark itself.[21] The mark is notable for the diversity of artistic production that it encompasses, including traditional carving, weaving, contemporary painting and sculpture, music, dance, graphic design, and tattoo art.[22] This holistic approach creates a vision of Māori cultural production that transcends media, focusing instead on holistic criteria of indigenous authenticity based on broader cultural values.

The mark has been endorsed by some of the most well-respected Māori artists, all honorary members of Te Ara Whakarei: Robert Jahnke (a sculptor), Manos Nathan (a ceramicist), Patricia Grace (a writer), Moana Maniapoto (a popular musician), Witi Ihimaera (a writer), Michael Parekowhai (an installation artist and painter), Cliff Whiting (a sculptor and celebrated marae carver), and Pita Sharples (the current leader of the Māori Party and Minister for Māori Affairs). In a 2006 review, some contemporary and multimedia artists commented that they felt as though they could not participate in the mark's community of practitioners. Here we see how the mark, despite welcoming a diversity of cultural production, also constitutes a version of culture. The requirements of standardization and comparison make the mark much more suitable to the kinds of cultural production that produces multiples. In this way, the mark was much more helpful for greenstone and wood carvers (those one artist described to me as "working at the higher end of craft"), who have consistently suffered the appropriation of the work

by nonindigenous carvers and the label "made in China." Contemporary artists working more in terms of individual style found it harder to aesthetically connect to the mark, unless they connected directly to a broader signification of indigeneity.

The divide between creating a market and a community was therefore a perpetual struggle for artists wishing to be involved with toi iho. Many of the founding artists (all of whom were made honorary members of the mark without having to go through the application process themselves) viewed the mark as a means to support other, less successful artists. The celebrated ceramicist Manos Nathan noted that while well-known artists in effect "became their own brand," the point of toi iho was for the older generation to support up-and-coming artists and to provide an "aspirational" framework, providing a benchmark of quality for artists to aspire toward as they strove to reach a higher level. Another lifetime member, Rangi Kipa, commented to me that he didn't feel the mark had done much for his own career—rather, he wanted to "give back" to the mark, but using his own success to bring mana, or kudos and power, to the brand. It was noteworthy to me that all of the senior artists I talked to during my research felt as though they had no need for the brand in terms of their own career trajectory. At the same time, all of them were strong supporters of toi iho. This suggests that the benefits of the mark are perceived less in terms of individual profit and more in terms of creating a structure of support for a community of younger artists, and a sense of solidarity among Māori cultural producers.

It is clear from the ways in which some of the artists involved talked about the mark that thinking about quality, alongside authenticity, was key to the mark—and that a market could emerge from that, rather than the other way around. Within my own research and within the qualitative research done as part of the reviews commissioned by Creative New Zealand, there was little controversy surrounding the way in which the mark contributed to the commodification of Māori culture (indeed, many artists joined toi iho because they wanted help in marketing their work). Rather, tensions emerged around the process of evaluation, the community of appraisal, which was not universally accepted. The following comments demonstrate the spectrum of comments that emerged around this issue:

> I'm not going to let my work or my whakapapa be judged by a panel that comes from Government and therefore includes non-Māori people. (Te Kaha, pounamu carver, interview, November 13, 2009)[23]

For me it was an honour, having them look at my work and give me their opinions. You can't buy that kind of feedback. Even if they'd turned me down, that would have been valuable too, to know how I could make my work better. (carver, quoted in Oliver and Wehipeihana 2006: 11)

Why should my work be judged by people who can't even carve? And who only want to get their students in? I was given the mark right at the start, before you had to pay to apply. I wouldn't apply for it now. (paraphrased from interview with Blaine Terito, wood carver, October 23, 2009)

I think that the process of evaluation is very clear. There is a committee which meets every six months to evaluate the applications. They send the files out to other specialists who are able to evaluate specific applications and who then report back to the committee with their evaluation and recommendation (either for acceptance or for ways in which artists can improve their work). This means that every application is evaluated by at least two people and a committee. I think that's a pretty fair process. Much fairer and more inclusive than the more nepotistic or subjective evaluations of some other Māori arts organizations. (condensed from an interview with Rangi Kipa, December 17, 2010)

Within the community of Māori practitioners, discussion of the mark tended to focus on issues of inclusion, fears, and resentment in having to justify one's identity as an indigenous person, and concerns about the subjectivity of assessments of quality reflecting social inequalities that typically emerge within communities of value that are defined culturally. While many artists may not have joined the mark for these reasons, one of the mark's strengths is the way in which it presents all artists as equal—giving lesser-known artists the opportunity to be ranked alongside much more successful practitioners. For the most part, marks such as toi iho only really make sense when they are connected to products that are more, rather than less, the same, more rather than less associated with collective culture as opposed to specific individuals. It means something quite different to a greenstone carver than it does to a "contemporary artist." Nonetheless, the buy in of many artists, writers, and musicians must be seen as an act of solidarity and support more than an act of marketing (redefining, in turn, the act of marketing as one of social solidarity).

The mark also engendered a powerful sense of exclusion, especially from artists not working in Auckland, Wellington, or other urban centers. Reading the application

guidelines from afar, without the opportunity to talk to anyone involved in the mark, was intimidating for many artists who felt self-conscious about justifying their Māori cultural identity and being evaluated on the quality of their work. Applying for the mark demanded a great deal of confidence in whakapapa and ability, and this was intimidating to some newer artists, even though the mark also aimed to nurture new talent. In turn, the lack of investment has meant that apart from the development of artists' profiles, very little was actually offered to the artists by Creative New Zealand. One carver I spoke to described how he had expected some kind of support from the mark when he discovered that images of his work had been used on postcards without his permission but received no help in this matter. Another carver felt toi iho could do nothing more than he did to promote his work both in New Zealand and overseas.

Marks, Markets, and Indigenous Identity

The concerns of Māori artists to develop a forum for support, for cohesion, for promoting cultural value and to use this as a basis for developing a successful market was at odds with the government emphasis on the financial accountability of the mark (and the paradoxical, but perhaps not surprising, lack of serious commitment of government funds to this end). What is a trademark without a market? Ongoing debate about the place of government in mobilizing and marketing Māori resources has in recent years been extended through numerous claims to the Waitangi Tribunal asserting Māori ownership of the radio spectrum, the fisheries, the foreshore and seabed, and in the WAI 262 claim that asserted Māori IP rights in indigenous flora and fauna. Many artists also astutely recognized the ways in which the toi iho mark was itself a form of appropriation. As Te Kaha, a Tūhoe cultural activist and successful pounamu carver who is not a member of toi iho, commented to me, "toi iho is a useless and pathetic attempt of government to distract attention away from the real issues of *tino rangatiratanga*. It is the Government's way of giving a sense of indigenous entitlement without giving any meaningful IP rights to *Māori*." Toi iho was supposed to support and protect Māori artists from exploitation; it was supposed to tweak existing IP regimes in such a way that communal and cultural rights would be valued and recognized. Instead, the mark was abandoned when it failed to make as much money as the government thought it should, demonstrating that "all government cares about is money" (Te Kaha, discussion, November 13, 2009).

During my time in New Zealand in 2009, I was based within the Mira Szászy Research

Centre in the University of Auckland Business School. The Research Centre is dedicated to Māori and Pacific research in business and economics, and it is interested in developing economic models based on such concepts as "spiritual capital" (Wolfgramm 2007) and an "economy of mana."[24] Underscoring this is an agenda that aims to explore the New Zealand economy from a Māori perspective and that thinks of Māori business and resources as outside of, or as separate from, state enterprise. At a meeting to discuss toi iho in November 2009, the Research Centre Director, Dr. Manuka Henare, commented that it was time to think about how such initiatives could be taken without the input or support of the state. In his own work, Henare is interested in underscoring the development of Māori trade that does not use state infrastructure but bypasses the nation directly (M. Henare 2005). Claims such as WAI 262, should they be fully upheld in the light of the extensive report published by the Waitangi Tribunal, would constitute New Zealand's natural resources as Māori. Should governance and sovereignty be conflated, the state might no longer profit from these resources. No wonder, then, that many of the discussions around Article II of the Treaty in fact obfuscate and perpetuate the disjuncture between the two languages. Biculturalism rather than reconciliation of two cultures is needed, the maintenance of their separation used to justify state sovereignty over resources. The state may claim that sovereignty and governance are different things. But this difference applies to Māori, not to the government.

Recent developments in IP, the 2002 Trade Marks Act, and the emergence and demise of toi iho are places in which this obfuscation may be seen in practice. Toi iho clearly was not viewed by Creative New Zealand as a mechanism to support Māori art. In that respect it *was* a success—while imperfect, it forged a visible artistic community and created a sense of artistic cohesion that was nationally recognizable. Nor was it a genuine attempt to forge a successful market, for it was not provided enough funding and sufficient support or scope for this enterprise. It is hard not to see it as Te Kaha does: as an attempt by the state to appropriate Māori art to make itself look good. Indeed, the greatest output of the mark was the development of its Web site (now offline), which visualized this artistic output and community for an international audience and provided a kind of online shopping channel for government to purchase official gifts for heads of state and the like.

An Indigenous Commons?

It might be helpful at this point to turn our analytic on its head; rather than asking about the nature of indigenous IP, we might ask rather about the identity and viability of an

indigenous cultural commons. While IP such as trademarking is rarely connected to ideas about the commons, the cultural commons has been cast as the necessary foil to (intellectual) property—generically imagined to be that which is open access, which is not regulated or restricted (e.g., Lessig 2001). However, what would happen if the commons also became indigenous in a way similar to the proposals of proponents of indigenous IP, stratified by different cultural norms about general access; hierarchies of entitlement; conditions of ownership; and the constitution of citizenship, sovereignty, and the public? How would that impact on the possibilities of indigenous IP?

In generic global discourse around IP rights, there is an "odd coupling of 'the indigenous' and 'the commons' that is produced by intellectual property discourse as a project of resistance" (Anderson and Bowrey 2005: 2). Both are, in the most instrumental terms, political "solutions" to "the tyranny of private property and commodification" (3). The juxtaposition of ideas about indigenous entitlement and that of a cultural commons is a powerful bifurcation that resonates with profound political and economic effect (see Hayden 2003). Principles of indigenous entitlement are based on exceptionalism and prior claim and are made in perpetuity (as read by Brown 1998; Kuper 2003; Niezen 2003). Philosophies of the cultural commons presume universalism and resist the confining claims of particular interest groups (whether cultures or corporations; see Boyle 1996, 2003, 2008; Brown 2003). These two perspectives share a critique of the way in which property and markets may be suitable mechanisms for "naturally" distributing the profits of culture, yet both argue for forms of enclosure that may in fact be effected via market mechanisms. In crude terms, indigenous groups advocating for indigenous IP argue for an alternative form of enclosure based on the transaction of collective rights in perpetuity. This is anathema to cultural commons activists, who draw on a model of individual authorship and property libertarianism as a way for "culture" to freely circulate (see Lessig 2001). There is, however, as Povinelli (2002) so poignantly documents, a political subtext to this juxtaposition. Many commentators (e.g., Brown 1998, 2003) draw explicitly on the cultural commons as a vehicle of democracy but fail to consider how such commons may also be understood as a way of removing sovereignty from certain polities (e.g., indigenous peoples) in favor of others (the nation-state), naturalizing one idea of culture while restricting the definitions of others. The idea of the commons is intimately connected to the concept of multicultural democracy that naturalizes a specific set of property relations and forms of social organization. Grappling with the problematic politics at the heart of these philosophies of entitlement forms the basis for government attempts to incorporate

traditional knowledge and indigenous identity into projects and plans for economic development in Aotearoa New Zealand.

A prominent framework for promotion of alternative understandings of indigenous cultural and intellectual property in Aotearoa New Zealand is the WAI 262 claim: a case put to the Waitangi Tribunal by six iwi regarding the government's obligations to recognize the connections between Māori and indigenous flora and fauna, which after nearly twenty years of hearings and deliberations produced an official report "into claims concerning New Zealand Law and Policy affecting Māori culture and identity" (Waitangi Tribunal 2011).

The case was initiated when two senior ladies (Mrs. Del Wihongi, from Te Rarawa, and Mrs. Saana Murray, from Ngāti Kuri) discovered the extent to which kūmara (sweet potato) was subject to scientific research (see M. Roberts et al. 2004), both within New Zealand and internationally. These community leaders and others became concerned that New Zealand's participation in a wide variety of international treaties and agreements (such as TRIPS) would make its commitment to free trade and international standards incompatible with its Treaty obligations. Despite the fact that the WAI 262 claim was made on behalf of only a small portion of iwi, it was holistic in its claims to define and frame Māori intellectual *and* cultural property rights. The claim argued that the Crown had failed to uphold its obligations to protect the tino rangatiratanga (sovereignty) and *kaitiakitanga* (guardianship) over indigenous flora and fauna and explicitly asserted that these were part of the taonga that Māori were given possession of through the Treaty. The claim also stated that the Crown failed to protect the taonga itself and breached the Treaty by agreeing to "international agreements and obligations that affect indigenous flora and fauna and intellectual property rights and rights to other taonga."[25]

The claim did a number of radical things: it articulated tino rangatiratanga and kaitiakitanga as explicit forms of resource management and substitutes for the state's IP regime; it explicitly addressed the definition of sovereignty over resources allocated to Māori in Article II of the Treaty, articulating a holistic account of indigenous rights as sovereignty; and it did this by expansively linking nature and culture connecting native plants and animals to traditional Māori knowledge (including carving, weaving, symbols, and designs). The contents of this domain are understood as taonga: "all elements of a tribal group's estate, material and non-material, tangible and intangible" (quoted in Solomon 2004: 235; see also Lavine 2010: 39). The claim, therefore, proposed a rethinking of sovereignty, epistemology, and practice throughout the ways in which the New Zealand

environment was both appreciated and exploited as intellectual property. In particular, the rubric of kaitiakitanga (understood by the Tribunal as meaning to "protect, preserve, control, regulate, use, develop, and/or transmit" [Te Rōpū Whakamana i te Tiriti o Waitang Waitangi Tribunal 2006: 5]) was developed as a competing rationale to "ownership" in this context.

In many ways, WAI 262 has been the most important, and most contentious, of claims to the Tribunal, not only because it redefines cultural and intellectual property but because it acknowledges that these property forms in fact articulate the boundaries of indigenous sovereignty. As much as it is a claim to constitute indigenous IP, the claim is one of self-determination. In that sense it is as much about an idea of a cultural commons— the demarcation of shared cultural resources—as it was about the ways in which property rights over culture might be effected. The claim challenged the remit of the government in defining what sovereignty actually is and took it to task concerning the ways in which sovereignty is separated from resource management. As one online commentator notes, "It is based on the rights of tangata whenua, not on the principles of the Treaty, or on rights to Aboriginal title in British law. Rather than focus on specific acts of the Crown in breach of the Treaty of Waitangi, it questions the right of the Crown to rule at all. Additionally, it questions the Crown's presumption of rights over everything not known at the time of the signing of the Treaty/Te Tiriti. . . . I believe it is no overstatement to say this is revolutionary."[26]

Not surprisingly the claim fed the fears of commentators who presumed that the blanket assertion of indigenous rights would undermine "the commons" and cut out the rational, natural rights of the liberal free market, as one right-wing pundit commented:

> When will this race-based lust for power and control stop, you might well ask? It won't— at least not unless there are major changes. As long as there are special Māori seats in Parliament with governing parties willing to offer those MPs powerful coalition partnerships, it won't stop. Not only will it not stop, but the demands are gaining momentum to the point where non-Māori New Zealanders are beginning to realise they are being increasingly marginalised by the cunning strategies of a greedy tribal elite, that now has its hands on the levers of power and its fingers in the public purse.[27]

The claim was important, not just in its political motivation or because of its potential to impact policy or practice, but also because of the radically alternative regime of

entitlement that it suggested by challenging the "fit" of generic legislation and indigenous ways of understanding entitlement and the relation to culture as property. For some in New Zealand, this vision is empowering, for others a great threat. The claimants stated that the government had failed to carry out its Treaty obligations to protect the treasures over which Māori have tino rangatiratanga (chieftanship or sovereignty), and they sought from the Tribunal the recommendation of redress through the legal system itself, and perhaps even an altering of the current IP regime.

Hearings, with testimony from expert witnesses, claimants, and the government, began in 1997 and ended in 2007. Many of the original claimants and judges passed away during the lengthy proceedings. The final report was released in April 2011. If the claim divorced indigenous and state ideas about IP, the report attempted to articulate a pluralistic regime in which these two frames were equal partners. The report emphasized the need for a postgrievance climate for claim making and was committed to upholding the principles of the Treaty and honoring the remit of biculturalism. Its authors criticized existing law for a failure to recognize collective and enduring rights, to extend moral rights beyond their limited purview, and to support *kaitiaki* and their role in protecting and conserving taonga works (Waitangi Tribunal 2011: 63). The time limitations of IPR, divisions between knowledge and work (especially in the case of copyright) or meaning and sign (in the case of trademarks), and the concept of a cultural commons (in relation to intellectual property, which signifies a domain freely open to appropriation) are all anathema to traditional understandings of guardianship and to Māori relationships to knowledge.[28]

Recent comments on the WAI 262 claim and the second indigenization of toi iho by a newly formed Māori agency are influencing those who are developing a national toolkit to formulate ideas that describe what I am starting to think of as an indigenous commons, a "public" yet indigenous space that sits uneasily within the structures of power of the settler colony. The WAI 262 report delineates a program for the national institutionalization of an indigenous framework for IP. It proposes that all commercial exploitation of taonga, or taonga-derived works, be evaluated by the guardians (kaitiaki) of the taonga, who themselves would be registered and authenticated by a commission, which would replace existing frameworks in place through IPONZ. The report also proposes that through kaitiaki, Māori knowledge systems (Mātauranga Māori) be allowed to define new relations of responsibility and entitlement: "This approach is not intended to create a new category of proprietary right, but is rather a way of recognising the relationship of

kaitiaki with taonga works and some aspects of Mātauranga Māori where it is proposed to exploit those things commercially. The kaitiaki right is inherently inalienable and is therefore not a proprietary right in the orthodox Western sense. Rather it would be a statutory participatory right in respect of decisions around proposals to exploit taonga works or Mātauranga Māori commercially. It may in appropriate cases amount to a right of veto, and it must be perpetual" (Waitangi Tribunal 2011: 92).

The report on the WAI 262 claim explicitly addresses both the bifurcation and entanglement of indigenous and state ideas about ownership. Ultimately, however, it notes, "Kaitiakitanga focuses on obligations and relationships arising from kinship; property focuses on the rights of owners" (Waitangi Tribunal 2011: 46). Yet the category of kaitiakitanga, as it currently stands, is not a legal category (unlike property) but rather a gesture of good faith in the interventions it makes into policy. Will it become a mainstream frame for the maintenance of rights and resources? Can it be translated into law, and what kind of law? The Tribunal has questioned this outsider status, arguing for a fuller incorporation of Māori values into the mechanisms that protect taonga and works derived from taonga. Like other Māori concepts (e.g., tino rangatiratanga), these terms have been appropriated into state vocabulary but are not necessarily imperatives for state action.[29] The nation-state still controls the power sharing and the ways in which indigenous IP is recognized and allowed.

Povinelli (2002) is ultimately skeptical of the incorporation of indigenous persons into the liberal multicultural state. She argues that such incorporation ironically enables the further subjection of indigenous peoples to the inequities of liberal governance (and Anderson and Bowrey [2009] describe how this process has inflected the production of IP regimes in settler states). It is hard not to see this as happening within the property regimes currently promoted by the government in New Zealand. However, the agency of brands and trademarks as compressed material forms may suggest new avenues for empowerment and the existence of toi iho, and the Māori Trade Marks Advisory Committee also suggests a possible reevaluation of not only the boundaries of IP (or the cultural basis of intellectual property) but also the boundaries of a cultural commons in Aotearoa. Both the Tribunal and the committee have insisted on a moral and cultural framework for evaluating the property potential of cultural production and for inflecting our understanding of cultural images even when they are not constituted as IP. The categories of mana and noa, and the subject position of kaitiakitanga, or guardianship, are frameworks through which to assume an ethical position of management over culture and from which more

formal property regimes might be developed. It is for this reason that I speculate on the ways in which these articulations might be seen to produce an alternative national space for culture, which I am calling an indigenous commons.

The demise of toi iho was ultimately accredited to a fundamental lack of support by the government for Māori culture and enterprise, adding to a long history of both disappointment and mistrust.[30] There is a constant pull between indigenous visions of the mark, which understand both the imagery of the mark and the forms that it references to inhabit a broader field of value and cultural connect, and the vision of the government, which sees trademarks in terms of narrowly defined economic efficacy and is invested in promoting a flatter vision of aesthetics in which value ultimately lies in form rather than its referent. This is the same distinction so often made between gift and commodity: the value of gifts lies within the social relations of which they are a part, while the value of the commodity is perceived (falsely) to lie purely within itself. The toi iho mark references more than itself or more than a vision of Māori art branded as acceptable and authentic—it also references an uneasy relationship between Māori and the state, and its failure, like that of its counterpart in Australia, demonstrates how the initial successes of these enterprises are evaluated in terms of the state's own values (in the case of toi iho, the production of revenue directly linked to the mark) rather than the cultural values that the mark was supposed to promote.

This may seem like a minor case study, but in fact toi iho, and the amendments made to the Trade Marks Act, may be used as windows into the negotiation of property rights in the context of settler-colonial nationalism. In both cases, a space is created for Māori to assert moral community, but in both cases the ultimate frame is government, which decidedly does not cede authority in the form of rights couched specifically in terms of property. As in treaty negotiations, there may be recourse to the Treaty's spirit, but ultimately law is segregated from morality, as sovereignty is from governance. The Waitangi Tribunal evaluates treaty, rather than moral, obligations. What would the implications be were the situation reversed and the ground of indigenous rights became the filter for defining a cultural commons, the moral framing the legal rather than the other way around? Toi iho and the Trade Marks Act challenge our understanding of how Māori really are being incorporated into the structures of law and government. Do they alter the form of the liberal nation-state? Or is this just a further co-option of indigenous peoples? Are existing IP regimes generic enough to incorporate indigenous values as necessary, or are sui generis mechanisms an imperative to constitute the ideal of indigenous intellectual property? As

Anderson and Bowrey note, "the norm of 'sharing' is conceived in relation to a 'post-colonial' sovereignty, while turning a blind eye to the non-sharing or partial sharing of colonial sovereignty" (2005: 23; see also Anderson and Bowrey 2009). This is different from the provincialization of copyright in Vanuatu, where an alternative legal epistemology, gleaned from ceremonial activity, is reified into kastom and in turn codified into generic state law.

While there is less of a sense of alterity in the ways in which people think about trademarks in New Zealand, the achievement of toi iho is the sense of national community among artists that the brand has empowered. The mark has failed in the hands of government. A group of founding artists, lawyers, and activists (including Manos Nathan, June Grant, Moana Maniapoto, Aroha Mead, Maui Solomon, and Elizabeth Ellis) has created—from the interim group Transition Toi Iho—the Toi Iho Kaitiaki Incorporation (TIKI) and is currently investigating ways to keep the mark alive. In doing so, they are constituting a new sovereignty over the brand—one that conceives of a certification regime that not only marks indigenous cultural production but also is fully authenticated and framed by indigenous values and governed by indigenous people. One of the first things they aim to do is make the application process less complicated for prospective artists. The seeming failure of the brand to generate market interest speaks to the particular foibles of the art market, in which artists are valued for their unique qualities and in a sense are devalued when presented as generic. As Te Kaha said, "Even if a Māori organisation took the mark over—how would they really be able to get at the heart of what was important about this work: the ancestral connection, passed down face to face over generations, the practice with purpose and meaning—form for function, not just for the market, the idea of balance—to make sure that the right things are given as well as taken."[31]

The power of contemporary Māori art, from carving to multimedia installation, is in the ways in which it generates a vision of indigeneity that is linked to individual identity and whakapapa as well as tribal and national politics and the way it can be used as a marker for national and indigenous identities. The case of trademarks and the branding of indigenous cultural production in the settler colony allow us to understand the nature of the provincializing process that may always be read in two ways: as a promotion of the subaltern and as a conduit by which the mainstream (or colonial) is relentlessly perpetuated, even at its margins, by those provincials who cannot let it go. However, it is inarguable that this paradoxical process does initiate transformation, and this kind of transformation is what I am terming *an ongoing process of indigenization*.

As in Vanuatu, there are multiple, complementary, competing, and co-produced visions of indigenous IP in Aotearoa New Zealand. Current national trademarks legislation asserts that more generic models of IP have the capacity to incorporate and protect indigenous rights. The Trade Marks Act of 2002 uses a broad moral rights framework and incorporates Māori values of tapu and noa as moral categories. As in Vanuatu, the indigenization of IP (defined as the provincializing processes through which the very concept of indigenous IP rights and forms are produced) is a process that questions existing power relations, sovereignty, and the participation of indigenous peoples in both the nation and within international markets.

Comparing indigenous expectations regarding entitlement in both countries demonstrates that the fault lines around the consolidation of indigenous IP lie in issues of governance and sovereignty. Copyright in Vanuatu and trademarks in New Zealand both raise provocative questions regarding the nature of indigenous culture as property *and* challenge our perceptions of the process of indigenization. Rather than seeing indigenization as a process of transformation from one system to another, a kind of reverse appropriation of the mainstream by the subaltern, in the New Zealand context the indigenization of intellectual property is a process of negotiation and leverage within the frame of the state.

In the second half of this book, I trace the way in which the cultural sector, most prominently institutionalized within museums, has been an active agent in the connection of indigenous culture to the national economy in both Vanuatu and Aotearoa New Zealand. In chapters 8 and 9, I focus on the ways in which cultural property discourse is translated into national economy discourse (each provincializing the other) in each place. Even though this book may be divided into ethnographic accounts of intellectual and cultural property, respectively, part of my overall argument is that the process of indigenization is one of categorical destabilization, breaking down boundaries between these two property forms. This is evident in the long tradition of linking Māori arts to a national market, a national cultural identity, and a set of state values that both utilize and transcend the alterity of the indigenous. This process is effected through the constitution of "exhibition value" (Benjamin [1936] 1992) and by the very forms through which indigenous intellectual and cultural property rights are recognized and constituted.

In the following chapter I suggest that some of these questions can be answered by analyzing the way in which local-national museologies and other theories of objects have emerged in both Vanuatu and Aotearoa New Zealand to explicitly reimagine indigenous entitlement. I connect the kind of crosscultural property theory I have been discussing to

the explicit way in which objects are valued in museums and how these values are extended outward into other arenas. These theories of materiality, of subject-object relations, mediated by the critical context of the national museum, provide a frame for understanding a broader movement to create indigenous and provincial theories of what cultural and intellectual properties actually are.

6 | Pacific Museology and Indigenous Property Theory

MY ACCOUNT OF COPYRIGHT in Vanuatu and trademarks and brands in Aotearoa New Zealand shows that the "indigenization" of intellectual property (IP) in both places draws together multiple frames and perspectives, from the global panindigenous rights movement to international law and heritage organizations, through to grassroots community- and village-led initiatives. I have been arguing that this process of indigenization is a form of provincialization, drawing attention to how the fields of indigeneity, property, and law are heavily reliant on a politics of recognition that is mediated profoundly by the infrastructure of the nation and also heavily implicated in colonial perspectives (see Merry 2000). Indigenous intellectual and cultural property discourses are used both to critique this colonial inheritance and to participate within it. "Culture" in this heightened context is more than a vague anthropological definition of a lifeway, way of being, set of practices, tradition, or inheritance. Rather, it becomes a rationale of ownership, a mode of entitlement, a reframing of property

relations (Kalinoe and Leach 2001; Humphrey and Verdery 2004; M. Henare 2005).

As both the toi iho trademark and Ambrym slit-gongs show us, the provincialization of IP is also a process of aestheticization, of creating a "property effect" by the constitution of certain forms and images. In many accounts of the ways in which cultural and intellectual property are mediated by indigenous identity politics and the frame of law, it is easy to forget the importance of the materiality and aesthetics of cultural and intellectual property. What actually is cultural property? What can, in fact, be IP? How can these "things" be owned, transacted, protected, legislated, and so forth? How does the form of these rights affect the ways in which rights can be constituted? In the remainder of this book, I continue to answer these questions, focusing specifically on the ways in which museums, as both state arbiters of national culture and cultural homes-away-from-home for indigenous peoples, have become crucial laboratories for exploring alternative models of ownership, understandings of entitlement, and modes of practice around the formal recognition of culture as property. The museums I discuss here raise important provocations to our conventional understanding of the object world as they expansively engage with different models of how culture can be materialized, substantiated, and owned. In this chapter, I examine the ways in which local museologies in Vanuatu and Aotearoa New Zealand have emerged at the forefront of indigenous rethinking of cultural and intellectual property rights, encapsulating many of the tensions, problems, politics, and paradoxes that this process entails. In chapters 7 and 8, I explore specifically the way in which museums play a part in the aestheticization (and, therefore, constitution) of cultural property forms, which I define not only in terms of objects and image but in terms of social practice and the formal imagination of economies and markets.

Comparative Museologies: Indigenous Theories of Objects

Despite many recent changes in practice and position, museum anthropology still has a tarnished reputation. Notwithstanding the crucial role of the museum as a critical laboratory for the earliest anthropologists (see Schaffer 1994; Herle and Rouse 1998; Edwards 2001; Gosden, Larson, and Petch 2007), contemporary understandings of this now-marginalized subdiscipline relegate museum anthropologists with perceived imperialist agendas to dusty storerooms and dry concerns with "material culture." Indigenous peoples still often associate museums as aligned with institutional concerns that are not in their

interests and with the culturally inappropriate study and display of their distant and recent ancestors. However, the emergence of indigenous museologies and museums provides an alternative perspective that positions these institutions at the vanguard of contemporary anthropological theory about representation, difference, power, and globalization.

Reconsidering the ethics of collecting; the substance of collections; the institutional, colonial, geopolitical, and social histories of circulating objects; and the materiality of culture in places like the Vanuatu Kaljoral Senta (VKS) has vastly helped me in my writing on the constitution of indigenous economies and in thinking about cultural and intellectual property. By briefly comparing some recent developments in the national museums of Vanuatu and Aotearoa New Zealand, I wish to highlight how these institutions marry colonial and indigenous perspectives in ways that re-theorize the value of collections and which in turn provide a provincial blueprint for rethinking entitlement and ownership of cultural resources. The indigenous museologies developed in these two places are forms that negotiate with the authority of the state, inserting indigenous values into organizational structures and representational conventions. Both the VKS and the National Museum of New Zealand Te Papa Tongarewa (Te Papa) are considered regional, indeed global, leaders in museum practice. Te Papa is a model for the incorporation of indigenous value in not just display, but within the dynamic national identity forged by the museum. The VKS is a model for many institutions struggling to make themselves relevant to grassroots and rural communities and to activate cultural preservation as a form of economic and cultural development. Together they provide a picture of how museums can provincialize the hegemonies of cultural representation through the mediation of scale, locality, and context. Both institutions are specifically engaged in definitional projects to expand the scope of cultural property away from narrowly defined museum collections and the objects of cultural property into the intangible world of IP. In the following sections, I introduce the institutional framework for museums in both Vanuatu and Aotearoa New Zealand. I end by analyzing the museological underpinnings of theories of indigenous culture and entitlement that have emerged in each place.

THE VANUATU CULTURAL CENTRE

In 1956 the Anglo-French Condominium Government of the New Hebrides decided to mark its fiftieth anniversary by laying a foundation stone for a cultural center in the capital, Port Vila.[1] The end of World War II marked (in most places) the beginning of the end of European empire. During the 1950s and 1960s the Condominium Government began a

FIGURE 9. The Vanuatu Cultural Centre and National Museum. (Photo by Jeffrey Wescott; reproduced with permission)

concerted policy of cultural development, attempting to establish rival Anglophile and Francophile indigenous elites in order to maintain political influence in the South Pacific.

From the start, the VKS comprised the National Museum and the National Library and Archive (see figure 9). By 1960 a Condominium Joint Standing Order had established a management board (with French, British, and ni-Vanuatu members). The Political Advisor to the British residency, Keith Woodward, took voluntary charge of the collections, with the primary objective being to implement "the exhibition of objects which illustrate the history, literature and natural resources of the New Hebrides" (Bolton 1993: 107).

At this time the VKS primarily displayed expatriate collections—the first proper exhibition being of birds and shells collected by the German naturalist Heinrich Bregulla. During this early period, indigenous tradition was not yet valued positively or deployed politically, but rather retained the "pagan" connotations formulated by early colonists and missionaries. The VKS seemed to have little relevance to contemporary development, and the museum had not yet been indigenously appropriated as a locally meaningful social space.

With the arrival in the 1970s of researchers such as Jean-Michel Charpentier, a linguist; Peter Crowe, an ethnomusicologist; Kirk Huffman, an anthropologist; and Darrel Tryon, a linguist, the work undertaken through the VKS began to focus less on the museum itself and became more about "getting Melanesians interested" (Bolton 1993) in the revival of kastom at the grassroots level through a series of research initiatives.[2] The first of these was the Oral Traditions Project, which trained fieldworkers from throughout the country in the arts of audiovisual recording and dictionary making. These local ethnographers worked in their communities on designated themes and met annually at the VKS, where they shared their research with one another. This became a model for collaborative engagement, appropriating or provincializing anthropological, archaeological, and linguistic methodologies as a way of connecting diverse cultural practitioners from throughout the archipelago (see Bedford, Spriggs, and Regenvanu 1999). Their work was made public in weekly radio programs (and subsequently television programs), newspaper columns, and the organization of arts festivals in various locations. The emphasis moved from language documentation and preservation (through the recording of oral histories, songs, and so on) to an interest in other forms of cultural production (the making of artifacts and ritual life) and later extended into an examination of the customary basis of everyday life (traditional gardening, medicine, marine tenure, and so forth).

The move toward grassroots research coincided with the growth of the independence movement in Vanuatu. Under the direction of the first salaried curator, Anglo-American Kirk Huffman,[3] the role of the VKS as a traditional meeting place was developed to encourage political meetings and even to house dissidents wanted by the Condominium police (Kirk Huffman, personal communication, March 2001). Under Huffman's leadership, the VKS was a dominant force in developing the First National Arts Festival in 1979, a symbol of national unity and cultural independence, and in 1980 it housed the official independence office (Huffman 1995: 92).

From independence onward the VKS continued to be a pivotal space in reconceptualizing a new national indigenous culture, one that looked very much to the grass roots, to elders and community leaders and to village life as a model. In 1989 Jack Keitadi, originally Huffman's deputy, became the first ni-Vanuatu curator of the VKS following Huffman's resignation. He was succeeded by Clarence Marae, a political appointee (as former minister of finance), and in 1995 Ralph Regenvanu, son of the former deputy prime minister, Sethy Regenvanu, was promoted from curator to director. Other staff members, such as Jacob Kapere, director of the National Photo, Film and Sound Archive

who has worked with the VKS since 1988, and Ambong Thompson, who directs the VKS radio program and worked for Radio Vanuatu for twenty-three years, have also spanned this formative period of transition from expatriate to indigenous leadership.

In 1995 the VKS moved from the main high street of Port Vila to a new headquarters opposite Parliament House in the suburb of Nambatu, and the inauguration day for the new complex, November 17, was designated National Culture Day. The site had been chosen in the 1980s and already housed the National Council of Chiefs (Malvatumauri). The building, the second largest in the country after Parliament, now incorporates the National Museum and a series of projects under the auspices of the Cultural Centre: the Oral Traditions Project; the National Photo, Film, and Sound Archive; the Women's Culture Project; the Vanuatu Cultural and Historical Sites Survey; the Juvenile Justice Project; the Traditional Marine Tenure Project; the National Library; and the Young People's Project. Today, the VKS has a staff of over forty people. It is also the base for expatriate researchers working on long-term contracts, funded by development agencies such as AusAID and Pacific People's Partnership, and for many shorter-term projects, staffed by ni-Vanuatu working on short-term contracts, as well as for regional operations such as the Pacific Island Museum Association.

In the work of the VKS, exhibition and display has been, and remains, a low priority in relation to other activities. However, the museum hall is a dynamic, continuously changing, and social space. The exhibition space in the new VKS was initially physically erected by VKS fieldworkers, each islander working with material from his or her island and it still retains a sense of this initial display, along with the layout of the inaugural display of the *Arts of Vanuatu* exhibition that traveled from Port Vila to Noumea, Paris, and Basel in 1996–1997 (see Huffman 1997). As a space it is subject to complex local agendas and is the product of the many voices that are held together by the VKS. Alongside the more "permanent" displays of artifacts, the exhibition hall has become a forum for various interest groups based in the VKS and, indeed, throughout Vanuatu. Recent VKS projects have given rise to panels of text, photographs, and cases of artifacts. Temporary displays brought in over the past few years have included an exhibition by the National Reserve Bank, examining the role of traditional currency in Vanuatu in the development of national currency; an exhibition *New Traditions*, mounted by a New Zealand curator in conjunction with several ni-Vanuatu contemporary artists; a display of historical domestic artifacts from the collection of a long-standing French resident of Vanuatu, the most notable exhibit being a large wrought-iron bed with pillows and quilt

that was placed just inside the gallery, flanked by the permanent display of pig tusks and model canoes.

The museological view of kastom as a reified form of performative cultural practice that could be presented in arts festivals and exhibitions gradually expanded out of the exhibition hall and into a model for sustainable living. Inevitably, this view became more and more oriented toward rethinking models of national development. In recent years, primarily under the guidance of then-director Ralph Regenvanu, the VKS has drawn on this mission of cultural activation to take a firmly activist position. Projects like the Sand Drawing Project or the Pig Bank Project, discussed in chapter 8, also became conservation projects (protecting the natural resources that were necessary for the maintenance of pigs or the knowledge of marine life to which many sand drawings referred). Conservation projects became involved with legal concerns over land rights, and the VKS established a research project to understand the complexity of kastom land tenure. Regenvanu left the museum to study for a law degree and then successfully ran for political office, becoming a member of Parliament for Port Vila in 2008 while continuing to direct the National Cultural Council until 2010.[4] Looking at land necessitated analyzing the distribution of authority and entitlement, and projects emerged that focused on juvenile justice and the relationship between chiefs and the police. The Pig Bank Project, funded by UNESCO, ultimately ended in the production of a National Charter for Self-Reliance and the government's proclamation of 2007–2008 as the Year of Traditional Economy (see chapter 8). All of these projects are directly aimed at effecting national change with the participation of people from villages throughout the archipelago and draw on different levels of discourse about cultural tradition and cultural heritage as models for economic, political, and social development. As such, funding gleaned from UNESCO and other international cultural heritage organizations is explicitly mobilized to very local agendas. The indigenization of the VKS provincializes the very idea of the museum—creating a socially activist political institution committed to being a conduit for the voices of the grass roots in a national arena.

The work of the VKS is also intimately engaged with contemporary anthropological practice. Guided by the National Cultural Research Policy, expatriate anthropological research is structured around the promotion of this engagement, with an emphasis on practical effect and on the strategic uses of fieldwork, text, and images in broader social work. This policy also influences the national perspective on archival materials, from the early policy of using anthropological materials in the VKS with the explicit agenda of "cultural

reawakening or revival" (Huffman 1997: 2) to the present-day policy to "ensure that cultural research projects are consistent with Vanuatu's own research priorities."[5] Such sustained engagement between national cultural institutions and diverse archives continues to activate the past products of anthropological research within local communities (Geismar 2009).

The VKS implements its agenda of social and political activism through a collaborative museology that works with an expanded definition of museum material. The archiving, as museum collections, of oral history, commentary on current and past events, and utopic visions of the past for the future (in the form of digital video, film, audio, and photographic material created by fieldworkers and communities) contributes toward an understanding of culture as property that, like other resources, has an active role in daily life, must be ultimately managed by its traditional caretakers, and which may also be expanded as a communicative medium into newly national and international spaces. An important provincial and indigenous museology is developed here, one that builds upon and extends the three dominant analytic paradigms for understanding museums. The first of these is the "exhibitionary complex" (Bennett 1988) model of museums as instituting national hegemonies via museum technologies of collection and display (see also Bennett 1995; Stanley 1998). The second is the growing awareness of the "postmuseum" as a space concerned less with conventional objects and more with the production of narratives and of visitor experiences and subjectivities (Ames 1992; Hein 2000; Hooper-Greenhill 2000). The third is the ideal of museums as "contact zones" in which these colonial institutions increasingly open their doors to native communities and allow for increased dialogue and assertions of representational control in their different spaces (Clifford 1997a; Peers and Brown 2003; Isaac 2007; Cooper 2008).

The VKS museological model contains all of these approaches and is at the forefront of a new Paradigm for Pacific museums: the indigenous museum (Erikson et al. 2002; Stanley 2007). The VKS is now de facto an indigenous space that explicitly uses the technologies and media of the "museum" with the explicit agenda of effecting change—cultural, political, social, and economic. Archives are made using multiple technologies, but they are ordered along local protocols and are not available for any generic museum-going public to peruse; rather, they are stratified according to archiving principles that were first implemented in villages rather than museum storerooms (see Geismar and Mohns 2011). Audiovisual documentation contained within the archives is seen as active and enabling rather than simply representational. Historical material is made contemporary through its incorporation into lived practices and a rhetoric of revival and re-use. In

this sense the work of the VKS does not only represent or mediate culture as an object in Vanuatu; it also creates a domain of contemporary practice. It does not follow the divisive logic of the ways in which government is organized into bureaucratic units. Rather than thinking of culture as separate from politics, economics, and social organization, it promulgates a holistic model of cultural practice and situates it at the heart of (international) development, national governance, and grassroots daily experience. At the same time, the VKS is more than a "cultural" center—it is a national space, an inclusive space (but one drawing on models of social and political organization based more on kastom than the multicultural nation-state). It is a space of political and economic activism and a space in which specific lifestyles are promulgated and practiced. This is exemplified in a statement by the current director of the VKS, Marcellin Abong, which opened the third national arts festival in November 2009:

> Intangible cultural heritage and the ethic of safeguarding, promoting and encouraging the living traditions and creative expression of our Vanuatu culture lie at the heart of the Vanuatu Cultural Center's Endeavour, and are in fact one of the primary reasons for the organization's existence. Our vision is "the preservation, protection and development of various aspects of the rich cultural heritage of Vanuatu" and the Vanuatu Cultural Centre code of ethics. The Vanuatu Cultural Centre is the cornerstone of our approach and philosophy. The Vanuatu Cultural Centre represents and advocates on behalf of the people of the Republic of Vanuatu, acting as a communication network and facilitating mechanism to bring people, resources and ideas together in the interest of the living creator communities of the Republic of Vanuatu. The advocacy role of the Vanuatu Cultural Centre as champion of cultural vitality play and inter-cultural understanding cannot be overstated, particularly in Vanuatu where, given the pressure of globalization and problems for development, culture often gets sidelined in the face of other priorities."[6]

NEW ZEALAND MUSEOLOGIES

The national framework and museum history of Aotearoa New Zealand is very different from that of Vanuatu. The containment and collection of Māori material culture was crucial to early colonial enterprise (see N. Allen 1998; M. Henare 2005; McCarthy 2007). In the present, museums in New Zealand reflect the tensions at the heart of the bicultural state, in particular through the classification and exhibition of Māori people and culture,

in which they mark Māori as both culturally unique and as aesthetic brands for the entire nation (see chapter 5). The staging of Māori protocols in museum galleries, the admission of ritual practice, and the acknowledgment of difference between Māori and non-Māori material also facilitate the ethos of biculturalism and the production of a national indigenous performative aesthetic.

Historically, the colonial engagement of Māori within museums forged cultural representation as a form of governance and from the start was alive to the entanglement of Māori cultural property, sovereignty, and museums. For instance, in 1901 the passing of the Māori Antiquities Act came hand in hand with a proposal to establish a National Māori Museum (A. Henare 2005a: 199). A colonial museum culture both relegated New Zealand's indigenous people to storerooms and collections and inspired a powerful renaissance in Maori cultural production that presented traditional carving, weaving, and architecture at tourist sites and places celebrating the "indigenous" nature of the dominion, in turn creating a national Māori style (see Neich 2001; A. Henare 2005b; McCarthy 2007). Powerful cultural treasures, donated through political exchange as vehicles of sovereignty, went on to become the centerpieces of large exhibition halls (see Tapsell 2000).

Within this local framework conflating museum and Māori culture, a specifically Māori museology emerged nationally and internationally with the curating of the landmark exhibition, *Te Māori*, in 1984. As discussed in chapter 5, *Te Māori* was exhibited in the United States from September 1984 through June 1986 where it was seen by more than half a million visitors, traveling from the Metropolitan Museum of Art in New York to the St. Louis Art Museum, the M. H. de Young Memorial Museum in San Francisco, and the Field Museum of Natural History in Chicago (see S. Mead and American Federation of Arts 1984; McCarthy 2007). The exhibition drew together the finest examples of Māori customary arts in New Zealand collections, focusing primarily on carving (in wood and stone), and was accompanied by cultural advisors and Māori elders who ensured that the correct protocols for opening the exhibition and touring the ancestral objects were followed. It was here that the category of taonga emerged on a global stage as a museological strategy to emphasize empowerment, collaboration, and participation as a form of ownership within museums. The term *taonga* in this context blended the respect conventionally given to fine art and museum collections with the ancestral power and relatedness (whakapapa) of these important artifacts, promoting a crossculturally understood view of cultural property.

The exhibition subsequently returned to New Zealand under the name *Te Hokinga*

Mai (the Return Home), and traveled to Wellington, Christchurch, Dunedin, and Auckland. Total attendance at the four venues in New Zealand was approximately 920,000 (Butts 2003: 88). In New Zealand, the *Te Māori* exhibition is frequently the reference point for the emergence of a new public, national, and international face for Māori culture—an exhibition for the age of biculturalism (S. Mead 2009). It is understood to be the starting point for Māori participation in museums in a way that has allowed for the incorporation of indigenous voices into many aspects of museum practice. *Te Māori* was also important because it was unifying for the Māori people: it was the first time that many of the pieces were exhibited out of their tribal territories, and it was the first time that so many objects from so many different parts of Aotearoa were exhibited in one place, nationally and internationally. The exhibition both provincialized museums and was itself provincial and essentializing, and it objectified a particular view of Māori art that fused a modernist primitivism (no coincidence that *Te Māori* was on in New York City at the same time as William Rubin's infamous exhibition, *Primitivism in Twentieth Century Art: Affinities of the Tribal and the Modern* at the Museum of Modern Art; see Clifford 1988b) with a politics of indigenous nationalism (see Thomas 1994: 188; McCarthy 2011).

The emergence of Māori museologies is a phenomenon that has long disrupted the conventional representational fabric of the nation, carving out a unique space for Māori in both the national and international arenas and empowering Māori explicitly in terms of cultural property rights (McCarthy and Cobley 2009: 403). Māori museologies prioritize the need to incorporate indigenous perspectives and recognize indigenous priority in establishing representational conventions. While this may not necessarily mean there is a uniform view of Māori attitudes and relationships to objects, the institutionalization of these indigenous museologies uses the specificities of indigenous culture to create a more generic vision of Māori identity constituted as a national imaginary. The Auckland War Memorial Museum Tamaki Paenga Hira and the National Museum of New Zealand Te Papa Tongarewa have probably been the most influential museums in forging a new and expressly national indigenous museology, one that focuses explicitly on the concepts of tikanga, kaitiaki, and taonga as organizational principles for museum practice, institutional culture, collaboration, and care of collections (see McCarthy 2011).[7] I focus on these two key national institutions here to highlight the ways in which newly national-indigenous museology engages with property relations, as both structured by the state and in negotiation with it.

Both the Auckland and Wellington museums were founded by key colonial collectors and swiftly became agents of governance through the acquisition and donation of artifacts that reflected the complex entanglements of Māori and Pākehā and the visions of powerful colonists about their nascent national culture. Since their inception, both museums have been used as places through which to infuse the state with a sense of national culture, drawing heavily on indigenous values and approaches to artifacts. As Conal McCarthy notes, "While the museum was itself a colonial artefact, it was never an unchallenged tool of settler rule and Māori always attempted to steer it towards their own ends" (2007: 202). In the present, both the Auckland Museum and Te Papa have integrated Māori values into many of their terms of reference—not only within exhibitions but at the heart of museum governance, thus providing a charter for the power-sharing possibilities of biculturalism.[8]

The redevelopment of Te Papa materializes this relationship explicitly. The only national museum of New Zealand (which developed out of the Dominion Museum, originally founded by the British in 1865 to house the collections of the Wellington Philosophical Society) reopened with much fanfare in 1998, having been rebuilt and reorganized from the bottom up (see Museum of New Zealand 2004; M. Henare 2005: chap. 6; Williams 2003, 2005b; Tapsell 2006b; Message 2006: chap. 6). It is now the only Crown museum with a board of directors appointed by the minister for culture and heritage. The museum is explicitly conceived of as a "forum" for the nation (White 2009), a place to rearticulate the shifting pattern of relations between Māori and Pākehā and a place in which to find one's cultural and national self.[9] In addition to galleries focused on Māori culture, settler/mainstream culture, and natural history, there are also smaller galleries dedicated to the Pacific Island and Asian peoples in New Zealand.[10]

The new museum was designed with a specific mandate following a particular vision of the nation: to acknowledge New Zealand as a "bicultural" state that recognizes the rights, claims, language, and culture of Māori citizens as equal and parallel to those of the settler-colonial origin. As a model for governance, biculturalism requires that the interrogation of key ideas and practices within this dualistic framework be extended to museum practices of conservation, collection management, acquisitions, exhibition, and more (O'Regan 1997). Ideas that are understood to be nonindigenous are required to be balanced by their indigenous counterparts. Within this context, museums such as Te Papa are profoundly aware of the symbolic load that they bear in putting this vision on display and are deeply engaged with developing practical ways of incorporating these ideals into everyday museum practices. As the Māori curator and academic Paul Tapsell

notes, "Finding balance between customary values (lore) and policy (law) is the new and exciting challenge in today's museums as they attempt to give meaning to the Treaty principle of partnership" (2005: 266). In New Zealand, museums are the best home for biculturalism—which in itself can be viewed as a complex representational strategy that inflects the form more than the substance of governance, and which remains heavily inflected by the organization of an Anglophile settler-colonial state.

As I have been arguing with regards to IP, tensions around biculturalism are also tensions of representation and interpretation and highlight the importance of aesthetic form and visual/material representation of the nation to political practice. The two official cultures of Aotearoa New Zealand are delineated in Te Papa using two very different display strategies. The section on New Zealand culture (tangata tiriti, people of the Treaty), called "Passports," sardonically presents the hardships and continuities of settler-colonial life (exemplified by the controversial placement of a work of abstract modernism by Colin McCahon next to a Kelvinator refrigerator) and draws on pastiche and irony, with a focus on "popular" culture. The hallowed area for Māori culture, resplendent with full marae (named Rongomaraeroa) and the Meeting House designed by celebrated carver Cliff Whiting, with an exterior glass installation by Robert Jahnke, constitutes Māori culture itself as a treasure, or taonga (see plate 4). In turn, the museum holds rotating iwi exhibitions that are curated by tribal representatives who determine the subject and work with the Māori curatorial team to select which objects will be displayed. For instance, the exhibition *Te Awa Tupua*—the Whanganui iwi exhibition—chose to focus extensively on the ownership conflict and colonization of the Whanganui River, a painful and contentious topic not disconnected to ongoing treaty claims. The museum, through this kind of collaboration, does not avoid representing contemporary cultural politics.

Aside from developing new aesthetics of display, which reflect different approaches to valued cultural artifacts, and developing new consultative processes for creating exhibitions, the museum is developing other key strategies to accommodate Māori values. For instance, the concept of *kaitiatitanga*, or guardianship, has emerged as a mode of holding collections in the museum that refuses to regard Māori collections as the sole property of the museum, but rather generates a relationship of trust and care with the implication of ongoing social connections (Geismar 2008). One model for this is Karanga Aotearoa, the National Repatriation Project, which took as its starting point the problematic of the museum's large collections of *tīpūna* Māori (Māori ancestors), including collections of *moko mōkai*, or preserved tattooed heads, which were popular items of collection in the

nineteenth century both within New Zealand and internationally.[11] The mission of the repatriation project is to reclaim these collections (and any other human remains) as subjects rather than objects (they cannot be formally accessioned as collections by the museum) and to facilitate their return from collections worldwide. This precipitated a necessary statement about the museum's right to hold these ancestors as objects in the collection and in a special place (Te Urupā) where they could be stored prior to reburial. The museum concept of kaitiakitanga, which is also frequently used to describe Māori relations to land (they are not the owners, but the custodians, who must hold the land in trust for both the past and the future), extends models of rights and ownership deliberately away from the confines and expectations of private property. In chapter 5, I discussed how this concept has been extended as an alternative form of ownership in the context of attempts to formulate a specifically Māori perspective on intellectual property rights. Rather than being a condition of ownership, guardianship is presented as a relational condition of consultation and collaboration that can draw these ancestors, and their descendants, into museum work in a nondemeaning way. Huhana Smith comments on this in the context of research at the museum, which draws on the principles of Mana taonga:

> The Mana taonga principle recognises the authority that derives from the whakapapa (genealogical reference system) of the creator of the cultural item. Such knowledge becomes the foundation for wider affiliated Maori participation at the museum, and especially when research reconnects key people to taonga. . . . The Mana taonga principle has long signalled that the national museum no longer has a unilateral right to determine how a taonga should be stored, exhibited, represented or reproduced. In a practical sense, Mana taonga provides iwi and communities with the right to define how affiliated taonga within Te Papa should be cared for and managed in accordance with their tikanga and custom. These rights cannot be erased and continue to exist for those taonga held within Te Papa's care. (2009: 8, 11)

The incorporation of Māori protocols and forms into the museum has not been easy. Unlike the VKS, which uses a national framework but seems to balance the effects of translation more toward multiple grassroots nationalisms, the hypernationalism of Te Papa has resulted in what some have viewed as a generification of indigeneity. Tapsell (2006b) is critical of the ways in which the museum's *marae* ignores the protocols of the *tangata whenua* (people of the land) of the place now called Wellington in favor of a pan-Māori

ownership focused on *taonga* as objects of collection rather than as forms enmeshed within the rights of the people of the place. The term *Māori* itself is a generification that subsumes important tribal differences. He comments that "even though our *taonga* exist in national museums they remain under the *mana*, the authority of those who belong to the land on which those buildings stand" (95). It is not only the museum that is the guardian of its collections; so too are the people of the place, standing in for the people of other places in networked indigeneity. In turn, the museum increasingly uses the term *taonga* to refer to all of the collections, not just the Māori collections (see Museum of New Zealand 2004)—taonga is used to provide a museological blueprint both specifically Māori and generically national at the same time.

As the preeminent national museum, Te Papa provides a window onto the tensions of the bicultural nation in which the fault lines between Māori and Pākehā are both productive of a unique national discourse and ultimately generative of representational discord, and where there is an aesthetic separation within practice between the consultative practices of the museum and a stylized form of display that provides a united substance representing the nation within the museum. Just like the fractures present within the ideology of biculturalism, within Te Papa there is ultimately a separation of Māori and Pākehā displays, the sole exception being a display about the Treaty of Waitangi, *Signs of a Nation Ngā Tohu Kotahitanga*, in which a series of generic but idiosyncratic voices are heard in a kind of whispering gallery commenting on the way in which the Treaty currently frames the nation. Many of these comments are extremely divisive.[12]

The natural history sections that deal with New Zealand's biological and geological history are framed within Te Papa by a series of popular immersive rides in which specifically Māori perspectives are co-opted into consumable experiences with dramatic special effects. In contrast, the Auckland War Memorial Museum has used some of its natural history gallery space to explore the possibilities of extending Māori museology away from conventionally defined cultural artifacts, taking a bicultural approach to the natural sciences (see Roberts and Haami 1999). In the Māori Natural History Te Ao Turoa Gallery, one enters to view a geological map of the Auckland region layered onto the floor. This is overlaid, above and below, with a Māori cartography that speaks to the origins of the islands and the importance of the constellations and Māori cosmology to the understanding of place. This map challenges us to view any cartography as a cultural experience of space and to understand that competing cosmologies order the experience of geology as a science. Other exhibits in the same gallery layer Linnean classification

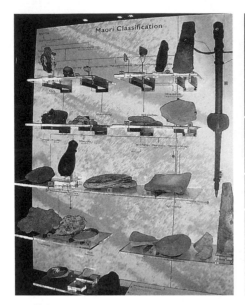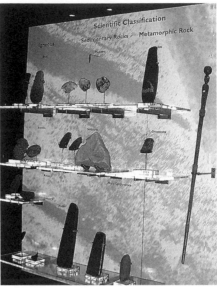

FIGURES 10 AND 11. Classification of rocks in the Māori Natural History/Te Ao Turoa Gallery in the Auckland War Memorial Museum, showing the "Māori" and scientific classification of rocks. (Photos: Haidy Geismar)

with Māori *whakapapa* (genealogy). As you move around a display case of sedimentary rocks, for instance, you see each schema presented as the legitimate family tree, placing these natural objects into a schema that understands how they constitute *mātauranga* (information, knowledge) within the Māori universe seen explicitly as a "scientific" framework, both destabilizing and reinforcing the division between these two ways of seeing (see figures 10 and 11). These lineages are not presented as either complementary or alternative, but emphatically co-exist. Whakapapa is presented as an overarching way of understanding the natural world, akin to science.[13] The gallery was seen very much to uphold the treaty obligations of the museum, aiming to free Maori knowledge "from the 'cultural closet' within which it has traditionally been constrained within our Museums, and allowed to stand alongside the scientific world view" (Roberts and Haami 1999: 22).

Similarly, the exhibition *Ko Tawa*, designed and curated by a former Tumuaki Māori (Māori director), Paul Tapsell, presented objects from the museum's Captain Gilbert Mair Collection, traveling from the Auckland Museum to the communities that originally

FIGURE 12. *Ko Tawa* installation shot at the Whangarei Museum. (Photo by Jade Tangihuia Baker; reproduced with permission)

exchanged them with Mair, a well-known early colonist and entrepreneur (see figure 12). Presented as iconic artifacts, spotlit and in the dark, this exhibition was nothing like the fine-arts presentation that, since the exhibition *Te Māori,* has strategically reified Māori taonga on the international museum stage (see chapter 5; Newton 1996).

A glance through the *Ko Tawa* catalogue provides the context that was salient to the display of the collection in regional museums that provided community access to the taonga, which were reproduced alongside their genealogies. Artifacts are presented as embedded in the landscape.[14] Their provenance is more than just a collection history of "owners" such as Mair; it is a narrative of traditional exchange, ancestral connection, and origin narratives in the implicit context of the nascent nation. Mair was embedded in personal and political networks with Māori people, and many of the objects in his collection were gifted, not purchased, alongside business deals and love affairs (J. Baker 2008). Most importantly, the research and traveling of this exhibition reflected these connections, returning as a process as well as an end result into communities. This is neither

a fine art display strategy nor an ethnographic perspective—this is a Māori (cultural) display. It privileges a Māori subject position, Māori styles of talking, Māori connections between taonga and place, and Māori understandings of exchange and connection as prime frames for representing objects using the conventional representational strategies of a more mainstream museology. It contextualizes these artifacts according to indigenous criteria for an indigenous audience first and foremost, but also makes this perspective accessible to a nonindigenous audience. Unlike *Te Māori*, which constructed a formalist aesthetic for taonga in keeping with modernist appropriations of so-called tribal art, *Ko Tawa* incorporated whakapapa (genealogy) and *kōrero* (traditional narratives) into the exhibitionary aesthetic itself. Increasingly, taonga have this expanded provenance; not a provenance of collection and display, as is the case in most museums, but a provenance of ancestry, community connection, and emplacement in cultural landscape. Research projects such as the lengthy fieldwork that accompanied the *Ko Tawa* project have been preoccupied with reuniting these histories to the objects (see J. Baker 2008; Tapsell 1997, 2000, 2006a).

These displays and other museum practices in both Vanuatu and Aotearoa New Zealand manifest museological models that engage in different ways with traditions of nationalism, public exhibition, classification, and collection but use these practices as a way to mediate indigenous values and produce a worldview increasingly reified as indigenous, which in turn is made broadly accessible to nonindigenous audiences. In this way they are what I have been describing as provincializing projects—they both utilize mainstream methods of cultural representation and subtly alter them. In both places, representational strategies are linked to progressive shifts to incorporate indigenous values into museum practice. In Vanuatu this worldview is presented back to government and the grass roots simultaneously. The participation it evokes is participation in development programs, in policy, and in local practice. In Aotearoa New Zealand, exhibitions such as *Ko Tawa* and the iwi exhibitions in *Te Papa* evoke a sense of participation in the mechanisms that symbolically imagine the nation to be inflected with significant Māori agency. These utopian visions differ in scale, impact, and organization, but at the heart of both of these new museologies is a profound rethinking of the basis of ownership and the entitlements and obligations of museums regarding their collections. In both places, these museologies are slowly contributing to the constitution of new (cultural) property relations and are increasingly used as models for a more expansive definition of ownership, and a form of advocacy for culture as a specific kind of resource.

Kastom and Taonga as "Museum" Models of (Cultural and Intellectual) Property

The museologies in Vanuatu and New Zealand use people's relations with objects as starting points to develop pivotal indigenous categories that I want to propose have become national models of "cultural" property, inflecting law, policy, practice, circulation, and public discourse. The categories of kastom and taonga both refer to a conglomeration of indigenous traditional forms (forms that expand, like the category of intangible cultural heritage, away from conservatively defined museum artifacts into multiple forms and practices). Both are also indigenous generifications that speak to a holistic understanding of the grass roots within national governance and bureaucracy and within global circulation, as well as becoming shorthand terms within communities for the expression of values specifically articulated as indigenous.

KASTOM

The term *kastom* (literally, Bislama for indigenous custom or tradition) and its variants in other Melanesian creoles and pidgins (e.g., *kastomu* in the Solomon Islands, *kastam* in Papua New Guinea) became a politicized buzzword during the pan-Melanesian drive toward independence. The concept has had a resounding effect on the formation of cultural and political identities for Pacific Islanders in local, national, and international environments and has spawned heated debates. Here, I focus on the tensions arising around the materialization of kastom, tensions that are primarily articulated in terms of ownership, entitlement, and the requisite indigenous identities that they require and which have been prominently explored in the work of the VKS.

Kastom provides an avenue for a particular kind of self-determination, one infused with colonial and postcolonial political struggle, where culture, particularly material culture, becomes a ground for both resistance and incorporation. Norton (1993: 741) identifies three dominant themes that run through the literature on kastom in Melanesia: a stress on the oppositional character of identity formation and the political climate in which this occurs (colonialism and the growth of indigenous forms of nationalism); the problematic of the "invention of tradition"; and the objectifications, or reifications, of culture that both of these approaches entail in constituting kastom as a form of "redemptive discourse" (750). Keesing (1982), in an early piece of writing, defined kastom as the strategic use of political symbolism by local agents. In this article, a Melanesian case study

mirroring Hobsbawm and Ranger's discussion of "the invention of tradition" (1983), Keesing wrote that "long before Europeans arrived in Pacific waters, Melanesian ideologues were at work creating myths, inventing ancestral rules, making up magical spells and devising rituals" (1982: 300).

The essays in Keesing's edited volume, *Mankind*, established a model that replaced a salvage anthropologist's view of traditional practice as immutable and authentic (albeit vulnerable) with a general view of kastom as invented tradition—malleable, made up, and politically contingent. Kastom was understood as a political strategy in the face of colonization that drew on the precolonial past to develop nascent forms of Melanesian nationalism. However, this view of invented tradition, with its attendant and controversial values of authenticity, denied the ways in which kastom was a term that not only organized cultural representation at the highest level but organized the ways in which people in this part of the world actually lived. This highlights a paradox that has emerged within both anthropological and native understandings of kastom, whereby it is seen to be both contingent and enduring, recently constructed as a result of external influences and yet autochthonous, both local and national. Anthropologists were not helped by the fact that within Melanesia there is remarkable diversity in customary practice as well as experiences of colonialism and in many places a reluctance to codify and overly determine the meaning of kastom.

Despite this lack of codification, kastom was, and is, a meaningful and authentic category on the ground. Melanesian spokesmen for independence such as Jean Marie Tjibaou in New Caledonia and Father Walter Lini in Vanuatu spoke passionately of "the Melanesian Way," describing a shared body of tradition. Yet at the same time they recognized an inherent flexibility to the category of kastom at the local level—looking to the grass roots as guiding authorities. Keesing noted that the term's power rises from such polysemy (1982; see also Jolly 1994b: 247), while Tonkinson (1982) commented that within these incipient narratives of indigenous nationalisms, the paradoxical nature of kastom made it an excellent vehicle with which to carry political categories constructed in opposition to colonial domination: "As long as the notion of kastom remained vague and undefined, or at least undifferentiated, it was an excellent vehicle for the expression of the indigenous persons' sense of cultural loss and anger at the Europeans whose domination of the country was responsible for it" (308).

Writings by Lindstrom, Jolly (1982), and Larcom (1982), all working in Vanuatu, emphasized the importance of the kastom category as an expression of the tensions

between tradition and modernity, past and present, center and periphery that consti-
tuted indigenous identities. As an exploitable political category, the category of kastom
within the anthropological literature began to be viewed as a crucial mediator between the
abstract and symbolic, the material and the immaterial (e.g., see Keller 1988).

Over time the meanings, or potential meanings, of kastom have changed for both
indigenous and anthropological commentators. In 1992, in a special edition of *Oceania*,
Linnekin, writing about Vanuatu, followed Wagner (1975) in suggesting that all views
of culture are invented (or constructed) and that this is "characteristic of all social life
and is not restricted to the making of colonial and nationalist representations" (Linnekin
1992: 253). Kastom was seen more as a synonym for "culture"—or more specifically, self-
consciousness about culture—without the suggestion of spuriousness or the ethnocentric
polarization of authentic/inauthentic (or traditional/modern) that the ideas about the
"invention of tradition" seemed to suggest, and which had grated so profoundly on indig-
enous ears (see, e.g., Trask 1991).[15]

For Jolly (1992), the internal oppositional distinction in Vanuatu between kastom
and skul (in Bislama, school, representing "the European way") demonstrates that politi-
cized classifications about authentic traditions occur from within as well as from without,
and it also highlights how the category "indigenous" may be constituted out of such
insider/outsider relationships. While anthropologists still concur that kastom is funda-
mentally conceived within a political climate of nationalism, the ethnocentrism of anthro-
pological assumptions is increasingly criticized (Clifford 2001: 479).

The struggles of academics to define the meaning of kastom highlight an inherent
ambiguity and overt politicism that is built into the concept, which to an extent makes
it resistant to academic analysis. A common thread to the analyses described above is that
kastom is a representation of people's understandings of what makes them indigenous.
The complexity of indigenity asserts self-determination, rather than description or repre-
sentation, as the arbiter of authenticity.

In Vanuatu itself, the concept of kastom as indigenous form and practice was initially
appropriated, in opposition to the "ways of Europeans," by the Anglophone independence
movement, first called the New Hebrides Cultural Party, which, under the leadership of
Anglican pastor Father Walter Lini, met "to debate the impact of tourism, land alienation,
education, and other aspects of the effects of Westernization on their traditions and how
best to keep their customs alive" (MacClancy 2002: 91). As the independence movement
intensified, the party's name changed to the New Hebrides National Party and then to the

Vanu'aku Pati. Kastom became a vital symbol of a firmly oppositional indigenous national identity. Prior to independence, kastom (viewed as precolonial and non-Christian) had been negatively valued by Christian ni-Vanuatu and expatriates as pagan and devilish. During the struggle for independence, the term was appropriated with radical difference by the Francophone secessionists who, following Jimmy Stevens, used kastom as a justification for planning an alternative future for the archipelago to that of the nation-state, modeled on a series of autonomous islands and grounded in indigenous traditions that could be used to further economic and political activity (see Abong 2008; Tabani 2008).

After independence, the Anglophone majority fused precolonial kastom with Christianity as the joint foundations of the nation-state. Kastom was institutionalized within a new national program that worked to legitimate cultural and political identity and autonomy. At the same time, the concept of kastom could be used internally as a way to create a coherent independent nation-state from a collection of extremely diverse islands—celebrating the diversity of practice under the umbrella of a shared category. In this way, kastom became not only a political category, but increasingly a style of practice (cf. Handler 1990; Akin 2004). In turn, it has also become a way to articulate and formalize a model of alternative practice for development. Vanuatu has no known petroleum, natural gas, or valuable mineral deposits. The primary areas for development are in the realm of small-scale cash cropping (organic cocoa, vanilla, kava), tourism, and land development.[16] Throughout the twentieth century, kastom (or traditional culture) has been used as a mechanism to resist the appropriation of land (see chapter 7).

This open definition of kastom was inculcated and then extended by the VKS in several strategic ways. Whenever I ask people about kastom, I receive a wide diversity of responses stemming from a diversity of agendas. The former director of the VKS, Ralph Regenvanu, has emphasized that this diversity has been accepted by the VKS, which—in order to maximize the concept's grassroots potential and efficacy—does not attempt to overly codify kastom. However, by all accounts kastom is conceived within a national context as a shared category that can be used to emphasize local differences. This explains the resistance to translating the term into local languages, the word instead forming an entrenched part of the lingua franca, Bislama.

Within this context what can kastom be? Context sensitive, it can be a plethora of objects and activities; it can be seen as knowledge, practices, artifacts, the use of the environment, persons, language, and as a form of interpretation itself. At the same time, as the interpretations of the VKS show, kastom is more than a set of ideas, ideologies,

practices, and representations. It is also institutionalized, especially in the VKS and the Malvatumauri, and instituted in the revitalization of certain kinds of customary practice and increasingly in law such as copyright legislation (see chapter 4) and land tenure (see chapter 7). Moreover, it is also increasingly produced in object form—stemming from the capability of objects to connect, and move between, places, both between islands within the nation, and between nation-states in increasingly global networks. This is not to suggest that all of kastom is material, but rather that some objects (in Vanuatu) provide a good model for how kastom works.

In keeping with the importance of materiality to the constitution of kastom and the linkage of museological views of culture to understandings of wider political and social relations, just prior to independence the VKS became a primary institutional location for kastom, alongside the Malvatumauri. Despite early political connections with the independence movement, the VKS now tries to maintain a distance from party politics and considers itself nonpartisan, mediating between state and village, specifically representing kastom to the government and in town, again alongside and in collaboration with the Malvatumauri. Today, kastom is viewed in this institutional context as a grassroots phenomenon, positioned at the opposite end of the scale to "Westernization," mediated by an indigenous nation-state encapsulated in the work of the VKS.

Increasingly, debates about kastom in Vanuatu have been turning to the VKS for clarification and advice. Larcom describes a ni-Vanuatu "model of culture" that she identifies as having its roots in early anthropological work, now internalized by the VKS: "[The] view of culture has become ethnographic, not just in the work of outside inscribers . . . but in a new perception of *kastom* as something like a text to be constituted, integrated, taught and transmitted rather than invented" (1982: 336). The VKS's practical policy to protect, document, and revive kastom emerged in part out of an understanding of the power of objects engendered by salvage anthropologists, as well as from local and international discussion about authentic precolonial custom. But it also emerged from active preservationist desires, nostalgia, and the community activism of its key informants, the local fieldworkers.

Bolton's discussion of kastom, drawn from her experience establishing the Women's Culture Project, highlights a practice-oriented approach taken by the VKS to kastom: "At the VKS there is no issue about what *kastom* is. The issue is what is happening to *kastom*. The central idiom in terms of which *kastom* is understood at the VKS, indeed in most of Vanuatu, is vulnerability to loss, and to identify something as *kastom* is to

identify it as vulnerable. The work of the VKS is directed toward this characteristic of *kastom*. . . . Promotion, documentation, and revival are all ways to defend *kastom* against loss" (1994: 147–148). The assessment of "Western" forms of development in Vanuatu as potentially damaging engenders the need to "protect" or "salvage" indigenous customary practices. The category of kastom still remains ontologically ambiguous, yet it is increasingly configured as understandings of local practice as a resource that, through the work of the VKS with museum technologies (in Bolton's term, *documentation*), are increasingly manifested materially.

Hviding and Rio (2011: 4–6) note that despite tense academic discussions about authenticity and invention of tradition, or—even more broadly—culture, the kastom category may be seen as an indigenous parallel to that of cultural heritage or cultural property. Like heritage or cultural property, kastom as a concept emerges at the borders of local, national, and international frames of reference for "culture," and all of these concepts have been locally appropriated in such a way as to now carry messages of indigeneity (see Hall and Fenelon 2009).

There is one definition of kastom that is increasingly discussed by analysts working in the wider context of Melanesia: it takes a view of kastom as a resource, or a form of property, that resonates in international as well as local and national contexts, where it is more commonly thought of as "cultural property." While international thinking about cultural property began with concern over the illicit trade of artifacts of cultural value, or cultural heritage (UNESCO 1970, 1982), the definition has swiftly expanded in recent years to include other, less tangible, resources: "Cultural heritage includes intangible heritage, which we can define as the ensemble of creations deriving from a cultural community and based on tradition. These intangible forms of heritage, passed from generation to generation by word and movement, are modified through time by a process of collective recreation. They are ephemeral and thus, particularly vulnerable" (UNESCO 1999: 12). Here the idea of "rights in" becomes even more important. A general UNESCO aim is to galvanize sources "of cultural identity and contemporary creativity for sustainable human development" (12). However, such development remains politically contentious in economic terms and requires a galvanization of new forms of local ownership by indigenous persons in new contexts. This, to me, is an excellent definition of kastom, reflecting its current state of use in Vanuatu.

Just as with international definitions of cultural property, any discussion of kastom in Vanuatu implies a series of indigenous "rights in" that transcends the problematic

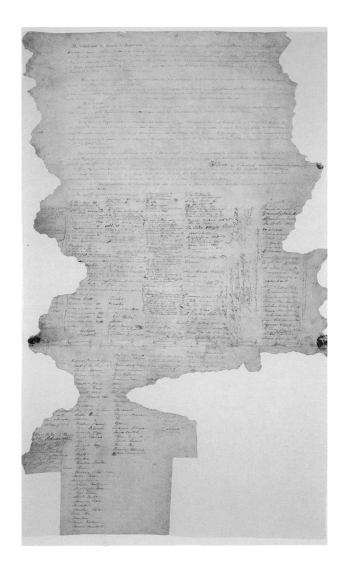

PLATE 1. Te Tiriti o Waitangi/The Treaty of Waitangi. The damage seen in the photograph occurred between 1877 and 1908 when inadequate storage led to both water and rodent damage. (Archives New Zealand/Te Rua Mahara O te Kāwanatanga, Wellington Office [Archives Reference: IA 9/9]. Reproduced with permission)

PLATE 2. Gordon Walters, *Makaro*; 1969, PVA and acrylic on canvas, 1523 mm x 1142 mm. Purchased 1970. Registration number: 1971-0021-1. (Reproduced courtesy of The Museum of New Zealand Te Papa Tongarewa)

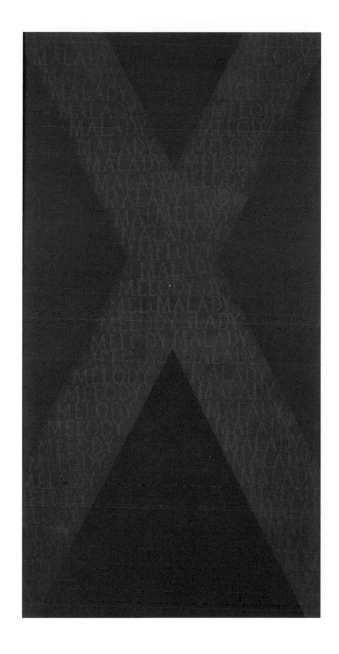

PLATE 3. Ralph Hotere, *Black painting XV*, from "Malady" a poem by Bill Manhire; 1970, acrylic on canvas, 1777 mm x 915 mm. Purchased 1971. Registration number: 1971-0024-2. (Reproduced courtesy of The Museum of New Zealand Te Papa Tongarewa)

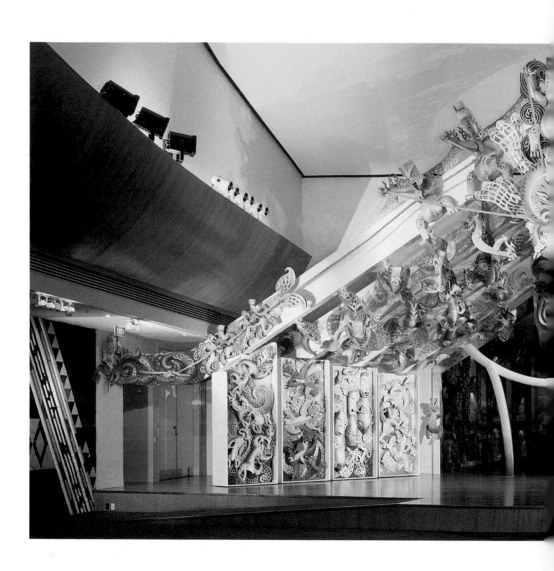

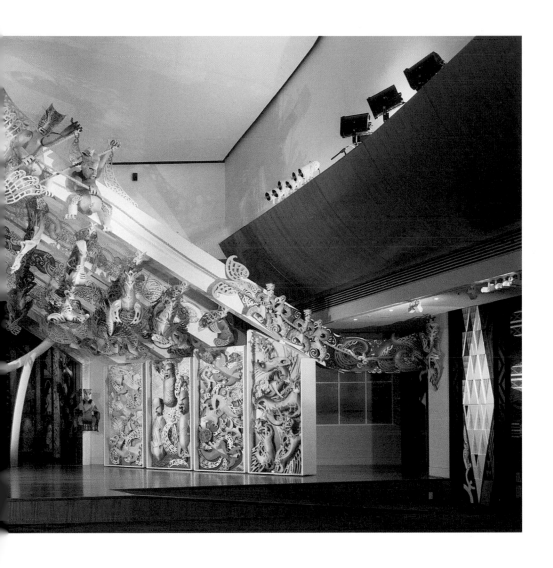

PLATE 4. The marae at Te Papa Tongarewa is called Rongomaraeroa. The wharenui (meeting house) is called Te Hono ki Hawaiki and is the creation of master carver, Cliff Whiting. (Reproduced courtesy of The Museum of New Zealand Te Papa Tongarewa)

PLATE 5. Ngaahina Hohaia, detail (embroidered poi) of Roimata Toroa installation, Govett-Brewster Art Gallery Collection. (Reproduced with kind permission of the artist)

PLATE 6. Mere pounamu (greenstone hand club), "Wehiwehi." Maker unknown, Ngati Wehiwehi of Tainui; Waikato kawakawa. 336 mm (l) x 92.67 mm (w) x 14.57 mm (d) 100 mm (l) bunch of tassels. Purchased 2001. (Courtesy of the Museum of New Zealand Te Papa Tonagrewa [ME022722]. Permission to reproduce granted by the people of Ngati Wehi Wehi and Te Papa)

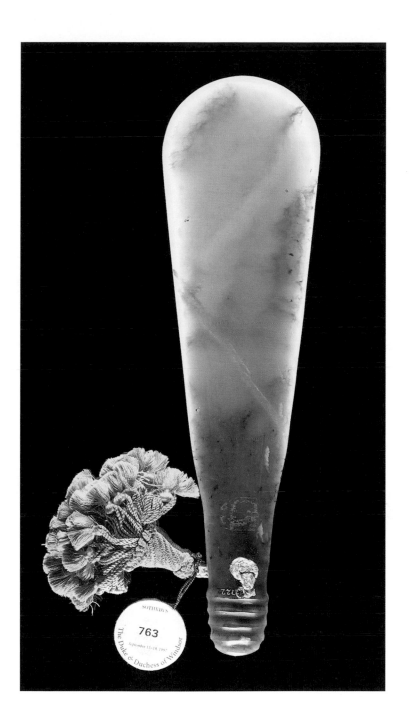

PLATE 7. Huhana Smith. Detail: *Sale by Epithet*, 2002. Oil on canvas, 1375 x 1375 x 40 mm. (Reproduced with permission of the artist and courtesy of Waikato Museum, Trust Waikato Collection, Te Whare Taonga o Waikato)

ARTIST STATEMENT: "This painting comes from the *Traffic* exhibition in 2002, which highlighted concerns over exploitation of taonga Māori or indigenous cultural material by the auction houses of the world. The painting referenced pages from Sotheby's catalogues. It was a personal attempt to make the taonga disappear as an imaginary protection device from the auction catalogue where the taonga are viewed and then "worshipped by a group of charismatic actors who sit in front of them and slyly bid" (Geismar 2001).

of defining what it is or is not (and see chapter 1 for an expanded discussion of rights in Vanuatu). Kastom therefore always exists as a set of rights in relation to the connections between persons and places within ever-widening spheres of political interaction. Rowlands (2002) outlines some of the problematic, reactionary ideas about ethnicity and origins that the possessive category of cultural property has engendered globally, but he comments that

> the idea that cultural heritage represents a system of relationships has the advantage . . . of avoiding the binary categories of public/private, collective/individual that notions of property lead us into. It encourages the belief that indigenous people and professional museum curators may be "guardians" of heritage and share responsibilities in a moral activity rather than disputes over ownership. This is clearly the way things are going at present, but it is by no means certain that this will not be swamped by the sheer scale and complexity of globalization. The massive expansion of international legislation and the institutions required to administer the protection of cultural and intellectual property imply global solutions that will have to be made relevant to each particular case. It seems most unlikely that this will happen and instead legal regimes will be deployed to mediate with and represent local interests. (132)

Ethnographic enquiry in Vanuatu demonstrates that ideas about cultural heritage are consolidated by the category of kastom. Both are fundamentally constructed in local, national, and regional forums as an indigenous possession, claimed by people who are made indigenous through inalienable connections to local places in an ever-widening geopolitical environment. In this sense, kastom exemplifies the position taken throughout this book—it is a theory of being indigenous that constitutes multiple perspectives and subject-positions. As in the case of kastom law described briefly in chapter 2, kastom presents a theory of national alternative that is increasingly used as a charter for development.

TAONGA

The term *taonga* functions in Aotearoa New Zealand in a similar way to kastom in Vanuatu. It provides a material and symbolic hook into immaterial issues of identity and rights within a nationalizing context. Despite a similar history of academic deconstruction of the authenticity of tradition using the rubric of invention (see Hanson 1989), in the present day the connection between Māori and taonga is part of what constitutes authentic

indigeneity. Translated by Williams as "property, anything which is highly prized," taonga is a Māori term that is now loosely translated as "treasured possession," or highly prized artifacts, valuables, or treasure (S. Mead 1990), but is increasingly used as a substitution in context for a number of English words including *antiquity*, *resource*, and *cultural/intellectual property* from an indigenous perspective.[17] From a polysemic start, where it was used to refer to multiple kinds of resources, the term was galvanized in 1840 within the Treaty of Waitangi, where it was used to refer to specifically Māori property, and it has come to index the substance of indigenous possessions, the location of indigenous value, and the continuation of that particular use in the ways in which the Treaty is valorized and discussed in the present-day context of the Waitangi Tribunal (see Lavine 2010). It is also used increasingly to refer to abstract relations of sovereignty over cultural resources that may be as varied as language, community, or venerable elders—a social relation or a right in, as much as an artifact or practice. Like kastom, taonga is defined primarily as an indigenous concept that emerges in the context of a negotiated nationalism (hence its prime importance within the Treaty of Waitangi).

Māori scholar Hirini (Sidney) Moko Mead describes taonga as united by being filled with the *ihi* (power), *wehi* (awesomeness), and *wāna* (authority) of the ancestors. Embedded within specific genealogies (whakapapa), tribal stories, and histories and inalienably connected to named people and places, taonga are manifestations of important connections and relationships between land and people and between generations, mediated by ancestral spirit. These connections are made manifest in the kōrero (exegetical talk) and whakairo (the formal process of ornamentation, or artistic production (S. Mead 1990: 165). Paul Tapsell (2000) writes:

> A *taonga* is any item, object or thing that represents a Māori kin group's ancestral identity with their particular land and resources. *Taonga* can be tangible, like a greenstone pendant, a geo-thermal hot pool, or a meeting house, or they can be intangible, like the knowledge to weave, to recite geneaology, or even the briefest of proverbs. As *taonga* are passed down through the generations they become more valuable as the number of descendents increase over time. (13)

Taonga are defined not only as specific forms, tangible or intangible, but by the engagement of specified forms with encapsulating webs of Māori relationships and histories. Tapsell (1997) compares taonga to two phenomena of nature: the tui bird and the

comet. Like the tui, kin group–owned taonga weave in and out of iwi and hapū life. They reflect the joy of the locality and connect the past to the present, ancestors to descendants, people to land. Like a comet, those taonga—no longer controlled by kin group or tribe—blaze on the horizon, universally impressive. However, like a comet, they will always reemerge at the same place and will consistently connect back to natural cycles of time and space. These are not just objects: they are social *and* natural beings. As such, they cannot be owned in the narrow sense of private property: "At home it is a maxim that you cannot 'own' a *taonga* because they are your ancestors. You may become their *hunga tiaki*, or guardian, but this does not change that fact that you belong to them, not the other way around. What is owned, perhaps, is the obligation and responsibility passed down by ancestors requiring descendants to protect, interpret, *manage* and transmit the kin group's *taonga* to future generations" (Tapsell 1997: 362).

Taonga thus articulate a Māori vision of cultural property—they define Māori entitlement, yet they may not always be controlled by Māori. They may be used in diverse representational contexts, but fundamentally, what makes taonga is their status as Māori, rather than the ways in which they are used as resources. In this way, taonga show us how property may be linked to cultural identity, regardless of "legal" ownership. Taonga have always been connected to the establishment of hierarchies of entitlement, mediated by the process of legitimation afforded by Māori identity politics, forged by genealogies in practice.

Debates about the nature of taonga range from an assessment of the authenticity of use, to the translation of the term both from Māori into English and from past into present, to the limits of definition within the Treaty of Waitangi and its applicability to the myriad things considered to be taonga in the present day. It is my contention that these debates, like so many others discussed above regarding the invention of tradition, are distractions from the main point: that the concept of sovereignty is fundamentally salient to that of taonga. The Treaty of Waitangi, which made the country a British colony, consists of two texts. Key to much debate in the present day is the translation between English and Māori versions (see chapter 3; see also Orange 1987). In Māori, the Treaty promised to uphold the absolute authority, or sovereignty, of the Māori chiefs over their lands, living places, and their *me ō rātou taonga katoa*, translated as "those things which Māori deem valuable and wish to retain."[18] The British version glossed this concept simply as "valuables." Amiria Henare argues that part of the efficacy of the term *taonga* in contemporary treaty (and other) negotiations lies in the insurmountable differences between Māori and English that are enshrined by a founding document that exists in two languages, which in turn has itself

been conceptualized as a taonga (2007: 57). The principle of untranslatability permits a strategy of exceptionalism, melding with the politics of indigeneity. Some Māori argue today that the Treaty gave the British rights of governance but not of sovereignty, but it is generally agreed that taonga are the substance of sovereignty. The limits of sovereignty (and indigeneity) are thus often contested in relation to the definition of taonga. Much as there are debates over the ways in which the U.S. Constitution should be interpreted in law, there are originalists who argue that the definition of taonga should be restricted to the sense of the term when the Treaty was drafted and contextualists who argue that the term should be expanded to include new forms of valuables and property, including recently discovered IP, such as patents for genetic material, rights to the fisheries, and so on.

Many of these contestations are dealt with pragmatically in forums such as the Waitangi Tribunal through recourse to the epilogue of the Treaty that acknowledges that all parties are in agreement as to its general spirit. In recent years, Parliament has chosen to refer to the principles of the Treaty rather than to its more literal content.[19] Yet despite the ambiguities of translation, it is increasingly apparent that ideas about taonga are deeply embedded within national debates about property rights more generally. While it may seem self-evident to note that both of these categories are enmeshed in discourses of indigenous sovereignty, we seem to have forgotten that the same is true of commodities around the world; look at the political crises and issues of sovereignty that have emerged in the twentieth century around, for example, the trade of oil. Indeed, the sovereignty of property is such a hot topic that it tends to be analytically negated. For example, Brown (2003) uses the notion of a global cultural commons to criticize the property claims of indigenous rights movements. While many of these claims obviously have political motivations, Brown's underdefined concept of a global cultural commons, despite its best intentions, may be construed like a modern-day version of that old ideological justification of a grab for sovereignty, *terra nullius*. Let's claim an empty space so we can create the kinds of property relations (and political sovereignty) most useful to us (see Appiah 2006 for another iteration of this perspective). Right or wrong, the net effect of this is that indigenous sovereignties are negated in the interest of more powerful stakeholders.

Same but Different

Kastom and taonga may be seen as two sides of the same coin. Both have emerged as nation-specific indigenous discourses that merge the contemporary practices of indigenous people

in Vanuatu and Aotearoa New Zealand with an interest in representing indigenous modes of being and practice. As I have argued, both may be seen as local constructions that bear the same conceptual weight as cultural and intellectual property—discourses, ideologies, practices, and frameworks concerned with the indigenization of resources and indigenous sovereignty. At the same time, each speaks differently to the fundamental questions of materiality (see Miller 2005), the nature of objects and entitlements, and the boundaries of self-determination in practice. These differences, I argue, also speak to the differences in settler-colonial and postcolonial constructions of indigeneity. Kastom, as the doctrine of a postcolonial nation struggling to assert itself internationally and to negotiate with its colonial legacies, is a practice-based category. Taonga is increasingly a representational trope, with high-end applications in national policy and bureaucratic frameworks. Within the settler-colonial state, especially in the context of biculturalism, with its glossy emphasis on culture rather than politics, representational control, and by extension control over objects as a way of positioning ownership claims to resources, becomes tantamount to the internal dynamic of self-determination. Ni-Vanuatu do not have to stake claims to land, fisheries, and other natural resources in the same way. Rather, they need to draw on the postcolonial project of "decolonizing the mind" (wa Thiongo 1986) and reclaiming practices and attitudes resolutely indigenous in the face of the external pressures from international organizations that continue to implement what are tantamount to colonial projects within their aspirations of national development. It is telling that New Zealand museums have undertaken a wide-scale international repatriation project, whereas repatriation is not really on the agenda for the VKS. Repatriation is often more an issue for indigenous people living in settler colonies whose ownership over other resources has for very long been co opted by the state. In Vanuatu there is relatively little interest in physical repatriation; people are more interested in activating kastom in their communities using museum collections than they are in delineating physical ownership of those collections. Taken together, kastom and taonga, as key organizational principles of indigenous lifeways in Vanuatu and Aotearoa New Zealand, may also be understood as organizational tropes for understanding the constitution of indigeneity itself as a property relation (not a commodity relation), a mode of strategically possessing culture, and in turn creating the kind of culture that can be possessed in multiple registers.

This chapter has provided a bridge between the first and second half of the book, continuing to emphasize the ways in which indigenous categories in Vanuatu and New Zealand intersect with ideas about intellectual and cultural property. If I have previously

been looking explicitly at IP law and its provincialization, I now turn to cultural property discourse and examine the ways in which it provides an avenue for the indigenization of the market and of the national economy. However, even though I have divided my discussion in this way, the total picture I present throughout this volume is of an ever-expanding field in which indigenous interest connects cultural and intellectual property, forging new discursive tropes and new institutional frames. The emergent museologies in Vanuatu and Aotearoa New Zealand I have described here are linked to specific concerns about control over resources and the staking of cultural claims. They connect generic models of cultural property to indigenous rights, indigenizing the generic and making the indigenous generic. It is therefore necessary to understand the interface between indigeneity, law, museums, and discourses of traditional ownership in order to understand how cultural and intellectual property are being reformed in both Vanuatu and New Zealand. Conceptual frames such as property and law are implemented through social and political institutions such as courts and museums. Museums in particular face the daily task of translating contemporary object-based law, policy, and philosophies into institutionalized practices. Unlike many other (national) institutions (such as courts), they explicitly acknowledge themselves as social entities aimed at inclusion at every level. This inclusion forms the remit of much of their practice (unlike most courts, where inclusion is a side effect or precondition for other kinds of work). Te Papa and the VKS started as provincial institutions—replicating colonial forms, aspiring from afar to colonial agendas. They now not only reflect the transformation of their nations; they have also played key roles in effecting this transformation. They are no longer only provincial in themselves but rather are centers in developing an indigenous perspective on cultural rights. Taonga and kastom are both discursive forms and calls to action that have provincialized national property relations by re-centering indigenous values. Throughout the second half of this volume, museum practices and artifacts provide a window into the ways in which ni-Vanuatu and Māori are making new kinds of intellectual and cultural property.

7 | Treasured Commodities

TAONGA AT AUCTION

THE CIRCUMSTANCES surrounding the toi iho trademark expose the tensions that occur when intellectual property (IP) regimes enclose indigenous identity in Aotearoa New Zealand. There are, however, other markets for culture and other avenues for the assertion of cultural rights. I move here from looking at the efficacy of IP in this domain to a domain more explicitly conceptualized as cultural property, highlighting a convergence in the ways in which these legal frames are connected to ideas about indigenous entitlement, identity, and sovereignty. This chapter discusses the market for certain kinds of *taonga* (Māori treasures or cultural property) in Aotearoa New Zealand, critically exploring the production of value in the marketplace, paying attention to both the form and the substance of market exchange. As in the case of copyright in Vanuatu, the commoditization of taonga at auction has engendered a particular form of political and economic intervention, making the marketplace a site of resistance to processes of commodification as much as a space that also creates expanded definitions of commodities. The interventions

of diverse constituencies into the auctioning of taonga reimagine the marketplace, the form and sociality of display, and the value of traditional artifacts. Auction houses become spaces where the dystopia of settler colonialism is overwhelmed and disrupted by the assertion of indigenous economic agency, which in turn undermines the utopia of free-market exchange.

In Aotearoa New Zealand the ideology of biculturalism, devised by a predominantly nonindigenous government to recognize its contractual obligations to indigenous Māori, holds in tension models of economy and governance that in turn depend on conceptually incompatible models of culture. As we saw in chapter 5, there are stark parallels between the modeling of the state and the modeling of value in the marketplaces for culture that emerge here: both mold ideas about property in order to establish sovereignty.[1] As we will see in this chapter, prosaic objects sold at auctions—flints and adzes, for instance—also engender intense discussion around these issues. Here, I discuss the auction market for Māori antiquities in New Zealand, focusing especially on interventions into their exchange and valuation by a number of different Māori interest groups, as a process of creative reimagination of market exchange.

Some interesting analytic and empirical tensions emerge in New Zealand around the market. As discussed in the introduction to this book, Māori gifting has been used by anthropologists and others to represent a paradigmatic alternative to commodity exchange, one that is generative rather than disruptive of social relations (see Mauss [1923–24] 2000, passim; Firth [1929] 1959; Strathern 1988; Weiner 1992; Graeber 2001; Miller 2001). At the same time, the cohabitation of diverse communities of Māori, Pacific Island, Asian, and European descent in Aotearoa New Zealand has inculcated intense public debate around whether society should be conceived in bi-or multicultural terms and how such models should be used as a basis for social, political, and economic development. In turn, despite its progressive social discourse and a seeming willingness to incorporate ideas about cultural alterity in the heart of state governance, Aotearoa New Zealand is also a nation that has embraced privatization and neoliberal economic theory to a perhaps unprecedented degree. As the economist John Kay has commented, "No country has modeled its policies more deliberately on the American business model—applause for self-interest, market fundamentalism, and the rolling back of the redistributive functions of the state—than New Zealand after 1984, not even the United States" (2003: 45).

Auction houses provide a staging ground for both the public contestation and

convergence of different conceptions of value, understandings of exchange, and complex political relationships. Emerging in the context of European mercantilism in the seventeenth and eighteenth centuries, art auctions in many ways are tangible exemplars of the disembodied notion of the free market that so pervades everyday discourse and government rhetoric around the world (see Geismar 2001). However, the auction market in Aotearoa New Zealand is subject to a much greater degree of intervention and accountability than the "free markets" of the European Union and the United States. The market for moveable cultural property is carefully regulated by the New Zealand government in keeping with often contested understandings of Crown sovereignty over the national cultural heritage. It is also increasingly influenced by global legislation around the movement of cultural property (e.g., UNESCO 1970), as well as by indigenous rights movements. In addition to such regulation, the market for Māori artifacts is also subject to many other interventions, most particularly by indigenous activists, but also increasingly by museum curators, who complicate the notion of Crown sovereignty and assert the primacy of indigenous entitlement and models of value. The sale of Māori artifacts in art auctions has therefore been swept up into a wider, increasingly expansive, debate about the definition of Māori property and the subsequent boundaries of entitlement, in both national and international spheres of exchange.

Auctions and Expectations

The semblance of a visible community that auctions depend upon makes them a good starting point for accessing the creative imaginary at work in constituting a marketplace for cultural property. Baudrillard describes auctions as ideal markets, "crucibles of values" (1981: 112), in which ideology and economy are negotiated within a particular matrix of space and time. It is the seemingly public nature of transaction that supports many people's assertions that auctions are ideal marketplaces despite the fact that the inevitable behind-the-scenes subterfuge, coupled by the use of proxy, telephone, and even online bidding, immediately complicates this notion of community. At the same time, the fact that auctions are freely open to the public and that certain kinds of attitudes, reactions, and transactions can be read by merely being there, allows the anthropologist an entry point into a world marked by closed doors, secrecy, and conservatism.

In turn, the art business—described so perfectly by Bourdieu as "the sale of things which have no price"—exposes how an irrational disavowal of commercialism is at the

FIGURE 13. Māori and Pacific artifact auction preview at Dunbar Sloane, Auckland, August 2004. (Photograph: Haidy Geismar)

heart of creating commercial value for objects defined primarily in terms of their uniqueness, authenticity, and pricelessness (Bourdieu 1993b: 75; see also Velthuis 2005). As a commodity, then, art seems to be extremely unlike a commodity. Rather than thinking

about what this can tell us about art, I ask what this can tell us about commodities and the market much more generally.

The limited literature around art auctions demonstrates how they are simultaneously exemplary of ideal markets and values and as well of the irony, paradoxes, failure, idiosyncrasies, cults of personality, fashions, intrigues, deceits, politics, and rhetoric that actually produce this idealized vision of how markets work. In this way, the auction market may be conceptualized as a border zone, foregrounding "the unresolvable oscillations, the restless toing-and-froing, and the cultural, commercial, and political crossings" that produce value (Spyer 1998: 1).

Māori at, Rather Than on, Auction

In an earlier piece of research and writing (Geismar 2001), I unpicked the equation between price and value production at tribal arts auctions, asking "what's in a price?" in relation to the international sale of "Oceanic art" (an international category that includes Māori art and artifacts).[2] I described the lengthy process that underpinned the procedure of bidding. The moment of sale is an exquisite ballet of negotiation, knowledge exchange, and sometimes even corruption between collectors, dealers, auctioneers, academics, curators, and unclassifiable persons taking place over a lengthy period, from the production and display of the auction catalogue, through the musings between vendor and auctioneer about estimates and reserves, to the social gala of the auction preview, to the breathless theater of the sale itself (see figure 13). The eventual price a piece will achieve at auction depends on much more than just the sale itself, and the continued negotiations embodied in prices have a continuing impact on the assignation of future prices and values. It is also important to realize that auctions do not always end in sales—pieces may be "passed over" (remain unbought), bought back by their owners in complex machinations, or simply avoided. It is this potential for failure and subversion that I focus on here.

One of the examples I focused on in my earlier study was the 1998 sale at Sotheby's New York of a "Magnificent Māori Figure," or *poutokomanawa*, from Heretaunga or Hawkes Bay, collected by Archbishop William Williams around 1870 (Geismar 2001: 35–36). The auction house went to great lengths to promote this piece, placing several full-page color images in the catalogue alongside an academic essay by Terrence Barrow, named as an "authority" on Māori art (see figure 14). In addition to this, Sotheby's arranged for a tour of the carved ancestor figure around galleries in Australia (but, tellingly, not

Important
African
and
Oceanic Art

SOTHEBY'S

New York Sunday November 22, 1998

FIGURE 14. Cover of a Sotheby's catalogue, showing the "Williams" poutokomanawa, November 22, 1998.

displaying it in New Zealand) before bringing it to New York for the sale. Just prior to the auction Sotheby's organized a symposium titled "Oceanic Art: Collecting and Elements in Connoisseurship," inviting curators and academics to speak to a gathering of prominent collectors and dealers.

The figure was sold on November 22, 1998, at its asking price of $1 million ($1,102,500 including all premiums), which at that time was the highest price ever achieved at auction for an object from the Pacific (excluding contemporary Aboriginal Australian art). The carving is now on display at the St. Louis Art Museum. This transaction was much fêted in the media at the time as a watershed in the market for Oceanic art. After many years lagging behind the market for so-called tribal art of Africa and the Americas, Pacific art seemed finally to be a serious investment. Indeed, since 1998 prices for the "archetypal" Oceanic collection items (New Caledonia Bird Clubs, New Guinea shields, Hawaiian calabashes, Fijian clubs, whaletooth necklaces, and so on), and especially for Māori artifacts (predominantly figurative carvings, feather cloaks, wooden treasure boxes, and greenstone clubs and pendants), have risen exponentially around the world. As one journalist commented, "Forget the plunging share-market—today's hottest investment could be Māori artifacts."[3]

But was the sale of the "Williams" poutokomanawa the success it really seemed to be? In contrast to the fierce bids around the highest-selling pieces of African, Australian, and American artifacts, the poutokomanawa was sold to a single absentee bidder at the lowest possible price, the reserve. While the price itself may have been unprecedented, all the efforts of the auction house to promote the piece failed to generate significant competition among collectors. One sales commentator noted, "The auction house presumably thought it would fetch an even higher price as the auctioneer took a very long time to knock it down."[4] After the sale the vendor, Dr. Woog, a Swiss medical equipment inventor, publicly expressed his dissatisfaction at the outcome. The resident expert, Terrence Barrow, commented to the press that Dr. Woog "was extremely disappointed and thought it would fetch two or three million dollars."[5] Indeed, in 1992 Dr. Woog had offered the piece to the National Museum of New Zealand, asking considerably more than it eventually sold for at Sotheby's. His offer was rejected.

The sale of this and other pieces and the subsequent rise of international prices have provoked increasing disquiet in New Zealand museums. Prior to the 1998 auction, Arapata Hakiwai of the Museum of New Zealand Te Papa Tongarewa, commented to the press that the museum had refused to bid for the piece: "Our role is to assist the iwi [Māori

tribes]. The last thing we want to be doing is being involved in inflating the market." A Māori member of Parliament, Rana Waitai, also commented: "Two million dollars was a scant figure compared to its value to the people of Kahunga." He described Sotheby's as "a tarted up, unscrupulous shark that was legally pawning off cultural treasures" (quoted in Howard 1998). Instead of purchasing the piece, there was a general calling for the poutokomanawa to be repatriated, as an important piece of Māori cultural property, to New Zealand. The refusal of Māori museum workers and political authorities to participate in or endorse the sale of the figure has had a broader impact on the market that should not be underestimated.

The questionable success of the sale or commoditization of the poutokomanawa is a provocative starting point for interrogating the ways in which the marketplace infiltrated ideas about cultural value, in addition of course to the ways in which cultural values infiltrate the marketplace. Despite reaching a million dollars, this sale was not considered to be a success. What does this tell us about the forms of value inculcated through such market exchanges? Did this sale open up a space for alternative models of value and evaluations of the market as much as it opened up a new market, to a new level of collector? How do divergent understandings of value publicly engage with one another in the marketplace, and what happens after that?

A Brief Note about the New Zealand Auction Market

The sale of taonga at auction at first glance discursively polarizes models of value around cultural property: many Māori hotly contest the rights of dealers and auctioneers to trade and assign prices to objects that they consider a priceless part of their cultural heritage and genealogy (whakapapa). In turn, while the cultural value of pieces is intensely exploited by dealers in the marketplace to increase prices, many dealers and collectors also claim a connection to artifacts that transcends mere monetary price. Objects are acknowledged by both Māori and non-Māori[6] to potentially have powerful effects on those whose hands they pass through, and there were many stories, told by dealers and collectors about noted collectors becoming ill, or even dying, after buying particular artifacts. At the same time, Māori increasingly enter the market on its own terms, negotiating sales and buying pieces, while dealers assert that the artifacts they trade in were initially transformed into commodities by Māori people themselves. Thus, what at first glance seems to be a clearly delineated social, political, and economic space with "Māori" on one side and "Pākehā" on

the other, turns out to be infinitely more complex. The auction house is therefore a para-doxical space in which multiple perspectives coexist and in turn influence one another, continually reconfiguring prices and understandings of ownership. The staunch resolve of many Māori to publicly bring their own models of value into the auction house has had a powerful effect on the prices that artifacts sell for, not only within New Zealand, but as the case of the Williams poutokomanawa demonstrates, even in the domain of the interna-tional auction market. Despite a vehement language of opposition, the exchange of taonga draws together multiple constituents and diverse understandings of value.

For some time, both museums and Māori have been intervening explicitly into partic-ular auction sales. For instance, on March 31, 1996, John Turei, a Tūhoe *kaumātua* (elder) made an impassioned speech at the start of an auction at the New Zealand auctioneer Webb's, asking private collectors not to bid for a native pigeon cloak dating from the 1870s. Mr. Turei had been approached by both the Rangitane Tribe and the Museum of New Zealand to do what he could to ensure that the cloak was not sold to private collec-tors. The cloak was locally well known, having been passed down through one family until its last owner decided to sell it at auction. After John Turei's protest, the cloak was sold to the Museum of New Zealand for nz$13,000 with no competition; evidently, Mr. Turei's speech was successful in deterring private collectors from competitively bidding for the piece. The auctioneer, Peter Webb, said he had agreed that Mr. Turei could make a speech before the auction. He commented, "Ordinarily, we would have expected that cloak to fetch $20,000 plus . . . [now] there is a real risk of frustrated private owners preferring to risk smuggling them out of the country to sell them on international markets."[7] This case gives us a good introduction to the ways in which Māori are able to enter auction sale-rooms, assert customary authority, effect public opinions about the process of commodity exchange, and influence the outcomes of sales. It also highlights the increasingly pivotal roles that museums have in determining the nature of these transactions.

In a second case study, Te Kaha, a Tūhoe activist (see chapter 5), stole *The Urewera Mural* by the celebrated New Zealand artist Colin McCahon (valued at approximately nz$2 million) from the Aniwaniwa Visitor Centre at Lake Waikaremoana in June 1997. The mural was commissioned from McCahon by the visitor center and contains impor-tant iconography relating to Tūhoe sovereignty, including a flag of the resistance leader Te Kooti and inscriptions in Māori and English reading "'Tūhoe, Urewera, Their Land." McCahon was not a Māori artist but his work was deeply engaged with the landscapes of Aotearoa and with indigenous presence. The mural's theft aimed to draw attention to

ongoing claims by Tūhoe for custodianship of the Urewera National Park. The painting was recovered through the mediation of well-known collector Jenny Gibbs, who also paid Te Kaha's fines. Te Kaha's punishment was two hundred hours of community service to be undertaken at the Auckland Art Gallery, where he worked on an exhibition of the Urewera mural in Auckland, alongside key Tūhoe objects. Ian Wedde, the curator and consultant for the then-nascent Te Papa, commented:

> The reasons for Tūhoe anger over the painting are complex. They touch directly on the relationship of memory and culture; how these are inscribed in land; how this inscription may be represented; how that representation may involve language; and how that language may, or may not, be invested in, or owned in some sense, by agencies outside the iwi itself. There is an important distinction to bear in mind here, as in the case of historical representations of Maori as portrait subjects, between the objective value of the art work, often vested in the artist's signature; and the value of the art's object as such: the wholly present significance of what is represented. A Western value system tends to prioritise the economic value of the art as coextensive with the artist's reputation; Maori will tend to prioritise the social value of what is represented, as coextensive with whakapapa (genealogy) and whenua (place). The two systems are by no means mutually exclusive; but there is a powerful tension between them which increases as they are moved further apart. Because the economic value of McCahon's work is notoriously increasing in step with his reputation, there is increasing pressure, in the case of the Urewera Mural, to mark the value of what the painting represents, in step with Tūhoe ownership of that significance. In a sense, there is tension and even competition between artist's signature and Tūhoe sovereignty.[8]

In the previous chapter, I described at length the complicity of processes of appropriation and appreciation and how they played out in the aestheticization of Māori culture, particularly in the medium of New Zealand contemporary art. The sale of Māori artifacts has also long been an arena that the government has used to think about the definition of national as well as indigenous cultural heritage (see chapter 3). I want to suggest here that the institutional home of cultural property legislation, the museum, has been more successful in navigating these waters than the framework currently in place for IP law. The movement of all Aotearoa New Zealand cultural property, including the market for Māori artifacts, is constrained by the Protected Objects

Act, which in August 2006 replaced the Antiquities Act of 1975, which itself emerged from the Māori Antiquities Act of 1901 (amended in 1904).[9] Despite its ostensible focus on all antiquities, now defined as any objects older than fifty years, this legislation was established specifically to establish and record the ownership of Māori artifacts and to control the sale of these artifacts within the nation, and it speaks to the salience of Māori taonga as a blueprint for the protection of national cultural heritage (exemplified by the use of Māori values in contemporary museology in Aotearoa New Zealand, as discussed in the introduction).[10] The amended act has a special category for Māori artifacts, *taonga tuturu*, and most of the amendments in both 1904 and 2006 are concerned with the transaction of objects now explicitly defined as taonga.[11] The three auction houses of New Zealand—Dunbar Sloane, Webb's, and Cordey's—hold annual "Artifacts" sales that sell primarily Māori antiquities, often alongside a small number of Pacific Island objects. Despite being subject to similar legislation in theory, antiquarian books, furniture, and other "European" artifacts are sold separately and rarely encounter the kinds of contestation found in sales of Māori artifacts.

The antiquities market is highly regulated. As it currently stands, the Protected Objects Act requires that all dealers of artifacts found before 1976 must be licensed, and all collectors of registered artifacts must make New Zealand their primary residence, must declare any prior police record, and must themselves be officially registered with an authorized museum in their area. Collectors and dealers are supposed to notify the Ministry for Culture and Heritage and the Museum of New Zealand Te Papa Tongarewa, which houses the artifact registry, when they sell a piece or even change their place of residence. Theoretically, it should be possible to trace any registered artifact to its location within New Zealand. It's hard to imagine such surveillance being tolerated by wealthy collectors in New York or London. The small number of auction houses (three), dealers (sixteen currently listed on the government Web site) and collectors (around three thousand) means that all those with a serious interest in either trading or collecting Māori artifacts are well known to one another, making open market activities relatively easier to track.[12] It is worth noting that this tightly knit community, marked by an enthusiasm for trading Māori artifacts in this heavily politicized environment, has resulted in a market in which prices at auction may actually be higher than those of New York, Paris, or Brussels, even taking into account the relative weakness of the New Zealand dollar. Indeed, one dealer was only half-joking to me when he commented that he smuggles objects into New Zealand—exactly the

opposite effect that one might expect such intense regulation to engender.

Such specific national regulation of the marketplace therefore gives researchers a good deal more public and institutional knowledge about both artifacts and persons involved in the market than is usually available to them. It is museum curators who are increasingly the arbiters of the marketplace—they are required by law to examine and register all objects prior to sale, and therefore it is often up to them to determine or confirm which artifacts are in fact "antiquities." Curators also manage the registry of artifacts, and increasingly they enter the marketplace as buyers for their institutions, as well as acting as advisors to communities wishing to enter or intervene in any particular sale.

The Protected Objects Act has emerged out of a number of concerns about guarding cultural property and restricting the trade of national heritage. Despite its increased focus on the specificity of Māori material culture, the Act—like all national legislation— subsumes Māori artifacts into the wider category of national cultural heritage, to be either managed by the Crown or owned by New Zealanders, their fate not necessarily to be determined by Māori people, but by a more inclusive notion of New Zealand citizenship. Some members of New Zealand's indigenous population repudiate this approach; they contest the relegation of their cosmologies, property claims, and understandings of value and entitlement to minority status. For example, to supplement the protective mechanisms of the Antiquities Act, Tau Henare, member of Parliament for Northern Māori, proposed the Taonga Māori Protection Bill in 1996. This private member's bill (which has not become law but has fed into the amendments to the Antiquities Act) was intended to supplement the old Antiquities Act in radical ways that included proposals to audit state institutions to ensure the protection of taonga in their collections and to establish a Taonga Māori register for objects abroad, with the eventual aim of repatriation back to New Zealand. The Taonga Māori Protection Bill was specific where official governmental regulation is generic. It advocated a perspective on Māori culture as exceptional, rather than as the symbolic capital of a national cultural commons, and it encapsulates popular Māori sentiment about controlling, and restricting, the trade in Taonga Māori. It also spearheaded a provocative critique of practices of dealing and collection.

Biculturalism and Market Values

The social, political, and economic tensions that emerge within the national regulation of the auction market for Māori artifacts are framed by the complex bicultural dynamic in

New Zealand: a treaty-based political contract between Māori (indigenous people from Aotearoa) and Pākehā (settlers in New Zealand, primarily of European descent), subject to continual negotiation (which I have already discussed in chapters 2, 3, 5, and 6).

As a political ideology, biculturalism relies on both the fusing and polarization of cultural identity and subsequent policy decisions. The sale of taonga at auction at first glance polarizes models of value and arguments about the legitimacy of exchange along bicultural lines: many Māori hotly contest the rights of non-Māori dealers and auctioneers to trade and assign prices to objects that they consider a priceless part of their cultural heritage and genealogy (whakapapa). Indeed, the sale of taonga is often described as anathema to traditional forms of exchange, familiar to all anthropologists as embedded within social relations of reciprocity or of gifting.

However, just as biculturalism unites as well as polarizes Pākehā and Māori identities and ways of doing things, the auctioning of taonga also complicates these oppositional models. Talking with Pākehā dealers and collectors highlights how much they are invested in the cultural value of taonga and that pricing itself reflects a complicated understanding of cultural and symbolic value. I was very struck during research by a similarity in the ways in which Pākehā dealers and collectors often talked about the objects on sale or in their collections with the same tone of awe and reverence, and the same references to the spiritual powers of particular artifacts, that Māori also referred to when discussing certain taonga. Both groups told me many anecdotes about the sale of particular pieces causing harm to the person who had bought them, in several cases even bringing about their death due to the powers of particular treasures and also the questionable suitability of the collectors who possessed them. Certainly, Māori understandings about the agency and power of taonga extend beyond these cultural boundaries, in rhetoric at least.

So what at first glance seems to be a clearly delineated social, political, and economic space with Māori on one side and Pākehā on the other thus turns out to be infinitely more complex. The auction house, like the Aotearoa New Zealand nation, is therefore a paradoxical place in which multiple perspectives coexist and in turn influence one another, continually reconfiguring prices and understandings of ownership, exchange, and value.

Taonga and Commodities/Taonga or Commodity?

So how can we develop a language that describes the complexity and paradox of biculturalism and of the market and that acknowledges the emergence of oppositional rhetorics

without being forced to use them as analytic categories? Despite their rhetorical opposition, the concepts of taonga and commodity are endlessly expansive. Almost anything has the potential to be either. However, unlike taonga, which are usually considered to be irrevocably taonga, commodities are commonly considered to be a particular phase in the life history of an entity. Starting with the seminal work of Appadurai (1986) and Kopytoff (1986), anthropologists tend to define commodities as being one part of the cultural biography of things rather than through any inherent quality of a particular artifact. In this way, commodities are commonly defined in terms of what they are not: entities, often part of chains, whose economic value transcends or obscures their cultural value; things that are alienable, not inalienable; things whose identity is defined by particular kinds of exchange relations and no others.

More recently, however, particular attention has been paid to the ways in which commodities are mediated, or even made, by their materiality, putting a concern for substance back into analyses of the form of exchange.[13] Peter Stallybrass's (1998) essay on Marx's coat brilliantly describes how Marx's own awareness of the complex commodity status of his overcoat, which he had to repeatedly move in and out of hock at the time when he was working in the British Library writing *Das Kapital*, informed his understanding of the fundamental tensions inherent in commodity between the commodity as thing and the commodity as exchange value, feeding into his insights about commodity fetishism. Similarly, Martin Holbraad (2005), in his discussion of the use of money in Cuban divination, highlights how it is the very multiplicity, or the abstracted and generic qualities, of money that give it great power in Ifa rituals. Commodities are thus material forms that in turn influence forms of exchange as much as they are engendered by them. Commodity exchange, like gift exchange, is nuanced and affected as much by the kinds of things exchanged as the exchange relations that surround it.

The category of taonga might give us a better articulation of the mediation between materiality and mode of exchange that would serve us well in thinking about commodities (see chapter 3; Mauss [1923–24] 2000; Weiner 1992; and Graeber 2001: 169–188). In New Zealand, categories of taonga and commodity increasingly encircle each other. At first glance, the art market seems to be immediately disruptive of Māori's relationship to taonga for three reasons: because it seems to break down the chain of intergenerational transaction and reciprocity (*utu*) that marks the customary movement of taonga within and between communities;[14] because it is a context that, while relying on the inclusion of as many Māori artifacts as possible, has tended to include relatively few Māori

people—almost no dealers and collectors of taonga are Māori; and because most people tend to (mistakenly) view market and commodity exchange as singular transactions of objects taking place at particular places and times rather than as a configuration of ongoing social and political relationships.

However, as more and more Māori enter the marketplace, we can see that rather than being anathema to Māori cosmology, the concept of taonga is a strongly regulating institution within the art market, which establishes a particular form of exchange and form of entitlement. Māori use the marketplace to expand the definition of both taonga and commodity, increasingly merging them together in successful forms of intervention.

Intervention

I now want to talk about two kinds of intervention into the market for taonga in New Zealand: one activist and community based and one institutional and museum based. The two cases that follow deal with the substance of trade and with the form of exchange, respectively. Each can be used to unravel some of the complex ways in which the market becomes a crucible, or melting pot, of value and exposes the complex interrelationships between the form and concept of taonga and commodities.

KEN MAIR AND PARTINGTON'S
PHOTOGRAPHS OF WHANGANUI MĀORI

On September 22, 2001, a group of activists from Whanganui, led by Ken Mair, disrupted the sale at Webb's auction house of three hundred images taken of Whanganui Māori in the late nineteenth century by the studio photographer William Partington. At one stage, Mair took over the microphone and made intimidating statements to prospective buyers. The sale was abandoned shortly after. Eventually, the photographs were tendered, or put up for private sale. As a result of the protest, a private sale was negotiated between Webb's and the Whanganui Regional Museum with funds from the museum and the Whanganui River Māori Trust Board and the community. The museum now permanently houses the collection and has already published some of the images in a book as part of an ongoing project to rediscover their history and identity.[15]

The sale had come to the attention of Ken Mair because of the efforts that Webb's had made to promote the auction locally in order to generate as much interest as possible. After the auction, Peter Webb commented, "We have no intention of speaking to Mr.

Mair . . . he's not welcome on our marae [appropriating the Māori term for sacred meeting ground for the auction salesroom] because of the way they went about it. They had every opportunity to talk to us in advance of the sale but they wanted to make a political point." As in the case of the feather cloak, Webb identified the negative effect of the activism as driving sales underground: "If it continues people who collect and have collections of this sort or material won't put it on the open market for fear of getting involved in this kind of kerfuffle."[16]

However, running alongside the dispute around how markets should be run, who should run them, and who should own taonga was a discussion about whether or not the photographs "were really" taonga and at the same time really commodities: at the heart of the auction dispute was the contested identity of a set of photographs made by a Pākehā [settler of European descent] photographer of Māori people.

Mair told the media, "Our perspective is these photos are us and they're real to us. . . . We just don't see ourselves for sale." In other press coverage, the well-known IP rights lawyer Maui Solomon and Ken Mair were quoted as saying that "auctioning photographs of your nineteenth century Māori ancestors is like selling your mother."[17]

In response, Webb countered, "Photographs belong to the European culture, Māori never invented photographs and didn't invent the camera. It's just the imagery that they claim ownership of . . . the problem is with the image itself. . . . Māori are now claiming that even photographs of the Whanganui River belong to them because the river belongs to them . . . it gets very tricky. . . . It's not our job as fine art auctioneers to solve that problem."[18] Indeed, asked whether the sale of photographs and the images, particularly those of young, bare-breasted women, could be regarded as offensive, Webb said that he understood that the subjects had consented and believed that they had been paid to pose: "I think Partington found them fascinating subjects. I think a few people would find them offensive but they were typical, fashionable poses of the time."[19]

We can see that part of Mair's eventual success, in addition to having the upper hand of drama and publicity at the performance of the sale, was in being able to use the category of taonga (with the presumptions of sovereignty that it entails) to encompass these photographic images. The contestation that emerged over the status of the images was not only a political contestation over representation and representational technologies, but also a contest about the framing of historical and present-day relationships between Māori and Pākehā. Mair's investment of the photographs with ancestral spirit mapped the use of photographs in contemporary meeting houses, where ancestors may be embodied in

prints as much as in the *pou*, or figurative carvings, that support the rib cage of the building (itself conceived as the physical body of the ancestors). Materiality and substance are thus crucial in delineating the forms of sovereignty and entitlement that comprise value.

MERE AND THE DUKE OF WINDSOR

A second example of auction intervention and activism concerns two greenstone *mere* (ceremonial clubs) from Tainui dating back to the late 1700s that had previously belonged to the Duke of Windsor. After much agitation around their sale at auction, the two greenstone clubs, known as Wehi Wehi and Kauwhata, were returned to New Zealand and eventually entered the custodianship of the Museum of New Zealand Te Papa Tongarewa in 2002.

The mere had originally been gifted by two prominent Māori (the fourth Māori king, Te Rata Mahuta [Ngati Mahuta] and King Movement leader Tupu Taingakawa Te Waharoa [Ngati Haua]) to the Prince of Wales in 1920, at a large gathering of Māori iwi and hapū in Rotorua. Presumably, this was considered to be an official gift from Māori to a representative of the British Crown, aimed to consolidate connections between chiefly lineages and to consolidate power in the context of growing disenfranchisement and alienation of Māori from the state of New Zealand. After the king's abdication in 1936, the line between personal property and property of the Crown was blurred. Evidently, the new Duke of Windsor considered the mere to be his private property rather than property of the Crown, as they remained with him until he died. After the duke's death in 1972, despite an initial effort of Tainui tribal representatives to reclaim the mere (H. Smith 2009: 23), his widow sold them along with other objects from their estate to Mohamed Al Fayed, the owner of Harrods in London. He, in turn, was scheduled to auction the mere in 1997. Three days before the auction, Princess Diana and Dodi Fayed were killed in a car accident and the auction was postponed. In 1998 the mere were auctioned at Sotheby's New York to raise funds for the Dodi Fayed International Charitable Foundation, ignoring requests from the tribe in New Zealand that they be returned following the traditional laws of reciprocity. The eminent New Zealand historian Michael King, who had been asked to research the origin of the mere for the Tainui tribe, said that during their exchange, one mere had been handed to the duke with the handle pointing to him while the other one was handed with the handle pointing to the donor, signifying that the clubs still belonged to Tainui and should be returned after the duke's death.[20]

Al Fayed's move to put the mere up for auction in 1998 prompted political agitation

from prominent Māori such as Tau Henare and Tukoroirangi Morgan, who lobbied for the mere to be returned to New Zealand. Morgan commented, "I cannot believe that the old people would have given them the *taonga* without a rider on them (that they be returned). Auctioning the mere breaches the spirit in which they were given."[21] This agitation raised awareness of the taonga and increased interest in the mere, and by extension it boosted the prices at auction. Prior to the auction, representatives from Te Papa refused to comment on the sale because they were fearful that any expression of interest would affect its outcome.[22] Representatives of Tainui felt that it would have been inappropriate to purchase the mere, as they had originally been given without an accompanying monetary transaction.[23]

Te Papa eventually lost the mere in Sotheby's New York to Dunbar Sloane, who bid approximately NZ$143,000 (more than ten times over the estimate) over the telephone on behalf of a New Zealand collector who wished to remain anonymous (H. Smith 2009: 25).[24] But this was not the end of the sale. After the auction, public appeals were made to the collector to return them to the tribe. While commentators such as Tukoroirangi Morgan said that they were pleased a "kiwi" had purchased the mere, they still felt it would be more appropriate for them to be "returned in the way they were given."[25] After a lengthy, often fraught, period of somewhat pressured negotiation with the private collector, Te Papa, in negotiation with tribal authorities, secured the taonga in late 2001 from the private collector for the same amount as had been initially paid, using government funds. The label in Te Papa Tongarewa reads:

> These mere pounamu (greenstone weapons) commemorate significant ancestors, Kauwhata and Wehi Wehi, of Tainui whakapapa (genealogy). The mere have also been associated with a succession of prominent Kingitanga [King Movement] leaders of Waikato.
>
> In 1920 in Rotorua, the mere were presented to the Prince of Wales by the fourth Māori "King" Te Rata Mahuta (Ngāti Mahuta), and the King Movement leader Tupu Taingakawa Te Waharoa (Ngāti Haua) while the prince was visiting New Zealand. They were auctioned in 1972 and came into the possession of the Egyptian tycoon Mohammed Al Fayed, the owner of Harrods. They were sold again by auction in New York in 1998 to an anonymous New Zealand collector. The collector entered into negotiations with Te Papa in 2001, and in 2002, the Museum obtained these important and impressive *taonga* (treasures).

In contrast to the case of the Partington photographs, the status of the mere as taonga was not at question. Instead, their recognition as particular kinds of taonga demanded that they be exchanged in a particular manner. At every level, the nature of their transaction and subsequently the nature of entitlement and obligation of their owners were challenged and reconfigured. The insertion of this recognition into the marketplace altered the ways in which the taonga were traded and it amplified the conditions of sale.

Both of these examples show how Māori may successfully use alternative models for both the substance and form of exchange to impact the marketplace and influence the outcome of sales and the continuing process of valuation for taonga. Salient to my discussion has been the presence of the Museum of New Zealand Te Papa Tongarewa. It is usually rather difficult to draw out the interrelationships between museums and markets as institutional frameworks that collaborate to produce and promote value, because each of these institutions is more commonly invested in maintaining itself as separate from the other (often all the more to exploit the legitimacy that museums provide markets and the continued regeneration that markets provide museums). However, in New Zealand, Māori curators are increasingly positioning themselves as critics of the market and attempting to mold the market according to very different criteria than those involved in the machinations behind the scenes between dealers, auctioneers, collectors, and curators at institutions such as the Metropolitan Museum of Art in New York (see Muscarella 2000).

The philosophy of taonga, used in the marketplace for culture as an explicit substitute for commodity, defines these engagements. By definition, all objects in New Zealand museums (and not just the Māori ones) are classified as taonga—they are inalienable items of cultural property and heritage. They are objects that reference complex relations—of collection, of citizenship, of national and local identities. They are objects of knowledge with important genealogies. As Paul Williams comments, "Te Papa promotes itself as a vessel in both senses of the word: a container for valued treasures and a vehicle for collective understanding" (2005a: 83).

The Māori presence in the museum again displays the tensions and paradoxes of biculturalism. The Museum of New Zealand Te Papa Tongarewa is arguably one of the most high-profile bicultural institutions in New Zealand and acts as both a symbol and an agent within many discussions about biculturalism, sovereignty issues, and cultural representation.[26] Opening in 1998 to both fanfare and criticism, Te Papa Tongarewa is one of the few institutions in New Zealand that has been expressly built from the bottom up with a bicultural mandate. Every level of the building's design and operation is considered in bicultural

terms and thus is also perceived to be publicly accountable to the tensions and contestations that this political ideology engenders. It is a kind of experiment in representing the political and cultural form of the nation, but as an active institution it wields agency in the definition of how these conceptual domains are delineated and to what end (see chapter 3).

The market is thus a troubling context for Māori curators at Te Papa Tongarewa. It is associated with negative values that are anathema to Māori cultural values. Curators most commonly talk about the market in terms of trying to take things away from it—to this end, they enter frequently as collectors and are deeply engaged with the market process of valuation—by bidding, fending off dealers, and so on. Curators are extremely aware that providing information to dealers and auction houses makes them complicit in authenticating the market, and they are eager to interrogate the bicultural mandate of the museum in relation to such processes of valuation and to develop valuation policies and procedures that, again paradoxically, do not rely on the market activities in which they themselves also participate. The politics of expertise that construct value are intrinsically linked to the marking of financial value as they are in many other art markets, as may be seen in the following comments by curators on the registration process in which they authenticate objects for sale:

I try to keep the forms as "bland" as possible, to put as little of my own opinion in as possible, just to give descriptions so that artefacts can be recognised, rather than endorsements.

I try to gather as much as I can of the provenance and collection history of the piece— this might be the only chance we have to gather it, before the object is sold, and the story is lost.

Registration is the worst part of my job. I hate doing it, knowing that things are coming into the museum, but that they aren't staying, that we are losing them.

Some comments I have are in relation to the view that auctioneers may be ignoring or deliberately withholding specific Māori provenance information. This has been a concern of mine for a number of years, as someone who has been responsible for the registration of *taonga* under the NZ 1975 Antiquities Act. I have found it well worthwhile, in fact more than that, to contact the vendors directly as part of the registration process.

There have been quite a few instances where the provenance information supplied via the auctioneer was not entirely correct, or missed important details, or a letter from the vendor with these details on has not been forwarded through from the auctioneer, etc. There has also been at least one instance where I know that information was deliberately withheld by an auctioneer. If not deliberate it would seem they have no great incentive or inclination for recording all the relevant details, particularly when this may have a negative influence on sale prices. So apart from making sure the antiquities information is as full and correct as possible the other important reason is to check up on the auctioneers and let them know that details they supply are being independently verified. This not only helps keep them honest but I think is important for ensuring that iwi at least still have the chance of knowing the *taonga* being auctioned is "one of theirs," and possibly acquiring it, or working with a museum to see if they may acquire it. It is probably more common for a regional museum or Te Papa to acquire a provenanced *taonga*, with the consent of the local/relevant iwi, hapū or whānau who are unable to afford to buy it back themselves. A provenanced *taonga* will be of more interest to a museum than a similar *taonga* which is unprovenanced. The other benefit would seem to be that private collectors are being put off acquiring provenanced *taonga* Māori, thus making it easier for iwi or museums to acquire them, when they are identified as such. However when the provenance isn't identified because it is ignored or withheld, then that works against us.[27]

However, the increasing intervention of curators into market sales is, in turn, having a lasting effect on the configuration of the marketplace and on the ways in which dealers and collectors have responded to the debates and politics of the marketing of taonga. For instance, the impact of museums on the marketplace has also filtered through into the language of commerce. The discourse of repatriation and of cultural heritage increasingly informs the rhetoric of the marketplace. Many dealers and collectors justify their work by asserting that they are doing a public service by keeping artifacts in New Zealand, encouraging their return, and preserving and conserving important cultural heritage.[28] At one auction, in response to the protests of several Māori who had attended to criticize the sale of important tribal pieces, a notable collector stood up and rebutted the protestors. He asserted that it was thanks to the passions and finances of Pākehā collectors that many taonga have been conserved and protected and, indeed, remained in New Zealand.[29]

The appropriation by dealers of museum languages such as conservation and preservation has also been expanded to include the term "repatriation" to justify their work in

bringing taonga to auction. For example, in a preface to one auction catalogue, Dunbar Sloane, an auctioneer, wrote out a dealer's manifesto of sorts: "I, Dunbar Russell Sloane (personally), have been actively involved for at least 30 years in *repatriation* of Māori artifacts from Europe, sometimes 4 or 5 important items at a time (once a year). This involved the placement of advertisements in publications such as the Dublin Times, Liverpool Echo, and other local papers of many U.K. seaports. It also required frequenting auctions, car boot sales, and visiting many antique shops, and primitive art dealers."[30] It is clear, then, that provenance, which in this context is increasingly analogous to a form of genealogy, becomes a crucial ground of negotiation in the marketplace for both Māori and dealers/auctioneers. As the cases of Partington's photographs and Dunbar Sloane's collecting practices illustrate, how an object is identified—e.g., which constituency has most of the authority to speak for a taonga—will define how it can be transacted.[31]

Conclusion

At a Sotheby's auction of African and Oceanic art I attended in New York, bidding was fierce and prices high for all of the Pacific artifacts. Indeed, I encountered two anthropologists who left after the sale of Pacific artifacts, only half joking that they were going home to revalue their collection! Most of the Māori pieces were sold over the telephone to anonymous bidders. I knew specifically that many of them were purchased by people from New Zealand, leading me to speculate that the bidding war around certain tiki and carved feather boxes was made by several New Zealanders bidding against one another. It is evident that despite the idiosyncrasies of the New Zealand auction market, we can increasingly witness its influence within the international marketplace.

The paradox of biculturalism, a political ideology that relies on both the fusing and opposition of two models of culture, is also present in the marketplace. Both models demonstrate that value is intrinsically linked to sovereignty. The more taonga are commodified, the greater the polarization of models of value that surround them. Despite the assertion that market trade is anathema to the customary exchange of taonga, the marketplace is an arena that increasingly produces taonga.[32]

Unlike pounamu or the Radio Spectrum, there is consensus about the classification of Māori artifacts in the antiquities market as taonga. In fact, Pākehā collectors are as invested as Māori in these artifacts being considered taonga, although they also attempt to control the terms by which taonga are defined (removing provenances to establish generic

rather than specific identities in order to diminish the potential for Māori claims being a key emerging strategy).

Idealized models of exchange and of property relations have often been used as a cipher by anthropologists to discuss fundamental social, political, and conceptual differences across cultures. Commodities are associated with America in the same paradigmatic way that gifts are associated with Māori or Melanesians. However, what is more interesting to me is the intervention that each of these categories can make into the other. The auction salesroom has become a place within which dynamically opposed models of value and exchange are increasingly entangled, affecting in turn the very configuration of the institution that brought them all together: the marketplace. Māori ideologies of taonga, discourses of sovereignty over property, and concepts of alterity are now fully a part of the New Zealand marketplace, drawing dealers and collectors to participate in this discourse and participate in a guided process of valuation that has changed the commodity potentials of all sorts of things in Aotearoa New Zealand. As the case of the New York auction illustrates, this influence has the potential to spread beyond the national framework of New Zealand. This is an ultimate provincialization of the marketplace—reforming market structures with alternative values but ultimately making the market work, not only in a different way, but to different ends, re-centering a very different set of values and expectations regarding exchange. What is clear, however, is that whatever side of the ideological line one stands on in terms of how one recognizes and values the culture of the marketplace, we need to understand the more nuanced ways in which the process of commoditization is enacted, markets legislated, and exchange and entitlements consolidated. As Banner (2000) comments with regards to the loss of Māori land in the early days of the New Zealand colony, "There was an infinite number of equally free possible market economies in Māori land in the 19th century. It was not 'the market' that hurt the Māori, or even the colonial government's decision to set up a market; it was the government's set of choices among the multiple markets available" (92). It is this moment of choice, of decision making, that has been provincialized by Māori at auction.

My discussion of the emotional response, political contestations, and subsequent negotiations that have emerged within some sales of Māori taonga at auction shows us that there are many complicated understandings of value, exchange, and broader political relationships at stake in the marketplace. The concept of taonga may be used as a critique of a typical stereotype of commodities and commodity exchange and as a blueprint for a new form of market engagement and interaction. Unlike the fraught morality of government

delineated IP regimes, which it seems results in a failed market for Maori arts, the linkage of cultural property legislation and indigenously conceived models of cultural property has forged a significant intervention into the market, which has increased both monetary price and cultural value. Taken together, the cases of how "intellectual" and "cultural" property are negotiated in practice in Aotearoa New Zealand demonstrate how both are linked within a process of indigenization, or provincialization. By this I mean not that they become entirely indigenous—in the usual way in which indigeneity provides a charter for ideas of property radically different from commodities or global property regimes—but that they are inflected with indigenous agency, which in turn critiques and compromises some of the power relationships previously enshrined within the marketplace. An unfamiliar reversal, or provincialization, of expectation and outcome has indeed been effected on these very familiar processes of exchange and understandings of entitlement. In the next chapter, I chart how a similar process has been enacted through the specific revitalization of the traditional economy in Vanuatu, facilitated by a connection to intangible cultural heritage and its implementation as an alternative economic imaginary that resonates locally, nationally, and globally.

8 | Pig Banks

IMAGINING THE ECONOMY IN VANUATU

After twenty four years of independence, economic prosperity and self-sufficiency, as postulated by the original leaders, is still beyond our grasp. It is now time to seriously consider the potential that elements of our traditional economic systems possess and how these could be assimilated into our economic programs and utilized, not only for economic growth, but also to bring about a balanced life that is cherished by everyone.

VIRA TABE SELWYN GARU,
Malvatumauri National Council of Chiefs
(Huffman 2005: 7)

Where could culture, commerce and micro finance be best harmonized into a model for long lasting balanced benefits for the people of Vanuatu?

NOE SAKSAK ATUTU, Managing Director,
Vanuatu Credit Union League
(Huffman 2005: 8)

THE YEARS 2007 AND 2008 were each declared to be a Year of the Traditional Economy in Vanuatu (see figure 15). During this time, an ambitious exercise in national self-reliance was initiated, one that aimed to link the use of customary currencies to the development of credit unions, to reinvigorate traditional transaction in a national context, and to encourage a redistribution of wealth between island and town. A powerful utopia of an alternative economy was imagined, and seeds were sown in both government and communities for its implementation. The Year of the Traditional Economy (*Yia Blong Kastom Ekonomi*) grew out of an initiative of the Vanuatu Kaljoral Senta (VKS), funded by UNESCO and the Japanese Funds-in-trust for the Preservation and Promotion of Intangible Cultural Heritage, called the Traditional Money Banks in Vanuatu Project

(TMBV), nicknamed the Pig Bank Project. The project has also been described as a "Trojan horse" for kastom (Regenvanu 2006). Using the international languages of self-reliance and economic development, models of intangible cultural heritage, and grassroots understandings of both customary and international economies, the TMBV was strategically subversive—overtly provincializing. It intended, by sneaking kastom into a domain that usually excludes it, to provide a set of practical solutions or answers to the persistent questions that underlie contemporary life for many ni-Vanuatu. Some of these questions are: Why is our access to money and the fruits of international investment and development still so limited? Why has our government failed to deliver in its promises of self-reliance and development? How can we reconcile the international interests of finance with local desires to develop a strong "cultural" base? In what registers can we value kastom? And how can we make more money without selling out? In short, ni-Vanuatu, like many contemporary economic anthropologists and like Māori in New Zealand's auction houses, are interested in exploring the seemingly divisive relationship between the "economy" and "culture" and in developing new ways of thinking about their entanglement.

As we can see from the questions above, kastom has been mobilized as a resource for participation and as a powerful and unique imaginary to reclaim the terms of engagement with problems that are by no means unique to Vanuatu. We have seen, in the previous chapters, how Māori negotiate with the settler-colonial state and how both arbitrate the free market for cultural property in which taonga has become an organizing category for intellectual and cultural property. The case of toi iho shows what compromises are made when government appropriates indigenous identity as a brand for the nation. The case of the auctioning of taonga, however, shows how the "free market" configures cultural property discourse that in turn reconfigures the market. It is this convergence of indigenous idealism, cultural property (and heritage) discourse, and the market in Vanuatu to which I now turn.

For the VKS, an answer to some of the questions above lies within a broader shift of perspective. As in the case of the copyright regimes described in chapter 4, kastom becomes a way of envisioning a functioning and productive economic sphere that can be used as a model of good governance and economic development: a way of reimagining the (national) economy, not only in terms of alternatives (Maurer 2005) but also in terms of encompassment. In shifting the remit to answer the above questions away from governmental agencies (including the older Ministry of Co-operatives) and into a creative alliance between the VKS, the Malvatumauri (National Council of Chiefs), and the Vanuatu

FIGURE 15. Logo of the Yia Blong Kastom Ekonomi (Year of the Traditional Economy).

Credit Union League (VCUL), the TMBV not only aims to reconceptualize monetary transaction, using ideas about kastom and cultural heritage as a foil, but in addition intends to both exploit and subvert development discourse and the models provided by international economic agencies in order to promote connection to *and* independence from these same projects of nation building and international participation.

In this chapter, I explore the imaginings of the economy, both global and indigenous, which are built into the move both "back to" and "toward" kastom currencies in Vanuatu in the context of the development of a discourse of indigeneity in Vanuatu that takes local understandings of the economy as a primary context. While there is a lengthy literature on the ways in which national currencies mediate tradition and modernity in Melanesia (e.g., Gregory 1997; Akin and Robbins 1999; Foster 2002; Strathern 2005), less has been written about the ways in which local incorporations of cash into custom or custom into cash may be read as economic theories or about how money in particular frames indigenous rights (see Cattelino 2008 for this discussion in the context of Seminole Indians in Florida). This chapter describes how the TMBV develops an economic imaginary that reframes how ni-Vanuatu think about money and explores how pigs are used to strategically reframe the neoclassical stereotype of the free market using ideas about the indigenous economy as a counterfoil. Like many grassroots projects, which

intend to resist and reformulate global economic practices, a "social" theory of economics is built into the implementation of these practical solutions. At this early stage, where more has been modeled than enacted, I hope to suggest some of the possible effects of their intermingling.

I juxtapose how the economy is currently being reimagined within Vanuatu with the ways in which other people and agencies from the outside also imagine the traditional and modern economy of this South Pacific archipelago. Competing economic imaginaries coexist within the TMBV: an imaginary about global capitalism seen from a Melanesian vantage point; an imaginary about customary currency and values; an imaginary of cultural heritage as a basis for development gleaned from UNESCO; an imaginary about global economic indices from a London-based economics think tank. By using the term *imaginary*, I refer to the ways in which idealizations of social or economic order are in fact able to influence and affect both policy and practice. Within the imaginary of the Pig Bank, it could be argued, is the presence of pigs as imaginary currency and the kastom or indigenous sphere as an imagined national economy. By this I mean not that pigs and kastom are less real in terms of currency and economy than Vatu and the national GDP, but rather that they gain particular resonance when the possibility of their extension into the national and even international domain is imagined (regardless of its implementation).

Here, I obviously draw on Benedict Anderson's (1991) idea of the nation as an "imagined community," in which material mechanisms such as maps, museums, and population measurements create a sense of overarching connectivity that in turn provides a viable base for governance; for organization to a larger scale; and, indeed, for participation in modernity. Anderson is useful here, not for the assertion that nations are nothing more, or less, than senses of solidarity willed into being by representational and aesthetic technologies that underpin governmental hegemony, but for the way in which he demonstrates how these representations can have tremendous purchase on how people conduct themselves as citizens. These imaginaries are crucial structuring regimes (like Bourdieu's concept of the habitus, 1977) that impact the social orders that they purport to represent. Anderson's vision of the nation is constituted out of this sense of imagined kinship with a larger community. In the same way, economic imaginaries affect the constitution of economic practices. As all nations are in fact little more and nothing less than imagined entities, so it is true of economies. Timothy Mitchell's survey of how economics as a discipline makes its world demonstrates how "the work of economics . . . organizes the world in ways that provided economists with the opportunity to produce its facts" (2005:

304, 309; cf. Callon 1998). As much as pigs are profoundly a part of the reification of kastom as a nationally viable form of indigenous practice, the practice of customary activities, and the perpetuation of tradition, they provide an imaginary future, very similar to the imaginary futures envisaged within the abstract trades on the international stock market—futures which in some way are brought into being by the imaginations of agents in the marketplace.

In chapter 4, I described how national copyright legislation has been institutionalized in discourse and practice within Vanuatu through a process of (often creative) analogy. Here, I show how similar analogies are drawn in relation to the idea of currency and economy and I highlight the connection of analogy to imagination. The power of analogy lies in drawing two (or more) entities into a productive relationship based on their similarities *and* differences. This connection or relationship is creative—it also alters what it draws into view. Much as I challenged in chapter 4 the separation of national, international, and sui generis reckonings of copyright, I challenge the separation of indigenous, national, and international economy by highlighting how these categories are imagined to be analogous rather than simply alternative to each other.

Money and Pigs: Modeling Value and Exchange

A vibrant branch of economic anthropology has in a large part been concerned with providing a set of "alternative" renditions of "conventional" economic ideas about markets, money, and the instrumentality of exchange (Bloch and Parry 1989; Gregory 1997; Hart 2000; Gudeman 2001; Maurer 2006). Many take the work of Marcel Mauss as a starting point to radically re-envision the systemic potential of exchange and sociality (Graeber 2001; Hart 2007).[1] Such an anthropology of economy challenges the limiting assumption that commodity transactions are standardized; are generic; make use of universally exchangeable currencies; are independent of family, political, or social ties; are regulated by seemingly impersonal forces of supply and demand; and are based on a rule of equilibrium or cost equivalence. It challenges the model of society that emerges out of the market economy in which the maximization of profit or self-interest is the primary interest of individuals and the assumption that this maximization will, in turn, regulate social relationships. At its heart such an anthropology challenges the belief that a disembodied notion of the free market can be mapped onto social, political, and

cultural orders, or at least cautions against the ill effects of trying to do this (see Polanyi [1957] 1971, [1944] 2001; Dalton 1967; Gregory 1997).

One of the most powerful tools in the rethinking of these ideas over the past one hundred years has been the idea of the gift. Gift exchanges may be irrational where commodity exchange is supposedly rational. Gifts may be understood as inalienable rather than alienable; they link people together rather than constitute them as individuals. Unlike a commodity transaction, which is supposedly limited to a particular space and time, gift exchange is primarily defined by the ongoing relations it engenders—the obligation of perpetual reciprocity. Mauss's formulation of the gift was as much a social comment on life in contemporary Europe in 1925, in the wake of the Russian Revolution, as it was on Māori gift exchange or Northwest Coast Canadian Potlatch (see Graeber 2000, 2001; Hart 2007). Rather than writing the anthropology of "strange" economics, Mauss was intent on proving that there was a genuinely viable alternative to the economic program of industrial capitalism. His challenge was to plant a seed of doubt around the naturalization of the free-market economy. There is, thus, built into much of the study of economy in cultural context a critique of commodity exchange, or at least of our views and assumptions of what commodity exchange actually is, drawing on the idea of alternatives, in which different forms are juxtaposed against one another as incommensurable. This, then, becomes a starting point that needs to be untangled before any real study of "cultural" economy can be undertaken—an awareness of the "context of context" (Strathern 1988: 10).

The concept of money has provided both an analytic stumbling block and an avenue toward a provocative rethinking of the economy. Ironically, perhaps, given the extreme abstraction that we now currently associate with national currencies, it is the materiality of money that has provided the largest of these stumbling blocks to anthropological analysis. The very tactility and formal circulation of currency seems, at first glance, to be anathema to the underlying economic abstractions (of guaranteed, standardized value, of political economy) that these same tokens refer to. In a cogent essay, "Notes towards an Anthropology of Money" (2005), Keith Hart criticizes the dominant anthropological perspective on money, which acknowledges the social role of money in non-Western society but fails, he argues, to take into account the social and analytic work that goes into making money, an abstract, alienated supra-cultural entity in Western society. In critiquing the primitivism inherent within the anthropology of money, Hart emphasizes that money is idea *and* object, an index of social memory (most especially the memory of exchanges that fundamentally form society). He writes that

the meaning of money is that each of us makes it, separately and together. It is a symbol of our individual relationship to the community. This relationship may be conceived of, much as the state would have it, as a durable ground on which to stand, anchoring identity in a collective memory whose concrete symbol is money. Or it may be viewed as a more creative process where we each generate the personal credit linking us to society in the form of multiple communities. This requires us to accept that society rests on nothing more solid than the transient exchanges we participate in. (2005: 14)

This is very much in contrast to the ways in which state and local currencies are normally differentiated vis-à-vis their tactility, their fungibility, and their potential for either fetishization or abstraction (cf. Holbraad 2005). In an earlier piece of writing, Hart (1986) noted how state currency itself symbolically embodies these tensions—"heads" representing state intervention into exchange, "tails" representing the more material value of money. There has, in recent years, been a growing understanding of money—or perhaps, to use a less loaded term, currency—in places as diverse as Cuba and Papua New Guinea as cultural material, invested with qualities such as liquidity, divisibility, transportability, and concealability, which has significant agency as it flows within exchange relations (Akin and Robbins 1999: 4–5; Walsh 2003). Following on from Hart, I argue that money, and currency, are ways of formally imagining the economy in efficacious ways. The shared community, formal instantiation, and symbolic power of money seem to powerfully bring the economy into view. Of course, what we see is our own idealization of, and our own involvement in, economic enterprise that in turn is what comprises economic activity.

Pigs/Money/Indigeneity

Akin and Robbins stress that, in Melanesia, all currencies, "both indigenous and state, have important instrumental qualities that distinguish them from other kinds of objects and allow them to exercise a powerful force in shaping and reshaping social life" (1999: 2). This paradox of difference and similarity, and the ways in which money structures social relationships and vice versa, ensures that money is one of the most evocative forms, which in turn gives form to powerful economic imaginaries. From the relationship between theories of taonga and of commodities discussed in the last chapter, to the abstract unbounded multiplicity of the international stock market (e.g., Zaloom 2003) and the ways in which money mediates domestic and gender relations (e.g., Zelizer 1989), money becomes a

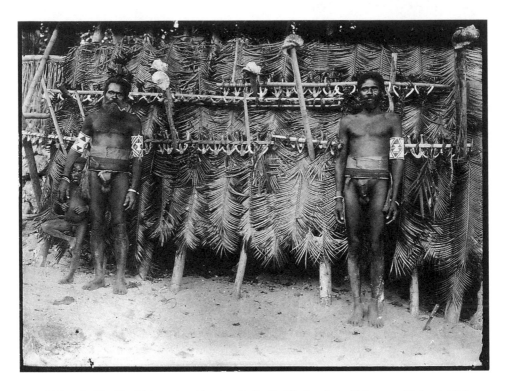

FIGURE 16. "Stand for pig's jaws returned four days after the rite of Nambeng Boat, with Bageran and Meltegersende." (Photo and caption by John Layard, taken on Atchin, 1914. Reproduced by permission of University of Cambridge Museum of Archaeology and Anthropology [N.98513])

powerful organizing mechanism for materializing the economy in all its intricacies.

Money is famous for materially mediating different forms of exchange and engagements with different social institutions in the Pacific (see Foster 1998; Akin and Robbins 1999). There has been a lengthy history of equivalence, conversion, and translation between pigs and state currencies in Vanuatu, one that increasingly understands both to be the standardized media of exchange underpinning society, but which at the same time understands the implications that form has on exchange and vice versa. There has been a long history of equivalency between pigs and cash. As early as 1914, the anthropologist John Layard documented that when he was on Atchin in North East Malakula, a crescent-tusker was worth four pounds, a curved-tusker about six pounds, a re-entrant tusker between ten and fifteen pounds, and a circle tusker upward of thirty pounds (see figure 16). He also quotes form Père

Godefroy, writing from the neighboring island of Vao, who in 1915 described a circle-tusker as fetching forty pounds, and a circle-plus-re-entrant tusker reaching as much as fifty or sixty pounds (Layard 1942: 254–255). Layard describes these prices as "astounding."[2] Value in pigs and in money were conceived of as equivalent even as they were opposed as types of currency. For many years, the object of working in the cash economy on Malakula was to purchase pigs to move ahead in ritual exchanges, bride payments, and so on (see chapter 4). As in the case of copyright, kastom exchanges and money have long been entwined.

One of the questions raised within the imaginary of the Traditional Money Banks Project was "but are pigs really money?" These questions are not ones of form, applicability, or exchange, but rather are issues of authenticity and recognition. Both pigs and state currency are forms of money in that they are standardized, material mediators of culturally bound exchange relations, which in turn create the foundational relationships of accountability, authority, and responsibility that we might term *society*. The ethnographic issue is to investigate the ways in which society is recognized and to examine how discourse complicates the practice of exchange by creating a series of powerful representations. As I have been arguing throughout this book, property forms are recognized and often represented in both Vanuatu and New Zealand in relation to indigenous identities. And recognition is ultimately connected to legitimacy and, by extension, to sovereignty, most especially in the context of indigeneity (as the galvanization of exceptional identity within particular colonial, postcolonial, or settler-colonial relations between people and the state). Or to put it otherwise, if state currency is a way of mapping past values onto visions of the future, what past and what future are being envisioned in the strategic banking of pigs?

Theory and Practice in the Pig Bank Project

We use pigs for many different things, in many different ways, for marriage, for buying land and paying for penis-wrappers for a child, to pay for carving a face on a drum, and the rights to carve a drum, to raise it upright we must kill a pig, put it in the ground and raise the drum on top of the pig. Pigs are our power and at the same time our money.

VIANNEY ATPATOUN, Vao, quoted in Tryon (1992): 7, translated from Bislama[3]

In 1990 the annual VKS fieldworker workshop convened around the topic, *Ples blong ol pig long kastom laef long Vanuatu* (the place of pigs in the customary life of Vanuatu). Thirty-nine fieldworkers from sixteen different islands met to discuss their year's research into

the meaning and importance of pigs (Tryon 1992). They described how pigs are used in ceremonies such as marriage; in status-alteration rituals like initiation, circumcision, grade taking, and funerals; to forge relationships between people; to consolidate chiefly power; to pay for copyrights and carving rights to carve drums and canoes and to build houses and nakamals (men's lodges); to pay compensation and fines; to open festivals; to purchase land; to clear ground in order to make gardens and plant yams; and to exchange with cash. They described how the exchange of pigs formed part of strategic inter-island alliances (for example, between the islands of Malo and Malakula, Pentecost and Ambae, Malakula and Ambrym). They explained how pigs were classified and valued across the archipelago by the size and circularity of their tusks, by the return of tusks and jaws, their age and size, and whether or not they were intersex/hermaphrodite. Many stories about the arrival of pigs in the archipelago describe how pig was born of woman and highlight the crucial interrelationships between human and porcine identity. Other stories highlight the crucial role of pigs in exchange, both between ni-Vanuatu and as markers of the first relations developed with white people, signifying the interrelationship between pigs and political authority, local and now national governance. Vianney Atpatoun substantiated this in the rest of his narrative:

> In 1984 when Chief Kalman made his nimangki ceremony, I went to take photographs and make recordings. At this time, I wanted to give the chief some money to do this, but I didn't have it. So I took some money and bought a pig. Alé, I went, and he gave the right to me to have a stone of my own, and I put my pig on this stone. At the same time, he gave a name to me. In the language of Big Nambas they say that in this way I can't go into the long line of chiefs. In the Big Nambas language they call this vilvil: vilvil is when you are down low, and you cannot raise your status. You have to come many times, give many pigs, and take many nimangki grades before you can just come into the long line of chiefs. (Vianney Atpatoun, Vao, in Tryon [1992]: 12, translated from Bislama)

Pigs were described as intimately connected to the production and reproduction of social and political relations, to the generation of indigenous economic ideas. They are associated with hierarchy and legitimate entitlement, with counting and valuation, and with classification. All of these social processes are both inculcated by the exchange and rearing of pigs and by the bodies of pigs themselves. For instance, pigs are valued for their circular tusks, which in turn become both ritual currency, markers of customary status and authority, and

important ways to generate cash (see chapter 4). As valuable forms of currency, pigs—like money—are both standardizable and variable. While they are universally valued throughout Vanuatu, they also have specific qualities of value that vary from area to area. In Pentecost and Malakula, the value of the pig is in its tusks; in Ambrym in the body of the pig itself (Noé Saksak, director of the Vanuatu National Credit Union League, personal communication, July 21, 2006). Pigs are also understood to be extensions of persons, detachable and exchangeable channels of human agency, spirit, and relationships.

> Before, before, there were not yet pigs in Vanuatu. We from Malakula, from Vao, know that before we did not use to have pigs. But we used many different things to make *nimangki*. We made *nimangki* with ants, counting one to one hundred, and saltwater crabs on the beach. One would collect up to a hundred of them and once you reached one hundred, you win. And lizards, doves—we would make traps and catch them as well in the same way. At this time there were no pigs. We used all of these things, until a woman came to my station in the bush. . . . There is a stone pig memorial there which is a *naravwe*—a female and a male [hermaphrodite]. The stone is long and I can see that the tusk and face really look like a pig. . . . After this woman came to us, she married a man from another *nasara*. Now she gave birth to a small baby pig at this other *nasara*, Tolamp. At this place, this pig gave birth to seven babies. Then, the children of this woman, when they were grown up, they came to make payment to their mother's village, a place where there is a plantation now called Leuru. So we, of Vao, and from North Malakula, pigs come directly from my place. . . . Pigs come directly from a woman from my place. . . . That's why it's tabu for us to eat female pigs. (Vianney Atpatoun, Vao, in Tryon [1992]: 12, translated from Bislama)

Layard, who worked on Malakula in 1914–1915, recorded that there were three basic uses of pigs in exchange: pigs were used as payment, as gifts, and as sacrificial offerings (1942: 251–252). However, there was also considerable ambiguity between these types of exchange of pigs, which Layard and others struggled to untangle. There was, and is, significant debate, bargaining, and negotiation about the nature and number of pigs within these diverse exchanges. On the surface of things, local differentiations of exchanges were crystallized by different categories of pigs. Certain activities, from secular assistance in building a canoe, to relations forged through the exchange of women, to ritual partnerships around mortuary ceremonies, were therefore ranked in value by the kinds of pigs used to

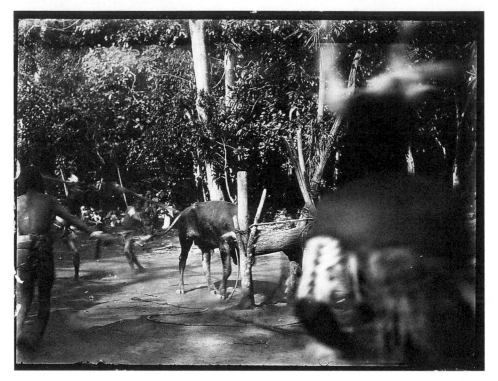

FIGURE 17. "A bullock bought for the occasion of the consecration of a whaler boat, as a novelty, being 'killed' with a torch." (Photo and caption by John Layard, taken on Atchin, 1914. Reproduced by permission of University of Cambridge Museum of Archaeology and Anthropology [N.98508])

compensate time, labor, and relationships engendered. The ranking of pigs permitted their use as loans, with the understanding that the accrual of interest was built into the organic development of pigs from small to large entities, with smaller or larger tusks.

However, despite the long-standing practice of converting pigs into money in order to reckon their value, even these seemingly fixed units of pigs (measured primarily by shape of tusk, size of body, and age) were not fixed in the same way that currency is fixed to token and number. Layard's field photographs show exchanges in which a bullock is sacrificed instead of a tusker at a grade-taking ceremony (see figure 17), or where dead pigs are still "sacrificed." Layard terms this "a novelty" (Geismar and Herle 2010: 251), but it speaks to the possibility of innovation and substitution that is at the heart of how pigs have traditionally been used within exchange. Indeed, the idea of substitution and replacement is

FIGURE 18. Bernadin Samy of Vao Island, Malakula, with a pig whose tusk is starting to grow through its cheek (tevtev), August 2, 2006. (Photograph: Haidy Geismar)

built into the use of pigs. In the Maki ceremonies of status alteration, variants of which exist throughout North and North Central Vanuatu (see chapter 4), it is widely recognized that pigs are used as a medium of exchange in lieu of human beings (and, indeed, the idea of ranking pigs is intimately connected to the ranks of men within this ceremonial and social complex). Further back, before people were sacrificed, Malakulans made Maki with ants and before that with sprouting coconuts. The principle of substitutability and exchange is thus built into the idea of using pigs as a measure of value. This is a different kind of substitutability to the perceived abstraction of so-called currency or money. The abstracted sense of value in pigs is not fixed in standardized units but is intimately connected to their shifting form, the shifting forms of exchange, and the endless process of negotiation between the two that comprises the social solidarity that these relations are

aimed to effect. It is this flexibility that sets apart the ways in which pigs are conceptualized as currency in contrast to the ways in which national banknotes are used and understood to have value.

The flexibility of pigs as singular sources of many different kinds of value is reflected in the material realities of how pigs are protectively, often secretly, reared. The owner of a pig whose tusks form two full circles will often hide his pig from public view—both to overwhelm spectators when it is finally ceremonially revealed and also to protect his investment from sabotage or theft. Today, it is very unusual to see a pig with two full-circled tusks; there are few of them, and they are kept possessively out of sight. While the conversion rate between pigs and state currency has stayed roughly the same, the existing number of pigs has diminished. The idea of the Pig Bank reflects this dual imaginary of local currency—one that exists out of sight but with profound efficacy and creative potential (see figure 18).

The Traditional Money Bank Project

> Pigs are not a commodity, they are not a medium of exchange. They are more than that. Before in *kastom*, pigs were life. Pigs were the same as human beings. For example, if you killed a man dead, you could give a pig and they would accept it as good enough as compensation, value. Personally I find that you cannot just talk about pigs in one window, without talking about other issues like land, relationships that we have, rights, status, inside a community. . . . For white men, it is fine to commercialize pigs, we can understand that, but in a Vanuatu context we can't. We see that at certain times, we must exchange pigs for cash, but we want to promote the part that is non-monetary. That is what makes us different.
>
> REGGIE KAIMBONG, TMBV project, July 13, 2006,
> author interview, translated from Bislama

As a result of the VKS fieldworker meeting in 1990, one of the fieldworkers, James Teslo, arrived at the 1992 meeting in Port Vila with a request for VKS assistance in setting up a Pig Bank, which would ensure that there was a continuous supply of tusker pigs available to those who needed them in his area, but who might not, due to the effects of Christianity and cash, have had the resources to maintain their own pigs to the required level (Huffman 2005: 28). This idea was enthusiastically supported by many other fieldworkers, who also felt that they

did not have the traditional wealth to participate fully in kastom life. The Pig Bank Project emerged, therefore, as much from an acknowledgment that pigs were no longer what they used to be as from the belief that pigs continued to be viable forms of customary currency.

The first stages of the Pig Bank Project, now called, with UNESCO sponsorship, the Traditional Money Banks Project, surveyed and identified the communities where demand for "traditional banks" were likely to have the most beneficial effect. Several areas were highlighted: North Pentecost; Southern Malakula; Malo; Banks Islands; and Port Vila, Vanuatu's capital city. The project was both inclusive, involving several different regions in Vanuatu, and exclusive, using specific islands as templates for a broader perspective on the traditional economy that would eventually impact the entire archipelago.

Once established, the initial survey of the project recommended that not only tusked pigs be targeted, but also woven and dyed money mats and shell money. Pigs, however, were acknowledged as being a universal traditional wealth item in all areas of the archipelago. Huffman, drawing on the rhetoric of the UNESCO Intangible Cultural Heritage (ICH) division that was sponsoring the project, was also careful to recognize the importance of intangibility and spirituality in assigning value to "these traditional wealth items," emphasizing that currency needs to be understood in terms of both the material object and the immaterial sociality with which it was involved (2005: 12). As with copyright, the making of an analogy between pigs (or mats or shells) and money by no means undermines the specificity of local engagements with any particular form of currency. Instead, it draws on this specificity to model or imagine an economy in which indigenous values and practices encompass Western-styled market values rather than the other way around. Huffman explicitly sets out this analogy: "economic concepts of loan, credit, investment, interest and compound interest do exist in traditional cultures of this area, as do concepts of banking. However the depository or 'bank' is not a social institution as such but rather individuals and relationships" (2005: 12).

But the project aimed not only for a conceptual encompassment but for practical outcomes, namely, the integration in a more balanced way of traditional economic practices into modern cash-based transaction and banking, an integration that would rely on a formal mechanism of translation and conversion between these two domains. Again, the power of analogy—presupposing both similitude *and* difference (or comparison *and* translation) between two entities—connects these imaginaries, and, in turn, this connection filters the possibility of imagining how pigs and money might be most profitably transacted. For the VKS, an answer to these kinds of questions lies in a shift of perspective,

encompassed by the forging of productive conceptual analogies, in this case between pigs and money. In this context kastom, or nationally recognized indigenous tradition, becomes a way of envisioning a functioning and productive economic sphere that can be used as a model of good governance and economic development: a way of reimagining the (national) economy, not simply in terms of alternatives (cf. Maurer 2005) but in terms of encompassment. This is where I think the Pig Bank Project has a lot to teach anthropologists: if many paradigmatic anthropological accounts of economy engage with ideas about alterity (for instance, the alterity of the gift, the alterity of personhood rather than commodities as a form of property, the seeming alterity of so-called alternative currencies), the Pig Bank Project develops an analytic framework of analogy drawing productive similarities between entities so selected because of their differences.

Huffman's final report proposed a series of practical recommendations in order to implement the TMBV project, with the final intention of creating a synthetic economy that would enable people to continuously and productively convert between traditional wealth items and money, merging the attendant modes of transaction and social implications of these diverse forms and substances of exchange. In the first instance, this process of translation was filtered through grassroots initiatives to create stores of valuables and biodiversity projects to protect the natural resources required in their production. This agenda was linked to multiple government agencies through an action plan devised during a workshop on the island of Uripiv in March 2005.

After the meeting in Uripiv, it was decided that a series of action-oriented research visits would be initiated to islands chosen for their reputations as past centers of traditional wealth and as sites where traditional wealth needed to be reinvigorated: South Malakula, an area famed for its *bisnis pig* (or ritual culture focused around the rearing, exchange, and sacrifice of valuable tusker and hermaphrodite pigs); North Pentecost, an area famous for the circulation of red mats; and the Rowa Island in the Banks, an area famed for its past production of shell money. In the final report a series of recommendations were proposed to continue this dual process of recognition and revival. These were arranged around the material forms of particular wealth items.

It was suggested that the "pure-blooded" Melanesian pig, such as the Kapia hairless pig on Tanna or the intersex Malo and North Pentecost pigs, be protected in conjunction with the Department of Agriculture and Livestock. A pig fence project was to be initiated in which, working through the VKS, male fieldworkers would be given an initial investment of wire fences with which they could create pig farms or banks in order to stockpile pigs.

A quota system was to be developed so that a certain percentage of pigs (30 percent was suggested in the first instance) could be raised to be sold, a second percentage to be eaten, and a third percentage to be used for kastom. Once more, the project aims to hold these spheres of use and exchange separate, while at the same time emphasizing their unity (e.g., the point of the project is that pigs can be exchanged for money to be used in kastom, which eventually results in their being eaten after being ceremonially killed and ritually exchanged). The simultaneous distinction and blurring between pigs and purpose maps onto the ways in which pigs have always been traded and exemplifies the nature of pigs as valuables.

Similarly, emphasis was to be placed on the conservation of the root of the plant *Ventilago neocaledonica* used in the dying of mats on Ambae and Pentecost (whose red color gives value to the fine white mats woven there) and on shell money, with a conservation project to revitalize an extensive stock of the *som* shell used by the people of Rowa island. Also, both of these conservation projects were also to be linked to the ongoing work of the VKS to revive cultural practices in areas where they were diminished. At grassroots levels people were encouraged to resist leasing land; to feed more pigs and grow more yams, taro, trees to make canoes (e.g., rely more on traditional resources); to incorporate traditional wealth items and languages into school and medical facilities; and to establish savings clubs and credit unions (more about which below).

This action plan proposed that the National Council of Chiefs (Malvatumauri) provide leadership in kastom issues, requiring that customary fines, for instance, may only be paid for in traditional wealth items and removing the eighty thousand Vatu bride price policy; that the Ministry of Education adopt a policy of paying school fees in traditional wealth items; that the Ministry of Health adopt a policy of paying medical fees with traditional wealth items; that the Ministry of Agriculture, Forestry, Fisheries and Livestock protect customary resources; that the Judicial Services Commission promote a policy of paying court fines with traditional currency; that the University of South Pacific accept traditional wealth as fees; that the Vanuatu Co-operative Federation operate a shipping service and allocate funds for the purchase of traditional wealth items; and that the Vanuatu Credit Union League develop a mechanism of exchange between cash and traditional wealth items. The final objective of the project was to found a pig bank in South-West Malakula, a mat bank in Port Vila, and a yam bank in Epi, alongside widescale establishment of credit leagues. The year 2007 was declared the year of customary wealth and it was subsequently extended into 2008. As an inaugural project, the Port Vila Public Library declared that it would accept mats as payment for membership.

The VKS proposed, at the outset, to furnish key fieldworkers in these areas with an initial investment of wire fencing in order to start the process of stockpiling pigs for kastom exchange and ceremonies. Reggie Kaimbong, the project manager, immediately realized that once you started to fence pigs, you of course had to think about land. The complexities of land-as-commodity in Vanuatu thus underscored the ways in which other kinds of objects were theorized as commodities. He commented that he felt that the next stage was

to get a registry of every island, *nasara*, who has land, who has pigs. Because the *nasara* provides a common bond for the community—don't forget at the end of the day we want the communities to remain intact. It's not all about pigs, it's about keeping the community intact. First, give me the list of your *nasara* and try to identify your *nasara* and who else belongs to this *nasara*, map your boundary as a base. And then we can talk about pigs, because you cannot talk about pigs with somebody else's *nasara*. . . . Once you are in the village, which is a new thing just created when the missionaries came. But back there, your *nasaras*, you were there and you know your land boundaries, so as soon as we start to encourage this and you know that what we are talking about is all about them. . . . It isn't possible just to talk about pigs in isolation from other systems and other sectors, which is why we have come out with a road map or master plan, we call Vanuatu Self-Reliance 2020, which is a much bigger strategy which includes governance, food security, social welfare with security, environment with resource management, trade with investment. (Reggie Kaimbong, TMBV project, July 13, 2006, author interview, translated from Bislama)

The substance of pigs (and mats and yams) was used to substantiate a vision of the economy that understood it as intrinsic to social organization. In turn, a radical revisioning of society was engendered that demanded a shift of the economic base away from participation solely in the cash economy and back toward a self-sustaining lifestyle.

At the Limits of Equivalency:
Pigs, Land, and Indigenous Identity

As Reggie Kaimbong's comment indicates, land is often heralded as the ultimate form of property in Vanuatu. It is, under the constitution, inalienable (although it may be leased on long-term contract); it embodies and constitutes social, familial, and political relationships; and it is used as a model for understanding people's relationship to culture, to the

state, and even to the World Trade Organization. As Kaimbong acknowledged, the TBMV has led the VKS directly back to the issue of land and the desire to establish a national register of places. This links up to other VKS projects such as the archaeological projects of the Vanuatu Cultural and Historic Site Survey but also aims to be entirely comprehensive. Before the project can be implemented, a land tenure register, which equates to a social and political tree of relationships, a metalevel family tree or genealogy, needs to be constructed. How can pig banks be created unless people understand which land they can put their pigs on and who, through this land, has access to them?

This drive to allocate formal land rights emerges from the reestablishment of customary land tenure by the national constitution, and it is a direct response to very real tensions throughout Vanuatu in which land rights are being consolidated in a variety of different manners at a variety of different levels. From contestation around the original site of villages and the origins of families and individuals to the unsettlement of Efate Islanders, who are now living on an island on which almost every inch of shorefront land has been alienated on long-term lease, the politics of land in Vanuatu are highly complex. Rather than try to map out ethnographic specificities, for the purpose of this discussion I emphasize how land, like pigs, is an uncommon common currency, set apart from money yet continually translated into monetary value.

Tensions over land as commodity are by no means unique to Vanuatu. Within economic theory, land has provided fertile ground for thinking about the concept of value. Throughout the twentieth century, Marxist-inspired governments have felt that the only way to create an equal society was to put all land into collective ownership. Like Vanuatu, Romania, for instance, just after the fall of socialism was relatively marginal in global economic terms and struggled under the double pressure of models of residual socialism and dynamic free-market privatization (see Verdery 2003). While transition in 1980 in Vanuatu was from a chaotic and disorganized colonial administration to indigenous rule (heavily influenced by the Melanesian Socialist Movement; see Regenvanu 1993), in both countries, and in many others, land has become a crucial and perplexing cipher for local-national-international engagement, a repository for the failures of development and a crucial tool in rethinking the nature of value. Within both transitions, land reform coupled to property reform became a philosophical and political marker of economic imaginaries and their connection to new social orders. As Verdery so astutely comments, "Land may not be an object at all but a site at which many forms of beings intersect" (2003: 17). The boundaries of exclusion and entitlement map onto the perceived boundaries of space and place.

Locke's theory of value is frequently referenced by property theorists as a justification for an understanding of property that unites resource and human agency (or labor) (e.g., J. Leach 2003; Bodenhorn 2004; J. Anderson 2009b). Land is often heralded as a perfect case study: what gives land value as property is the human agency wielded over it through cultivation or other kinds of use. It is this connection that prompted early colonists in places like Australia to promulgate the narrative of terra nullius—the country was not owned because the land was seemingly so little used. Subsequent debates about sovereignty and entitlement have negated terra nullius not only through the demonstration and recognition of native title in Australia but through the development of alternative philosophies of connection to land, which do not hinge on the value of land as being cultivated (nature valued through the addition of culture). Indigenous theories tend to reverse this, asserting that indigenous people are only present because of the prior presence of ancestral spirit in landscape. Land authenticates people rather than the other way around. Land, then, may in fact be a slightly different form of property to the imagined terrain envisaged by property theorists. This is best demonstrated by the anthropology of land that highlights a crucial interdependency between people and place (see Myers 1991; Jolly 1994b).

As for many indigenous peoples and postcolonial nations, land in Vanuatu is a crucial marker of self-determination: "Where this spiritual connection with the land has not been lost, no-one is homeless, jobless or without food. . . . The freedom to be our own bosses, to control our labor and our lives stems from the attitude towards the land" (Simo 2005: 11). Land tenure exemplifies some of the paradoxes and encirclements of kastom. While there are evidently multiple legal regimes in play for the deployment of land including kastom title (which incorporates diverse local understandings of land tenure) and title afforded in the more open marketplace (which since independence has been limited to, at most, seventy-five-year land leases), nevertheless, by 2007 it was estimated that 90 percent of coastal property on the island of Efate was in nonindigenous hands, demonstrating in a way that all roads seem to be leading to the same place. At the same time, another pathway has opened up, and a discourse of custodianship is increasingly contrasted with one of ownership (drawing on an international language of indigeneity that refuses a private property relation between people and place, mirrored in the ways in which Māori envision themselves as guardians rather than owners of their taonga; see chapter 3).[4] However, as Joel Simo acknowledges in his report to the VKS on the National Review of Customary Land Tribunal in Vanuatu, "customary law applies to both customary and leased land" (2005: 1).[5] As with the formulation of kastom and copyright (chapter 4) or the rendition

of money in the TMBV, the definition of land as property and of modes of transaction and engagement thus depend on principles of indigenous sovereignty even to participate willingly and equally in the marketplace. These are the ongoing tensions that ni-Vanuatu citizens struggle with as they seek to define themselves both locally and internationally.

Competing Discourses of Indigeneity and the Economy

The Pig Bank Project does not represent the first time that alternative economies have been proposed as political solutions in Vanuatu, and some of this history will be traced later in this chapter. There is, however, a competing discourse of indigeneity and economy that has emerged adjacent to the Pig Bank Project that highlights how the international rhetoric of indigenous rights feeds into the politics of recognition in Vanuatu. The Melanesian Institute of Science, Philosophy, Humanity and Technology of the Turaga Nation in Pentecost Island was founded by Chief Vuhunanwelenvanua in 1997 and is currently co-led by him, Chief Viraleo Boborenvanua, and Motarilavoa Hilda Lini; its headquarters are in the village of Lavatmagemu in North Pentecost. The institute runs under the auspices of the Turaga Development Model for Economic Self Reliance and Human Security Program, which was initiated on Pentecost in 1953 in response to the changing dynamic of colonial life on the island and the increasing reliance on cash for well-being. The establishment of the Tanmarahi kastom reserve and the kastom banking system, Tanbunia, on the island connected the institutionalization of the Turaga people as a "nation" with an educational infrastructure (the institute teaches from a kastom base, purely in Raga language and uses a newly enshrined indigenous graphic system instead of a Western alphabet). The Tanbunia has its head office at Lavatmagemu, Pentecost, with more than fourteen branches. As of October 2012, it provides banking services to 3,863 depositors around Vanuatu and pays a salary to 1,863 people. The bank operates savings accounts, checking accounts, and investment accounts for its depositors. It deals in both Vatu currency and custom currencies, namely, pig's tusks, live pigs, and *Selmane* (shell money), which is not a traditional form of wealth in Pentecost but is now recognized as a national form of indigenous wealth.

The politics of the indigenous bolsters the recognition of a kastom economy as one part of an independent "nation." In 2007 the Turaga Nation and its official institutions hosted a meeting and developed the Lavatmagemu Dekleresen, which outlined the collective position of the Vanuatu's Indigenous People's (VIP) Forum that now meets on a regular

basis throughout the archipelago. The forum subsequently presented its Dekleresen concerning the deployment of land and natural resources to the UN Permanent Forum on Indigenous Peoples in New York City, and the Turaga Nation gained recognition there as an indigenous people. Within Vanuatu, despite grassroots support, the legitimacy of this indigenous nation within the indigenous nation has been called into question many times, both at community and national levels.

During the Year of the Traditional Economy, the Turaga Nation made an official request to the National Reserve Bank to have the Livatu, its currency, accepted by the Reserve Bank as an official currency of Vanuatu and to create a custom reserve bank (see Reserve Bank of Vanuatu 2008; Tanmarahi i Tanbunia non Guiguinvanua 2008). Livatu is the only accepted currency in the Turaga area. Upon entering, any visitor is required to bring customary wealth (pigs, tusks, mats) and then will be able to convert these into spendable Livatu. Vatu are not recognized as a currency of value. Each member of the Nation has a bankbook and an account, within which are deposited millions of Livatu (at the time of their application for state recognition the Livatu economy was valued at ten billion Vatu; Reserve Bank of Vanuatu 2008: 3).[6]

The Vanuatu Cultural Centre invited the Turaga Nation to send representatives to an early meeting at Uripiv to discuss the creation of a National Strategy for Self-Reliance and the developing Pig Bank Project, but they refused to include the Livatu as a traditional money within the remit of their research, primarily because of the lack of consensus even within Pentecost about the legitimacy of both the currency and the Turaga Nation. Indeed, some of the most virulent critics of the authenticity of Livatu come from residents and community members in North Pentecost, and membership in the Nation has become sharply divisive. In contrast to the case of the Turaga Nation, headed by Hilda Lini, who has extensive experience on the indigenous rights global circuit, the language of indigeneity drawn on by the VKS has its origins more in the work of UNESCO and the fusion of mainstream scientific and cultural research. For the Turaga Nation, indigenous currencies explicitly position themselves against national currency, which the Turaga recognize as oppressive and (neo)colonial. The politics of the Turaga Nation have marginalized them from national governance, but more than anything, their own powerful imaginary posits an alternative—a world where they are millionaires and are not dependent on outside sources of wealth generation. In 2007 they declared that the Livatu and Selmane were official national currencies and in September 2009, despite the rejection of their claims by the Reserve Bank, they notified their 25,000 members that the Livatu was valued at

thirty billion Vatu and that they were ready for the declaration of Custom Economic Independence, which they framed specifically as a liberation movement (see Tanmarahi i Tanbunia non Guiguinvanua 2008).

The Reserve Bank of Vanuatu concluded that the proposal to recognize Livatu as a national currency was impractical and impossible on a number of different grounds, ranging from the fact that a currency such as Selmane was not recognized everywhere in Vanuatu as money to the fact that the supply was not consistent, the Livatu and Selmane were not appropriately quantifiable, and that there was no satisfactory methodology for their valuation—in short, that they were not enough like national currency to be included at the national level. In turn, the community discord present in North Pentecost and the relatively short life of this new currency meant that the Livatu is also not enough like traditional/customary currency in terms of the VKS work to define Traditional Economy. In this way, the indigenous economy posited by the Turaga Nation is the alternative to the alternative. Like the secessionist movements that fought against the Anglophone Vanua'aku Pati prior to independence, indigeneity has been established with its own hegemony in independent Vanuatu. This is not to judge either reckoning of the indigenous but merely to observe that there are competing (counter) narratives and that the national economy provides a frame for their articulation and materialization.

Economic Models and Efficacious Alternatives

Community currency movements across the world, such as LETS, the Toronto Dollar, and Ithaca HOURS attempt to reanimate the notion of money within contexts of limited circulation. Such initiatives tend to focus on the embeddedness of valued time (or labor) as a quantifiable, representational medium of exchange or to focus on the specificity or materiality of local productions or natural resources. Ultimately, many of these currencies function as add-ons to more conventional money exchanges—they provide a kind of halfway house between the socialized reciprocity of close-knit community transaction (e.g., neighbors helping each other out) and the need to buy in all kinds of support (e.g., fixing a leaky drainpipe). More universal (often national, or in the case of the U.S. dollar or Euro, international) currency is often a conceptual if not a financial underpinning of these systems. For this reason, Maurer calls Ithaca HOURS "counterfeit counterfeits" (2005: 99) in that they attempt to create an alternative currency but in fact bolster the existing currency of U.S. dollars. The equivalency of pigs and cash in Vanuatu does, I argue, something rather

dissimilar. Indigenous currency developments differ from other community currency movements because of the ultimate reference point, which lies not in human labor but in land and a totalizing understanding of the environment as an indigenous resource.

Resisting the homogenization of economic development posited by the World Trade Organization but using similar international toolkits, the TMBV focused around traditional wealth items, all of which have long-standing histories of conversion and translation into other national currency, from pounds, schillings, and pence, to francs, to Vatu. Rather than focus on ideas of alterity or equivalence, the TMBV is ultimately interested in the potentials of translation, using criteria of indigeneity as a base. Huffman notes, "It should be pointed out here right at the beginning . . . that we are not here dealing with western economic concepts *versus* traditional ni-Vanuatu ones. . . . There are major basic theoretical—or more properly—spiritual, ethical and moral differences, though, that indicate that the two systems can co-exist if these differences are respected" (2005: 31). The TMBV project has developed the idea of using credit unions as institutionalized currency converters that both encourage saving toward community development and a to-and-fro between traditional and cash currencies. Therefore, loans could be guaranteed or even repaid by pigs and, in theory, money could be exchanged for pigs and mats. Huffman notes that, customarily, borrowed pigs are repaid using a rate of interest calculated by the rate of tusk growth plus an extra amount and notes the sophisticated dialogue that exists around the relative equivalencies of pigs and tusks (2005: 42). Noé Saksak, the head of the Vanuatu Credit Union League, described how credit unions are able to forge links between different systems and map alternative models of exchange and currency onto one another; in short, they have the capability to draw analogies. Credit unions, as they are being figured within the TMBV, are thus able to both reconceptualize economic transactions and bring the cash economy to rural areas under the rubric of kastom.

From Cooperative to Cargo Cult and Back Again

Cargo cults are fundamentally about imagination: the imagination of "modernity" by those at its margins (Worsley 1968), the imagination of "primitives" by those who study them (Lindstrom 1993), and the imagination of radically different utopias by those who also live within them. Fundamentally, they are also about implementing imagined economies, and in this sense it is instructive to turn briefly to the history of cargo cults in Vanuatu to understand the ways in which reimagining the economy is a

firmly indigenous enterprise, but one that intersects with outside interests in ways both provocative and creative.

In Vanuatu, both credit unions and cooperatives have a lengthy history that spans the period of colonial and postcolonial economic encounter.[7] In the early days of the Condominium government, cooperatives were encouraged as mediating bodies that could draw communities into supposedly nonpolitical working groups in order to productively transact with traders, missionaries, and colonial officials. However, these cooperatives, under the rubric of "native companies," soon became agencies for wielding significant political authority and often came to compete with the economic institutions these colonial institutions were trying to monopolize (see figure 19). Native companies—enterprises that sought to marry local interests within the framework of colonial commerce—were provocative institutions frequently glossed by colonial authorities as cargo cults. The mimetic appropriation of economic practice by local people did not square with their subjectivity as colonized beings who needed external supervision, especially in the management of business. As we saw in the case of copyright in Vanuatu, the colonial governor did not believe that ni-Vanuatu were essentially capable of administering a sui generis intellectual property regime even as they did recognize graded society entitlement as a form of copyright. Like the wrangling over copyright, the tensions over native companies and cargo cults bring the economy into view. This envisionment was, I argue, a crucial precursor for the delineation of projects such as the TMBV project.

The Malekula Native Company (MALNATCO) started life as a cooperative founded on North Malakula in 1939 by Paul Tamlumlum, from Longana, Ambae, and Etienne Kaku and Ragrag (Charley or Melteg Saulidal) from Matanvat, North Malakula (see Ponter 1983 for a full history of MALNATCO in the context of Vanuatu cooperatives). From the outset, the organization mediated between ni-Vanuatu from throughout the region and their creditors and purchasers, primarily local missionaries. The company was founded to collect and trade copra from throughout the region and to provide a collective base to invest in local enterprise and facilities, including schools and hospitals (see Guiart 1951, 1956; Regenvanu 1993). Very quickly, however, the company evolved from its cooperative base, moving beyond mere copra production and trade. Exploiting the labor of migrants from other islands, the cooperative directed that huge tracts of land on Malakula be cleared for plantations. The organizers converted to Catholicism and a distinctly millenarian and religious framework began to infiltrate trading relationships. During World War II, the organization was greatly impressed by American riches and efficiency, and its leaders aligned themselves with the United States

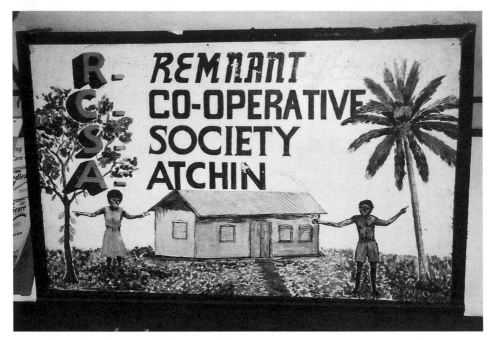

FIGURE 19. Painted sign for the Remnani Co-operative Society, Atchin, August 2006. (Photograph: Haidy Geismar)

in opposition to the colonial presences of France and the United Kingdom. Condominium officials became increasingly unsettled over the power of the movement to organize large numbers of ni-Vanuatu across many different islands around a social—and increasingly political—agenda, and over the power of the organization to monopolize local and regional trade. Several of the key leaders, including Paul Tamlumlum, were arrested by the authorities and imprisoned at Port Sandwich (in Lamap).

Around this time both British and French officials—influenced heavily by the development of the explicitly anticolonial and millenarian John Frum cult on Tanna and the so-called Naked cult on Santo—began to talk about MALNATCO as a kind of cargo cult (see Guiart 1951, 1956; Tabani 2008). However, despite the religious and pseudo-militaristic nature of the organization, MALNATCO remained first and foremost a local cooperative. Condominium authorities projected their fears of cargo cultism onto the growing economic success of the company, and its threat of competition eventually resulted in the suppression of the company as a dangerous political entity. There is thus an inherent

ambiguity regarding cargo cults whereby they are viewed both as primitive engagements with modernity and as dangerous protonationalist movements toward governance (see Tabani 2008). The cooperative, under the influence of key British traders, was eventually dismantled into a number of regional and smaller associations that proved much easier to monopolize. The response of colonial authorities and the general ways in which cargo cults have been understood show how economic institutions such as cooperatives are entangled with political fears and the very real implementation of economic authority, in addition to providing a vehicle for local manifestations of sociality within new (economic) frameworks. The structure of cooperatives was deeply embedded within colonial hierarchies and religious and missionary networks, as well as village-level desires and imaginaries. The shift from cooperative to cargo cult may be seen to emerge when indigenous agency attempts supersede that of the colonial authorities. A similar tension emerged around copyright for similar reasons (as described in chapter 3). The term *native company* perhaps embodies these complex relationships better than *cooperative* and *credit union*. It also signifies the ways in which the economy might be locally produced, using the same forms but with different motivations and outcomes to the ventures of colonial businessmen or missionaries.

In a sense, it was impossible for a native company to succeed in the period prior to independence. The state, as the corporation writ large, was unable to relinquish such a degree of economic authority. In a similar way, as people tried to assert their rights to enforce customary entitlement via the rubric of copyright, they were punished for sorcery (see chapter 3). Contemporary attempts to establish and enshrine customary copyright in law or to promote successful indigenous business should in principle be much more successful. It seems fairly clear to me that when they fail, it is because they are still being held accountable to systems of law, governance, and economy that are designed to better serve those with outside interests.

Economic Imaginaries

I have spent some time in this chapter describing how an imaginary of traditional economy has been drawn out of the engagement of traditional practice and national business (both cultural and political) and how the conflation of pigs and money has been used to reframe indigenous lifestyles. The complex formulation of the traditional economy has long assumed that participation in the cash economy is desirable, but the formulation seeks to reframe its raison d'être within a complex politics of self-determination that, at its most

powerful, has been called a cargo cult. As with copyright, the envisioning of the economy brings multiple perspectives together. I have focused on the local-national, from the colonial imaginary of the cargo cult to the indigenous imagining of the pig bank. We also need to take into account international imaginaries and their impact.

INTANGIBLE CULTURAL HERITAGE
AS ECONOMIC IMAGINARY

Huffman draws an explicit link between the tradition of raising tusker pigs, along with the attendant male graded societies in North and Central Vanuatu (which, as we have seen above, are increasingly used as markers of property rights in land), and the sand drawings recently accredited by UNESCO as an exemplar of the Oral and Intangible Heritage of Humanity. Not only is it possible to draw analogies between the materialization of sociality in the form of sand drawing (which is a literal inscription of place onto the ground) and the sociality engendered by the hierarchical tiers of pig sacrifice, exchange, and purchase of status within the graded societies (see Rio 2005; Taylor 2005), but this connection also highlights the ways in which UNESCO projects a vision of intangible cultural heritage that may be used to conceptualize not only regional networks but also the form of cultural exchange within this region. In turn, these networks of cultural exchange have been used to visualize relations of entitlement, from the ways in which copyright is networked (see chapter 4) to the ways in which pigs and money may be productively conjoined. These imaginaries bring into being a series of straw men that interlock and are encompassed by one another. The specter of "the economy," which analyzes well-being in association with access to and consumption of resources viewed in terms of Gross Domestic Product and a monetary standard, is encompassed by a view of the economy that uses the language of heritage and resource management and its emphasis on the "right to culture" (T. Eriksen 2001: 127) as a model for a new form of economic regimentation. In particular, this is articulated by the UNESCO model of intangible cultural heritage, within which Vanuatu has played an instrumental role in developing (being among the first nineteen countries with identified Masterpieces of Oral and Intangible Heritage of Humanity). Intangible cultural heritage "is culture, [and] like natural heritage, it is alive. The task, then, is to sustain the whole system as a living entity and not just to collect 'intangible artifacts' " (Kirschenblatt-Gimblett 2004: 53).

The TMBV, through its funding by UNESCO and Japanese cultural institutions, draws an explicit link between traditional economy and UNESCO's concept of the Oral

and Intangible Heritage of Humanity. This connection also highlights the ways in which UNESCO constructs a vision of cultural heritage that may be expanded out from heritage preservation and conservation into more explicitly political and economic policy-making domains.[8]

Why do I link intangible cultural heritage to the TMBV, other than the fact that it was the guiding trope of UNESCO thinking about culture and rights at the time of the project? Intangible Cultural Heritage was expressly developed in response to the perceived inadequacy of other regimes to protect traditional knowledge and expressions of culture (what was, in earlier incarnations, often called folklore) precisely because of the communal and intangible properties of these cultural manifestations. Following the Japanese concept of Living National Treasures, UNESCO defines intangible cultural heritage (ICH) as a relationship between persons, things, and their environment (UNESCO 2000, 2002; also see the introduction of this book). As Barbara Kirschenblatt-Gimblett comments,

> However much these measures are intended to *safeguard* something that already exists, their most dramatic effect is to build the capacity for something new, including an internationally agreed-upon concept of heritage, cultural inventories, cultural policy, documentation, archives, research institutes, and the life. In a word, safeguarding requires highly specialized skills that are of a different order from the equally specialized skills needed for the actual performance of Kutiyattam or Bunraky or Georgian polyphonic song. (2004: 55)

I am less interested in the specific intricacies of ICH as a newly made international category (with the attendant issues of list-making, evaluation, global hierarchies, the requisite state authorization, and processes of bureaucratization) than in the ways that the category may become a resonant tool in forums outside of UNESCO, in particular as a way into thinking about the protection of cultural rights and resources within an intellectual property framework (see Marrie 2009: 183). Taking the Japanese model of Living Cultural Treasures as a starting point, ICH is conceptualized as being "alive" (Kirschenblatt-Gimblett 2004: 53). In the Pig Bank Project, this maps onto an imagining of the economy that sees it as a social organism as well as an institutional deployment around material resources. Cultural heritage has been liberated from both museum and theme park and has become a recognizable mode of social engagement and even governmentality. In this way ICH is more productive here than perhaps within its original framework, where it creates tourist destinations and is problematically expansive.

In making the key agents of the Pig Bank Project cultural center fieldworkers; in promoting regional credit union activities alongside cultural centers, biodiversity projects, and traditional resource management projects; and in linking traditional wealth items to UNESCO-funded projects around ICH, the Pig Bank Project has explicitly reimagined the economy in Vanuatu. If ICH may be criticized by some as a peculiar form of cultural reification, a globalizing concept that homogenizes the idea of culture as performance, while at the same time drawing boundary lines between naturalized "Western" nation-state cultures and indigenous, minority, and "non-Western" culture, it is, I argue, a remarkably efficacious alternative model for the economy and economic development. A provincialization that allows grassroots definitions to infiltrate internationalist theory and institutional frameworks, the category ICH opens up avenues for international participation and allows ni-Vanuatu to travel and have their voices heard in key international forums. As a global category, intangible cultural heritage may solve some of the perennial problems of property qua commodity taken for granted within much economic theorizing, namely, providing a space for understanding resources as total social facts.

Alternative (Global) Imaginaries

The imaginary synergy between, for instance, pigs and money that has led to a productive model of economic development, has emerged not only from within Vanuatu or in UNESCO-led initiatives. In 2006 the *Happy Planet Index*, devised by the London-based New Economics Foundation (NEF) and whose tag line reads "economics as if people and the planet mattered," announced that Vanuatu was "the happiest place on earth." Its pronouncement was based on a quantitative algorithm that incorporates the indices of life expectancy and the subjectivity of "life satisfaction" with a measurement of an "ecological footprint" that links the sense of well-being to environmental policy and ecological well-being as much as to national income based on GDP.[9] "In doing so," the NEF writes, the *Happy Planet Index* "strips our view of the economy back to its absolute basics: what goes in (natural resources) and what comes out (human lives of differing length and happiness)," factoring out political instability, war, and other such blips in human experience (Marks, Simms, Thompson, and Abdallah 2006: 28–29).

Within the index, islands perform well (with all of the G8 countries scoring particularly low on the chart). Vanuatu, along with the neighboring Solomon Islands, ranked so

highly because of the relatively high numbers of people living off the land (70 percent, according to the 1999 census), the relative underpopulation of the country, and the lack of integration into global consumption of natural resources. On the NEF Web site, one can map one's own happiness index and be given a place in this hierarchy of nations. It should be noted that in 2009, the NEF released the *Happy Planet Index*, version 2. Tellingly, in this version Vanuatu was not featured due to lack of data. In the interim, some had challenged the actual methods of data retrieval from Vanuatu and questioned the NEF's pool of informants. Nonetheless, the imaginary of Vanuatu as an idyllic island paradise, with low-consuming citizens content to draw sustenance from their customary base, remains a powerful imaginary fueling the possibility of an alternative economy.

The NEF connects itself to the growing movement within economics to theorize happiness (in a neat twist, a leading proponent of this is Richard Layard, an economist at the London School of Economics and the son of anthropologist John Layard, who first theorized about pigs in Vanuatu in British anthropology). Happiness quantified, like indigeneity theorized, is an enticing alternative for those who imagine economies. This concept of happiness is increasingly used to justify economic policy making with emphasis on, say, environmental protection rather than corporate profit in terms of resource management.[10]

Imagination and Affect: How Pigs Provincialize the Economy

Like sand drawing, pigs have been drawn into discussions of national heritage both in the practice of rearing and exchange and through the ways in which they provide a useful form of consolidated imaginary to symbolize a particular kind of indigenous economic theory. Chris Gregory describes how the origin of the term *symbol* is intricately tied up with money: the ancient Greek Symbolon was a coin divided into two pieces, held by each of two parties to a contract or agreement (1997: 250). Both coins and pigs, therefore, encapsulate a complex semiotics—each refers to relationships and guarantees made in the social world and is the source of value for these relationships. In this chapter, I have described the emergence of an economic imaginary in Vanuatu that, if not new, is acknowledged by state and international agencies in a newly empowering way.

In 2000, the VKS marked the twentieth anniversary of independence and of the establishment of the Reserve Bank with an exhibition entitled *Mani blong yumi: Money in Vanuatu Society*. Display cases were reorganized to present examples of mats, stones,

shells, and pigs tusks and jaws (indeed, the double circle pig's tusk on loan from the queen of England was nearly stolen during the exhibition). Weaving throughout was a narrative that detailed the gradual emergence of money through intercultural trade from the time of Captain Cook onward and the development of parallel spheres of exchange between cash and pigs, feathers, shells, and so on. The establishment of the Reserve Bank was intended to forge economic stability and growth. Now, with the first decade of the twenty-first century over, Vanuatu is more associated with talk of "dirty tax havens" and the "arc of instability" than it is with a successful federal banking system and a viable local economy (see Rawlings 2004). The reformulation of the economy proposed by the TMBV gives an alternative framework for Vanuatu—one not focused on the idea of a true alternative commodity (cf. Maurer 2005), but one that reframes the purpose of the economy and, most importantly, incorporates local values within all exchanges. This imaginary in itself is a powerful alternative, a political intervention, using globally recognized language to talk back to the economists who frequently visit the country and attempt to reframe the commodity potential of customary resources to the primary benefit of international investors.

The Pig Bank Project demonstrates the efficacious nature of these economic imaginaries in creating alternative utopias that profoundly alter the ways in which people can interact with the nation and with the "economy." Once more, this speaks to a politics of the indigenous whereby the usual dichotomies between cash and mats or pig, between culture and casinos, are turned on their head—a provincializing process. Just as American Indians use the revenues from gambling to build museums and fund cultural and language revitalization programs in the face of challenges to their authenticity (see Cattelino 2008), ni-Vanuatu use a toolkit of kastom to craft a utopic national economy, in turn provincializing or critiquing the development models they are presented with by advocates of development and globalization. The challenge is to see whether these imagined economies can be made into concrete national models or if they work best at a grassroots level, within smaller rather than larger spheres of exchange. Cultural property, modeled here as cultural heritage, has provided a platform for rearticulating the national economy. Intangible cultural heritage has provided a toolkit to imagine an alternative frame of value—in a loose way, a form of intellectual and cultural property in an increasingly global market.

Conclusion

AN ONGOING PROBLEM for the anthropology of cultural and intellectual property is how to define and discuss indigenous models of ownership, entitlement, and law given that the frames of property, rights, and law are themselves colonial constructs. Within this closed circuit, the indigenous mobilization of identity and difference as asset and resource has been read as a strategy of resistance (Miller 1995), of nation building (Li 2010), and as a resource in itself (Coombe 2005: 52).[1] In turn, neoliberal policies of governance and economy have been shown, sinisterly, to play a role in constituting these very cultural identities and differences (Harvey 2005; Comaroff and Comaroff 2009; Hirsch 2010). We may even understand anthropological discourses of incommensurability (A. Henare 2007) or radical cultural essentialism to emerge "in the shadow of the liberal diaspora" (Povinelli 2001: 320; Rata 2003; van Meijl 2009a).

In this book, I have aimed to cut a different pathway through these debates. I have presented a sustained argument that we need to understand the intersections of

indigeneity and intellectual and cultural property as a provincializing move that desta-bilizes our certainty about what is local and what is global. Chakrabarty's rendition of the provincializing project has been invaluable for exploring the ways in which colonial law and property relations have been re-centered in Vanuatu and Aotearoa New Zealand. New Zealand and Vanuatu are also provincial in a second, more colloquial, definition that refers to the conservative emulation of a center. In both places property regimes are emulated by governments enthralled by the possibilities of profiting from the interests of the World Trade Organization, the TRIPS Agreement, the common law, models of multi-cultural democracy, and a cultural commons. This dual notion of the province is a helpful way to articulate the tensions and paradoxes that lie within indigenous renditions of intel-lectual and cultural property in the Pacific and helps us to understand the ways in which this process might differ in postcolonial and settler-colonial contexts.

By charting the ways in which indigenous interventions alter intellectual and cultural property, I have shown here how notions of radical cultural difference are the *tools* with which indigenous players challenge state sovereignty over many types of resources. My accounts of copyright in Vanuatu and trademarks in New Zealand, and of the local appli-cation of global cultural property policies in both countries, show that these so-called generic property regimes are *always* constituted in a provincial context. Analytic failure to recognize the provincial nature of the TRIPS agreement, or the standardized copy-right legislation promoted by the WTO, is part of the reason why indigenous people are often criticized for bringing "too much" culture to the table (e.g., by Brown 1998). Here, I provincialize the anthropological project itself by refusing to reify cultural difference in my own analytic, and comparative, framework. The indigenous projects I have chronicled work with ideas about radical alterity *and* within so-called generic structures of gover-nance and law. They destabilize all of these seemingly bounded categories. The activists I have worked with challenge the foundations of the generic by highlighting the exclu-sions, negations, and ideologies that have constituted them as indigenous people and that constitute what is considered to be normative or standard.

The two pairings of ethnographic chapters presented here allow us to understand, side by side, the ways in which ni-Vanuatu and Māori are reworking the policies and practices that inflect local understandings of indigenous rights, economic and political sovereignty, and the commoditization of tradition. The provincializing process and the indigenization of intellectual and cultural property takes place on an aesthetic platform in which key forms instantiate property rights and sovereignties. The first set of chap-ters showed how intellectual property (IP) is an important frame for asserting alternative

visions of ownership and for channeling control over markets by the grass roots into the international marketplace. Both copyright in Vanuatu and trademarks in New Zealand have emerged out of a dialogue about the extent to which indigenous rights are recognized by the nation and the implications of this process of recognition in guarding the authority of the state. The British district agent in North Central Vanuatu deliberately refused in the 1950s to recognize the status of high-ranking men in Ambrym by denying their right to enforce copyrights. He did this by refusing to recognize their claims to entitlement *as* copyright. Similarly, by disinvesting in the toi iho mark, the New Zealand government defined trademarks solely in terms of their economic value in national and international markets, refusing to acknowledge the social solidarity and investigation into cultural values that these trademarks also embodied. Ambrym chiefs have ensured that their model of copyright has become a hidden template within the generic copyright legislation adopted by Vanuatu in preparation for its accession into the WTO. The status of the Māori Trade Mark Advisory Committee, on the other hand, is extralegal. Their decisions are not binding but rather create an ethical frame for the commissioner of trademarks. In its report on the WAI 262 claim, the Waitangi Tribunal proposed the establishment of an independent commission that would usurp the role of the NZ Intellectual Property Office (IPONZ) and institutionalize Māori values of guardianship as an alternative property relation. It remains to be seen if these suggestions will be acted on by the state. These politics of recognition and refusal are intimately related to the insecurities of the colonial state, yet also effect the very constitution of state property regimes.

My second pairing of chapters highlighted how museums and cultural policy makers have been particularly effective in providing new national templates for the commodification of culture. Both Vanuatu and New Zealand have embarked on a challenging mission to reevaluate the local resonance of generic property regimes and contextualize these laws in relation to their provincial sense of themselves as Pacific nations. This might be a form of *Ethnicity, Inc.* (Comaroff and Comaroff 2009) but it also develops very different models of accountability, consultancy, and power sharing that draw ideas from the cultural sector into dialogue with other institutions of governance and public policy.

In New Zealand the rubric of guardianship *(kaitiakitanga)* has been successfully nationalized within museum practice to become a more generic alternative to the private property and commodity logic implied in the state's current cultural and intellectual property regimes. The discourse of guardianship is now enormously influential in rethinking property relations. It has altered the ethics and sense of moral responsibility in the auction market, forcing collectors to consider their practice in ethical terms of obligation and

reciprocity. This is mirrored in the stringent regulation of the marketplace demanded by the Protected Objects Act of 2006. Indeed, antiquities legislation in New Zealand has always been provincial. The first antiquities legislation in New Zealand, in 1901, was specifically designed to protect Māori cultural property and to create a sense of national sovereignty over Māori treasures.

In Vanuatu the reification of kastom by the VKS, not only into museum objects but also into a series of national practices and discourses, has successfully co-opted the term in provocative reassessments of land tenure and national economy. The work of the VKS to institutionalize the traditional economy acts—in Ralph Regenvanu's words—as a "trojan horse" for kastom in government planning for national self-reliance. The VKS has provincialized intangible cultural heritage and reproduced it as a template for national economic development, which is itself a provocative critique of the responsibilities the country now faces as the newest member of the WTO. Intangible cultural heritage (the traditional economy) is now institutionalized through credit unions and land tenure registries. As in the case of Māori art at auction, the Vanuatu Pig Bank Project has provoked a profound rethinking of models of value and of the social implications of commodification and commodity exchange.

In both Vanuatu and New Zealand, there is an explicit acknowledgment that conversation about what comprises indigenous cultural and intellectual property is in fact a discussion about sovereignty. The current readings of Article 2 of the Treaty of Waitangi ensure that there is a certain level of national accountability to evaluate the relationship between governance and sovereignty and the balancing of obligations in a bicultural nation. The balance of power, however, remains skewed toward the Crown, which has institutionalized critique from within (in organs such as the Waitangi Tribunal). New Zealand only recently and reluctantly agreed (in 2010) to sign the Universal Declaration of the Rights of Indigenous Peoples, despite a template for that Declaration having been developed locally in Mataatua in 1993. A concept of a nationally acceptable Māori remit over generic understandings of intellectual and cultural property (and its counterpart, an indigenous commons) is therefore fraught with competing imaginaries. The failure and subsequent reemergence of toi iho as a native trademark shows that even within the long-standing history of appropriating indigenous cultural production as national aesthetic, the linking of aesthetics to authority allows for agency to move in surprising directions. In its government iteration, toi iho was empty of genuine self-determination—full of governance and lacking in sovereignty—but it currently stands poised to constitute an

indigenous-run marketplace indifferent to pleasing government, part of a broader move to constitute a Māori economy that might be able to compete with that of the nation-state.

Vanuatu's history has been marked by the weakness of state infrastructure and the failure of many national development initiatives (such as the cooperative movement). However, with new leaders such as Ralph Regenvanu and the grassroots infrastructure developed by the vks, the state is being re-imagined (see Hviding and Rio 2011; Rousseau 2012). The Vanuatu government is carefully considering the implications of generic legislation for food security, land management, and resource extraction. The proposals developed through the vks Traditional Money Bank Project draw on infrastructures, such as the local and national council of chiefs, which already have a significant space in Vanuatu's National Constitution, allowing for the possibility of significant changes within structures of governance and, as in the case of intangible cultural heritage, an opportunity to influence or provincialize the generic.

It may be that none of these projects emerge fully fledged as substitutes for the colonial models of ip, resource management, and sovereignty that have long been in place. They have emerged out of a dialogue about indigenous rights that itself is part of the colonial project. Logically, it is therefore impossible for one "system" to replace another—given that neither the colonial nor indigenous system exists independently of the other. However, all of the projects I have described here suggest a form of alteration that is much more radical, in which the conduits of authority, the rationales of sovereignty, and the obligations of the market are channeled in different directions, according to different values, benefiting different people. It is this potential for the reshaping of agency that has largely been ignored by anthropologists, who have focused more on positing an essential division between cultures that are suited to ip regimes and those that are not (differentiated by ideologies of individual versus collective ownership, by the idea of limited versus unlimited terms of protection, respectively). Perhaps the most important point of the ethnography I have presented here is that it is the structures of power and authority that refuse to give up one version of rights for another, not any epistemological or ontological incommensurability between these competing models of entitlement.

In drawing this book to a close, it is necessary to return briefly to my methodology, an exercise in comparison, which I advocate in order to make sense of the different ways in which indigenous people navigate the language and law of cultural and intellectual property and, indeed, make it their own. The mode of analysis contained within this book embodies the complex ways in which context, value, practice, and policy are layered upon

one another in the constitution of intellectual and cultural property regimes. The Pacific is an important place to chart this interplay. As Ralph Regenvanu has commented,

> firstly, Pacific Island states have the highest proportion of indigenous people within the national population of any region in the world. Secondly, these states have the highest rate of traditional land ownership (the proportion of the total land area held under traditional customary land tenure) of any region in the world. Thirdly, Pacific Island societies embody and demonstrate a very high level of cultural continuity with previous generations; that is, the majority of Pacific Islanders enact aspects of their traditional culture on a daily basis in their lives. Fourthly, all the Pacific Island states are poorer developing countries. (2006: 1)

New Zealand holds an ambiguous position in this vision of the Pacific. If we consider it a Pacific Island country, then it is the exception to most of these rules. Māori comprise approximately 15 percent of New Zealand's population and are predominantly urbanized. Most do not speak Māori as their first language, and they live within a relatively vibrant and affluent national economy, which itself supports other Pacific Island nations (and is sometimes charged with colonial intent). However, shared concerns for the viability of indigenous culture, for indigenous sovereignty, and for the promotion of a sense of "indigenous modernity" close the gap between these divergent GDPs. A country like New Zealand, which increasingly thinks of itself as a "Pacific Island nation," is therefore also fertile ground to assess the growing indigenization of intellectual and cultural property and the aspirations and limitations contained within the Pacific region.

It should by now be apparent that competing movements of enclosure are jostling for attention within the South Pacific. Despite their differences, in both Aotearoa New Zealand and Vanuatu, cultural and intellectual property fuse to provide a filter through which both to discuss sovereignty, indigenous and national, and to constrain and facilitate the circulation of indigenous culture. In New Zealand, the formal recognition by the government of Māori intellectual and cultural property is curtailed by the power-sharing limitations of the settler-colonial state in policing the boundaries of indigenous entitlement. In Vanuatu, where these boundaries are conceived in a more expansive way, the limits are bureaucratic—what can and cannot be implemented given the limitations of a relatively weak government in such a diverse nation, facing the constraints of international pressures to develop along a particular trajectory.

By comparing the similarities and differences in how intellectual and cultural property are made provincial, and indigenized, in Vanuatu and New Zealand, I have also asked you, the reader, to challenge seemingly static models of intellectual and cultural property. In both countries, key actors are fusing international discourses of indigenous rights, cultural heritage, cultural property, and traditional knowledge to create their own brands of IP. Intellectual property becomes the focus of this critique because of the power that it holds within global markets. As the cases of both the auctioning of Māori art(ifacts) and the development of a utopian vision for self-sustainability in Vanuatu, the re-articulation of IP provides a space for a powerful re-envisioning of the market for culture. We then witness another kind of enclosure—that of IP by cultural property regimes. If IP circumscribes indigenous culture in ways that tend to privilege the corporation (*Ethnicity, Inc.*), cultural property provides a framework to explore and expand the possibility of governance within an expanded sphere that might alter the framework of transaction, privileging the community, the intangible, and ideals of value that present themselves as resistant to commodification. The relationship between intellectual and cultural property thus provides us with one last comparative context and a further exemplification of how these categories may in fact alter one another.

A comparative mode of analysis unpacks many of our assumptions about the nature of cultural and intellectual property. These are not just legal and political regimes, they are material and aesthetic instantiations of colonial histories and global interests. They contain dialogues about sovereignty and work to coproduce ideas of indigeneity and identity. By emphasizing the ways in which intellectual and cultural property may be indigenized, I have provincialized an anthropology of property that still makes many judgments about the authenticity of commodification and the market and their relation to indigenous persons. Focusing on the ways in which intellectual and cultural property are profoundly co-opted into grassroots assertions of sovereignty draws attention to *our* own provincialism, the "sovereignty-talk" (Brown 2010) that underpins *our* thinking about the public good, the commons, creative practice, and citizenship. This thinking often remains unconsidered and uncontested in the academic literature, which tends to focus on the forms of resistance and alterity. I have explored this dynamic here in a different way—in places where (indigenous) culture is not the alternative to the market, but increasingly a condition for its existence.

Within this volume, intellectual and cultural property have emerged as powerful imaginaries that are used by communities, often brokered by cultural activists working

in museums, to develop ideas about indigenous sovereignty and alternative economies. Museums themselves are cultural institutions that mediate between the imperatives of their state sponsors and their commitment and obligation to community engagement and direct collaboration. In this way, museums are a perfect ethnographic window into the way in which law is a fluid field of discourse and practice mediated through the institutional authority of the state and through the activities and perceptions of its citizens (Darian-Smith 2007). In all of the ethnographic examples I have developed here, law is present not only as an institutional framework, a way of structuring political authority, and a form of practice that enables (and disables) grassroots participation in the nation—it is also presented as an imagined frame, made malleable by diverse actors who see it as a road for recognition and the attainment of authority and entitlement (Coombe 2004). The ways in which IP and cultural property "work" in Vanuatu and Aotearoa New Zealand is through a continual dialectic between the very possibility of entitlement that law structures and the imagination of possible entitlement that the legal domain promises. In turn, this imagined space recreates the actual ways in which law is articulated, codified, and practiced.

This book has detailed the energy and creativity that indigenous players have put into creating new economic and legal philosophies and practices in Aotearoa and Vanuatu. The key issue that remains at the end of this volume is still one of colonial and postcolonial power. Do these new utopias have the ability to alter the power dynamic that ultimately shapes the distribution of key resources? Are museums such as Te Papa really places that develop new models of cultural property that work for the nation as a whole, or are they places where cultural power is ceded in a limited way as to make the nation "look good"? Does the Vanuatu Cultural Centre and the National Council of Chiefs really have the potential to impact practice and policy in ways similar to the Vanuatu Parliament? Are the Māori protestors buying at auction limiting transactions, or paradoxically does imbuing these objects with greater cultural value serve to merely generate higher prices, to the benefit of key, nonindigenous, collectors?

I am optimistic about the future potential for indigenous people to activate these resources within frameworks of their own making. I am less optimistic about the ways in which this potential will be recognized or enabled by the state. I intended this book to suggest the possibility of alternative relationships between indigenous people and state governance and to open a space for rethinking our assumptions about the boundaries of property. This debate has been built into the constitution of intellectual and cultural property from their conception as legal structures and discourses that mediate a shifting

landscape of form and entitlement. Almost since the start, property rights have been negotiated with indigenous people, who were either conceived as treaty partners or as negated legal beings. These histories continue to play out, inflecting the form of new kinds of property, exchange, and entitlement. But, today, indigenous people have a new kind of voice, a new kind of authority and entitlement, which, while seeking recognition, also requires new kinds of partnership.

Ultimately, the models of cultural property developed within these pages are attempts to envision alternative futures for the relation between state, global market, and indigenous peoples. The cultural interests, political engagement, and identity of indigenous people in Vanuatu and Aotearoa New Zealand are less vulnerable to the fluctuation of global markets than the nation-state that encompasses them. Vanuatu's traditional economy is constituted as an alternative to the failures of international participation to bring monetary wealth to all citizens. The failure of toi iho to generate an income worthy of government investment has not hampered the emergence of a strong visible community of Māori artists, intent on using aesthetics as a way to promote the cultural values of self-determination. In this way, treasured possessions come to mediate between sovereignty and the state, between market and culture, and themselves instantiate a space in between. It is in this space that we can still think about the possibility of alternatives, what they might be, and how they might work.

Notes

Preface

1. These are two real cases that arose in the countries I discuss in this volume: Vanuatu and Aotearoa New Zealand. In the first case, the people of South Pentecost claimed that the Nagol Land Dive, the inspiration for bungee jumping, was their intellectual property and have discussed suing the developer of the bungee jump, A. J. Hackett. Full details of the legal case history can be found at the Pacific Islands Legal Information Institute of the University of the South Pacific, www.paclii.org (accessed January 13, 2011). More tangibly, the Vanuatu National Film and Sound Unit asserted Pentecost Islanders' moral rights to the jump and forbade all documentary filmmaking for the indefinite future until appropriate compensation and consent can be implemented. See the Cultural Research and Filming Policy of the Vanuatu Cultural Centre, online at www.vanuatuculture.org. In the second case, the U.S.-based company Lego produced a series of toys that drew from the iconography and nomenclature of Māori culture heroes. In 2001 a group of Māori people threatened legal action for the perceived trademarking of Māori names. The company had in fact only trademarked the collective name "bionicle" and agreed to stop using Māori words commercially. Since then Lego has not created character names using any living languages.

2. Throughout this volume I use the term *indigenous* to mean the first peoples of territories later subject to colonization, who have experienced the process of being transformed (and sometimes not!) into citizens of a nation-state not initially of their own making, often through violent means. Indigenous peoples may still be living under the rule of colonial states or they may now be independent and self-governing. The terms *first nations*, *first peoples*, *native people*, *native nations*, and *aboriginal* all have their own specific geopolitical origins but, given the focus of this book, which looks at the interface between indigenous and international, I use the nomenclature recognized by the United Nations (UN) in the Declaration of the Rights of Indigenous Peoples.

3. While New Zealand is the official name of this country, following the bicultural framework established in later recognition of the Treaty of Waitangi, the country is frequently referred to as Aotearoa New Zealand. When, on occasion, I only use the term *New Zealand*, this is not just for the sake of brevity, but also in recognition that the state ultimately incorporates its indigenous people. The interchangeable use, throughout this book, of the terms *Aotearoa* (most commonly translated from Te Reo Māori as the Land of the Long White Cloud), *Aotearoa New Zealand*, and *New Zealand* should therefore be read as strategic, aiming to draw attention to the imbalances in how New Zealand is constituted as a "bicultural" nation.

1 Mapping the Terrain

1. The list of LDCs (Least Developed Countries) created by the United Nations has charted countries that exhibit the lowest indicators of socioeconomic development. The "knowledge economy" is an expression coined by Peter Drucker (e.g., 1969: chap. 12) that refers to an economy based on knowledge, an extension of the information society—the most developed economy of late capitalism. See www.dol.govt.nz (accessed March 25, 2011).

2. See the *Declaration on the Importance and Value of Universal Museums* (2003), signed by the directors of a number of major institutions, including the British Museum and the Metropolitan Museum of Art. The *Declaration* can be read at www.tomflynn.co.uk (accessed April 1, 2011). See also Prott (2009).

3. In 1997 UNESCO adopted a draft resolution proposing the creation of an international distinction for the manifestation of intangible cultural heritage and associated cultural spaces. The first *Proclamation of Masterpieces of the Oral and Intangible Heritage of Humanity* (UNESCO, with the Vanuatu Cultural Centre 2000) was issued in 2001, with subsequent proclamations in 2003, 2005, and 2009, which collectively identified a list of ninety outstanding examples of the world's intangible cultural heritage, including Brazilian samba, the Costa Rican oxcart and ox-herding traditions, and the cultural spaces of the Bedu in Petra and Wadi Rum.

4. The Intangible Cultural Heritage Convention's emphasis on practice and process may be seen to combat the problematic objectification of cultural heritage, with its more narrow focus on monuments and museum pieces, which in turn seem to be more rigidly owned within the rubric of private property rights (Kirshenblatt-Gimblett 2004). If some museum directors can strenuously assert the rights to own cultural heritage from other places using a model of private property (e.g., Cuno 2008), the ideal of intangible cultural heritage, with its initial reference to living cultural treasures (venerated cultural practitioners) of Japan, defies ownership in this way. As Bendix and Hafstein (2009) point out, "The subject of cultural property is by default exclusive, subject to misappropriation and entitled to restitution; the subject of cultural heritage tends rather to be an inclusive subject, a collective 'we' that is entreated to stand together to prevent degradation and loss rather than theft by an other" (2). Of course, this "we" still presumes a kind of property relation: one that both constitutes and relies on the logic of nationalism, and which may also stand as other to the interests and claims of indigenous peoples. See also Hafstein (2004), Brown (2005), Byrne (2009), Marrie (2009), Smith and Akagawa (2009), and Alvizatou (2011).

5. See, for example, Harrison (1992, 1999, 2002), Foster (1998, 2002), Carrier (1998), Strathern (1999, 2001a), Kalinoe and Leach (2001), Sykes (2001), Hirsch (2002), Kirsch (2006), and Moutu (2007, 2009).

6. Papua New Guinea (and particularly the Highlands region) has often been used as a metonym for Melanesia despite the obvious particularities of its history, geography, and political makeup. Recent volumes by Bell and Geismar (2009) and by Hviding and Rio (2011) seek to expand the focus away from Papua New Guinea to develop a more accurate and expanded sense of Melanesia with an additional focus on the Solomon Islands, Vanuatu, Fiji, and New Caledonia. At the same time, despite the regional emphasis of this volume, it is important to acknowledge nuanced differences throughout the region. The "place" of Melanesia—with its paradigmatic anthropological associations with gifts, big men, spectacle, conspicuous consumption, and weak states—in fact has intense regional variation.

7. For instance, Leach says of his work in Papua New Guinea, "There is a particular conception of integrity and continuity, a relevance based on the needs of the state, or individual identity, embodied in the notion of cultural property which, I contend, denies the creativity that Nekgini speakers see as inherent in the practices of 'kastom.' This in turn rests upon a contrast in assumptions about the relationship between objects and persons entailed in the UNESCO notion of cultural property, and the Nekgini notion of 'kastom' " (J. Leach 2003: 124; see also Aragon and Leach 2008). Harrison (1992) comments, "Western intellectual property law seeks to define products of human creativity that can be alienated from their creators and exchanged for other commodities in a system concerned with establishing the relative values

of the objects exchanged. In Papua New Guinea, the ownership of intangibles does not necessarily include the possibility of alienation, and the exchange of intangibles does not determine their value" (234). Other examples of this dualistic perspective can be found in the work of anthropologists (e.g., Harrison 1993, 2000; Leach 2000, 2003) and activists (e.g., Posey and Dutfield 1996; Linda Smith 1999) as well as policy advisors, lawyers, and other commentators working both in the Pacific and beyond (e.g., Lindstrom and White 1994; Secretariat of the Pacific Community 1999; Whimp and Busse 2000: 19; Janke 2003; van Meijl 2009b). In recent years, thorough ethnographic engagement, in the Pacific and beyond, has demonstrated that the boundaries between archetypal property forms, such as gifts and commodities (and, by extension, the forms of sociality that they are perceived to engender) are not as well delineated as many originally conceived (e.g., Gregory 1982; Strathern 1988; Weiner 1992; Godelier 1999; Mauss [1923–24] 2000) and that an intrinsic entanglement of alienation, animation, and ambiguity characterizes exchange domains such as those of currency (Foster 1998; Akin and Robbins 1999) or the ownership and production of cultural identity (Battaglia 1995; Errington and Gewertz 2001). Despite the sensitivity of this ethnographic work, categories of gifts and commodities remain profoundly polarizing yet are also fertile grounds for rethinking economic relationships in cultural context.

8. For instance, willingness to countenance indigenous involvement at the level of policy has pushed the WIPO into taking its UN obligations more seriously, exemplified by its advocacy to reconnect IP to a human rights framework in many nation-states, in the academy, and in the work of nongovernmental organizations.

9. Traditional knowledge (TK), traditional cultural expressions (TCE), and expressions of folklore (EoF) are discussed mainly under the auspices of the WIPO within the Intergovernmental Committee on Intellectual Property and Genetic Resources, Traditional Knowledge, and Folklore that became operational in 2001. "WIPO has used the term 'Traditional Knowledge' to refer to tradition-based literary, artistic or scientific works; performances; inventions; scientific discoveries; designs; marks; names and symbols; undisclosed information; and all other tradition-based innovations and creations resulting from intellectual activity in the industrial, scientific, literary or artistic fields. The notion 'tradition-based' refers to knowledge systems, creations, innovations and cultural expressions which have generally been transmitted from generation to generation and that are generally regarded as pertaining to a particular people or its territory, that have generally been developed in a non-systematic way and that are constantly evolving in response to a changing environment" (Kongolo 2008: 34). See also Anderson and Torsen (2010).

10. Bislama is Vanuatu's national creole that emerged initially as a language of international trade. Bislama is a reference to the much-coveted sea cucumber, or *bêche-de-mer*.

11. Here I draw on Geertz's discussion of law as "part of a distinctive manner of imagining the real" (1993: 184).

12. While the focus of this book is the Pacific region and the unique forms that indigenization takes there, many other regions are developing and implementing similar indigenizations of property regimes and modes of governance. See, for example, de Sousa Santos on broader rethinking of Western governmentality (2009a, 2009b) and also Postero (2007), Lazar (2008), Goodale (2009), and de la Cadena (2010), who all describe the emergence of a mainstream "indigenous" government in Bolivia, as other examples.

13. Structural adjustment is a development policy instituted by the International Monetary Fund and World Bank in which debt is restructured through loans that contain specific conditions regarding economic development. Such programs have been criticized for implementing free-trade and free-market policies and for pushing deregulation and privatization in ways that are more ideological than ideal for the overall economic well-being of the citizens of developing countries.

14. Ethnographic here means a documentation of the everyday deliberations, negotiations of context, cultural complexity, and polyphony through which property relations are constructed.

15. In this sense, the idea of "cultural context" for property is actually a red herring—property, by definition, contains its own context and its own culture (see Strathern 1981; Bodenhorn 2004).

16. See, for example, this acknowledgment, here a blatant celebration, of the geopolitics of the TRIPS agreement: "In response to this ongoing and massive foreign taking of U.S.-owned intellectual properties, the United States has championed the creation of a new body of international laws and protections, called the Trade Related Intellectual Property System (TRIPS), which is administered by the World Trade Organization (WTO). The initiative for creating TRIPS came from two U.S. corporate C.E.O.s, John R. Opel of IBM and Edmund T. Pratt Jr. of Pfizer pharmaceuticals, more than twenty years ago. Working together and behind the scenes, these two visionaries led a decade-long campaign that in the mid-1990s imposed a U.S style system of intellectual property laws on almost all other nations. . . . If this new global regime works, *the protection of intellectual properties owned by Americans and creative people everywhere* will be strengthened. It will be one of the twentieth century's great successes in international law and foreign relations" (Choate 2005: 18; emphasis added).

17. Personal communication, October 29, 2007.

18. For instance, in its initial British incarnation, the Statute of Anne (1710) aimed to limit the monopolies of the printing presses by promoting the rights of authors and prohibiting the uncompensated copying of literary works, but in fact it worked to the advantage of the Stationer's Company, extending the terms of *their* copyrights (Aoki 1996: 1329).

19. I use a working definition of sovereignty following that of the Declaration on the Rights of Indigenous Peoples and the Treaty of Waitangi (or interpretations thereof), which assert that sovereignty is the right to self-determination in place and exists in uneasy relationship to concepts of governance. Aoki notes that "sovereignty was a double-edged sword, particularly when the pattern of sovereignty premised on territorial exclusivity within politically drawn boundaries acted *within* the sovereign nation-state against its own citizens" (1996: 1312). Agamben notes that there is a fundamental paradox of sovereignty following Schmit's definition of the sovereign as "he who decides on the state of exception" (1998: 11). Thus, there is the inherent paradox for indigenous peoples, such as Māori, who define themselves as entitled through their exceptional status. They, in turn, redefine the boundaries of such exceptionalism as it is encompassed by the nation-state (see also Povinelli 2002).

20. Morales's model for mobilizing Bolivia's gas resources is a good example. Also see Comaroff and Comaroff (2009) for numerous accounts of the ways in which "ethnicity, inc.," offers both dead ends and fruitful avenues for empowerment and emancipation.

21. Here I draw on Les Field's work on abalone as an inspiration. His work takes the material complex of native engagements with abalone in California as a starting point to investigate the ways in which connections to complex resources reflect crucial interpretive issues around "recognized status and . . . the sovereignty over their cultural identities" (2008: 25) and in turn how enmeshed sovereignty is for indigenous peoples' connection to these kinds of objects.

22. For example, the Zuni Museum chose to use the term *museum* only in order to raise funds, feeling dissatisfied with the colonial connotations of that word (Isaac 2007: 104). Many other institutions prefer to call themselves cultural centers, speaking *with* communities, rather than museums, which are historically presumed to speak *for* communities.

2 Mapping the Terrain

1. MacClancy (2002) and Bonnemaison (1994) give comprehensive histories of the archipelago, and a sophisticated high school syllabus developed by the Vanuatu Kaljoral Senta (Lightner and Naupa 2005) draws on documentary and archival resources as well as oral history. Miles (1998) compares British and French styles of colonialism, and Harrisson (1937) gives a lucid account of the early days of colonialism. Valjavec (1986) provides an overview of anthropology in Vanuatu until the research moratorium of 1985; Bolton (1999b) and Tryon (1999) give overviews of anthropological research during the 1990s.

2. I discuss the etymology and resonance of the category of kastom, the Bislama term glossed as "indigenous tradition," in greater detail in chapter 6.

3. Only some parts of the archipelago had indigenous hereditary chiefs; others had a political

structure of status achieved over a lifetime of ceremonial activity (see Bolton 1999c: 2).

4. The Phoenix Foundation was a libertarian enterprise founded by a U.S. investor named Michael Oliver in 1975. After several failed attempts to found libertarian republics (in Tonga and the Bahamas), the foundation turned its sights to Vanuatu, where it invested heavily in the secessionist movement headed by Jimmy Stevens by providing a constitution, currency, flag, passports, and radio station. The uprising was eventually squashed through the intervention of the Papua New Guinea Defence Force, and the foundation lost its chance of forging a capitalist paradise in the Pacific Islands.

5. At the time of writing, October 2012, 100 Vatu is just under US$1.

6. I have reproduced this as it was presented by the Waitangi Tribunal Web site (www.wait angi-tribunal.govt.nz), that is, without the usual macrons used in contemporary Māori orthography.

7. "The declaration is a short handwritten document of four articles. It states that all sovereign power and authority in the land (Kō te Kīngitanga kō te mana i te w[h]enua) resided with the chiefs 'in their collective capacity,' expressed as the United Tribes of New Zealand. It also states that the chiefs would meet annually at Waitangi to make laws. In return for the 'friendship and protection' that Māori were to give British subjects in New Zealand, the chiefs entreated King William IV 'to continue to be the parent of their infant state' and 'its Protector from all attempts upon its independence.'" This text has been taken from the official translation provided by Archives New Zealand (http://archives.govt.nz).

8. This is not to diminish the importance of tribal politics that maintain distinctly localized frameworks in which many indigenous people in Aotearoa will not refer to themselves as Māori, but as Tūhoe, Ngā Puhi, Ngāi Tahu, and so forth. This very real sense of separation is a powerful frame, but here I focus on the frame of unity, which uses the overarching idea of indigeneity as both a bargaining strategy with, and a form of resistance to, the power of the Crown.

9. The Māori Land Court Te Kooti Whenua Māori (formerly the Native Land Court), which oversees cases pertaining to Māori-owned land, is the only Māori judicial court dedicated to Māori affairs and is answerable to the Ministry of Justice and to the Ministry of Māori Affairs. The initial role of the Land Court was to define the land rights of Māori people under Māori custom and to translate those rights or customary titles into land titles recognizable under European law. However, it was often used as a vehicle for colonial exploitation and for the programmatic alienation of Māori land (e.g., the transference of land into a commodity that could then be alienated).

10. The Māori population declined from 47,330 in 1874 to 46,141 in 1881 (Dalziel 1997: 104).

11. The official assessment of who is Māori in Aotearoa New Zealand has shifted over the years

away from evaluation by degrees of "blood" or the identity of family members to definitions based also on affiliation and self-identification. Since 1986 it has been possible to identify with more than one ethnic group on the census. In the 2006 census, 643,977 people (17.7 percent of the total population) said that they had Māori ancestry but 565,329 (15 percent) identified with the Māori ethnic group.

12. *Rangatiratanga o te moni* is the Māori term for capitalism.

3 Indigeneity and Law in the Pacific

1. Trask defines settler colonialism as a "society in which the indigenous culture and people have been murdered, suppressed, or marginalized for the benefit of settlers. . . . In settler societies, the issue of civil rights is primarily an issue about how to protect settlers against each other and against the state. Injustices done against native people, such as genocide, land dispossession, language banning, family disintegration, and cultural exploitation are not part of this intrasettler discussion and are therefore not within the parameters of civil rights" (1999: 25).

2. The paradox of settler colonialism is that it produces indigenous people (as people whose subject position is forcibly altered into an exceptional minority), but it also produces a profound sense of inauthenticity. Critiques of the tribal basis of indigeneity, such as that of Hanson (1989), in which he argues that Māori culture is an "invented tradition," may seem rational within the academy, but they become extremely painful in the settler colony (see Lindstrom and White 1994; Trask 1991, 1999).

3. In 1999, out of a total population of 186,678, ni-Vanuatu numbered 184,329, with other ethnicities (primarily Chinese, Australian, Other Pacific, Vietnamese, New Zealanders, French, and British) numbering 2,349. Ni-Vanuatu therefore were 98.7 percent of the total population (Vanuatu National Statistics Office 2000b). Vanuatu does not recognize dual nationality. Citizenship may be extended to people of French, British, Vietnamese, Chinese, and other descent, and persons who have lived in the country longer than ten years may apply for the status of ni-Vanuatu but must renounce citizenship elsewhere.

4. Alex Golub ("Rex") recently commented in a blog posting (2010) on the site *Savage Minds*, "But in fact Papua New Guineans are indigenous only in the (often oppressive) eco-authentic sense: they are brown, they have 'exotic' languages and cultures, and they live in a place full of endangered species of animals. They are not, however, 'indigenous' in the much more important political-emancipatory sense: there is (and was) no real settler colonialism in Papua New Guinea, no large scale expropriation of land, and not even an ethnic majority to oppress minority groups. Despite how easy it is for outsiders to shoe horn Papua New Guinea into popular and easy paradigms of indigenous struggle, such a construal of Papua New Guinea's story does not do the

country justice." He argues that Papua New Guineans should insist on being "citizens, not indigenes." In my own comment to this posting, I observed that this perspective negated the force and utility of the term *indigenous* at national, regional, and international levels and that indigenous rights are always first and foremost the rights of citizens. They are not mutually exclusive. Golub's point underscores that many people take a reductionist view of the indigenous rights movements, focusing on their epistemic inconsistencies rather than their political realities.

5. See the web site (www.lesterhall.com) of the Pākehā artist Lester Hall for a visual articulation of Pākehā identity and critique of indigeneity.

6. This perspective emerged within the Critical Legal Studies Movement of the 1970s (see Unger 1986), which itself was formative for both legal anthropology and law and society. See also Donovan and Anderson (2003), Merry and Brenneis (2003), Wastell (2007), Riles (2004), Moore (1978, 2001, 2005), and Merry (1988). These works outline a trajectory by which law is recognized to be not just a series of rules and regulations enforced from the top down, but a form of discourse, culturally determined and socially pliable, subject to multiple agencies and interpretations, and politically contingent.

7. All countries in the Pacific Island region have laws emanating from several different sources. Vanuatu has a written constitution considered to be "supreme law"; written legislation from colonial legislatures; postcolonial written legislation; written legislation enacted by the legislatures of both France and the United Kingdom; and locally and unwritten rules of both custom and common law (Corrin-Care and Paterson 2007: 5). New Zealand follows the common law tradition. Its "constitution" is comprised of unwritten constitutional conventions, parliamentary statutes, treaties, letters patent, court decisions, and Orders-in-Council. The country was established as a constitutional monarchy that recognized the British Crown as sovereign under the Act of Settlement of 1701 (her person represented in New Zealand by the governor general). However, the Statute of Westminster Adoption Act of 1947, later repealed by the Constitution Act of 1896, gave New Zealand full parliamentary autonomy while maintaining the queen of the United Kingdom as the queen of New Zealand (Brookfield 2006: 85).

8. Article 95(3) of the constitution states, "Customary law shall continue to have effect as a part of the law of the Republic." Customary law is therefore formally provided for within written law, but little guidance is given the courts as to the situations when customary law should be applied, or how it is even to be recognized on a case-by-case basis (Corrin-Care and Paterson 2007: 52). For the most part, the state law courts have chosen not to turn to "customary law" (as they recognize it) in their rulings, nor is there a parallel structure that codifies customary law in ways similar to state law (see Forsyth 2009a: 162). As Corrin-Care and Paterson point out, "Since the constitution authorises the making of laws by Parliament, customary law may be viewed as subordinate to the provisions of Acts of Parliament of Vanuatu" (2007: 55).

9. Since independence the other legal frameworks recognized by the constitution are Acts of Parliament of Vanuatu; Joint Regulations in existence on July 30, 1980—which continue in force until repealed by the Vanuatu Parliament; British and French laws in existence on July 30, 1980—including Acts of Parliament, subsidiary legislation and English common law and equity, which continue in force until repealed by the Vanuatu Parliament; and the (unwritten) customary laws of Vanuatu (Corrin-Care and Paterson 2007). While French law remains a potential source, it is infrequently referred to or used (Jowitt 2008), and the British law under operation is frozen in time to 1980.

10. There are many differing perspectives on, and definitions of, legal pluralism. For some the term connotes a perspective on law that considers it more broadly than a "legal centrist" perspective—taking into account the diversity of different authorities, both institutional and informal, and systems that adjudicate disputes and allocate legal authority in any society (see Griffiths 1986 and Merry 1988 for discussion of different perspectives following the publication of Griffiths's seminal article). For others the term does not account sufficiently for the power differentials that should distinguish state from other legal frames in terms of any experience of law. As Moore (2001: 107) notes, today pluralism can refer to the ways in which the state recognizes other social fields as sources of "law"; to internal divisions and diversities within state infrastructures; to international and transnational legal instruments that may compete with the state nationally (e.g., the European Union); to the presence of nongovernmental agencies and their impact on the field of law; and to "the ways in which law may depend on the collaboration of non-state social fields for its implementation; and so on."

11. Sorcery's unruliness and problematic moral position draw it into a relationship with Christianity (another, perhaps the most dominant, moral authority in Vanuatu) as well as law. Rio (2010) recounts the case of a young Malakulan girl found dead on the floor of a local disco. The case precipitated accusations of sorcery and a series of legal debates around sorcery that eventually ended up with a conviction of the accused from the Supreme Court (the only sorcery case to date to enter that domain). The decision was based more on Christian principles of overcoming the presence of the devil than on any evidence-based decision (194–195). This case highlights the ways in which the state legal system itself is not necessarily "out" of kastom. Like those who practice sorcery, its participants are jurists, lawyers, churchgoers, and traditional authorities (see also Rousseau 2008).

12. In the case of both the mountain and the pounamu, Ngāi Tahu were given symbolic ownership but were not given total rights of disposal. What does this tell us about the relationship between property and sovereignty? That the interpretation of Article II of the Treaty separates sovereignty from governance, with the implication that ownership can be divided between symbolic possession and the right to mobilize resources. Ngāi Tahu are the

traditional custodians of pounamu, but they are not able to determine who can mine several of the deposits of the South Island, which remain in the charge of the government.

13. For instance, the pan-Māori fisheries settlements require that iwi comply with certain principles of organization (e.g., a registry of members, a trustlike structure, and so forth) in order to receive settlements. Given the dispersal of Māori between rural and urban areas and the challenges to delineate authentic indigenous identity, one may see how something as seemingly innocuous as an iwi registry might have reverberating political and social consequences. In turn, there are also implications in conceptualizing iwi members as shareholders rather than members of a social community or political unit.

14. The six iwi are Ngāti Kuri, Ngāti Wai, Te Rarawa, Ngāti Porou, Ngāti Kahungunu, and Ngāti Koata.

15. The full version of the Act is at www.legislation.govt.nz (accessed October 12, 2012).

16. For instance, Article 8j of the convention states: "Each contracting Party shall, as far as possible and as appropriate: Subject to national legislation, respect, preserve and maintain knowledge, innovations and practices of indigenous and local communities embodying traditional lifestyles relevant for the conservation and sustainable use of biological diversity and promote their wider application with the approval and involvement of the holders of such knowledge, innovations and practices and encourage the equitable sharing of the benefits arising from the utilization of such knowledge innovations and practices." Available at www.cbd.int/traditional/ (accessed January 13, 2011).

17. Notable examples are the Australian Native Title Act of 1993, adopted when unique laws were needed to deal with the overturning of *terra nullius*, and database protection laws (for example, the European Union has adopted legislation to provide sui generis protection preventing unauthorized use of data compilations).

18. It was developed by a series of regional groups in which Vanuatu was a member (the Pacific Islands Forum Secretariat, Secretariat of the Pacific Community [SPC], Secretariat of the Pacific Regional Environment Programme ([SPREP]), and the UNESCO Pacific Regional Office with the input of WIPO).

19. The Model Law for the Protection of Traditional Knowledge and Expressions of Culture is a draft law establishing a new range of statutory rights for traditional owners of traditional knowledge and expressions of culture. If an individual country wishes to enact the model law, it is free to adopt and/or adapt the provisions as it sees fit in accordance with national needs, the wishes of its traditional communities, legal drafting traditions, and so on. Matters of detail or implementation are left to be determined by national laws and systems.

20. The National Māori Congress (Te Whakakotahitanga o ngā Iwi o Aotearoa) was formally established on July 13, 1990, by the United Tribes of Aotearoa New Zealand. The Congress is

made up of forty-five participating tribes and bodies and was established in order to create a national body, administratively independent from the government.

21. The Draft Declaration was debated extensively within the permanent forum for indigenous peoples and within the United Nations as a whole. The most virulent opposition to it came, perhaps not surprisingly, from the settler-colonial nations of Australia, New Zealand, Canada, and the United States, who were the only four member states to vote against the Declaration. (On July 7, 2009, the New Zealand government announced that it would support the Declaration.) On Thursday, June 29, 2006, the Human Rights Council adopted the Declaration on the Rights of Indigenous Peoples and recommended its adoption by the General Assembly. (It was adopted during the sixty-second session of the United Nations on September 13, 2007.)

22. Article 31 of the UN Declaration determines, first, that indigenous peoples have the right to maintain, control, protect, and develop their cultural heritage, traditional knowledge, and traditional cultural expressions, as well as the manifestations of their sciences, technologies, and cultures, including human and genetic resources, seeds, medicines, knowledge of the properties of fauna and flora, oral traditions, literatures, designs, sports and traditional games, and visual and performing arts. They also have the right to maintain, control, protect, and develop their IP over such cultural heritage, traditional knowledge, and traditional cultural expressions. Second, Article 31 determines that, along with indigenous peoples, states shall take effective measures to recognize and protect the exercise of these rights. See the United Nations Declaration on the Rights of Indigenous Peoples, available at www.un.org (accessed August 1, 2011).

4 : Copyright in Context

1. There was a great deal of contention about Vanuatu's accession to the WTO. Despite the agreement of Parliament, grassroots pressure from multiple avenues—including the National Council of Chiefs and the Vanuatu Christian Council—developed into a movement, "Say no to WTO." The president of Vanuatu refused to sign the Protocol of Accession in an attempt to stymie Vanuatu's formal accession, claiming that it would not be legal until he did. The government appealed his decision in the Supreme Court and he was eventually required to sign the Agreement. Vanuatu joined the WTO in August 2012.

2. See UNESCO (1970, 1999, 2005). Prior to the passing of the Copyright Act there were no specific legal mechanisms protecting ni-Vanuatu intellectual property rights (IPR) outside of the country. Supporting internal legislation was in place within the Vanuatu National Cultural Council Act, the Preservation of Sites and Artifacts Act, the Island Courts Act, and

elements of the criminal code (i.e., on the desecration of graves). The policy of the National Council of Chiefs (see Bongmatur 1994) and the *Vanuatu Cultural Research Policy* (Vanuatu Cultural Council 1997, currently being updated) had also initiated discussion about IPR, particularly in relation to kastom. The research policy, understood as a sui generis way of extending traditional copyright to traditional knowledge, was drafted in 1995 after the lifting of a ten-year moratorium on all foreign sociological, scientific, and ethnographic research, due in part to disaffection with certain researchers and in keeping with a drive to give ni-Vanuatu the rights to conduct, create, and present their own research.

3. For instance, in 1993 the Convention of Biological Diversity (Ratification) Act No. 23 of 1992 entered into force, creating obligations to legislate nationally for the protection of Traditional Biological Knowledge, adhere to prior informed consent, and access benefit sharing when accessing biological resources in scientific research. As the ni-Vanuatu lawyer Marie Hakwa comments, "This greatly affects the traditional 'norms' relating to copyright and patenting of innovations and practices based on TBK" (2003: vi).

4. In addition to the Copyright and Related Rights Act, new Trademarks, Designs, and Patents Acts have all been passed by the Vanuatu Parliament.

5. Part 7 of the Act, the "Offence in Relation to Expressions of Indigenous Culture," deals with the "Offence to Contravene Custom." Section 41(1) decrees: "If a person does an act of a kind mentioned in subsection 8(1) or 23(1) in relation to an expression of indigenous culture (for example, *reproduces an indigenous carving in material form*) and the person: (a) is not one of the custom owners of the expression; or (b) has not been sanctioned or authorised by the custom owners to do the act in relation to the expression; or (c) has not done the act in accordance with the rules of custom; the person is guilty of an offence punishable on conviction by a fine not exceeding 1,000,000 Vatu [$8,800] or a term of imprisonment not exceeding one year, or both" (Republic of Vanuatu 2000: 32; emphasis added). Despite the expansiveness of the category of "expression of indigenous culture," it should also be noted that, unlike the ownership of land in the constitution, the provisions of the Copyright Act do not grant perpetual ownership to custom owners rather lifetime plus fifty years following more generic documents that emphasize "private" ownership rights rather than "collective" ownership rights.

6. In turn, the presence of the colonial body of law may also provide avenues for the assertion of copyright and other IP regimes. As Forsyth (2009b) comments, "There is therefore an argument to be made that the *Copyright Act 1956* (UK) (including amendments up until 1976) theoretically applies" (1).

7. In this chapter, I focus on the most material form of IP, copyright. Strategic analogies have also been forged around patents in Vanuatu, for instance, in the Kava Act No. 7 of 2002, which

patents local kava knowledge and production (I thank Lamont Lindstrom for drawing my attention to this legislation), as well as more generic patent, trademark, and design legislation. Whereas previous academic analyses of copyright in Vanuatu have drawn an analogy between the ceremonial creation and enforcement of a multitude of rights, many of which are required to reproduce knowledge and maintain social and political hierarchies (e.g., Lindstrom 1990: 72; Huffman 1996), Marilyn Strathern has noted that such analogies may on occasion be inappropriate. For instance, in her subtle discussion of New Ireland Malanggan (2001b), she notes that although the production of Malanggan carvings is commonly considered to be governed by an indigenous copyright system (see Gunn 1987), indigenous exegesis suggests that the true locus of Malanggan is in the mind of the producer, rather than in the form of carved wood (see Küchler 1987, 1992). Here, the emphasis on intangible individual creativity within patent legislation might be a more appropriate form of comparison than the more material emphasis of copyright law. Although Strathern is at pains to point out that New Irelanders "do not think of Malanggan as inventions (application of technology) nor as describing the original inventive step (patents)" (2001b: 15), copyright (and its neo-Melanesian transliteration *kopiraet*) is a term that has passed into common parlance throughout the Pacific Islands, even for some Malanggan producers. My discussion of copyright in Vanuatu therefore follows this locally drawn analogy and use of copyright terminology. I develop the term *analogy* here because it presupposes both similarities and differences between compared entities.

8. See the Web site for the Commission on Intellectual Property Rights (www.iprcommission .org/graphic/about.htm).

9. Huffman (1996), Lindstrom (1997), and Rio (2002), among others, have linked the ceremonial creation and enforcement of a customary entitlement to the category of copyright. In addition, copyright has provided a narrative framework to assertively respond to the expansive incursions of nationalization and increased tourism into villages (e.g., Bongmatur 1994; Jolly 1994b).

10. All filming of the Land Dive has now been banned (except for that by indigenous filmmakers) as the people of South Pentecost work out how to map their "copyright" claims onto royalties for the imagery of the divers in film, video, and television. "The Vanuatu Cultural Centre, the institution mandated to regulate commercial filming of cultural subjects in Vanuatu under section 6(2)(l) of the 'Vanuatu National Cultural Council' act (chapter 186 of the Laws of the Republic of Vanuatu) has declared a moratorium or ban on all commercial filming by foreign film companies of the Nagol or Pentecost land dive ceremony, effective from the 1st of January 2006. This moratorium has been declared in response to growing concerns about the increasing distortion of this traditional ceremony due to growing commercialization and about the lack of transparency in the distribution of fees paid by foreign film companies to communities to

film this event. This moratorium has been declared after consultation with chiefs, community leaders and the Member of Parliament for South Pentecost" (see www.vanuatuculture.org [accessed July 2, 2009], and www.paclii.org.vu regarding the case of the Nagol Jump [1992] VUSCS; [1980–1994] Van LR 545).

11. The generic term *nimangki* (or *namanggi*; see Crowley 1995) is not entirely uncontested. The presence of this term in the Bislama lexicon exposes an academic bias toward the graded society of southern Malakula, on which much linguistic and anthropological research has focused (e.g., Deacon 1934; Charpentier 1982). To add to the confusion, Nimangki (with a capital N) is also the proper name for the local graded society of southern Malakula, as Maghe is for North Ambrym. In this book, I use the term *graded society* because of its general salience within the ethnography of the region (e.g., see M. Allen 1981b). At present, the term *nimangki* is used as a self-conscious construction of regional identity mainly by people of Malakula and Ambrym (both in town and island) when talking in Bislama. It is also used within the Vanuatu Cultural Centre (which focused much of its early work on the island of Malakula) and is gradually becoming more widespread in Port Vila. Lissant Bolton (personal communication, September 2002) has commented that nimangki is not much recognized on Ambae and in other parts of northern Vanuatu, where the graded societies nonetheless share many basic configurations with those of Malakula and elsewhere. Thus, I acknowledge that nimangki is only a partial, tentatively national, description. Nevertheless, I hope that this confusing nomenclature elicits some tensions in perspective that increasingly inform national appreciations of local practices and vice versa as well as the importance of the North Central region of Vanuatu in formulating national categories such as copyright.

12. Rivers (1914); J. Layard (1928, 1942); Deacon (1934); Patterson (1976, 1981, 1996, 2002); M. Allen (1981a, 1981b, 1984); Blackwood (1981); Jolly (1991, 1994a); Bonnemaison (1996); and Huffman (1996), among others, have all described the diversity of ceremonial transaction that constitutes customary male status in the region. Much of this work has been as concerned with the interconnections between graded societies as a regional complex as it has with describing any one particular society. For instance, Rivers (1914), Deacon (1934), and J. Layard (1942) all attempted to grapple with the diffusion of the ceremonial complexes of northern and North Central Vanuatu. Arthur Bernard Deacon (working in South West Bay) and John Layard (working on the small island of Atchin) both considered Malakula to be the origin point for the dissemination of a graded society to neighboring islands, respectively termed Nimangki and Maki (see J. Layard 1942: 689–692, 696). This understanding is reiterated by ni-Vanuatu from Malakula and Ambrym in the present day and informs contemporary copyright claims in both southern Malakula and North Ambrym (see Geismar 2003a: chap. 5). Some evidence, however, indicates that a few Malakulan titles may have been introduced from

Ambae and North Pentecost in the nineteenth century (J. Layard 1942: 380–381; Jolly 1991: 51). Nevertheless, a general consensus prevails in both written literature and oral history that southern Malakula was the origin point for a graded society that was exchanged throughout Malakula, to Epi, Paama, and through West to North Ambrym (see Huffman 1996: 190). It is the final end point of this particular series of transactions, in North Ambrym, to which I refer throughout this chapter; indeed, North Ambrym is famed throughout Vanuatu for its tradition of importing "culture" from other places.

13. Although female counterparts for these hierarchical systems often exist, they are not linked to a public discourse of copyright, and in general, the public stratification of entitlement in Vanuatu remains an exclusively male preserve in accordance with highly conventional gender divides. In addition, knowledge of these ritual systems, both male and female, is generally restricted to the initiated. Many anthropologists have written on the topic, and more importantly, ni-Vanuatu fieldworkers are currently maintaining and documenting their own traditions in a way that is culturally appropriate. I position myself as an uninitiated woman. I do not attempt to give any detailed description of the Maghe, or any other graded society, but focus instead on the most public elements of the complex as they emerged in relation to ideas about copyright for men and women throughout Vanuatu. Gender is of prime importance in the regulation of entitlement, as will be seen later in the case of an expatriate female dealer. A detailed consideration of this topic, however, is beyond the scope of this book. Here I simply note that the copyright complex I discuss has emerged in relation to male authority and material culture. I discuss more of the nuances of copyright and gender in Geismar (2005).

14. The practices of the graded societies have been widely affected by the advent of both Christianity and colonialism. For example, Knut M. Rio (2002: chap. 1) reports that in North Ambrym, Maghe is rarely practiced in full (see also Jolly 1982 for discussion of the impacts of Christianity and kastom on Pentecost), and Ralph Regenvanu commented to me that "there is now no recognized ultimate custom authority on Ambrym anymore . . . and each camp is interpreting *kastom* in its own interest—the common ground of understanding about *kastom* is rapidly growing smaller" (personal communication, February 15, 2002). Here, I focus on some ways in which ideas about the graded society are galvanized in the present, without entering into debates about customary authenticity or providing a historical account of ritual practice.

15. Vertical slit-drums are a crucial musical and visual component of many ritual ceremonies and are an intrinsic part of the ceremonial (and public) spaces of every North Ambrym village. At the same time, they have a higher national and international profile than any other kind of artifact in Vanuatu; North Ambrym slit-drums and ranked figures are prominent within public spaces throughout Port Vila. They are prominent as public carvings in Nouméa, the capital city

of the neighboring French territory of New Caledonia, and have been collected by museums worldwide. The success of these carvings in a plethora of contexts has precipitated increased local interest in establishing exclusive entitlements to both produce and circulate kastom in widening spheres of exchange. Guiart (1950, 1953, 1956), Clausen (1960), Patterson (1976, 1996), Patand-Celerier (1997), and Rio (1997, 2000) give detailed accounts of the history and iconography of vertical slit-drums of North Ambrym.

16. It is also important to realize that the precedents set by the legal claims of nearby indigenous communities have been very influential, most notably the ways in which Aboriginal Australians have reframed their relationship to their production of sacred imagery by explicitly drawing on copyright law.

17. In Fean, the language of North Ambrym, the word for copyright is given as *namyelku*, but the transliteration *kopiraet* is used increasingly even when people speak in their local language. I conducted research in Bislama rather than in North Ambrym language. This does not negate the vitality of the terms copyright or kopiraet to local reckonings of authority as they increasingly take place within the zone of nation and beyond, requiring the use of Bislama over the local language for communication.

18. Throughout this discussion I refer to Bongmatur as Chief Willie, as do most people in Vanuatu.

19. In requesting that I transcribe his genealogy in 2001, Chief Willie built on life histories that he had already recounted to Bolton in 1997 (published 1999c) and to Lindstrom in 1992 (unpublished; see also Macdonald-Milne and Thomas 1981). These accounts provide a more detailed commentary on Chief Willie's life.

20. The presence of the half a million U.S. troops (see M. Rodman 2001: 108) stationed in the archipelago during World War II inspired a boom in the production of trinkets for the market—bows, arrows, grass skirts, and so on. The relative isolation of the North Ambrym region, however, and the conversion of locals to Christianity en masse only in the 1970s meant that systematic commercialization of kastom carvings did not occur until the numbers of tourists started to increase with the growth in air travel and the (limited) development of tourist infrastructures in the islands. Although Vanuatu has by no means been developed to support mass tourism, the revenues brought in by local ventures—small island-style accommodations, transport, and the sale of artifacts—is an important part of the local economy, for many providing the most direct access to earning small sums of cash.

21. The drum presented to the British monarch is now in the Cambridge Museum of Archaeology and Anthropology. A senior member of the diplomatic service wrote to the resident commissioner at the time, "The Queen is prepared to accept the gong and that she would wish it to be offered to the School of Anthropology at Cambridge, or if they do not want it, the Imperial Institute. Her Majesty does not wish it to be set up in Windsor Park. I should be grateful if you

would inform Chief Tofor of Her Majesty's decision, at the same time conveying in suitable terms her thanks for the gift" (Mayall 1969).

22. Today, despite having resisted the advent of Christianity for many years, every Fanla villager claims an allegiance to either the Presbyterian or Seventh Day Adventist Church, and by the time of my stay in Fanla, the Seventh Day Adventist Church had achieved majority membership, despite being the more recent arrival to the area.

23. The phenomenon of killing pigs belonging to kastom villagers, and thus sabotaging participation in ceremonial life, has been commented on by Jean Guiart (1950). At the time of Guiart's writing, both the Presbyterians and Seventh Day Adventists along the coasts were devising idiosyncratic methods of killing the pigs of the still-pagan villagers of the interior (Fanla region).

24. I have not used the real names of the participants in the case discussed here. The very public nature of the contestation over rights resulted in significant press coverage in Vanuatu that I quote from in this account. The weekly development of the debate in the pages of the *Trading Post* newspaper (now called the *Vanuatu Daily Post*) allowed for the parties concerned to intercede in the debate. Although not necessarily a definitive explanation of the events that transpired, the account exposes some of the political tensions and contradictions surrounding local enforcements of copyright.

25. Indeed, in the wake of the year of the Traditional Economy in 2007 (see chapter 7), the Malvatumauri decreed that cash money could not be used to pay customary fines.

5 | Trademarking Māori

1. "Given that the written and printed word alike were often treated as *taonga*, and that *taonga* were instantiations of personal (including ancestral) effect, perhaps the 'miracle' of text was that, as a special kind of *taonga*, it enabled a form of distributed personhood involving the *mana*, *tapu*, and *hau* of the person—their ancestral efficacy and power, in other words—as well as their 'thoughts.' It is against this background that the notion of the Treaty of Waitangi as a *taonga*, a living document, should be understood" (A. Henare 2007: 64).

2. "It turns out that Māori have always cut and pasted materials to hand—quite literally in the case of Te Kooti's flag—to produce what they take themselves to be. Yet this apparent politics of identity can hardly be called essentialist. . . . That recognition is the object of demands for sovereignty: the need to be heard in terms of one's own making (not the same thing as making native self-understanding an object of knowledge), to even be able to make yourself heard" (Turner 2002: 90).

3. "In Māori culture, an elegantly tattooed face was a great source of pride to a warrior, for it made him fierce in battle," said Ed Golden (executive director of North American Ford Brand

Design). "The F-150 has a great history and has consistently been the leader among full-size pick-ups—it is certainly fierce in battle" (Ford Motor Company, Ford F-150 Lightning Rod, n.d., www.babez.de/ford/f150lightning.php; accessed October 12, 2012).

4. During my fieldwork there was a minor media scandal in which a television journalist, a New Zealander of Pakistani descent, was accused of being racist during a satirical skit that lampooned the treaty process. Māori TV launched a complaint to the Broadcasting Standards Authority, and a public discussion was initiated about the limits of satire. The refusal of Māori to allow their identity to be presented in certain ways and the public level of awareness of these issues contribute to a broader sense of Māori culture as an object to be appropriately owned and represented.

5. Piri Sciascia, discussion of Te Māori at the MĀORI ART MARKet, Te Rauparaha Arena, Porirua, New Zealand, October 9, 2009. When I looked online for Te Māori.com, I found it had already been taken by a documentary film production company, so I am unsure as to what the next steps for brand promotion will be. My account here focuses on preliminary discussions and imagined economies rather than any kind of current implementation.

6. Public discussion held at Te Rauparaha Arena, Porirua, New Zealand, October 9, 2009.

7. The Silver Hand mark in Alaska (Graburn 2004; Hollowell 2004) and the now-defunct Desart trademark for Aboriginal Australians (Janke 2003) are administrated and created within a framework of government support for indigenous arts that uses this aesthetic process to delineate the boundaries of authentic indigenous persons and to use that as a ground for indigenous entitlement (rather than any framework drawing on indigenous epistemology, indigenous aesthetics, and indigenous values, as is increasingly the case in Aotearoa New Zealand).

8. This statement was taken from the now-defunct government Web site, www.toiiho.com, which has now been replaced by www.toiiho.co.uk.

9. Updates will be posted on http://toiiho.blogspot.com (accessed August 2, 2011).

10. New Zealand's current government has dismantled many of the former Labour government's commitments to indigenous rights and governance. This lack of commitment is exemplified by the curtailment of the Traditional Knowledge Program, set up during the previous government's tenure, within the Ministry for Economic Development (see Ministry of Economic Development 2007).

11. See the Trade Marks Act of 2002 (www.legislation.govt.nz).

12. The commissioner's decisions can be found online at the Web site for the Intellectual Property Office of New Zealand (www.iponz.govt.nz).

13. The Mainly Māori mark is for collectives, most participants of which are of Māori descent, who work together to produce, present, or perform works. The toi iho Māori Co-Production mark acknowledges the growth of innovative, collaborative ventures between Māori and non-Māori.

There is also a mark that licensed retail stockists can use. This initially suggested to me an optimistic presentation of the way in which indigenous identity can be inclusive and collaborative in Aotearoa New Zealand. However, in practice there was very little pickup within the marks specifying co-production or Mainly Māori. As of 2012 no group had applied for the Mainly Māori mark.

14. Te Waka Toi is an arts board constituted by Section 13 of the Arts Council of New Zealand Toi Aotearoa Act of 1994 (Te Waka Toi). Creative New Zealand is the government body that implements the strategic direction and policy set by the Arts Council of New Zealand.

15. As of 2006, despite more than 2,500 artist applications being distributed, only 233 people had applied for the mark, out of which 150 were licensed, and about 50 of these were Te Ara Whakarei (or honorary members) (Oliver and Wehipeihana 2006: x). Approximately 75 percent of artists who have become licensed renew annually, demonstrating that there is both pickup and ambivalence surrounding the mark.

16. In a review of the mark from 2002 to 2005 (Oliver and Wehipeihana 2006), no indication was given of the mark being a failure. Indeed, it was considered a success by most of its stakeholders. Concerns were for the recognition of the brand, but it was noted that the brand was still in its infancy. The prime concerns were the admissions processes and the accountability behind accepting or rejecting artists, and these concerns were very much oriented toward the artistic community, which itself had less impact on the actual functioning of the brand as a marketing tool. A 2007 report concluded that the limited funding for the mark meant that the "objectives of the programme are only being partially met" and that a stronger emphasis was needed on artists' development (Pattillo 2007: 3). The latter report was not oriented toward qualitative or quantitative research (drawing instead on the earlier review and on a review of consumer research conducted by other consultants), and it seemed obvious to me that it had been commissioned to model the possibility and outcomes of discontinuing the mark, here presented as one option out of many. However, the report itself concluded that the preferred model was to integrate the mark within Creative New Zealand as a whole.

17. The Australian mark was only taken up by about 160 artists, and the National Indigenous Arts Advocacy Association, which had developed the mark, closed its doors in 2002 due to withdrawal of government funding. The Australian definition of authenticity was given as "a declaration by Indigenous Australian artists of identity with, belonging to, knowledge about, respect for and responsibility towards the worlds of art they create. Identity is about upbringing, beliefs, stories, cultural ways of living and thinking, and knowing what it is to be Aboriginal or Torres Strait Islander. Belonging means to be either connected with stories about country or connected with the experiences of history in being Indigenous in Australia. Knowledge is about the familiarity gained from actual experience and also having a clear and

certain individual perception of expression. Respect and responsibility is about having regard for and looking after culture. It is about acting in a way which is sensitive to others and which does not exploit other peoples' identity, knowledge and belonging" (as quoted in Janke 2003: case study 8, 4).

18. The Māori artist design team and advisory group consisted of Dr. Pakaariki Harrison, Robert Jahnke, Kereti Rautangata, Jacob Scott, Manos Nathan, June Grant, Ata Te Kanawa, Hirinia Melbourne, Shane Cotton, Hinemoa Harrison, Erenora Puketapu-Hetet, Ngahuia Te Awekotuku, Te Maari Gardiner, Toby Mills, Jonathan Mane-Wheoki, and Keri Kaa.

19. Rule 1.2 states a person is of Māori descent if one of the following two options is followed. The first option is when descent is verified to Creative New Zealand in writing by (1) a Kaumātua or Kuia of a person's iwi; (2) a representative of a person's iwi, Rūnanga, or Trust Board; (3) a representative of an Urban Māori Authority; or (4) a person recognized by Creative New Zealand as a highly regarded person in the Māori community. The second option is when Creative New Zealand, after having considered such evidence as it deems appropriate, determines that the person is of Māori descent (Arts Council of New Zealand Toi Aotearoa 2002: 3).

20. I summarize this from interviews with a number of different artists who were either holders of the mark or who had not applied for it.

21. Section 5.3 of the *Rules Governing the Use by Artists of the Toi Iho™ Maori Made Mark* states the following: "The Mark may only be used in connection with a Work which is: (a) Distinguishable as a work of Māori art or craft being a Work which comprises an implicit or explicit reference to something Māori; (b) Within an Approved Art form Category; (c) A work of quality; (d) In the case of a person holding an Annual or a Renewal Licence either: (i) Made after the date that a License applicable to the Art Form Category to which the Work belongs is first issued; or (ii) Submitted with the Application Form and approved by Creative New Zealand as an exception to Rule 5.3 (d)(i); (e) Either: (i) An Artwork which is conceived and created entirely by an Artist; or (ii) A Performance which is conceived, created or performed entirely by the Artist; and (f) If the work is an Artwork and any part is, or appears to be, made of greenstone (pounamu), bone, wood, paua shell or flax fibre a Work which is made, or in which those parts are made, from greenstone (pounamou), bone, wood, paua shell or flax fibre which comes from New Zealand" (Arts Council of New Zealand Toi Aotearoa 2002).

22. Notably absent from the list of toi iho artists is the younger generation of contemporary artists (e.g., Wayne Youle, Lisa Reihana, Brett Graham, Natalie Robertson, and so on). In the aftermath of its dissolution, many contemporary artists said that they did not need the mark, exemplified by a comment made by the sculptor Brett Graham in a segment on *Native Affairs*, a topical news program broadcast by Māori television, where he asserted that for contemporary artists the mark was "irrelevant" (Graham on *Native Affairs*, first broadcast on November 16, 2009).

23. While in fact there are no non-Māori people on the application panel, Te Kaha's comment highlights how any government initiative is seen by some people to be antithetical to the interests of Māori. This view is not shared by all Māori—indeed, many participants felt very much that it was a Māori program, led by Māori for Māori, and were all the more upset at the way in which the government was able to close it down, seemingly overnight.

24. "Regional and Local Economies of Mana: Indigenous Business, Economic Development, and Well-Being in Oceania," a talk given by Dr. Manuka Henare at the Pacific Alternatives: Cultural Heritage and Political Innovation in Oceania Conference, University of Hawai'i at Manoa, March 26, 2009.

25. A summary, by the Tribunal, of the WAI 262 claim on a Web site (www.med.govt.nz), distills the elements of the claim into four main areas:

"Mātauranga Māori (traditional knowledge): concerning the retention and protection of knowledge regarding ngā toi Māori (arts), *whakairo* (carving), history, oral tradition, Waiata, Te Reo Māori, and rongoā Māori (Māori medicine and healing). The claimants' concern is about the protection and retention of such knowledge. They note that traditional knowledge systems are being increasingly targeted internationally.

Māori cultural property (tangible manifestation of mātauranga Māori): as affected by the failure of legislation and policies to protect existing Māori collective ownership of cultural taonga and to protect against exploitation and misappropriation of cultural taonga, for example, traditional artefacts, carvings, and *mokomokai* (preserved heads).

Māori intellectual and cultural property rights: as affected by New Zealand's intellectual property legislation, international obligations, and proposed law reforms. Issues include the patenting of life form inventions, the inappropriate registration of trademarks based on Māori text and imagery, and the unsuitable nature of intellectual property rights for the protection of both Māori traditional knowledge and cultural property.

Environmental, resource, and conservation management: including concerns about bioprospecting and access to indigenous flora and fauna, biotechnological developments involving indigenous genetic material, ownership claims to resources and species, and iwi-Māori participation in decision making on these matters. As such, the 'flora and fauna claim' currently encompasses popular thinking on indigenous cultural and intellectual property in New Zealand, conceived as holistic claims to both the natural world and the cultural knowledge derived from it. While the claim is couched more in terms of Treaty violations (that these taonga were not protected under the terms of Article II), the more pressing concern for the Tribunal is what the implications that the issues of ownership (or of indigenous entitlement) it evokes will have on the deployment of natural resources in Aoteaora New Zealand—a massive part of the national economy—and the role that

Māori will play in this as an interest group" (accessed November 10, 2009; macrons reproduced as used on web site).

26. The WAI 262 flora and fauna claim and the Mātaatua Declaration legal statements of tino rangatiratanga are available at http://indymedia.org.nz (accessed July 14, 2010).

27. Newman (2011).

28. The concept of the commons developed by Boyle and Lessig focuses on public domain free from corporate interest and freely available for use. This is a different version of the commons to the notion of a commons as a regime subject to communal resource management. I thank Rosemary Coombe for drawing my attention to this distinction.

29. Metge (2010) discusses the way in which this selective appropriation is filtered into the very language of New Zealand English, which co-opts many Māori words without necessarily the moral obligations that their use might suggest.

30. Māori metaphors for the colonial government include the sand fly, which skitters around the edges of things, slowly eroding them; the eel, which slithers about in your hands as you try to grasp it, more often than not escaping, leaving you holding only a dirty mess; and the East Coast sharks that herd the smaller fish into coves only to devour them (Manuka Henare, personal communication, October 10, 2009).

31. Te Kaha, interview with author, November 13, 2009.

6 Pacific Museology

1. For a more detailed history of the VKS, see Bolton (1993, 1994, 1996, 1997, 1999b, 2003b), Tryon (1999), and Geismar and Tilley (2003).

2. The cataloguing of objects was not even begun until 1989 (Huffman, personal communication, March 2001).

3. Huffman was appointed first as salaried curator in 1976, but he was unable to take up his position straight away. The French linguist Jean Michel Charpentier was curator until 1977, when Huffman took up the position, remaining there until 1989 (Bolton 2003b: 37).

4. The new and current director of the VKS is Marcellin Abong, a trained archaeologist and a francophone ni-Vanuatu from Lamap, South Malakula.

5. The Vanuatu Cultural Research Policy can be accessed via the VKS Web site at www.vanuatu culture.org. A moratorium on research was in place from 1985 to 1995 until this cultural policy could be created.

6. Quotation taken from author's notes of speech given by Marcellin Abong, director of the Vanuatu Cultural Centre, at the opening of the Third National Arts Festival in Port Vila.

7. This is not to underestimate the influence of regional museums, such as the Rotorua and

Gisbourne Museums, in mediating between local communities, especially Māori, but also between different museologies and a national framework, and in constituting iwi- and hapu-based museologies (see Soutar and Spedding 2000; Tapsell 2000; Butts 2003; M. Henare 2005).

8. At the time of writing, the Auckland Museum had just experienced a number of changes in management. A new Canadian museum director had been brought in to "clean house," as a result of which many Māori staff were let go or left, including the person holding the influential position of Tumuaki Māori/Māori director, and the commitment of the museum toward integrating Māori values into the heart of its practice significantly lessened. The Canadian director was then dismissed in early 2010 after a board review of her role; the dismissal was provoked not only by massive alienation of museum staff but also by a very public conflict she had with the descendants of Sir Edmund Hillary. The inflection of more corporate museological principles (e.g., thinking of the visitor as consumer, a focus on visitor experience, a move away from "old-fashioned" collecting and display strategies, and an emphasis on revenue and consumption) informed the contemporary background for museum culture in New Zealand, against which indigenous museology must struggle to be heard.

9. Despite the board's adopting a bicultural policy, there is no stipulation for Maori representation on the board of directors (Waitangi Tribunal 2011: 493).

10. What is interesting in these displays is that, unlike "universal survey museums" of culture such as the British Museum, Te Papa does not take a bird's-eye perspective on other places. The Pacific Island exhibition, only recently revamped, focuses on the engagement between New Zealand and other Pacific Islands, including troubled histories of the labor trade and contemporary issues of New Zealand's own colonial expansion into the region.

11. See the section on repatriation and the draft Kōiwi Tangata Policy, dated October 1, 2010, at www.tepapa.govt.nz (accessed January 11, 2011).

12. This display is currently under review with plans for complete renovation.

13. "In its literal translation, the word whakapapa means 'to place in layers, upon one another.' In its genealogical sense, it provides a framework for an understanding of historical descent, pattern, and linkages, whereby everything, animate and inanimate, is connected together into a single 'family tree' or 'taxonomy of the universe'" (Roberts and Wills 1998: 54).

14. This view of taonga as embedded in landscape was not new to the *Ko Tawa* exhibition but drew on representational and ontological paradigms that had emerged in the Waitangi Tribunal reports in the 1980s and 1990s, where maps, ancestors, and taonga were presented formally as interconnected. This display strategy was also used in many of Te Papa's iwi exhibitions. I thank Jade Baker for this observation.

15. "What appears as careful wording and sophisticated theoretical language in academic discourse is often translated in journalistic political debate as an assertion that 'they made

it up.' And given that many Europeans construct Pacific cultures as eternal essences, this is tantamount to saying that a tradition is false or a fabrication" (Jolly and Thomas 1992: 242–243).

16. The Pacific Islands were originally globalized in relation to the commodification of whaling; sea cucumber; and, most importantly, copra (dried coconut). Since then, a number of cash crop "fads" have had profound economic effect. Kava, or *Piper methysticum*, is a root indigenous to Vanuatu. Traditionally used in ceremonial contexts, its calming effects have translated well into recreational activities throughout the islands, where kava bars are called *nakamals*, after the men's houses where kava was traditionally drunk (Lebot et al. 1992). The root was picked up enthusiastically by the alternative health industries and processed and packaged as a natural tranquilizer. In 2001 several studies alleged that kava caused liver toxicity and the European Union, the principal consumer, banned its sale and importation, causing the bottom to fall out of the market, thereby limiting one of Vanuatu's most lucrative exports. These studies have been discredited, but in that time a number of other countries have emerged as kava producers, most notably Hawaii. Ni-Vanuatu are now looking for ways to use the geographical indicator form of trademarking and to constitute kava as a form of IP (see Lindstrom 2009).

17. Mauss also noted that the term *taonga* "denotes everything which may be rightly considered property, which makes a man rich, powerful or influential, and which can be exchanged or used as compensation: that is to say, such objects of value" (quoted in Weiner 1992: 214).

18. This translation was provided by Paul Williams in a personal communication.

19. These principles have been tentatively outlined by the Waitangi Tribunal as the principle of the government's right to govern, as recognized and acknowledged by Māori tribes; the principle of tribal self-regulation, especially around tribal resources; the principle of partnership and good faith; the principle of active participation in decision making; the principle of active protection of Māori by the Crown; and the principle of redress for past grievances (condensed from O'Regan 1997: 19–20).

7 | Treasured Commodities

1. Indigenous sovereignty is not modeled in relation to separate models of the nation (as it is in Canada and the United States). I thank Paul Williams for this observation.

2. This research fed directly into my work in Aotearoa New Zealand. As a result of this initial publication, I was invited to Wellington by the Māori team of the Museum of New Zealand Te Papa Tongarewa. Initially, I attended a meeting at the museum that was considered something of a crisis summit in response to concerns that the growth in market prices would

result in an upstepping of international trade in Māori artifacts, ultimately widening the gap between Māori and their taonga. In conjunction with Senior Curator Māori Huhana Smith, I developed a research project that would investigate the configuration of the auction market in New Zealand with the explicit intent of reassessing the museum's role in the marketplace and museum policies of valuation for its Māori collections. As well as working within Te Papa Tongarewa, I worked with auctioneers, dealers, and curators in both Auckland and Wellington, trying to understand the complex and emotional underpinnings of the sale of Māori taonga.

3. Ninness (2002). See also Hambleton (2004).

4. See Carter B. Horsley, African and Oceanic Art, Sotheby's, November 22, 1998, reviewed online at www.thecityreview.com (accessed October 14, 2012).

5. Quoted in "Carving Price Upsets Vendor" (1998).

6. The model of biculturalism, drawn from the terms of the Treaty of Waitangi, relies in New Zealand on the division of New Zealanders into Māori and non-Māori. Colloquially, non-Māori are often conflated with the term Pākehā, a Māori word meaning foreigner, white person, or European and is a nonethnic marker used primarily to refer to white people of Anglophone European descent. Pākehā has increasingly come to be a self-ascribed cultural identity by many New Zealanders (see King 1985, 1999). However, increasing attention has been drawn to the fact that the bicultural equation explicitly ignores more recent immigrant communities to Aotearoa New Zealand, most notably the substantial numbers of Pacific Islanders and an even more substantial number of Asian residents and citizens, and there is uncertainty and insecurity as to whether the term *Pākehā* is pejorative. Most of the troublesome transactions in the marketplace polarize Māori and Pākehā identities (e.g., I came across no instances of Māori traders or dealers or of Asian auctioneers in the situations of conflict I was chronicling).

7. Quoted in Sheeran (1996).

8. Wedde (1997).

9. Manuka Henare describes how the passing of the Maori Antiquities Act of 1901 was linked to proposed plans to establish a National Maori Museum (2005: 199).

10. Schedule Four of the Protected Objects Act of 1975 lists nine categories of protected New Zealand objects. They are archaeological, ethnographic, and historical objects of non–New Zealand origin, relating to New Zealand; art objects including fine, decorative, and popular art; documentary heritage objects; Ngā taonga tūturu (meaning objects that relate to Māori culture, history, or society); natural science objects; New Zealand archaeological objects; numismatic and philatelic objects; science, technology, industry, economy, and transport objects; and social history objects. A copy of the Act can be found at www.legislation.govt .nz. The Act was updated with the specific intention of facilitating New Zealand's becoming a signatory to the UNESCO Convention on the Means of Prohibiting and Preventing the illicit

Import, Export and Transfer of Ownership of Cultural Property (1970) and the UNIDROIT Convention on Stolen or Illegally Exported Cultural Objects (1995) to which New Zealand became a signatory in 2007 and both of which are now included in the updated Act. Another primary focus of the amendment was to assess the ownership and custody of newly found Māori taonga, which under the old Act automatically became the property of the Crown—a co-option that was directly against the principles of the Treaty of Waitangi, as upheld by the Waitangi Tribunal.

11. Ngā taonga tuturu are defined as a type of object that "(a) relates to Māori culture, history or society; and (b) was, or appears to have been: (i) manufactured or modified in New Zealand by Māori, or (ii) brought into New Zealand by Māori, or (iii) used by Māori; and (c) is more than 50 years old" (as outlined in Section 2 of the Act, www.legislation.govt.nz). As the advisory on the Ministry for Culture and Heritage Web site states, under the heading, "What this means for Māori": "The amended Act improves the process for transferring ownership of newly-found Māori cultural objects (which are called *nga taonga tūturu*, replacing the term artifacts) from the Crown to individuals and groups. The process of claiming ownership through the Māori Land Court will be simplified. The processes for trading privately owned *taonga* and becoming a registered collector will not change" (this introduction can be found on the Web site for Manatū Taonga, the Ministry for Culture and Heritage, www.mch.govt.nz [accessed October 12, 2012]).

12. There are approximately 2,560 registered artifact collectors, including both individuals and organizations, and approximately 5,100 registered artifacts on file (Ailsa Cain, Adviser, Heritage Operations, NZ Ministry for Culture and Heritage, personal communication, November 21, 2004). As of October 12, 2012, there were only fourteen licensed traders of privately owned artifacts in New Zealand, according to the government. This information can be found under the section "Licensed Dealers" on the home page of the Ministry for Culture and Heritage (www.mch.govt.nz).

13. Some other examples of this are Taussig (1980) on commodity fetishism in Colombian mines, Foster (1998) on money in Papua New Guinea, Saunders (1999) on Amerindian attitudes to gold, and Walsh (2003) on emeralds in Madagascar.

14. Out of respect to the tribal elders and authorities on Māori custom and protocol, I would like to emphasize at this point that I make no claim to speak for or represent definitive Māori perspectives or understandings. Rather, I am trying to highlight how different models of value emerge within the complex cultural field of the marketplace and how the concept of taonga may be used as an alternative model of value and to promote an alternative model of exchange.

15. Many of the images have been published in *Te Awa: Partington's Photographs of Whanganui Māori* (2003).

16. Quoted in Purdy (2001).

17. Quoted in Quirke (2001).

18. Purdy (2001).

19. Quirke (2001).

20. Quoted in Te Anga (1998c).

21. Quoted in Te Anga (1998b).

22. "Te Papa Mum on Mere Bid" (1998).

23. Quoted in Te Anga (1998a).

24. Huhana Smith (2009) notes, "What is of particular interest from a Maori curatorial perspective is that Kauwhata is actually the elder of the two mere pounamu in both whakapapa and in terms of manufacture. This mere has a purported provenance to Potatau te Wherowhero, a provenance unknown by the auction house. It achieved the lesser price. Wehi Wehi, the mere pounamu named after the son of Kauwhata, is a larger and more glossy mere, proving soundly that aesthetics (without all the other more interesting details) plays a compelling part in determining hammer price overall" (25).

25. Quoted in Te Anga (1998a).

26. See O'Regan (1997), Williams (2001, 2003), and A. Henare (2004).

27. These comments are drawn from Geismar (2004).

28. And this is not a new thing. Cory-Pearce (2007) demonstrates how the language of repatriation has long been used both as a justification for commercial transaction around Māori material and as a way to use such material culture to consolidate an inclusive notion of New Zealand citizenship.

29. Ross Millar, personal communication, July 2004.

30. Sloane (2002), emphasis added.

31. See Geismar (2001: 36). Dunbar Sloane was also responsible for valuing the Treaty of Waitangi for fiscal purposes, a process he told me he conducted by imagining how much someone like Bill Gates would pay for the Treaty if he were to buy it and by comparing it to both the Declaration of Independence and the Magna Carta!

32. Two recent examples of this can be found, first, in the claiming by Māori of the radio spectrum as taonga in the face of a government auction of the airwaves, and, second, in the reallocation of jade as Māori-owned pounamu (greenstone) on the South Island in the face of growing mining activity and competition from Asian suppliers.

8 | Pig Banks

1. The VKS has been deeply engaged with the work of practicing anthropologists who have collaborated on many curatorial, policy, and practical projects since the national research moratorium

was lifted in 1995 (see Bolton 1999c). Following the directives of the new National Cultural Research Policy, people with formal anthropological training have been involved, as part of their fieldwork for masters, doctoral, and postdoctoral research in projects to reclaim the concept of kastom for women (Bolton 2003b); to develop UNESCO's framework for Intangible Cultural Heritage, using sand drawing as a filter (Zagala 2004); to report on the workings of juvenile justice (Rousseau 2004); to document the general predicament of young people in town (Mitchell 2004); and so on. These anthropological engagements bring a different imaginary to the other, more global, imaginaries present in Vanuatu—those of development discourse, international investment, and so forth.

2. If we factor in relative prices, and one calculation places £4 in 1914 at £250 in 2004 (the Economic History Association has a fascinating service through which relative values can be charted, called Measuring Wealth, www.measuringworth.com; accessed October 12, 2012), then we are looking at a similar price for pigs in the present day. In 2006, a circle-tusker on Vao was worth about 40,000 Vatu (or around £200).

3. I quote here from one account, that of Vianney Atpatoun—former VKS of the Small Island of Vao, off Malakula Island (with whom I have worked extensively)—with the acknowledgment that there is a great diversity in the understanding of the meaning, origin, and symbolism of pigs in Vanuatu, even as pigs, through projects held in the VKS, are made increasingly generic markers of traditional economic life.

4. "Current national land laws, with their emphasis on land 'ownership,' have been developed under a government system where the government and business want to control land practice. These laws are not in accordance with Vanuatu *kastom* as they do not operate on collective land rights of a clan or family, rather they are based on individual land ownership. For a person to 'own' land, he must register his land to gain title to the land, which is recorded in the Land Registry at the Ministry of Lands. When a man registers his title to land under national law, he has removed the land from the control of his *nasara* and has placed it under the control of the government and money. Moreover, the titled land no longer belongs to a collective group of people but belongs to the individual who signed his name on the title in the Land Registry book, as according to law" (Simo 2005: 5).

5. Article 74 of the Vanuatu constitution decrees, "The rules of custom shall form the basis of ownership and use of the land in the Republic of Vanuatu." The Constitution of Vanuatu can be read online at www.parliament.gov.vu (accessed October 12, 2012).

6. The BBC reported that the Livatu was valued at US$1 billion in 2007. See Harding (2007).

7. Credit unions are essentially cooperative societies that offer loans to their members from collective savings built up by the members themselves. Ideally, they are formed not to make profits, but to maximize benefits to their members, benefits that may include social gain as much as financial profit. The main difference between a credit union and a cooperative is that

while cooperatives both purchase and sell to other organizations, credit unions only transact with their own members. In turn, an intrinsic part of the official theory of credit unions is an emphasis on social awareness and education, most particularly education about financial institutions.

8. The proclamation declaring sand drawing as ICH says, "This rich and dynamic graphic tradition has developed as a means of communication among the members of some 80 different language groups inhabiting the central and northern islands of Vanuatu. The drawings also function as mnemonic devices to record and transmit rituals, mythological lore and a wealth of oral information about local histories, cosmologies, kinship systems, song cycles, farming techniques, architectural and craft design, and choreographic patterns. Most sand drawings possess several functions and layers of meaning: they can be 'read' as artistic works, repositories of information, illustration for stories, signatures, or simply messages and objects of contemplation. Sand drawings are not merely 'pictures,' but refer to a combination of knowledge, songs, and stories with sacred or profane meanings. As attractive symbols of Vanuatu identity, the drawings are often showcased as a form of decorative folklore for tourists and other commercial purposes. If left unchecked, this tendency to appreciate sand drawings on a purely aesthetic level may result in the loss of the tradition's deeper symbolic significance and original social function" (available at www.unesco.org). In its broadest sense, Article 2.1 of the Convention defines "the intangible cultural heritage" to mean "the practices, representations, expressions, knowledges, skills—as well as the instruments, objects, artefacts and cultural spaces associated therewith—that communities, groups and, in some cases, individuals, recognize as part of their cultural heritage. This intangible cultural heritage, transmitted from generation to generation, is constantly recreated by communities and groups in response to their environment, their interaction with nature and their history, and provides them with a sense of identity and continuity, thus promoting respect for cultural diversity and human creativity. For the purposes of this Convention, consideration will be given solely to such intangible cultural heritage as is compatible with existing international human rights instruments, as well as with the requirements of mutual respect among communities, groups and individuals, and of sustainable development."

9. "Like previous indices, it is multidimensional, composed of distinct variables, each reflecting different aspects of the human condition. However, unlike previous indices it . . . makes no explicit use of income or income-adjusted measures . . . utilises both objective and subjective data . . . combines fundamental inputs and ultimate ends. . . . The HPI reflects the average years of happy life produced by a given society, nation or group of nations, per unit of planetary resources consumed. Put another way, it represents the efficiency with which countries convert the earth's finite resources into well-being experienced by their citizens" (Marks, Simms,

Thompson, and Abdallah 2006: 2–3). Even Vanuatu, with an HPI of 68.2, failed to reach the target index set by NEF of 83.5. Another interesting point is that the remoteness from international markets in Vanuatu is cited as a possible cause of increased happiness in its population.

10. See R. Layard (2003).

Conclusion

1. Comaroff and Comaroff's account of *Ethnicity, Inc.* charts the ways in which ethnically based property regimes are constituted out of "a fixation on belonging and its boundaries, the intervention of capital from the outside, a counterintuitive connection between enterprise and ethno-genesis, the assertion of sovereignty against the state, the foundational salience of territory, and the frequent resort to lawfare" (2009: 140). In New Zealand, Rata's discussion of "neotribal capitalism" (2000, 2003) parallels the Comaroffs' formulation of *Ethnicity, Inc.*

References

Abong, Marcellin. 2008. *La pirogue du dark bush: Aperçus critiques sur l'histoire du nagriamel*. Port Vila, Vanuatu: VKS Publications.

Agamben, Giorgio. 1998. *Homo Sacer: Sovereign Power and Bare Life*, trans. Daniel Heller-Roazen. Stanford, Calif.: Stanford University Press.

Akin, David. 2004. "Ancestral Vigilance and the Corrective Conscience: Kastom as Culture in a Melanesian Society." *Anthropological Theory* 4 (3): 299–324.

Akin, David, and Joel Robbins, eds. 1999. *Money and Modernity: State and Local Currencies in Melanesia*. Pittsburgh: University of Pittsburgh Press.

Allen, Chadwick. 2002. *Blood Narrative: Indigenous Identity in American Indian and Maori Literary and Activist Texts*. Durham, N.C.: Duke University Press.

Allen, Michael. 1967. *Male Cults and Secret Initiations in Melanesia*. Melbourne: Melbourne University Press.

———. 1981a. "Innovation, Inversion and Revolution as Political Tactics in West Aoba." In *Vanuatu: Politics, Economics and Ritual in Island Melanesia*, ed. Michael Allen, 105–134. Sydney: Academic Press.

———. 1981b. *Vanuatu: Politics, Economics and Ritual in Island Melanesia*. Sydney: Academic Press.

———. 1984. "Elders, Chiefs and Big Men: Authority Legitimation and Political Evolution in Melanesia." *American Ethnologist* 11 (1): 20–41.

Allen, Ngapine. 1998. "Maori Vision and the Imperialist Gaze." In *Colonialism and the Object: Empire, Material Culture and the Museum*, ed. Tim Barringer and Tom Flynn, 144–152. London: Routledge.

Alvizatou, Marilena. 2011. "Intangible Cultural Heritage as Erasure: Rethinking Cultural Preservation and Contemporary Museum Practice." *International Journal of Cultural Property* 18 (1): 37–61.

Ames, Michael M. 1992. *Cannibal Tours and Glass Boxes: The Anthropology of Museums*. Vancouver: University of British Columbia Press.

Anderson, Benedict. 1991. *Imagined Communities: Reflections on the Origin and Spread of Nationalism*. London: Verso.

Anderson, Jane. 2005. "The Making of Indigenous Knowledge in Intellectual Property Law in Australia." *International Journal of Cultural Property* 12 (3): 347.

———. 2009a. "(Colonial) Archives and (Copyright) Law." *Copie* 4. Available at http://nomore-potlucks.org (accessed October 6, 2009).

———. 2009b. *Law, Knowledge, Culture: The Production of Indigenous Knowledge in Intellectual Property Law*. Cheltenham, U.K.: Edward Elgar.

———. 2010. "Indigenous/Traditional Knowledge and Intellectual Property." Center for the Study of the Public Domain, Duke University School of Law. Available at www.law.duke.edu (accessed January 24, 2011).

Anderson, Jane, and Kathy Bowrey. 2005. "The Imaginary Politics of Access to Knowledge: Whose Cultural Agendas Are Being Advanced?" Unpublished manuscript.

———. 2009. "The Politics of Global Information Sharing: Whose Cultural Agendas Are Being Advanced?" *Social and Legal Studies* 18 (4): 479–504.

Anderson, Jane, and Molly Torsen. 2010. "Intellectual Property and the Safeguarding of Traditional Cultures: Legal Issues and Practical Options for Museums, Libraries and Archives." World Intellectual Property Organization. Available at www.wipo.int (accessed January 12, 2011).

Aoki, Keith. 1996. "(Intellectual) Property and Sovereignty: Notes toward a Cultural Geography of Authorship." *Stanford Law Review* 48 (5): 1293–1355.

Appadurai, Arjun. 1986. "Introduction: Commodities and the Politics of Value." In *The Social Life of Things: Commodities in Cultural Perspective*, ed. Arjun Appadurai, 3–63. Cambridge: Cambridge University Press.

———. 1990. "Disjuncture and Difference in the Global Cultural Economy." *Public Culture* 2 (2): 1–24.

Appiah, Kwame Anthony. 2006. *Cosmopolitanism: Ethics in a World of Strangers*. New York: W. W. Norton.

Aragon, Lorraine V., and James Leach. 2008. "Arts and Owners: Intellectual Property Law and the Politics of Scale in Indonesian Arts." *American Ethnologist* 35 (4): 607–631.

Arts Council of New Zealand Toi Aotearoa. 2002. *Rules Governing the Use by Artists of the Toi Iho™ Maori Made Mark*. Wellington: Creative New Zealand.

Arvidsson, Adam. 2007. "The Logic of the Brand." *Dipartimento di Sociologia e ricerca socialie Quaderni*. 36: 7–32. Available at http://www4.soc.unitn.it:8080.

Baker, Jade. 2006. "Mair's Relationship with Iwi: Te Hononga o Tawa i Ngā Iwi." In *Ko Tawa: Māori Treasures of New Zealand*, ed. Paul Tapsell, 67–86. Auckland: David Bateman.

———. 2008. "Te Pahitauā: Border Negotiators." *International Journal of Cultural Property* 15 (2): 141.

Baker, Kriselle. 2009. "A World of Black and Light: Ralph Hotere 1968–1977." Unpublished PhD dissertation, Department of Art History, University of Auckland.

Banner, Stuart. 2000. "Conquest by Contract: Wealth Transfer and Land Market Structure in Colonial New Zealand." *Law and Society Review* 34 (1): 47–96.

Barclay, Barry. 2005. *Mana Tuturu: Maori Treasures and Intellectual Property Rights*. Honolulu: University of Hawai'i Press.

Bargh, Maria. 2007. "Māori Development and Neoliberalism." In *Resistance: An Indigenous Response to Neoliberalism*, ed. Maria Bargh, 25–44. Wellington: Huia Publishers.

Battaglia, Debbora. 1995. "On Active Nostalgia: Self-Prospecting among Urban Trobrianders." In *Rhetorics of Self-Making*, ed. Debbora Battaglia, 77–97. Berkeley: University of California Press.

Baudrillard, Jean. 1981. "The Art Auction, Sign Exchange and Sumptuary Value." In *For a Critique of the Political Economy of the Sign*, by Jean Baudrillard, 112–122. St. Louis: Telos Press.

Bedford, Stuart, Christophe Sand, and Sean P. Connaughton. 2007. *Oceanic Explorations: Lapita and Western Pacific Settlement*. Terra Australis, vol. 26. Canberra: Australia National University Press.

Bedford, Stuart, Matthew Spriggs, and Ralph Regenvanu. 1999. "The Australian National University-Vanuatu Cultural Centre Archaeology Project, 1994–97: Aims and Results." *Oceania* 70 (1): 16.

Belgrave, Michael, Merata Kawharu, and David Williams, eds. 2005. *Waitangi Revisited: Perspectives on the Treaty of Waitangi*. Oxford: Oxford University Press.

Belich, James. 1997. "The Governors and the Māori." In *The Oxford Illustrated History of New Zealand*, 2nd ed., ed. Keith Sinclair, 75–98. Oxford: Oxford University Press.

Bell, Joshua A., and Haidy Geismar. 2009. "Materialising Oceania: New Ethnographies of Things in Melanesia and Polynesia." *Australian Journal of Anthropology* 20 (1): 3–27.

Bendix, Regina. 2008. "Expressive Resources: Knowledge, Agency and European Ethnology." *Anthropological Journal of European Cultures* 17 (2): 114–129.

Bendix, Regina, and Valdimar Tryggvi Hafstein. 2009. "Culture and Property: An Introduction." *Ethnologia Euripaea* 39 (2): 5–10.

Benjamin, Walter. (1936) 1992. "The Work of Art in the Age of Mechanical Reproduction." In *Illuminations*, ed. Hannah Arendt, 211–244. London: Fontana Press.

Bennett, Tony. 1988. "The Exhibitionary Complex." *New Formations* 4 (1): 73–102.

———. 1995. *The Birth of the Museum: History, Theory, Politics.* London: Routledge.

Bently, Lionel. 2008. "The Making of Modern Trade Mark Law: The Construction of the Legal Concept of Trade Mark (1860–1880)." In *Trade Marks and Brands: An Interdisciplinary Critique*, ed. Lionel Bently, Jennifer Davis, and Jane C. Ginsburg, 3–42. Cambridge: Cambridge University Press.

Bevan, Andrew, and David Wengrow. 2010. *Cultures of Commodity Branding.* Publications of the Institute of Archaeology, University College, London. Walnut Creek, Calif.: Left Coast Press.

Binney, Judith. 1997. "Māori Prophet Leaders." In *The Oxford Illustrated History of New Zealand*, 2nd ed., ed. Keith Sinclair, 153–184. Oxford: Oxford University Press.

Biolsi, Thomas. 2005. "Imagined Geographies: Sovereignty, Indigenous Space, and American Indian Struggle." *American Ethnologist* 32 (2): 239–259.

Blackwood, Peter. 1981. "Rank, Exchange and Leadership in Four Vanuatu Societies." In *Vanuatu: Politics, Economics and Ritual in Island Melanesia*, ed. Michael Allen, 33–84. Sydney: Academic Press.

Blakeney, Michael. 1996. *Trade Related Aspects of Intellectual Property Rights: A Concise Guide to the TRIPs Agreement.* London: Sweet and Maxwell.

Bloch, Maurice, and Jonathan P. Parry, eds. 1989. *Money and the Morality of Exchange.* Cambridge: Cambridge University Press.

Bodenhorn, Barbara. 2004. "Is Being 'Really Iñupiaq' a Form of Cultural Property?" In *Properties of Culture—Culture as Property, Pathways to Reform in Post-Soviet Siberia*, ed. Erich Kasten, 35–50. Berlin: Dietrich Reimer Verlag.

Bolton, Lissant. 1993. "Dancing in Mats: Extending Kastom to Women in Vanuatu." Unpublished PhD dissertation, University of Manchester.

———. 1994. "The Vanuatu Cultural Centre and Its Own Community." *Journal of Museum Ethnography* 6 (October 1994): 67–78.

———. 1996. "Tahigogana's Sisters: Women, Mats and Landscape on Ambae." In *Arts of Vanuatu*, ed. Joël Bonnemaison, Kirk Huffman, Christian Kaufmann, and Darrell Tryon, 112–119. Bathurst, Australia: Crawford House.

———. 1997. "A Place Containing Many Places: Museums and the Use of Objects to Represent Place in Melanesia." *Australian Journal of Anthropology* 8 (2): 18–34.

———. 1999a. "Radio and the Redefinition of Kastom in Vanuatu." In *Voyaging through the*

Contemporary Pacific, ed. David Hanlon and Geoffrey M. White, 377–402. Lanham, Md.: Rowman and Littlefield..

———. 1999b. "Introduction: Fieldwork, Fieldworkers." *Oceania* 70 (1): 1–9.

———. 1999c. *Chief Willie Bongmatur Maldo and the Incorporation of Chiefs into the Vanuatu State.* State, Society and Governance in Melanesia Project, vol. 2. Canberra: Research School of Pacific and Asian Studies, Australian National University.

———. 2003a. "Gender, Status and Introduced Clothing in Vanuatu." In *Clothing the Pacific*, ed. Chloe Colchester, 119–140. Oxford: Berg.

———. 2003b. *Unfolding the Moon: Enacting Women's Kastom in Vanuatu.* Honolulu: University of Hawai'i Press.

Bongmatur, Willie. 1994. "National Cultural Policies." In *Culture-Kastom-Tradition: Developing Cultural Policy in Melanesia*, ed. Lamont Lindstrom and Geoffrey M. White, 85. Suva, Fiji: Institute of Pacific Studies, University of the South Pacific.

Bonnemaison, Joël. 1986. *L'Arbre et la pirogue*. Paris: Editions de l'ORSTOM.

———. 1994. *The Tree and the Canoe: History and Ethnography of Tanna*, ed. Josée Pénot-Demetry. Honolulu: University of Hawai'i Press.

———. 1996. "Graded Societies and Societies Based on Title: Forms and Rites of Traditional Power in Vanuatu." In *Arts of Vanuatu*, ed. Joël Bonnemaison, Kirk Huffman, Christian Kaufmann, and Darrell Tryon, 200–204. Bathurst, Australia: Crawford House.

Bourdieu, Pierre. 1977. *Outline of a Theory of Practice*. Cambridge: Cambridge University Press.

———. 1993a. *The Field of Cultural Production: Essays on Art and Literature*. London: Polity Press.

———. 1993b. "The Production of Belief: Contribution to an Economy of Symbolic Goods." In *The Field of Cultural Production: Essays on Art and Literature*, by Pierre Bourdieu, 74–112. London: Polity Press.

Boyle, James. 1996. *Shamans, Software, and Spleens: Law and the Construction of the Information Society*. Cambridge, Mass.: Harvard University Press.

———. 2003. "The Second Enclosure Movement and the Construction of the Public Domain." *Law and Contemporary Problems* 66 (33): 33–74.

———. 2008. *The Public Domain: Enclosing the Commons of the Mind*. New Haven, Conn.: Yale University Press.

Brookfield, F. M. 2006. *Waitangi and Indigenous Rights: Revolution, Law, and Legitimation*. Auckland: Auckland University Press.

Brown, Michael F. 1998. "Can Culture Be Copyrighted?" *Current Anthropology* 39 (2): 193–222.

———. 2003. *Who Owns Native Culture?* Cambridge, Mass.: Harvard University Press.

———. 2004. "Heritage as Property." In *Property in Question: Value Transformation in the Global Economy*, ed. Caroline Humphrey and Katherine Verdery, 49–68. Oxford: Berg.

———. 2005. "Heritage Trouble: Recent Work on the Protection of Intangible Cultural Property." *International Journal of Cultural Property* 12 (1): 40–61.

———. 2010. "Culture, Property, and Peoplehood: A Comment on Carpenter, Katyal, and Riley's 'In Defense of Property.'" *International Journal of Cultural Property* 17 (3): 569–579.

Buck-Morss, Susan. 1992. "Aesthetics and Anaesthetics: Walter Benjamin's Artwork Essay Reconsidered." *October* 62 (Autumn 1992): 3–41.

Busse, Mark. 2008. "Museums and the Things in Them Should Be Alive." *International Journal of Cultural Property* 15 (2): 189–200.

Butts, David James. 2003. *Maori and Museums: The Politics of Indigenous Recognition*. Unpublished PhD dissertation, Massey University.

Byrne, Denis. 2009. "A Critique of Unfeeling Heritage." In *Intangible Heritage*, ed. Laurajane Smith and Natsuko Akagawa, 229–252. Oxford: Routledge.

Callon, Michel. 1998. "The Embeddedness of Economic Markets in Economics." In *The Laws of the Markets*, ed. Michel Callon, 1–57. Oxford: Blackwell.

Carneiro da Cunha, Manuela. 2009. *"Culture" and Culture: Traditional Knowledge and Intellectual Rights*. Chicago: Prickly Paradigm Press.

Carpenter, Kristen A., Sonia K. Katyal, and Angela R. Riley. 2009. "In Defense of Property." *Yale Law Journal* 118 (6): 1022–1125.

———. 2010. "Clarifying Cultural Property." *International Journal of Cultural Property* 17 (3): 581–598.

Carrier, James G. 1998. "Property and Social Relations in Melanesian Anthropology." In *Property Relations: Renewing the Anthropological Tradition*, ed. Chris Hann, 85–103. Cambridge: Cambridge University Press.

"Carving Price Upsets Vendor." 1998. *The Press* (Christchurch), November 25.

Cattelino, Jessica R. 2005. "Tribal Gaming and Indigenous Sovereignty with Notes from Seminole Country." *American Studies* 46 (3–4): 187–204.

———. 2008. *High Stakes: Florida Seminole Gaming and Sovereignty*. Durham, N.C.: Duke University Press.

———. 2010. "The Double Bind of American Indian Need-based Sovereignty." *Cultural Anthropology* 25 (2): 235–262.

Chakrabarty, Dipesh. 2000. *Provincializing Europe: Postcolonial Thought and Historical Difference*. Princeton, N.J.: Princeton University Press.

Chakrabarty, Dipesh, with Amitav Ghosh. 2002. "A Conversation on Provincializing Europe." *Radical History Review* 83: 146–172.

Chapman, Audrey R. 2001. "Approaching Intellectual Property as a Human Right: Obligations Related to Article 15(1)(c)." *Copyright Bulletin* 35 (3): 4–36.

Charpentier, Jean-Michel. 1982. *Linguistic Atlas of South Malakula*. Paris: Selaf.

Chave, Anna. 1992. "Minimalism and the Rhetoric of Power." In *Art in Modern Culture: An Anthology of Critical Texts*, ed. Francis Frascina and Jonathan Harris, 264–282. London: Phaidon.

Choate, Pat. 2005. *Hot Property: The Stealing of Ideas in an Age of Globalization*. New York: Knopf.

Clausen, Raymond. 1960. "Slit Drums and Ritual in Malekula." In *Three Regions of Melanesian Art: New Guinea and the New Hebrides*, 16–21. New York: Museum of Primitive Art.

Clifford, James. 1988a. "Identity in Mashpee." In *The Predicament of Culture: Twentieth-Century Ethnography, Literature and Art*, by James Clifford, 179–205. Cambridge, Mass.: Harvard University Press.

———. 1988b. "Histories of the Tribal and the Modern." In *The Predicament of Culture: Twentieth-Century Ethnography, Literature and Art*, by James Clifford, 189–215. Cambridge, Mass.: Harvard University Press.

———. 1997a. "Museums as Contact Zones." In *Routes: Travel and Translation in the Late Twentieth Century*, by James Clifford, 188–220. Cambridge, Mass.: Harvard University Press.

———. 1997b. *Routes: Travel and Translation in the Late Twentieth Century*. Cambridge, Mass.: Harvard University Press.

———. 2001. "Indigenous Articulations." *The Contemporary Pacific* 13 (2): 468–490.

Coates, Kenneth, Paul G. McHugh, and Mason Durie. 1998. *Living Relationships = Kōkiri Ngātahi: The Treaty of Waitangi in the New Millennium*. Wellington: Victoria University Press.

Comaroff, John L., and Jean Comaroff. 1993. *Modernity and Its Malcontents: Ritual and Power in Postcolonial Africa*. Chicago: University of Chicago Press.

———. 2009. *Ethnicity, Inc.* Chicago: University of Chicago Press.

Commission on Intellectual Property Rights. 2002. *Integrating Intellectual Property Rights and Development Policy*. London: Commission on Intellectual Property Rights. Available at www.iprcommission.org (accessed January 24, 2011).

Conway, Danielle M. 2009. "Indigenizing Intellectual Property Law: Customary Law, Legal Pluralism, and the Protection of Indigenous People's Rights, Identity, and Resources." *Texas Wesleyan Law Review* 15 (2): 207–256.

Coombe, Rosemary J. 1996. "Embodied Trademarks: Mimesis and Alterity on America's Commercial Frontiers." *Cultural Anthropology* 11 (2): 202–224.

———. 1998a. *The Cultural Life of Intellectual Properties: Authorship, Appropriation and the Law*. Durham, N.C.: Duke University Press.

———. 1998b. "Response to Michael F. Brown." *Current Anthropology* 39 (2): 207–208.

———. 2004. "Commodity Culture, Private Censorship, Branded Environments, and Global Trade Politics: Intellectual Property as a Topic of Law and Society Research." In *The*

Blackwell Companion to Law and Society, ed. Austin Sarat, 369–391. New York: Blackwell.

———. 2005. "Legal Claims to Culture in and against the Market: Neoliberalism and the Global Proliferation of Meaningful Difference." *Law, Culture and the Humanities* 1: 35–52.

———. 2009. "The Expanding Purview of Cultural Properties and Their Politics." *Annual Review of Law and Social Science* 5 (1): 393–412.

Coombes, Annie E. 2006. "Introduction: Memory and History in Settler Colonialism." In *Rethinking Settler Colonialism: History and Memory in Australia, Canada, Aotearoa New Zealand and South Africa*, ed. Annie E. Coombes, 1–12. Manchester: Manchester University Press.

Cooper, Karen Coody. 2008. *Spirited Encounters: American Indians Protest Museum Policies and Practices*. Lanham, Md.: AltaMira Press.

Coote, Jeremy. 1992. " 'Marvels of Everyday Vision': The Anthropology of Aesthetics and the Cattle-Keeping Nilotes." In *Anthropology, Art and Aesthetics*, ed. Jeremy Coote and Anthony Shelton, 245–274. Oxford: Oxford University Press.

Corntassel, Jeff J., and Tomas Hopkins Primeau. 1995. "Indigenous 'Sovereignty' and International Law: Revised Strategies for Pursuing 'Self-determination.' " *Human Rights Quarterly* 17 (2): 343–365.

Corrin-Care, Jennifer, and Don Paterson. 2007. *Introduction to South Pacific Law*. 2nd ed. London: Routledge-Cavendish.

Cory-Pearce, Elizabeth. 2007. "Locating Authorship: Creativity and Borrowing in the Writing of Ethnography and the Production of Anthropological Knowledge." In *Creativity and Cultural Improvisation*, ed. Elizabeth Hallam and Tim Ingold, 127–151. Oxford: Berg.

Crowley, Terry. 1995. *A New Bislama Dictionary*. Suva, Fiji: Institute of Pacific Studies, University of the South Pacific.

Cullwick, Jonas. 2012. "Vanuatu Commissioner Says Labor Migration May Improve Economy." *Vanuatu Daily Post*, July 13, 2012.

Cuno, James B., ed. 2008. *Who Owns Antiquity? Museums and the Battle over Our Ancient Heritage*. Princeton, N.J.: Princeton University Press.

———. 2009. *Whose Culture? The Promise of Museums and the Debate over Antiquities*. Princeton, N.J.: Princeton University Press.

Curry, Steven. 2004. *Indigenous Sovereignty and the Democratic Project*. Aldershot, U.K.: Ashgate.

Dalton, George. 1967. *Tribal and Peasant Economies: Readings in Economic Anthropology*. American Museum Sourcebooks in Anthropology. Garden City, N.Y.: American Museum of Natural History, by the Natural History Press.

Dalziel, Raewyn. 1997. "Railways and Relief Centres (1870–90)." In *The Oxford Illustrated History of New Zealand*, 2nd ed., ed. Keith Sinclair, 99–124. Oxford: Oxford University Press.

Darian-Smith, Eve. 2007. *Ethnography and Law*. Burlington, Vt.: Ashgate.

de Fontenay, Patrick. 2000. "The Financial Sector in Vanuatu: Reforms and New Challenges." *Pacific Economic Bulletin* 15 (1): 17–26.

de la Cadena, Marisol. 2010. "Indigenous Cosmopolitics in the Andes: Conceptual Reflections Beyond 'Politics.'" *Cultural Anthropology* 25 (2): 334–370.

de la Cadena, Marisol, and Orin Starn, eds. 2007. *Indigenous Experience Today*. Oxford: Berg.

de Sousa Santos, Boaventura. 2009a. "A Non-Occidentalist West? Learned Ignorance and the Ecology of Knowledge." *Theory Culture Society* 26 (7–8): 103–125.

———. 2009b. "Towards a Multicultural Conception of Human Rights." In *International Human Rights Law in a Global Context*, ed. Felipe Gómez Isa and Koen de Feyter, 97–121. Bilbao, Spain: University of Deusto.

Deacon, A. Bernard. 1934. *Malekula: A Vanishing People*. London: George Routledge and Sons.

Deacon, A. Bernard, and Camilla H. Wedgwood. 1934. "Geometrical Drawings from Malekula and Other Islands of the New Hebrides." *Journal of the Royal Anthropological Institute of Great Britain and Ireland* 64 (January–June 1934): 129–175.

Declaration on the Importance and Value of Universal Museums. 2003. Reprinted in *Museum Frictions: Public Cultures/Global Transformations*, ed. Ivan Karp, Corrine A. Kratz, Lynn Szwaja, and Tomas Ybarra-Frausto, 247–248. Durham, N.C.: Duke University Press.

Denoon, Donald, Philippa Mein Smith, and Marivic Wyndham. 2000. *A History of Australia, New Zealand and the Pacific*. The Blackwell History of the World. Oxford: Blackwell.

Donovan, James M., and H. Edwin Anderson. 2003. *Anthropology and Law*. New York: Berghahn Books.

Drucker, Peter F. 1969. *The Age of Discontinuity: Guidelines to Our Changing Society*. New York: Harper and Row.

Durie, Mason. 1998. *Te Mana te Kāwanatanga—The Politics of Māori Self-determination*. New York: Oxford University Press.

———. 2003. *Nga Kahui Pou: Launching Maori Futures*. Wellington: Huia.

Edwards, Elizabeth. 2001. *Raw Histories: Photographs, Anthropology and Museums*. Oxford: Berg.

Eriksen, Annelin. 2009. "'New Life': Pentecostalism as Social Critique in Vanuatu." *Ethnos: Journal of Anthropology* 74 (2): 175–198.

Eriksen, Thomas Hylland. 2001. "Between Universalism and Relativism: A Critique of the UNESCO Concept of Culture." In *Culture and Rights: Anthropological Perspectives*, ed. Jane Cowan, Marie-Benedicte Dembour, and Richard A. Wilson, 127–148. Cambridge: Cambridge University Press.

Erikson, Patricia Pierce, Helma Ward, and Kirk Wachendorf. 2002. *Voices of a Thousand People: The Makah Cultural and Research Center*. Lincoln: University of Nebraska Press.

Errington, Frederick, and Deborah Gewertz. 2001. "On the Generification of Culture: From Blow Fish to Melanesian." *Journal of the Royal Anthropological Institute* 7 (3): 509–525.

Feld, Steven. 2000. "A Sweet Lullaby for World Music." *Public Culture* 12 (1): 145–171.

Field, Les W. 2008. *Abalone Tales: Collaborative Explorations of Sovereignty and Identity in Native California*. Durham, N.C.: Duke University Press.

Firth, Raymond. (1929) 1959. *Economics of the New Zealand Maori*. Wellington: R. E. Owen.

Forsyth, Miranda. 2003. "Intellectual Property Laws in the South Pacific: Friend or Foe?" *Journal of South Pacific Law* 7 (1): 6–8.

———. 2009a. *A Bird That Flies with Two Wings: The Kastom and State Justice Systems in Vanuatu*. Canberra: Australian National University Press.

———. 2009b. "Legal Opinion on Copyright Liability of the Contracting Company in Vanuatu." Unpublished manuscript.

Foster, Robert J. 1998. "Your Money, Our Money, the Government's Money: Finance and Fetishism in Melanesia." In *Border Fetishisms: Material Objects in Unstable Spaces*, ed. Patricia Spyer, 60–91. London: Routledge.

———. 2002. *Materializing the Nation: Commodities, Consumption, and Media in Papua New Guinea*. Bloomington: Indiana University Press.

———. 2007. "The Work of the New Economy: Consumers, Brands and Value Creation." *Cultural Anthropology* 22 (4): 707–731.

Fox, Richard G., and Andre Gingrich. 2002. "Introduction." In *Anthropology, by Comparison*, ed. Richard G. Fox and Andre Gingrich. London: Routledge.

Gay, Daniel. 2005. "Vanuatu's Suspended Accession Bid: Second Thoughts?" In *Managing the Challenges of WTO Participation—45 Case Studies*, ed. Peter Gallagher, Patrick Low, and Andrew L. Stoler, 590–606. Cambridge: Cambridge University Press and World Trade Organization.

Geertz, Clifford. 1993. *Local Knowledge: Further Essays in Interpretive Anthropology*. London: Fontana.

Geismar, Haidy. 2001. "What's in a Price? An Ethnography of Tribal Art at Auction." *Journal of Material Culture* 6 (1): 25–47.

———. 2003a. "Museums, Markets and Material Culture: Presentations and Prestations in Vanuatu, South West Pacific." Unpublished PhD dissertation, Department of Anthropology, University of London.

———. 2003b. *Vanuatu Stael: Kastom and Creativity*. Cambridge: Cambridge University Museum of Archaeology and Anthropology.

———. 2004. *Alternative Market Values? Interventions into Auctions of Taonga Maori in Aotearoa New Zealand*. Unpublished research report compiled for the Maori Research Team at The Museum of New Zealand Te Papa Tongarewa.

———. 2005. "Footsteps on Malakula: A Report on a Photographic Research Project." *Journal of Museum Ethnography* 17: 191–207.

———. 2008. "Cultural Property, Museums, and the Pacific: Reframing the Debates." *International Journal of Cultural Property* 15 (2): 109–122.

———. 2009. "Contemporary Traditions: Museum Collecting and Creativity in Vanuatu." In *Re-presenting Pacific Arts*, ed. Karen Stevenson and Virginia Lee Webb, 70–88. Bathurst: Crawford House.

———. 2010. "The Terrible Tale of the Trader's Wife: Photo-elicitation on Atchin and Vao." In *Moving Images: John Layard, Fieldwork and Photography on Malakula since 1914*, ed. Haidy Geismar and Anita Herle. Honolulu: Crawford House and the University of Hawai'i Press.

———. Forthcoming. "Indigenizing Intellectual Property Rights: Wai 262."

Geismar, Haidy, and Anita Herle. 2010. *Moving Images: John Layard, Photography and Fieldwork on Malakula since 1914*, 259–292. Honolulu: Crawford House and the University of Hawai'i Press.

Geismar, Haidy, Anita Herle, and Numa Fred Longga. 2007. *John Layard Long Malakula 1914–1915*. Cambridge: Cambridge University Museum of Archaeology and Anthropology.

Geismar, Haidy, and William Mohns. 2011. "Database Relations: Rethinking the Database in the Vanuatu Cultural Centre and National Museum." In *The Aesthetics of Nations: Anthropological and Historical Approaches*, ed. Nayanika Mookherjee and Christopher Pinney, S126–S148. Special issue of *Journal of the Royal Anthropological Institute*.

Geismar, Haidy, and Christopher Tilley. 2003. "Negotiating Materiality: International and Local Museum Practices at the Vanuatu Cultural Centre and National Museum." *Oceania* 73 (3): 170–188.

Gell, Alfred. 1992. "The Technology of Enchantment and the Enchantment of Technology." In *Anthropology, Art and Aesthetics*, ed. J. Coote and A. Shelton, 40–66. New York: Oxford University Press.

———. 1993. *Wrapping in Images: Tattooing in Polynesia*. Oxford: Clarendon Press.

———. 1998. *Art and Agency: An Anthropological Theory*. Oxford: Clarendon Press.

Gershon, Ilana. 2008. "Being Explicit about Culture: Maori, Neoliberalism, and the New Zealand Parliament." *American Anthropologist* 110 (4): 422–431.

Godelier, Maurice. 1999. *The Enigma of the Gift*. Cambridge: Polity Press.

Goldsmith, Michael. 2009. "Who Owns Native Nature? Discourses of Rights to Land, Culture, and Knowledge in New Zealand." *International Journal of Cultural Property* 16 (Special Issue 3): 325–339.

Golub, Alex. 2010. "Indigenes or Citizens in Papua New Guinea?" June 3. Available at http://savageminds.org (accessed October 12, 2012).

Goodale, Mark. 2009. *Dilemmas of Modernity: Bolivian Encounters with Law and Liberalism*. Stanford, Calif.: Stanford University Press.

Gorecki, Paul. 1996. "The Original Colonisation of Vanuatu." In *Arts of Vanuatu*, ed. Joël Bonnemaison, Kirk Huffman, Christian Kaufmann, and Darrell Tryon, 62–65. Bathurst: Crawford House Publishing.

Gosden, Chris, Frances Larson, and Alison Petch. 2007. *Knowing Things: Exploring the Collections at the Pitt Rivers Museum, 1884–1945*. Oxford: Oxford University Press.

Gourguechon, Charlene. 1977. *Journey to the End of the World: A Three-Year Adventure in the New Hebrides*. New York: Charles Scribner's Sons.

Graburn, Nelson H. H. 2004. "Authentic Inuit Art: Creation and Exclusion in the Canadian North." *Journal of Material Culture* 9 (2): 141–159.

Graeber, David. 2001. *Toward an Anthropological Theory of Value: The False Coin of Our Own Dreams*. New York: Palgrave.

———. 2000. "Give It Away." *In These Times* 24 (19), August 21, 2000. Available at www.inthese times.com (accessed October 12, 2012).

Green, Tony. 1992. "Modernism and Modernization." In *Headlands: Thinking through New Zealand Art*, ed. Mary Barr, 147–160. Sydney: Museum of Contemporary Art.

Gregory, Christopher A. 1982. *Gifts and Commodities*. New York: Academic Press.

———. 1997. *Savage Money: The Anthropology and Politics of Commodity Exchange*. Amsterdam: Harwood Academic Publishers.

Griffiths, John. 1986. "What Is Legal Pluralism?" *Journal of Legal Pluralism and Unofficial Law* 24: 1–55.

Grosheide, F. W., and Johannes Jacobus Brinkhof, eds. 2004. *Intellectual Property Law, 2004: Articles on Crossing Borders between Traditional and Actual*. Antwerp, Belgium: Intersentia.

Gudeman, Stephen. 2001. *The Anthropology of Economy: Community, Market, and Culture*. Oxford: Blackwell.

Guiart, Jean. 1950. "L'Apres-guerre a Ambrym." *Journal de La Société des Océanistes* 6 (6): 238–241.

———. 1951. "Cargo Cults and Political Evolution in Melanesia." *Mankind* 4 (6): 227–229.

———. 1953. "Notes sur les Tambours d'Ambrym." *Journal de La Société des Océanistes* (Special Issue 12): 334–336.

———. 1956. "Unité culturelle et variations locales dans le Centre Nord des Nouvelles-Hébrides." *Journal de La Société des Océanistes* (Special Issue 12): 217–225.

Gunn, Michael. 1987. "The Transfer of Malangan Ownership on Tabar." In *Assemblage of Spirits: Idea and Image in New Ireland*, ed. Louise Lincoln, 74–83. New York: George Braziller in Association with the Minneapolis Institute of Arts.

Haddon, Alfred Cort. 1936. *Canoes of Oceania*, ed. J. Hornell. Honolulu: Bernice P. Bishop Museum.

Hafstein, Valdimar. 2004. "The Making of Intangible Cultural Heritage: Tradition and Authenticity, Community and Humanity." Unpublished PhD dissertation, University of California, Berkeley.

Hakwa, Marie T. 2003. *A Review of Vanuatu's Recognition and Protection of Traditional Biodiversity Knowledge*. Final Report for the Environment Unit and the Ministry of Lands. Port Vila: Vanuatu.

Halbert, Deborah J. 2005. *Resisting Intellectual Property*. London: Routledge.

Hall, Thomas D., and James V. Fenelon, eds. 2009. *Indigenous Peoples and Globalization: Resistance and Revitalization*. Boulder, Colo.: Paradigm Publishers.

Halliburton, Murphy. 2011. "Resistance or Inaction? Protecting Ayurvedic Medical Knowledge and Problems of Agency." *American Ethnologist* 38 (1): 86–101.

Hambleton, Jennifer. 2004. "An Investigation into the Aotearoa/New Zealand Art Market for Maori Artifacts." Unpublished research paper, Department of Economics, Waikato Management School, University of Waikato.

Hamer, David. 1997. "Centralization and Nationalism (1891–1912)." In *The Oxford Illustrated History of New Zealand*, 2nd ed., ed. Keith Sinclair, 125–152. Oxford: Oxford University Press.

Hamilton, Jennifer Anne. 2009. *Indigeneity in the Courtroom: Law, Culture, and the Production of Difference in North American Courts*. New York: Routledge.

Handler, Richard. 1988. *Nationalism and the Politics of Culture in Quebec*. Madison: University of Wisconsin Press.

———. 1990. "Consuming Culture (Genuine and Spurious) as Style." *Cultural Anthropology* 5 (3): 346–357.

Hann, C. M. 1998. *Property Relations: Renewing the Anthropological Tradition*. New York: Cambridge University Press.

Hanson, Allan. 1989. "The Making of the Maori: Culture Invention and Its Logic." *American Anthropologist* 91 (4): 890–902.

Harding, Andrew. 2007. "Paying in Pig Tusks in Vanuatu." July 4. Available at http://news.bbc .co.uk (accessed October 14, 2012).

Harris, Ricci, and Bridget Robson, eds. 2007. *Hauora: Maori Standards of Health IV: A Study of the Years 2000–2005*. Wellington: Te Ropu Rangahau Hauora a Eru Pomare.

Harrison, Simon. 1992. "Ritual as Intellectual Property." *Man* 27 (2): 225–244.

———. 1993. "The Commerce of Cultures in Melanesia." *Man* 28 (1): 139–158.

———. 1999. *Stealing People's Names*. Cambridge: Cambridge University Press.

———. 2000. "From Prestige Goods to Legacies? Property and the Objectification of Culture in Melanesia." *Comparative Studies in Society and History* 42 (3): 662–679.

———. 2002. "The Politics of Resemblance: Ethnicity, Trademarks, Head-Hunting." *Journal of the Royal Anthropological Institute* 8 (2): 211–232.

———. 2007. "A Phenomenology of Trademark Ownership." In *Fracturing Resemblances: Identity*

and Mimetic Conflict in Melanesia and the West, by Simon Harrison, 27–35. New York: Berghahn Books.

Harrisson, Tom. 1937. *Savage Civilization*. London: Victor Gollancz.

Hart, Keith. 1986. "Heads or Tails? Two Sides of the Coin." *Man* 21 (4): 637–656.

———. 2000. *The Memory Bank: Money in an Unequal World*. London: Profile.

———. 2005. "Notes towards an Anthropology of Money." *Kritikos: An International and Interdisciplinary Journal of Postmodern Cultural Sound, Text and Image* 2. Available at http:// garnet.acnes.fsu.edu (accessed September 12, 2006).

———. 2007. "Marcel Mauss: In Pursuit of the Whole." *Comparative Studies in Society and History* 49 (2): 473.

Harvey, David. 2005. *A Brief History of Neoliberalism*. Oxford: Oxford University Press.

Hau'ofa, Epeli. 1993. "Our Sea of Islands." In *A New Oceania: Rediscovering Our Sea of Islands*, ed. Eric Waddell, Vijay Naidu, and Epili Hau'ofa, 2–16. Suva, Fiji: School of Social and Economic Development, University of the South Pacific.

Hayden, Cori. 2003. *When Nature Goes Public: The Making and Unmaking of Bioprospecting in Mexico*. Princeton, N.J.: Princeton University Press.

Hein, Hilde S. 2000. *The Museum in Transition: A Philosophical Perspective*. Washington, D.C.: Smithsonian Institution Press.

Henare, Amiria. 2004. "Rewriting the Script: Te Papa Tongarewa The Museum of New Zealand." *Social Analysis* 48 (1): 55–63.

———. 2005a. *Museums, Anthropology and Imperial Exchange*. Cambridge: Cambridge University Press.

———. 2005b. "Nga Aho Tipuna (Ancestral Threads): Maori Cloaks from New Zealand." In *Clothing as Material Culture*, ed. Susanne Küchler and Daniel Miller, 121–138. Oxford: Berg.

———. 2007. "Taonga Maori: Encompassing Rights and Property in New Zealand." In *Thinking through Things: Theorising Artefacts Ethnographically*, ed. Amiria Henare, Martin Holbraad, and Sari Wastell, 57–83. London: University College London.

Henare, Amiria, Martin Holbraad, and Sari Wastell, eds. 2007. *Thinking through Things: Theorising Artefacts Ethnographically*. London: Routledge.

Henare, Manuka. 2003. "The Changing Images of Nineteenth Century Māori Society—From Tribes to Nation." Unpublished PhD dissertation, Māori Studies, University of Victoria.

———. 2005. "The Implications of Globalization for Indigenous Communities of NZ-Aotearoa and Elsewhere: A Step towards Te Ao Mârama or towards Te Po?" In *Sovereignty under Siege? Globalization and New Zealand*, ed. Robert Patman and Chris Rudd, 111–128. Aldershot, U.K.: Ashgate.

Herle, Anita, and Sandra Rouse, eds. 1998. *Cambridge and the Torres Straits: Centenary Essays on*

the *1898 Anthropological Expedition*. Cambridge: Cambridge University Press.

Hirsch, Eric. 2002. "Malinowski's Intellectual Property." *Anthropology Today* 18 (2): 1–2.

———. 2010. "Property and Persons: New Forms and Contests in the Era of Neoliberalism." *Annual Review of Anthropology* 39: 347–360.

Hobsbawm, Eric J., and Terence O. Ranger. 1983. *The Invention of Tradition*. Cambridge: Cambridge University Press.

Holbraad, Martin. 2005. "Expending Multiplicity: Money in Cuban Ifá Cults." *Journal of the Royal Anthropological Institute* 11 (2): 231–254.

Hollowell, Julie. 2004. "Intellectual Property Protection and the Market for Alaska Native Arts and Crafts." In *Indigenous Intellectual Property Rights: Legal Obstacles and Innovative Solutions*, ed. Mary Riley, 55–98. Walnut Creek, Calif.: Altamira Press.

Hooper-Greenhill, Eilean. 2000. *Museums and the Interpretation of Visual Culture*. New York: Routledge.

Horse Capture, George P., Duane Champagne, and Chandler C. Jackson. 2007. *American Indian Nations: Yesterday, Today, and Tomorrow*. Lanham, Md.: Altamira Press.

Howard, Keith. 1998. "Repatriation of Maori Figure Not Expected." *The Dominion* (Wellington), November 24.

Huffer, Elise, and Ropate Qalo. 2004. "Have We Been Thinking Upside Down? The Contemporary Emergence of Pacific Theoretical Thought." *The Contemporary Pacific* 16 (1): 87–116.

Huffman, Kirk. 1995. "Travels and Travails with Felix Speiser: A Personal Perspective." *Journal of the Pacific Arts Association* (11–12): 90–138.

———. 1996. "Trading, Cultural Exchange and Copyright: Important Aspects of Vanuatu Arts." In *Arts of Vanuatu*, ed. Joël Bonnemaison, Kirk Huffman, Christian Kaufmann, and Darrell Tryon, 182–195. Bathurst, Australia: Crawford House.

———. 1997. "Vanuatu Arts." *Journal of the Pacific Arts Association* 15: 1–15.

———. 2005. *Traditional Money Banks in Vanuatu: Project Survey Report*. Port Vila: Vanuatu National Cultural Council.

Humphrey, Caroline, and Katherine Verdery. 2004. "Introduction: Raising Questions about Property." In *Property in Question: Value Transformation in the Global Economy*, ed. Caroline Humphrey and Katherine Verdery, 1–25. Oxford: Berg.

Hviding, Edvard, and Knut M. Rio, eds. 2011. *Made in Oceania: Social Movements, Cultural Heritage and the State*. Oxford: Sean Kingston.

Isaac, Gwyneira. 2007. *Mediating Knowledges: Origins of a Zuni Tribal Museum*. Tucson: University of Arizona Press.

Jahnke, Robert, and Huia Tomlins Jahnke. 2003. "The Politics of Maori Image and Design." *He Pukenga Kōrero: A Journal of Māori Studies* 7 (1): 5–37.

Janke, Terri. 1998. "Indigenous Cultural and Intellectual Property Rights: An Australian Perspective." In *Collective Human Rights of Pacific Peoples*, ed. Nin Tomas, 45–60. Auckland: International Research Unit for Maori and Indigenous Education, University of Auckland.

———. 2003. *Minding Culture: Case Studies on Intellectual Property and Traditional Cultural Expressions*. Geneva: World Intellectual Property Organisation.

Jeudy-Ballini, Monique, and Bernard Juillerat, eds. 2002. *People and Things: Social Mediations in Oceania*. Durham, N.C.: Carolina Academic Press.

Johnson, Miranda. 2008. "Making History Public: Indigenous Claims to Settler-States." *Public Culture* 20 (1): 97–117.

Jolly, Margaret. 1982. "Bird and Banyans of South Pentecost: Custom in Anti-Colonial Struggle." *Mankind* 13 (Special Issue 4): 338–356.

———. 1991. "Soaring Hawks and Grounded Persons: The Politics of Rank and Gender in North Vanuatu." In *Big Men and Great Men: Personifications of Power in Melanesia*, ed. Marilyn Strathern and Maurice Godelier, 48–80. Cambridge: Cambridge University Press.

———. 1992. "Spectres of Inauthenticity." *The Contemporary Pacific* 4 (1): 49–72.

———. 1994a. "Kastom as Commodity: The Land Dive as Indigenous Rite and Tourist Spectacle in Vanuatu." In *Culture-Kastom-Tradition: Developing Cultural Policy in Melanesia*, ed. Lamont Lindstrom and Geoffrey White, 131–146. Suva, Fiji: Institute of Pacific Studies, University of the South Pacific.

———. 1994b. *Women of the Place: Kastom, Colonialism, and Gender in Vanuatu*. Chur, Switzerland: Harwood Academic Publishers.

———. 2005. "Beyond the Horizon? Nationalisms, Feminisms, and Globalization in the Pacific." *Ethnohistory* 52 (Special Issue): 137–166.

Jolly, Margaret, and Nicholas Thomas, eds. 1992. *The Politics of Tradition in the Pacific. Oceania* 62 (Special Issue 4).

Jowitt, Anita. 2008. "The Future of Law in the South Pacific." *Journal of South Pacific Law* 12 (1): 43–48.

Kalinoe, Lawrence Kuna, and James Leach, eds. 2001. *Rationales of Ownership: Ethnographic Studies of Transactions and Claims to Ownership in Contemporary Papua New Guinea*. New Delhi: UBS Publishers' Distributors.

Kay, John. 2003. *The Truth about Markets: Their Genius, Their Limits, Their Follies*. London: Penguin Books.

Keesing, Roger M. 1982. "Kastom in Melanesia: An Overview." *Mankind* 13 (Special Issue 4): 297–301.

Keesing, Roger M., and Robert Tonkinson, eds. 1982. *Reinventing Traditional Culture: The Politics of Kastom in Island Melanesia. Mankind* 13 (Special Issue 4).

Keller, Janet. 1988. "Woven World: Neotraditional Symbols of Unity in Vanuatu." *Mankind* 18 (1): 1–13.

King, Michael. 1985. *Being Pakeha: An Encounter with New Zealand and the Maori Renaissance.* London: Hodder and Stoughton.

———. 1999. *Being Pakeha Now.* Auckland: Penguin Books.

Kirsch, Stuart. 2006. *Reverse Anthropology: Indigenous Analysis of Social and Environmental Relations in New Guinea.* Stanford, Calif.: Stanford University Press.

———. 2010. "Reverse Anthropology Redux." *Pacific Studies* 33 (1): 84–101.

Kirshenblatt-Gimblett, Barbara. 2004. "Intangible Heritage as Metacultural Production." *Museum International* 56 (1–2): 52–65.

Kongolo, Tshimanga. 2008. *Unsettled International Intellectual Property Issues.* Alphen aan den Rijn, The Netherlands: Kluwer Law International.

Kopytoff, Igor. 1986. "The Cultural Biography of Things: Commoditization as Process." In *The Social Life of Things: Commodities in Cultural Perspective*, ed. Arjun Appadurai, 64–94. Cambridge: Cambridge University Press.

Küchler, Susanne. 1987. "Malangan: Art and Memory in a Melanesian Society." *Man* 22 (2): 238–255.

———. 1992. "Making Skins: Malangan and the Idiom of Kinship in New Ireland." In *Anthropology, Art and Aesthetics*, ed. Jeremy Coote and Anthony Shelton, 94–112. Oxford: Oxford University Press.

Kuper, Adam. 2003. "The Return of the Native." *Current Anthropology* 44 (3): 389–395.

Langton, Marcia. 2006. *Settling with Indigenous People: Modern Treaty and Agreement-Making.* Annandale, Australia: Federation Press.

Langton, Marcia, and Council for Aboriginal Reconciliation. 1994. *Valuing Cultures: Recognising Indigenous Cultures as a Valued Part of Australian Heritage.* Key issue paper, vol. 3. Canberra: Australian Government Publication Service.

Larcom, Joan. 1982. "The Invention of Convention." *Mankind* 13 (Special Issue 4): 330–337.

Lavine, Hal B. 2010. "Claiming Indigenous Rights to Culture, Flora, and Fauna: A Contemporary Case from New Zealand." *PoLAR: Political and Legal Anthropology Review* 33 (1): 36–56.

Layard, John W. 1928. "Degree-Taking Rites in South West Bay, Malekula (with Plates XIV–XIX)." *Journal of the Royal Anthropological Institute of Great Britain and Ireland* 58: 139–223.

———. 1942. *Stone Men of Malekula.* London: Chatto and Windus.

Layard, Richard. 2003. "Happiness: Has Social Science a Clue?" Lionel Robbins Memorial Lectures, the London School of Economics, March 3, 4, 5. Available at http://cep.lse.ac.uk (accessed July 20, 2008).

Lazar, Sian. 2008. *El Alto, Rebel City: Self and Citizenship in Andean Bolivia*. Durham, N.C.: Duke University Press.

Leach, James. 2000. "Situated Connections: Rights and Intellectual Resources in a Rai Coast Society." *Social Anthropology* 8 (2): 163–179.

———. 2003. "Owning Creativity: Cultural Property and the Efficacy of Custom on the Rai Coast of Papua New Guinea." *Journal of Material Culture* 8 (2): 123–143.

———. 2008. "An Anthropological Approach to Transactions Involving Names and Marks, Drawing on Melanesia." In *Trade Marks and Brands: An Interdisciplinary Critique*, ed. Lionel Bently, Jennifer Davis, and Jane Ginsburg, 319–342. Cambridge: Cambridge University Press.

Leach, Michael J. 1967. "Memorandum from the Information Officer and Co-Operative Societies Officer." February 6, 1967, F2/5. Vanuatu National Archives, Port Vila.

Lebot, Vincent, Mark David Merlin, and Lamont Lindstrom. 1992. *Kava: The Pacific Drug*. Psychoactive Plants of the World. New Haven, Conn.: Yale University Press.

Lessig, Lawrence. 2001. *The Future of Ideas: The Fate of the Commons in a Connected World*. New York: Random House.

Li, Tanya. 2009. "Indigeneity, Capitalism and Countermovements." Working Paper, Markets and Modernities, University of Toronto. Available at www.utoronto.ca (accessed January 21, 2011).

———. 2010. "Indigeneity, Capitalism, and the Management of Dispossession." *Current Anthropology* 51 (3): 385–414.

Lightner, Sara, and Anna Naupa. 2005. *Histri Blong Yumi Long Vanuatu: An Educational Resource*. Port Vila, Vanuatu: Vanuatu Kaljoral Senta.

Lindstrom, Lamont. 1990. *Knowledge and Power in a South Pacific Society*. Washington, D.C.: Smithsonian Institution Press.

———. 1993. *Cargo Cult: Strange Stories of Desire from Melanesia and Beyond*. Honolulu: Center for Pacific Islands Studies, School of Hawaiian, Asian, and Pacific Studies and University of Hawai'i Press.

———. 1997. "Chiefs in Vanuatu Today." In *Chiefs Today: Traditional Pacific Leadership and the Post-Colonial State*, ed. Geoffrey White and Lamont Lindstrom, 211–229. Stanford, Calif.: Stanford University Press.

———. 2009. "Kava Pirates in Vanuatu?" *International Journal of Cultural Property* 16 (3): 291–308.

Lindstrom, Lamont, and James Gwero. 1998. *Big Wok: Storian Blong Wol Wo Tu Long Vanuatu*. Suva, Fiji: University of the South Pacific.

Lindstrom, Lamont, and Geoffrey M. White, eds. 1994. *Culture-Kastom-Tradition: Developing Cultural Policy in Melanesia*. Suva, Fiji: Institute of Pacific Studies, University of the South Pacific.

———. 1995. "Anthropology's New Cargo: Future Horizons." *Ethnology* 34 (3): 201–209.

Lini, Walter. 1980. *Beyond Pandemonium: From the New Hebrides to Vanuatu*. Wellington: Asia Pacific Books in Association with the Institute of Pacific Studies of the University of the South Pacific, Suva, Fiji.

Linnekin, Jocelyn. 1992. "On the Theory and Politics of Cultural Construction in the Pacific." *Oceania* 64 (4): 249–263.

Lipset, David. 2004. "'The Trial': A Parody of the Law amid the Mockery of Men in Post-Colonial Papua New Guinea." *Journal of the Royal Anthropological Institute* 10 (1): 63–89.

Lury, Celia. 2009. "Brand as Assemblage: Assembling Culture." *Journal of Cultural Economy* 2 (1–2): 67–82.

MacClancy, Jeremy V. 1984. "Vanuatu since Independence: 1980–83." *Journal of Pacific History* 19 (2): 100–112.

———. 2002. *To Kill a Bird with Two Stones: A Short History of Vanuatu*. 3rd ed. Port Vila: Vanuatu Kaljoral Senta.

Macdonald-Milne, Brian, and Pamela Thomas, eds. 1981. *Yumi Stanap: Leaders and Leadership in a New Nation*. Suva, Fiji: Institute of Pacific Studies, University of the South Pacific.

Malinowski, Bronislaw. (1922) 2002. *Argonauts of the Western Pacific: An Account of Native Enterprise and Adventure in the Archipelagos of Melanesian New Guinea*. London: Routledge.

———. 1927. *Sex and Repression in Savage Society*. London: K. Paul, Trench, Trubner and Harcourt, Brace.

Manning, Paul. 2010. "The Semiotic of Brand." *Annual Review of Anthropology* 39: 33–49.

Māori Trade Marks Focus Group. 1997. *Māori and Trade Marks: A Discussion Paper*. Wellington: Ministry of Commerce.

Marks, Nic, Andrew Simms, Sam Thompson, and Saamah Abdallah. 2006. *The Happy Planet Index: An Index of Human Well-Being and Environmental Impact*. London: New Economics Foundation.

Marrie, Henrietta. 2009. "The UNESCO Convention for the Safeguarding of the Intangible Cultural Heritage and the Protection and Maintenance of the Intangible Cultural Heritage of Indigenous Peoples." In *Intangible Heritage*, ed. Laurajane Smith and Natsuko Akagawa, 169–192. Oxford: Routledge.

Maurer, Bill. 2005. *Mutual Life, Limited: Islamic Banking, Alternative Currencies, Lateral Reason*. Princeton, N.J.: Princeton University Press.

———. 2006. "The Anthropology of Money." *Annual Review of Anthropology* 35 (1): 15–36.

Mauss, Marcel. (1923–24) 2000. *The Gift: The Form and Reason for Exchange in Archaic Societies*. London: W. W. Norton.

Mayall, A. Lees. 1969. Letter to C. H. Allan, Esq., December 3. National Archives of Vanuatu, Port Vila.

Mazzarella, William. 2003. "'Very Bombay': Contending with the Global in an Indian Advertising Agency." *Cultural Anthropology* 18 (1): 33–71.

McCarthy, Conal. 2007. *Exhibiting Māori: A History of Colonial Cultures of Display.* Oxford: Berg.

———. 2011. *Museums and Māori: Heritage Professionals, Indigenous Collections, Current Practice.* Wellington: Te Papa Press.

McCarthy, Conal, and Joanna Cobley. 2009. *Museums and Museum Studies in New Zealand: A Survey of Historical Developments.* London: Blackwell.

McNeil, Kent. 1997. "The Meaning of Aboriginal Title." In *Aboriginal and Treaty Rights in Canada: Essays on Law, Equality and Respect for Difference*, ed. Michael Asch, 135–154. Vancouver: University of British Columbia Press.

Mead, Aroha Te Pareake. 2004. *Nga Tikanga, Nga Taonga: Cultural and Intellectual Property—The Rights of Indigenous Peoples.* Auckland: University of Auckland.

Mead, Sidney (Hirini) Moko. 1990. "The Nature of Taonga." Proceedings of the Taonga Maori Conference, New Zealand, November 18–27, 1990, 164–169. Wellington: Cultural Conservation Advisory Council, Department of Internal Affairs.

———. 2009. "Reflections on Te Maori." Unpublished presentation, September 11, 2009. Manuscript in collection of author.

Mead, Sidney Moko, and American Federation of Arts. 1984. *Te Maori: Maori Art from New Zealand Collections.* New York: Abrams in Association with the American Federation of Arts.

Melbourne, Hineani. 1995. *Maori Sovereignty: The Maori Perspective.* Auckland: Hodder Moa Beckett.

Merry, Sally Engle. 1988. "Legal Pluralism." *Law and Society Review* 22 (5): 869–896.

———. 2000. *Colonizing Hawai'i: The Cultural Power of Law.* Princeton, N.J.: Princeton University Press.

Merry, Sally Engle, and Donald L. Brenneis. 2004. *Law and Empire in the Pacific: Fiji and Hawai'i.* London: James Currey.

Message, Kylie. 2006. *New Museums and the Making of Culture.* Oxford: Berg.

Metge, Joan. 2010. "Huarangatia: Maori Words in New Zealand English." In *Tuamaka: The Challenge of Difference in Aotearoa New Zealand*, ed. Joan Metge, 55–107. Auckland: Auckland University Press.

Miles, William F. S. 1998. *Bridging Mental Boundaries in a Postcolonial Microcosm: Identity and Development in Vanuatu.* Honolulu: University of Hawai'i Press.

Miller, Daniel. 1991. "Primitive Art and the Necessity of Primitivism to Art." In *The Myth of Primitivism: Perspectives on Art*, ed. Susan Hiller, 35–52. London: Routledge.

———, ed. 1995. *Worlds Apart: Modernity through the Prism of the Local.* Association for Social Anthropology Decennial Conference Series, the Uses of Knowledge. New York: Routledge.

———. 2001. "Alienable Gifts and Inalienable Commodities." In *The Empire of Things: Regimes of Value and Material Culture*, ed. Fred Myers, 91–119. Santa Fe, N.M.: School of American Research Press.

———. 2005. "Materiality: An Introduction." In *Materiality*, ed. Daniel Miller, 1–50. Durham, N.C.: Duke University Press.

Ministry of Agriculture and Forestry. 2007. *A Biosecurity Science Strategy for New Zealand: Mahere Rautaki Putaiaio Whakamaru*. Wellington: MAF Biosecurity New Zealand.

Ministry of Economic Development/Manatū Ōhanga. 2007. *Te Mana Taumaru Mātauranga: Intellectual Property Guide for Māori Organisations and Communities*. Wellington: Ministry of Economic Development.

Mitchell, Jean. 2004. "Kilem Taem (Killing Time) in a Postcolonial Town: Young People and Settlements in Port Vila, Vanuatu." In *Globalization and Culture Change in the Pacific Islands*, ed. Victoria Lockwood, 358–377. Upper Saddle River, N.J.: Prentice Hall.

Mitchell, Timothy. 2005. "The Work of Economics: How a Discipline Makes Its World." *European Journal of Sociology* 46 (2): 297 320.

Mithlo, Nancy Marie. 2004. "Red Man's Burden: The Politics of Inclusion in Museum Settings." *American Indian Quarterly* 28 (3–4): 743–763.

Mookherjee, Nyanika, and Christopher Pinney. 2011. "The Aesthetics of Nations: Anthropological and Historical Approaches." *Journal of the Royal Anthropological Institute* (Special Issue).

Moor, Liz. 2007. *The Rise of Brands*. Oxford: Berg.

Moore, Sally Falk. 1978. *Law as Process: An Anthropological Approach*. London: Routledge and K. Paul.

———. 2001. "Certainties Undone: Fifty Turbulent Years of Legal Anthropology, 1949–1999." *Journal of the Royal Anthropological Institute* 7 (1): 95–116.

———. 2005. *Law and Anthropology: A Reader*. Malden, Mass.: Blackwell.

Moreton-Robinson, Aileen. 2007. *Sovereign Subjects: Indigenous Sovereignty Matters*. Crows Nest, Australia: Allen and Unwin.

Morgan, Owen. 2004. "Protecting Indigenous Signs and Trade Marks under the New Zealand Trade Marks Act 2002." *SSRN eLibrary*. Available at http://papers.ssrn.com (accessed April 1, 2011).

Morphy, H. 1992. "From Dull to Brilliant: The Aesthetics of Spiritual Power amongst the Yolngu." In *Anthropology, Art and Aesthetics*, ed. Jeremy Coote and Anthony Shelton, 181–208. Oxford: Oxford University Press.

Moutu, Andrew. 2007. "Collection as a Way of Being." In *Thinking through Things: Theorising Artefacts Ethnographically*, ed. Amiria Henare, Martin Holbraad, and Sari Wastell, 93–112. London: Routledge.

————. 2009. "The Dialectic of Creativity and Ownership in Intellectual Property Discourse." *International Journal of Cultural Property* 16 (3): 309–324.

Muscarella, Oscar White. 2000. *The Lie Became Great: The Forgery of Ancient Near Eastern Cultures.* New York: STYX Publications.

Museum of New Zealand. 2004. *Icons Nga Taonga: From the Museum of New Zealand Te Papa Tongarewa.* Wellington: Te Papa Press.

Myers, Fred R. (1986) 1991. *Pintupi Country, Pintupi Self: Sentiment, Place, and Politics among Western Desert Aborigines.* Berkeley: University of California Press.

————. 2002. *Painting Culture: The Making of an Aboriginal High Art.* Durham, N.C.: Duke University Press.

————. 2004. "Ontologies of the Image and Economies of Exchange." *American Ethnologist* 31 (1): 5–21.

Narokobi, Bernard. 1980. *The Melanesian Way: Total Cosmic Vision of Life.* Boroko: Institute of Papua New Guinea Studies.

Neich, Roger. 2001. *Carved Histories: Rotorua Ngati Tarawhai Woodcarving.* Auckland: Auckland University Press.

Newman, Murial. 2011. "WAI 262 Empowers Maori Elite." *NZCPR Weekly*, July 3, page 1. Available at www.nzcpr.com/weekly284.pdf (accessed September 15, 2011).

Newton, Douglas. 1996. "Old Wine in New Bottles, and the Reverse." In *Museums and the Making of "Ourselves": The Role of Objects in National Identity*, ed. Flora Kaplan, 269–290. Leicester: Leicester University Press.

Nicholas, Darcy. 2009. "Preface." In *Maori Art Market.* Wellington: Toi Maori Aotearoa Maori Art New Zealand.

Niezen, Ronald. 2003. *The Origins of Indigenism: Human Rights and the Politics of Identity.* Berkeley: University of California Press.

Ninness, Greg. 2002. "Tiki Fetches Ka Pai Price." *Sunday Star Times* (Auckland), July 28, 2002.

Norton, Robert. 1993. "Culture and Identity in the South Pacific: A Comparative Analysis." *Man* 28 (4): 741–759.

Oldham, Paul, and Miriam Anne Frank. 2008. "'We the Peoples…': The United Nations Declaration on the Rights of Indigenous Peoples." *Anthropology Today* 24 (2): 5–9.

Oliver, Pam, and Nan Wehipeihana. 2006. *Report on the Evaluation of Toi Iho™ 2002–2005.*

Orange, Claudia. 1987. *The Treaty of Waitangi.* Wellington: Allen and Unwin.

O'Regan, Gerard. 1997. *Bicultural Developments in Museums of Aotearoa: What Is the Current Status?* Wellington: Museum of New Zealand Te Papa Tongarewa and Museums Association of Aotearoa New Zealand.

O'Sullivan, Dominic. 2007. *Beyond Biculturalism: The Politics of an Indigenous Minority.* Wellington: Huia.

Panoho, Rangihiroa. 1992. "Maori: At the Centre, on the Margins." In *Headlands: Thinking Through New Zealand Art*, 122–134. Sydney: Museum of Contemporary Art.

Partington, W. H. T. 2003. *Te Awa: Partington's Photographs of Whanganui Māori*. Auckland: Random House New Zealand.

Patand-Celerier, Philip. 1997. "In the Land of the Slit Gongs That Are Still Standing." *World of Tribal Arts* 4 (2): 55–62.

Patterson, Mary. 1976. "Kinship, Marriage and Ritual in North Ambrym." Unpublished PhD dissertation, University of Sydney.

———. 1981. "Slings and Arrows: Rituals of Status Acquisition in North Ambrym." In *Vanuatu: Politics, Economics and Ritual in Island Melanesia*, ed. Michael Allen, 189–236. Sydney: Academic Press.

———. 1996. "Mastering the Arts: An Examination of the Context of the Production of Art in Ambrym." In *Arts of Vanuatu*, ed. Joël Bonnemaison, Kirk Huffman, Christian Kaufmann, and Darrell Tryon, 254–264. Bathurst, Australia: Crawford House.

———. 2002. "Moving Histories: An Analysis of the Dynamics of Place in North Ambrym, Vanuatu." *Australian Journal of Anthropology* 13 (2): 200–219.

Pattillo. 2007. *Review of the Toi Iho™: Report and Models for the Way Forward*. Wellington: Pattillo.

Peers, Laura L., and Alison K. Brown, eds. 2003. *Museums and Source Communities: A Routledge Reader*. London: Routledge.

Philibert, Jean-Marc. 1981. "Living under Two Flags: Selective Modernization in Erakor Village, Efate." In *Vanuatu: Politics, Economics and Ritual in Island Melanesia*, ed. Michael Allen, 315–336. Sydney: Academic Press.

Pigliasco, Guido. 2009. "Intangible Cultural Property, Tangible Databases, Visible Debates: The Sawau Project." *International Journal of Cultural Property* 16 (3): 255–272.

———. 2011. "Are the Grassroots Growing? Intangible Cultural Heritage Lawmaking in Fiji and Oceania." In *Made in Oceania: Social Movements, Cultural Heritage and the State*, ed. Edvard Hviding and Knut M. Rio, 321–337. Oxford: Sean Kingston.

Pinney, Christopher. 2002. "Creole Europe: The Reflection of a Reflection." *New Zealand Journal of Literature* 20 (Special Issue): 125–161.

Polanyi, Karl. (1957) 1971. *Trade and Market in the Early Empires*. Washington, D.C: Henry Regnery.

———. (1944) 2001. *The Great Transformation: The Political and Economic Origins of Our Time*. 2nd ed. Boston: Beacon Press.

Pomare, Eru W., Gail M. de Boer, New Zealand Department of Health, and Medical Research Council of New Zealand. 1988. *Hauora, Maori Standards of Health: A Study of the Years, 1970–1984*. Special Report Series, vol. 78. Wellington: Medical Research Council.

Ponter, Brian Anthony. 1983. "Co-operatives in Vanuatu 1962–1980." Unpublished PhD dissertation, University of the South Pacific.

Posey, Darrell Addison, and Graham Dutfield. 1996. *Beyond Intellectual Property: Toward Traditional Resource Rights for Indigenous Peoples and Local Communities.* Ottawa: International Development Research Centre.

Postero, Nancy Grey. 2007. *Now We Are Citizens: Indigenous Politics in Postmulticultural Bolivia.* Stanford, Calif.: Stanford University Press.

Pottage, Alain. 2004. "Who Owns Academic Knowledge?" *Cambridge Anthropology* 4 (1): 1–21.

Pottage, Alain, and Martha Mundy. 2004. *Law, Anthropology, and the Constitution of the Social: Making Persons and Things.* Cambridge: Cambridge University Press.

Povinelli, Elizabeth. 2001. "Radical Worlds: The Anthropology of Incommensurability and Inconceivability." *Annual Review of Anthropology* 30 (1): 319–334.

———. 2002. *The Cunning of Recognition: Indigenous Alterities and the Making of Australian Multiculturalism.* Durham, N.C.: Duke University Press.

Prott, Lyndel V. 2009. *Witnesses to History: A Compendium of Documents and Writings on the Return of Cultural Objects.* Paris: United Nations Educational, Scientific and Cultural Organization.

Purdy, Kim. 2001. "Maori Artworks Driven Underground." *Sunday Star Times* (Auckland), September 23, 2001.

Quirke, Michelle. 2001. "Maori Photo Storm." *The Dominion* (Wellington), September 21, 2001.

Radin, Margaret Jane. 1993. *Reinterpreting Property.* Chicago: University of Chicago Press.

Rata, Elizabeth. 2000. *A Political Economy of Neotribal Capitalism.* Lanham, Md.: Lexington Books.

———. 2003. "The Treaty and Neotribal Capitalism." *Public Sector* 26 (3): 2–6.

———. 2005. "Rethinking Biculturalism." *Anthropological Theory* 5 (3): 267–284.

Rawlings, Gregory E. 1999a. "Foundations of Urbanisation: Port Vila Town and Pango Village, Vanuatu." *Oceania* 70 (1): 72.

———. 1999b. "Villages, Islands and Tax Havens: The Global/Local Implications of a Financial Entrepôt in Vanuatu." *Canberra Anthropology* 22 (2): 37–50.

———. 2004. "Laws, Liquidity and Eurobonds: The Making of the Vanuatu Tax Haven." *Journal of Pacific History* 39 (3): 325–341.

Regenvanu, Ralph. 1993. "Who's Road: An Examination of 'Melanesian Socialism.'" Unpublished BA honors thesis, Development Studies, Australian National University.

———. 2006. "The 'Pig Bank': A Trojan Horse for Custom." Paper presented at the panel Vanuatu Taem: 1606–1906–2006, Annual Meeting of the Association for Social Anthropology in Oceania, San Diego, Calif., February 8, 2006.

———. 2008. "Issues with Land Reform in Vanuatu." *Journal of South Pacific Law* 12 (1): 63–67.

Regenvanu, Ralph, and Haidy Geismar. 2011. "Pig Banks: Re-Imagining the Economy in Vanuatu."

In *Social Movements, Cultural Heritage and the State in Oceania*, ed. Edvard Hviding, and Knut M. Rio, 31–50. Oxford: Sean Kingston.

Republic of Vanuatu. 2000. *Copyright and Related Rights Act no. 42 of 2000.*

Reserve Bank of Vanuatu, The. 2008. *Study on the Proposed Vanuatu Custom Currencies, Livatu and Selmane: Could They Be Nationally Accepted, and How Practical Are Their Convertibility and Interchangeability?* Port Vila: Reserve Bank of Vanuatu.

Riles, Annelise. 2004. "Law as Object." In *Law and Empires in the Pacific: Fiji and Hawai'i*, ed. Sally Engle Merry and Donald Brenneis, 187–212. Santa Fe, N.M.: School of American Research Press.

Rio, Knut M. 1997. "Standing Drums in Vanuatu: The Cultural Biography of a National Symbol." Unpublished dissertation for the degree of Cand. Polit., University of Bergen, Norway.

———. 2000. "A Cultural Biography of Ambrym Standing Drums." Paper presented at Walking About: Travel, Trade and Movement in Vanuatu, organized by the British Museum and the Centre for Cross-Cultural Research, Australian National University, Canberra, Australia, October 13–14, 2000.

———. 2002. "The Third Man: Manifestations of Agency on Ambrym Island, Vanuatu." Unpublished PhD dissertation, Department of Social Anthropology, University of Bergen, Norway.

———. 2005. "Discussions around a Sand-drawing: Creations of Agency and Society in Melanesia." *Journal of the Royal Anthropological Institute* 11 (3): 401–423.

———. 2010. "Handling Sorcery in a State System of Law: Magic, Violence and Kastom in Vanuatu." *Oceania* 80: 182–197.

Rivers, W. H. R. 1914. *The History of Melanesian Society.* Cambridge: Cambridge University Press.

Roberts, Kevin. 2005. *Lovemarks: The Future beyond Brands.* New York: PowerHouse Books.

Roberts, Mere, and Brad Haami. 1999. "Science and Other Knowledge Systems: Coming of Age in the New Millennium." *Pacific World* (54): 16–22.

Roberts, Mere, Bradford Haami, Richard Anthony Benton, Terre Satterfield, Melissa Finucane, Mark Henare, and Manuka Henare. 2004. "Whakapapa as a Maori Mental Construct: Some Implications for the Debate over Genetic Modification of Organisms." *The Contemporary Pacific* 16 (1): 1–28.

Roberts, Roma Mere, and Peter R. Wills. 1998. "Understanding Maori Epistemology: A Scientific Perspective." In *Tribal Epistemologies: Essays in the Philosophy of Anthropology*, ed. Helmut Wautischer, 51–86. Aldershot, U.K.: Ashgate.

Rodman, Margaret. 2001. *Houses Far from Home: British Colonial Space in the New Hebrides.* Honolulu: University of Hawai'i Press.

Rodman, William L., and Margaret Rodman. 1985. "Rethinking Kastom: On the Politics of Place Naming in Vanuatu." *Oceania* 40 (4): 242–251.

Rose, Carol M. 1994. *Property and Persuasion: Essays on the History, Theory, and Rhetoric of Ownership*. Boulder, Colo.: Westview Press.

Rousseau, Benedicta. 2003. *Final Report of the Juvenile Justice Project*. Port Vila, Vanuatu: Vanuatu Cultural Centre.

———. 2004. "The Achievement of Simultaneity: Kastom and Contemporary Vanuatu." Unpublished PhD dissertation, Department of Social Anthropology, University of Cambridge.

———. 2008. "This Is a Court of Law, Not a Court of Morality: Kastom and Custom in Vanuatu State Courts." *Journal of South Pacific Law* 12 (2): 15–27.

———. 2012. " 'Vot long stret man': Personality, Policy and the Election of Ralph Regenvanu, Vanuatu 2008." *The Contemporary Pacific* 24 (1): 98–119.

Rowlands, Michael. 2002. "The Power of Origins: Questions of Cultural Rights." In *The Material Culture Reader*, vol. 5, ed. Victor Buchli, 115–133. Oxford: Berg.

Rubin, William Stanley, ed. 1984. *"Primitivism" in 20th Century Art: Affinity of the Tribal and the Modern*. New York: Museum of Modern Art.

Rules Governing the Use by Artists of the Toi Iho™ Mark. 2002. Wellington: Creative New Zealand.

Sahlins, Marshall. 1999. "Two or Three Things I Know about Culture." *Journal of the Royal Anthropological Institute* 5 (3): 399–421.

Salmond, Amiria, and Anne Salmond. 2010. "Artefacts of Encounter." *Interdisciplinary Science Reviews* 35 (3–4): 302–317.

Saunders, Nicholas. 1999. "Biographies of Brilliance: Pearls, Transformations of Matter and Being, c. AD 1492." *World Archaeology* 31 (2): 243–257.

Schaffer, Simon. 1994. *From Physics to Anthropology—and Back Again*. Cambridge, U.K.: Prickly Pear Press.

Secretariat of the Pacific Community. 1999. "Report of Symposium on the Protection of Traditional Knowledge and Expressions of Indigenous Cultures in the Pacific Islands, Nouméa, New Caledonia." February 15–19, 1999. Archived at portal.unesco.org (accessed October 12, 2012).

———. 2002. *Regional Framework for the Protection of Traditional Knowledge and Expressions of Culture*. Nouméa, New Caledonia: Secretariat of the Pacific Community.

Seligman, C. G. (1910) 1976. *The Melanesians of British New Guinea*. New York: A.M.S. Press.

Sheeran, Garry. 1996. "Maori Plea Dampens Cloak Auction." *Sunday Star Times* (Auckland), March 31, 1996.

Shineberg, Dorothy. 1967. *They Came for Sandalwood: A Study of the Sandalwood Trade in the South-West Pacific, 1830–1865*. Melbourne: Melbourne University Press.

Simet, Jacob L. 2000. "Copyrighting Traditional Tolai Knowledge?" In *Protection of Intellectual, Biological and Cultural Property in Papua New Guinea*, ed. Kathy Whimp and Mark Busse, 62–80. Canberra: Asia Pacific Press.

Simo, Joel. 2005. *Report of the National Review of the Customary Land Tribunal Program in Vanuatu*. Port Vila: Vanuatu National Cultural Council.

Sinclair, Karen. 2003. *Maori Times, Maori Places: Prophetic Histories*. Lanham, Md.: Rowman and Littlefield.

Sloane, Dunbar. 2002. *Artifacts Sale Catalogue, November 21st*. Auckland: Dunbar Sloane.

Smith, Graham H. 2003. "Kaupapa Maori Theory: Theorizing Indigenous Transformation of Education and Schooling." Paper presented at Kaupapa Maori Symposium/ZARE/AARE Joint Conference, December 2003, Auckland.

Smith, Huhana. 2009. "Mana Taonga and the Micro World of Intricate Research and Findings around Taonga Maori at the Museum of New Zealand, Te Papa Tongarewa." *Sites: A Journal of Social Anthropology and Cultural Studies* 6 (2): 7–32.

Smith, Laurajane, and Natsuko Akagawa, eds. 2009. *Intangible Heritage*. London: Routledge.

Smith, Linda Tuhiwai. 1999. *Decolonizing Methodologies: Research and Indigenous Peoples*. London: Zed Books.

Smith, S. Percy. 1904. *Hawaiki: The Original Home of the Maori: With a Sketch of Polynesian History*. 2nd ed. London: Whitcombe and Tombs.

Solomon, Maui. 2001. "The Wai 262 Claim by Six Maori Tribes: An Interview with Maui Solomon." *Motion Magazine*. Available at www.inmotionmagazine.com (accessed March 7, 2005).

———. 2004. "Intellectual Property Rights and Indigenous People's Rights and Responsibilities." In *Indigenous Intellectual Property Rights: Legal Obstacles and Innovative Solutions*, vol. 10, ed. Mary Riley, 221–250. Walnut Creek, Calif.: Altamira Press.

———. 2006. "Protecting Maori Heritage in New Zealand." In *Art and Cultural Heritage: Law, Policy and Practice*, ed. Barbara T. Hoffman, 352–363. Cambridge: Cambridge University Press.

Soutar, Monty, and Mike Spedding. 2000. *Improving Bicultural Relationships—A Case Study: The C Company 28 Māori Battalion Collection and Exhibition at the Gisborne Museum and Arts Centre*. Wellington: Te Papa National Services.

Spyer, Patricia. 1998. "Introduction." In *Border Fetishisms: Material Objects in Unstable Spaces*, ed. Patricia Spyer, 1–12. London: Routledge.

Stallybrass, Peter. 1998. "Marx's Coat." In *Border Fetishisms: Material Objects in Unstable Spaces*, ed. Patricia Spyer, 183–208. New York: Routledge.

Stanley, Nick. 1998. *Being Ourselves for You: The Global Display of Cultures*. London: Middlesex University Press.

———, ed. 2007. *The Future of Indigenous Museums: Perspectives from the Southwest Pacific*. New York: Berghahn Books.

Stocking, George W., ed. 1985. *Objects and Others: Essays on Museums and Material Culture*. Madison: University of Wisconsin Press.

Strang, Veronica. 2006. "A Happy Coincidence? Symbiosis and Synthesis in Anthropological and Indigenous Knowledges." *Current Anthropology* 47 (6): 981–1008.

Strathern, Marilyn. 1981. "Culture in a Netbag: The Manufacture of a Subdiscipline in Anthropology." *Man* 16 (4): 665–688.

———. 1988. *The Gender of the Gift: Problems with Women and Problems with Society in Melanesia.* Berkeley: University of California Press.

———. 1999. *Property, Substance, and Effect: Anthropological Essays on Persons and Things.* London: Athlone Press.

———. 2001a. "Global and Local Contexts." In *Rationales of Ownership: Ethnographic Studies of Transactions and Claims to Ownership in Contemporary Papua New Guinea*, ed. Lawrence Kuna Kalinoe and James Leach, 107–127. New Delhi: UBS Publishers' Distributors.

———. 2001b. "The Patent and the Malanggan." *Theory, Culture and Society* 18 (4): 1–26.

———. 2005. "Money Appearing and Disappearing: Notes on Inflation in Papua New Guinea." In *A Polymath Anthropologist: Essays in Honour of Ann Chowning*, ed. Harriet Lyons, Ann Chowning, Claudia Gross, and Dorothy Ayers Counts, 113–120. Research in Anthropology and Linguistics Monograph Number 6. Auckland: Department of Anthropology, University of Auckland.

Strathern, Marilyn, and Eric Hirsch, eds. 2004. *Transactions and Creations: Property Debates and the Stimulus of Melanesia.* New York: Berghahn Books.

Strickland, April. 2011. "Legal Ta Moko-over: Maori Tattooing, Copyright and 'The Hangover 2,'" July 13, 2011. Available at www.materialworldblog.com, last accessed October 20, 2012.

Sykes, Karen, ed. 2001. *Cultural Property in the New Guinea Islands Region.* New Delhi: UBS Publishers' Distributors.

Tabani, Marc. 2008. "A Political History of Nagriamel on Santo, Vanuatu." *Oceania* 78 (3): 332–357.

Tahana, Yvonne. 2009. "$1 Million Maori Art Trademark for Chop." *New Zealand Herald*, October 22.

Tanmarahi i Tanbunia non Guiguinvanua. 2008. "Proposal to the Vanuatu Government and the Reserve Bank by Tanmarahi i Tabunia Non Guiguinvanua (Reserve System of Custom Currencies and Custom Bank)." Unpublished document, in collection of author.

Tapsell, Paul. 1997. "The Flight of Parerautu: An Investigation of Taonga from a Tribal Perspective." *Journal of the Polynesian Society* 106 (4): 323–374.

———. 2000. *Pukaki: A Comet Returns.* Auckland: Reed.

———. 2005. "From the Sideline: Tikanga, Treaty Values and Te Papa." In *Waitangi Revisited: Perspectives on the Treaty of Waitangi*, ed. Michael Belgrave, Merata Kawharu, and David Vernon Williams, 266–280. Oxford: Oxford University Press.

———. 2006a. *Maori Treasures of New Zealand: Ko Tawa.* Auckland: David Bateman in association with Auckland War Memorial Museum Tamaki Paenga Hira.

———. 2006b. "Taonga, Marae, Whenua—Negotiating Custodianship: A Maori Tribal Response to Te Papa: The Museum of New Zealand." In *Rethinking Settler Colonialism: History and Memory in Australia, Canada, Aotearoa New Zealand and South Africa*, ed. Annie E. Coombes, 86–99. Manchester, U.K.: Manchester University Press.

Tauli-Corpuz, Victoria. 1998. "TRIPS and Its Potential Impacts on Indigenous Peoples." *ECHOES: Justice, Peace and Creation News*. Available at www.wcc-coe.org (accessed January 24, 2011).

Taussig, Michael. 1980. *The Devil and Commodity Fetishism in South America*. Chapel Hill: University of North Carolina Press.

———. 1993. *Mimesis and Alterity: A Particular History of the Senses*. New York: Routledge.

Taylor, John. 2005. "Paths of Relationship, Spirals of Exchange: Imag(in)ing North Pentecost Kinship." *Australian Journal of Anthropology* 16 (1): 76–94.

———. 2008. "The Social Life of Rights: 'Gender Antagonism,' Modernity and Raet in Vanuatu." *Australian Journal of Anthropology* 19 (2): 165–178.

Te Anga, Nathan. 1998a. "MP Appeals to Anonymous Buyer to Pass on Two Mere." *Waikato Times* (New Zealand), February 23.

———. 1998b. "Tainui Rule Out Bidding for Greenstone Mere They Want Back." *Waikato Times* (New Zealand), February 19.

———. 1998c. "Tainui Wants Clubs Back, Not Auctioned in New York." *Waikato Times* (New Zealand), February 16.

"Te Papa Mum on Mere Bid." 1998. *The Evening Post* (Wellington). February 21.

Te Rōpū Whakamana i te Tiriti o Waitang Waitangi Tribunal. 2006. *WAI 262 the Flora and Fauna Intellectual Property Claim Statement of Issues*. Wellington: Ministry of Justice.

Thomas, Nicholas. 1991. *Entangled Objects: Exchange, Material Culture, and Colonialism in the Pacific*. Cambridge, Mass.: Harvard University Press.

———. 1994. *Colonialism's Culture: Anthropology, Travel, and Government*. Princeton, N.J.: Princeton University Press.

———. 1995. "Kiss the Baby Goodbye: 'Kowhaiwhai' and Aesthetics in Aotearoa New Zealand." *Critical Inquiry* 22 (1): 90–121.

———. 1997. *In Oceania: Visions, Artifacts, Histories*. Durham, N.C.: Duke University Press.

———. 1999. *Possessions: Indigenous Art/Colonial Culture*. New York: Thames and Hudson.

Tilley, Virginia. 2002. "New Help or New Hegemony? The Transnational Indigenous Peoples' Movement and 'Being Indian' in El Salvador." *Journal of Latin American Studies* 34 (3): 525–554.

Tjibaou, Jean-Marie, Michel Folco, Claude Rives, Chris Plant, Philippe Missotte, Committee for the Development of New Caledonia, and University of the South Pacific. 1978. *Kanake: The Melanesian Way*. Papeete, Tahiti: Les Editions du Pacifique.

Toa, Evelyne. 2004. *Melwe MF Assosiesen I Setap Blong Protektem Ambrym Tamtam*. Port Vila Presse. Available at www.news.vu.tam (accessed July 21, 2006).

Tonkinson, Robert. 1981. "Church and Kastom in South East Ambrym." In *Vanuatu: Politics, Economics and Ritual in Island Melanesia*, ed. Michael Allen, 237–267. Sydney: Academic Press.

———. 1982. "National Identity and the Problem of Kastom in Vanuatu." *Mankind* 13 (Special Issue 4): 306–315.

Trading Post. 1996a. "Ambrym Chief Denies Threatening Expatriate Business Woman." No. 140, May 11.

———. 1996b. "Ambrym Chiefs Threaten Expatriate Business Woman." No. 139, April 27.

———. 1996c. "Govt Says Ambrym Chiefs Must Pay Back the 140,000vt." No. 143, May 11.

Trask, Haunani-Kay. 1991. "Natives and Anthropologists: The Colonial Struggle." *The Contemporary Pacific* 3: 159–167.

———. 1999. *From a Native Daughter: Colonialism and Sovereignty in Hawai'i*. Rev. ed. Honolulu: University of Hawai'i Press.

Tryon, Darrell, ed. 1992. *Ples Blong Ol Pig Long Kastom Laef Long Vanuatu*. Port Vila: Vanuatu Cultural Centre.

———. 1996. "Dialect Chaining and the Use of Geographical Space." In *Arts of Vanuatu*, ed. Joël Bonnemaison, Kirk Huffman, Christian Kaufmann, and Darrell Tryon, 170–173. Bathurst, Australia: Crawford House.

———. 1999. "Ni-Vanuatu Research and Researchers." *Oceania* 70 (1): 9–15.

Turaga Nation. n.d. "TURAGA DEVELOPMENT MODEL FOR ECONOMIC SELF RELIANCE AND HUMAN SECURITY: A Contribution to Vanuatu Economic Self Reliance, the Millennium Development Goal 1, the LDC Brussels Programme of Action and the Planned Programme Agenda 2020." Unpublished document, Turaga, Pentecost. Copy in the collection of the author.

Turner, Stephen. 2002. "Sovereignty, or the Art of Being Native." *Cultural Critique* 51 (Spring 2002): 74–100.

UNESCO. 1970. *Convention on the Means of Prohibiting and Preventing the Illicit Import, Export and Transfer of Ownership of Cultural Property*. Available at www.beniculturali.it (accessed March 15, 2005).

———. 1982. *Return and Restitution of Cultural Property: A Brief Resume: Paper Provided to the Intergovernmental Committee for Promoting the Return of Cultural Property to Its Countries of Origin or Its Restitution in the Case of Illicit Appropriation*. Paris, CLT/CH/4.82.

———. 1999. *Cultural Heritage and Partnership*. Culture Sector: Cultural Heritage Division. Paris, UNESCO.

———. 2002. *Report of the First Session of the Intergovernmental Meeting of Experts on the Preliminary Draft Convention for the Safeguarding of the Intangible Cultural Heritage*. Paris: CLT-2002/CONF.203/5.

———. 2005. *Copyright: UNESCO Culture Sector.* Available at www.unesco.org (accessed March 7).

UNESCO, with the Vanuatu Cultural Centre. 2000. Draft of the *Proclamation of Masterpieces of the Oral and Intangible Heritage of Humanity.* Paris: UNESCO.

Unger, Roberto Mangabeira. 1986. *The Critical Legal Studies Movement.* Cambridge, Mass.: Harvard University Press.

United Nations. 2008. "United Nations Declaration of the Rights of Indigenous Peoples." New York: United Nations.

Vaidhyanathan, Siva. 2001. *Copyrights and Copywrongs: The Rise of Intellectual Property and How It Threatens Creativity.* New York: New York University Press.

Valjavec, Friedrich. 1986. "Anthropology in Vanuatu: A Selected Survey of Research." *Anthropos* 81 (4–6): 616–629.

van Meijl, Toon. 2009a. "Māori Intellectual Property Rights and the Formation of Ethnic Boundaries." *International Journal of Cultural Property* 16 (3): 341–355.

———. 2009b. "Pacific Discourses about Cultural Heritage and Its Protection: An Introduction." *International Journal of Cultural Property* 16 (3): 221–232.

Van Trease, Howard. 1987. *The Politics of Land in Vanuatu: From Colony to Independence.* Suva: Institute of Pacific Studies.

Vanuatu Cultural Council/Vanuatu Cultural Centre. 1997. *Vanuatu Cultural Research Policy.* Available at http://arts.anu.edu.au (accessed March 7, 2005).

Vanuatu National Statistics Office. 2000a. *Informal Sector Survey: Draft Copy.* Port Vila.

———. 2000b. *The 1999 Vanuatu National Population and Housing Census, Main Report.* Port Vila.

Velthuis, Olav. 2005. *Talking Prices: Symbolic Meanings of Prices on the Market for Contemporary Art.* Princeton, N.J.: Princeton University Press.

Verdery, Katherine. 2003. *The Vanishing Hectare: Property and Value in Postsocialist Transylvania.* Ithaca, N.Y.: Cornell University Press.

wa Thiongo, Ngũgĩ. 1986. *Decolonising the Mind: The Politics of Language in African Literature.* London: J. Currey and Heinemann.

Wagner, Roy. 1975. *The Invention of Culture.* Englewood Cliffs, N.J.: Prentice-Hall.

Waitangi Tribunal. 2011. "Ko Aotearoa Tēnei. A Report into Claims Concerning New Zealand Law and Policy Affecting Māori Culture and Identity. Te Taumata Tuarua. Wai 262." Vols. 1 and 2. Available at www.waitangitribunal.govt.nz (accessed July 24, 2011).

Walsh, Andrew. 2003. "'Hot Money' and Daring Consumption in a Northern Malagasy Sapphire-Mining Town." *American Ethnologist* 30 (2): 290–305.

Wastell, Sari. 2007. "Being Swazi, Being Human: Constitutionalism, Custom and Human Rights in Swaziland." In *The Practice of Human Rights: Tracking Law between the Global and the Local,* ed. Mark Goodale and Sally Engle Merry, 320–341. Cambridge: Cambridge University Press.

Wedde, Ian. 1997. "Living in Time: A Day at the Footie." Paper written for Museums Aotearoa's Engaging Practices symposium. Available at www.nzepc.auckland.ac.nz (accessed October 11, 2012).

———. 2000. *Ralph Hotere: Black Light*. Wellington: Te Papa Press and Dunedin Public Art Gallery.

Weiner, Annette B. 1992. *Inalienable Possessions: The Paradox of Keeping-While-Giving*. Berkeley: University of California Press.

Wengrow, David. 2008. "Prehistories of Commodity Branding." *Current Anthropology* 49 (1): 7–34.

Were, Graeme. 2005. "Thinking through Images: Kastom and the Coming of the Baha'is to Northern New Ireland, Papua New Guinea." *Journal of the Royal Anthropological Institute* 11 (4): 659–676.

Whimp, Kathy, and Mark Busse, eds. 2000. *Protection of Intellectual, Biological and Cultural Property in Papua New Guinea*. Port Moresby, Papua New Guinea: Conservation Melanesia and the Asia Pacific Press at Australian National University.

White, Georgina. 2009. "Our Space: A Forum for the Nation." Unpublished master's thesis, Program in Museum Studies, New York University.

Wicliffe, Judge Caren, Kahui Maranui, and Paul Meredith. 2002. "Access to Customary Law: New Zealand Issues." Paper presented at Visible Justice: Evolving Access to Law, September 11, 2002, Wellington, New Zealand.

Wilkins, Darvall K. 1967. Letter, March 16. F.297/3. Vanuatu National Archives, Port Vila.

Williams, Paul. 2001. "Parade: Reformulating Art and Identity at Te Papa, Museum of New Zealand." *Open Museum Journal* 3: 1–28.

———. 2003. "Te Papa: Aotearoa/New Zealand's Identity Complex." *New Zealand Journal of Art History* 24 (1): 11–24.

———. 2005a. "A Breach on the Beach: Te Papa and the Fraying of Biculturalism." *Museum and Society* 3 (2): 81–97.

———. 2005b. "Making 'Our Place': Biculturalism at New Zealand's New National Museum." In *Museums, Communities and Cultural Diversity*, 18–56. Taipei: National Museum of Taiwan.

———. 2006. "Reforming Nationhood: The Intersection of the Free Market and Biculturalism at the Museum of New Zealand Te Papa Tongarewa." In *South Pacific Museums: Experiments in Culture*, ed. Chris Healy and Andrea Whitcombe, 2–16. Sydney: Monash University ePress and the University of Sydney Press.

Wolfe, Patrick. 1999. *Settler Colonialism and the Transformation of Anthropology: The Politics and Poetics of an Ethnographic Event*. London: Cassell.

Wolfgramm, Rachel. 2007. "Continuity and Vitality of Worldview(s) in Organizational Cultural Orientations: Towards a Maori Perspective." Unpublished PhD dissertation, University of Auckland.

World Intellectual Property Organization. 2006. *Customary Law and the Intellectual Property System in the Protection of Traditional Cultural Expressions and Traditional Knowledge.* Issues paper, Version 3.0. Available at www.wipo.int (accessed January 24, 2011).

World Trade Organization. n.d. *What Are Intellectual Property Rights?* Available at www.wto.org (accessed March 7, 2005).

Worsley, Peter. 1968. *The Trumpet Shall Sound: A Study of "Cargo" Cults in Melanesia.* 2nd ed. New York: Schocken Books.

Wright, Michael. 2001. "Traditional Knowledge Protection: International, Regional and National Experiences—Legislative Initiatives in Vanuatu to Protect Expressions of Indigenous Culture." Paper presented at a workshop, Legal Experts on the Protection of Traditional Knowledge and Expressions of Culture, Noumea, New Caledonia, February 15–19, 1999.

Zagala, Stephen. 2004. "Vanuatu Sand Drawing." *Museum International* 56 (1–2): 32–35.

Zaloom, Caitlin. 2003. "Ambiguous Numbers: Trading Technologies and Interpretation in Financial Markets." *American Ethnologist* 30 (2): 258–272.

Zelizer, Viviana A. 1989. "The Social Meaning of Money: 'Special Monies.'" *American Journal of Sociology* 95 (2): 342–377.

Index

Page numbers written in italics denote illustrations.

Aotearoa (*cont.*)

42, 218*n*1, 221*n*13; foreign aid, 33; government, 36–43; history, 35–43; immigrants, 41; Land Wars, 39; legal system, 53–56, 225*n*7; Māori Antiquities Act of 1901, 161, 210, 242*n*9; map, *37*; Native Land Court, 39, 223*n*9; prison system, 42, 56; Protected Objects Act, 160–61, 162, 210, 242*n*10, 243*n*11; Taonga Māori Protection Bill (proposed), 162; Terrorism Suppression Amendment Act, 56; Trade Marks Act, 11, 101–03, 111, 117, 119; Trade Marks and Related Design Act, 22; and UN declaration of indigenous rights, 46; and World Trade Organization membership, 57, 208. *See also* Aotearoa New Zealand museologies; auction marketplace for *taonga*; biculturalism; intellectual property (IP) in New Zealand; Māori; toi iho trademarks; Treaty of Waitangi; Waitangi Tribunal

Aotearoa New Zealand museologies: bicultural perspectives in, 129–30, 131, 132–33, 135, 169–70, 240*n*9; colonial origins, 22–23, 129–30, 150; and concept of *kaitiakitanga* (guardianship), 133–34, 209; and concept of *taonga,* 98, 130, 133, 134–35, 138, 149; incorporation of Māori values, 130, 131, 132–35, 138, 161, 240*n*8; *Ko Tawa* exhibition, 136–38, 240*n*14; and Māori museology, 129–31, 133, 240*n*7–8; as provincializing project, 138, 150; repatriation project, 133–34, 149; role in auction marketplace, 153, 162, 169, 170–71; *Te Māori* exhibition, 97–98, 130–31, 138. *See also* Auckland

War Memorial Museum Tamaki Paenga Hira; Museum of New Zealand Te Papa Tongarewa

Appadurai, Arjun, 164

Assembly of God, 30

Atchin Island, 182, *182, 186,* 231*n*12

Atpatoun, Vianney, 183, 184, 245*n*3

Atutu, Noe Saksak, 175, 198

Auckland War Memorial Museum Tamaki Paenga Hira: founding of, 132; indigenous museology of, 131, 132, 137–38, 240*n*8; *Ko Tawa* exhibition, 136–38, 240*n*14; natural history displays, 135–36, *136*

auction marketplace for *taonga*: artifact registry, 161–62, 170–71, 243*n*12; bicultural dynamic in, 152, 162–63, 172–73; commoditization of *taonga* in, 151–52, 158, 163–65, 172–74, 176, 244*n*32; and concept of ideal marketplace, 153–55; and concept of *kaitiakitanga* (guardianship), 209–10; global regulation of, 153; government regulation of, 153, 160–62, 210; language of repatriation in, 171–72, 244*n*28; Māori activism and interventions in, 23, 50, 96–97, 152, 153, 158–60, 162, 163, 164–69, 173, 174; pricing in, 155–58, 159, 244*n*24; role of museum curators, 153, 162, 169, 170–71; sale of mere (gifted to Duke of Windsor), 167–69, 244*n*24; sale of Partington photographs, 165–67; sale of *poutokomanawa* (Williams collection), 155–58, 159

Australia: early labor trade, 30; indigeneity discourses, x, 46; indigenous trademark,

Ihimaera, Witi, 107

"In Defense of Property" (Carpenter, Katyal, and Riley), 19

Inalienable Possessions (Weiner), 27

indigenization: definition, 3–4. *See also* indigenous/indigeneity

indigenous/indigeneity: and cultural commons, 112–13, 115, 239*n*28; definitions of, 46, 218*n*2(Pref.); engagement with colonial structures, x, 43, 46, 49–50; global influences on, 20–21, 46–47, 48; and law, 20–21, 50–60; and property, 3, 9–13, 207–08, 247*n*1; in Vanuatu and New Zealand, 45, 46–50

intangible cultural heritage (ICH): as alternative economic imaginary, 202–04, 206, 210; emphasis on practice and process, 6–7, 219*n*4; initial listing of, 17, 218*n*3(Intro.); and Pig Bank Project, 202–04, 206; sand drawing as, 6–7, 16–17, 59, 246*n*8; UNESCO conceptualization of, 6–7, 17, 202–04, 218*n*3(Intro.), 219*n*4, 246*n*8; Vanuatu's role in framing, 17, 202, 210

intellectual property (IP): commoditization of, 62, 75–76, 82, 86–87, 90; comparative mode of analysis, 2–4, 26–28, 211–13; and concept of cultural commons, 112–13, 115, 239*n*28; convergence with cultural property, 2, 12–13, 150; definitions of, 2, 12; international protections for, 12; and sui generis law, 64–66, 67, 85–88, 199. *See also* copyright in Vanuatu; cultural property; property; World Intellectual Property Organization (WIPO)

intellectual property (IP) in New Zealand: appropriation of Māori symbols, 91, 93–95, 96–97, 102; indigenization of, 2, 3–4, 8, 89–91, 101–02, 118–20, 121–22; and indigenous cultural commons, 111–20, 239*n*28; and Māori branding, 22, 90, 91, 96–98, 101, 118, 235*n*4–5; and Māori trademarks, 90, 91, 100–102, 118; and Māori writing, 91, 93; Moana vs. Media XS case, 7–8, 96; New Zealand trademarks, 99–100, 119; Trade Marks Act, 11, 101–03, 111, 117, 119. *See also* Aotearoa New Zealand museologies; toi iho trademarks

intellectual property (IP) in Vanuatu: indigenization of, 2, 3–4, 121–22; kava as, 241*n*16. *See also* Copyright Act; copyright in Vanuatu

Intergovernmental Committee on Intellectual Property and Genetic Resources, Traditional Knowledge and Folklore, 13, 220*n*9

Ithaca HOURS, 197

Iti, Tama, 56

iwi (tribes), 36, 49, 54, 227*n*13–14

Jahnke, Huia Tomlins, 107

Jahnke, Robert, 95, 97–98, 107, 133

Janke, Terri, 11–12, 64

Japan, 41, 203

Jehovah's Witness, 30

John Frum movement, 31, 200

Jolly, Margaret, 140–41, 231*n*12, 241*n*15

Kaimbong, Reggie, 188, 192–93

kaitiakitanga (guardianship): and auction

marketplace, 209–10; as Māori relationship to land, 113, 114, 115–17, 134; and New Zealand museums, 133–34, 209. *See also* Waitangi Tribunal

Kaku, Etienne, 199

Kalinoe, Lawrence, 11

Kapere, Jacob, 125–26

Karanga Aotearoa National Repatriation Project, 133–34, 149

kastom (indigenous tradition): as alternative economic imaginary, 11, 50, 176–78, 219*n*7; definitions of, 47–48, 139, 142–45; and land rights, 143, 194–95, 210, 245*n*4; role in independence movement, 141–42; role in Vanuatu life, 34–35, 52–53, 139–45, 148–49, 176, 226*n*11; tensions with Christianity, 30, 34, 142; and Vanuatu Kaljoral Senta, 34–35, 125, 127, 139, 142–44, 149; as vision of cultural property, 67–68, 144–45, 148–49. *See also* Copyright Act; copyright in Vanuatu; Pig Bank Project; sorcery

Katyal, Sonia K., 19, 20

kaumātua (elders), 53

Kaupapa Māori principles, 40, 53, 97

kava, 142, 241*n*16

Kay, John, 152

Keesing, Roger M., 139–40

Keitadi, Jack, 125

King, Michael, 167

King Movement, 39

Kipa, Rangi, 108, 109

Kirsch, Stuart, 18

Kirschenblatt-Gimblett, Barbara, 203

kopiraet (copyright), 66, 70, 233*n*17. *See also* copyright in Vanuatu

Kopytoff, Igor, 164

Korea, 41

Kula exchange networks, 27

kūmara (sweet potato), 36, 113

Kuper, Adam, 15

land: in anthropological theory, 194; in economic theory, 193–94. *See also* Vanuatu

Land Dive ceremony, ix, 66, 87, 217*n*1, 230*n*10

"Lapita" people, 28

Larcom, Joan, 140–41, 143

law: as framework for understanding indigenous cultural and intellectual property, 20, 43, 50–60, 214; global frameworks, 56–58, 60; and legal pluralism, 52, 226*n*10; local frameworks, 51–56, 60; national frameworks, 58–60; New Zealand legal system, 53–56, 225*n*7; and sorcery, 52, 201, 226*n*11; Vanuatu legal system, 32–33, 51–53, 54, 55–56, 63–64, 225*n*7–8, 226*n*9. *See also* sui generis law

Layard, John, 182–83, 185, 186, 205, 231*n*12

Layard, Richard, 205

Leach, James, 96, 219*n*7

Lego Company, 96, 217*n*1

Lessig, Lawrence, 239*n*28

Lindstrom, Lamont, 140–41, 230*n*9

Lini, Motarilavoa Hilda, 48, 195, 196

Lini, Walter, 31, 48, 71–72, 140

Linnekin, Jocelyn, 141

Livatu (currency), 196–97, 246*n*6

Locke, John, 194

Luganville, 33

Mithlo, Nancy Marie, 23

Moana. *See* Maniapoto, Moana

Moana Maniapoto and The Tribe, 7–8, 96

Model Law. *See* Pacific Model Law

money/currency: alternative Vanuatu
 currencies, 195–97, 246*n*6; in ancient
 Greece, 205; in anthropological theory,
 179–81; community currency movements
 worldwide, 197; equivalency of Vanuatu
 pigs and cash, 182–88, 197–98, 201; role
 in Melanesia, 181–82. *See also* Pig Bank
 Project

Moore, Sally Falk, 226*n*10

Morgan, Tukoroirangi, 168

Moutu, Andrew, 11

Muller, Kal, 77

Murray, Mrs. Saana, 113

Museum of New Zealand Te Papa Tongarewa:
 author's work in, 9, 155, 241*n*2; as
 bicultural institution, 132–33, 135, 169–
 70, 240*n*9; documentary about, 91, 93;
 exhibition space, 132, 133, 135, 240*n*10;
 founding of, 132; and indigenous
 museology, 131, 132, 150; as leader in
 field, 123; Māori values incorporated into,
 132, 133–35, 138, 240*n*9; natural history
 displays, 135; photo, *92*; purchase of
 mere (gifted to Duke of Windsor), 168;
 thumbprint symbol, *92*, 93; Treaty of
 Waitangi exhibit, 135. *See also* Aotearoa
 New Zealand museologies

museums: indigenous, 123, 128–29; as
 institutions of colonialism, 22–23,
 129–30, 150, 222*n*22; and museum-
 age anthropology, 26–27, 122–23;
 and ownership of cultural resources, x,

22–23, 98, 119–20, 123, 160–61; three
 analytic paradigms, 128. *See also* Aotearoa
 New Zealand museologies; Auckland
 War Memorial Museum Tamaki Paenga
 Hira; Museum of New Zealand Te Papa
 Tongarewa; Vanuatu Kaljoral Senta (VKS)

Nagol Land Dive, 217*n*1, 230*n*10. *See also*
 Land Dive ceremony

Nagriamel movement, 31, 32, 223*n*4

Nathan, Manos, 107, 108, 118

National Copyright Act. *See* Copyright Act
 (Vanuatu)

National Council of Chiefs. *See* Malvatumauri
 (National Council of Chiefs)

National Cultural Council, 63–64, 127

National Māori Congress, 59, 227*n*20

Native Agent label, 95

Native Americans, 19, 206

Neil Thomas Ministry, 30

New Caledonia, 30, 48, 219*n*6

New Economics Foundation (NEF), 204–05

New Hebrides, 28, 223*n*3. *See also* Vanuatu

New Hebrides Cultural Association, 31

New Hebrides National Party, 71, 141

New Ireland Malanggan carvings, 230*n*7

New Zealand: as Aotearoa New Zealand,
 218*n*3(Pref.); map of, *37*. *See also*
 Aotearoa New Zealand

New Zealand Intellectual Property Office
 (IPONZ), 209

Ngā Puna Waihanga (arts organization),
 105–06

Ngāi Tahu, 54, 55, 226*n*12

Ngāi Tūhoe, 56

Ngata, Apirana, 39, 105

nimangki (graded societies). *See* graded
 societies (*nimangki*)
North Ambrym: and artifacts trade, 80–88;
 carvings, 67, 68, *69*, 70–71, 75–82, 86–
 87; and copyright issues, 52, 64, 66–67,
 68, 70–71, 75–88, 209, 233*n*17; graded
 societies, 22, 68, *69*, 70, 75–82, 86,
 231*n*12; slit-drum carvings, 75–77, *76*,
 77, 232*n*15; tourism, 77, 233*n*20; value of
 pigs, 185. *See also* Fanla (village); sorcery
Northwest Coast potlatches, 27, 180
Norton, Robert, 139
Notes Towards an Anthropology of Money
 (Hart), 180–81
Nuie, 41

Osea, Marie Ange, 81
O'Sullivan, Dominic, 41–42

Paama Island, 33
Pacific Islands: exchange culture of, 27;
 immigration to New Zealand, 41; social
 and historical interconnectedness, 25–26.
 See also Aotearoa New Zealand; Fiji; New
 Caledonia; Papua New Guinea; Samoa;
 Solomon Islands; Tonga; Vanuatu
Pacific Model Law, 51, 58–59, 65, 227*n*18–19
Pākehā (white settler), 38, 41, 48, 163, 242*n*6.
 See also biculturalism
Papua New Guinea: anthropological studies,
 10, 181, 219*n*6–7; independence, 31;
 indigenous population, 47–48, 224*n*4;
 New Ireland Malanggan carvings, 230*n*7;
 and Vanuatu rebellions, 32, 223*n*4
Pardington, Fiona, 95
Pardington, Neil, 95

Parekowhai, Michael, 107
Partington, William, 165, 166
Paterson, Don, 225*n*8
Patterson, Mary, 76, 77, 231*n*12
Pentecost Island, 33; kastom banking system,
 195–97; land dive ceremony, ix, 66, 87,
 217*n*1, 230*n*10; Pig Bank Project, 189,
 190; value of pigs on, 185
Pentecostal Christianity, 30
Philippines, 41
Phoenix Foundation, 32, 223*n*4
Pig Bank Project: as alternative economic
 imaginary, 23, 176–79, 202–04,
 206; analogies between indigenous
 and Western values, 179, 189–90; as
 conservation project, 127; equivalency
 of pigs and currency, 182–88, 197–98,
 201, 245*n*2–3; land rights issues, 192–95;
 link to intangible cultural heritage,
 202–04, 206; plan of action, 188–92;
 as provincializing project, 179, 205–06;
 UNESCO role in, 127, 175–76, 189
Pinney, Christopher, 4
Pomare, Maui, 39
Port Vila, 9; as capital, 17, 33; commercial
 trade, 31, 81–85; map of, *29*; and Pig
 Bank Project, 189
pounamu (greenstone): carving production,
 96; Māori as custodians of, 42, 54, 55,
 227*n*12; mining of, 244*n*32
Povinelli, Elizabeth, 46, 112, 116
Presbyterians, 30, 80, 234*n*22–23. *See also*
 Christianity
property: conflation with sovereignty,
 18–20, 222*n*21; indigenous vs. Western
 understandings of, 3, 6–7, 9–13,

111, 117, 209, 236n16; founding artists, 108, 118; history of, 105–10; licensing, 105, 236n15; management of, 103–05, 151, 210–11, 236n14; and Māori-state relations, 117, 176; as provincializing project, 22, 91, 208; relaunching of, 101, 116, 118, 210; three trademarks of, 103, 235n13. *See also* intellectual property (IP) in New Zealand

Tokelau, 41

Tonga, 27, 41

Tonkinson, Robert, 140

Torres Islands, 33

Trade Related Aspects of Intellectual Property Rights (TRIPS), 12, 45, 56–57, 208, 221n16

Trade Marks Act (New Zealand), 11, 101–03, 111, 117, 119

Trademark and Related Design Act, 22

trademarks: for Aboriginal Australians, 106, 236n17; alternative, 99; Merchandise Marks Act of United Kingdom, 99; New Zealand, 99–100, 119; origins of, 98–99. *See also* brands and branding; toi iho trademarks

traditional cultural expressions (TCE), 12–13, 58–59, 220n9

traditional knowledge (TK), 12–13, 58–59, 220n9

Traditional Money Banks in Vanuatu Project (TMBV). *See* Pig Bank Project

Transition Toi Iho, 118

Trask, Haunani-Kay, 224n1

Treaty of Waitangi: appraised value of document, 244n31; bicultural principles stemming from, 38–39, 218n3(Pref.), 242n6; excerpt, 35; failure to protect Māori rights, 39, 40, 93; media images of, 96; museum exhibits on, 135; principles of, 148, 241n19; signing of, 38, 91, 93; on sovereignty, 210, 222n19; and *taonga,* 146, 147–48; as *taonga,* 234n1; translation difficulties, 38, 147–48; Waitangi Tribunal as interpreter of, 53–55. *See also* Waitangi Tribunal

Treaty of Waitangi Act, 40

Trobriand Islands, 10, 27

Tryon, Darrel, 125

Tūhoe, 159–60

Tupu Taingakawa, Te Waharoa, 167, 168

Turaga Development Model for Economic Self Reliance and Human Security Program, 195

Turaga Nation, 48, 195–97

Turei, John, 159

Tuvalu, 41

Twain, Mark, 62

Tyson, Mike, 96

UNESCO: Convention on Biological Diversity, 57, 227n16, 229n3; funding for Pig Bank Project, 127, 175–76, 189; on intangible cultural heritage, 6–7, 17, 202–04, 218n3(Intro.), 219n4; protections of cultural and intellectual property, 12, 13, 57, 242n10

UNIDROIT Convention on Stolen or Illegally Exported Cultural Objects, 242n10

Unilever, 31

Union de la Population des Nouvelles-Hebrides, 31

United Kingdom. *See* Britain

United Nations: Declaration of the Rights
of Indigenous Peoples, 46, 59, 210,
218*n*2(Pref.), 222*n*19, 228*n*21–22; Least
Developed Countries, 1, 218*n*1; terrorism
resolutions, 56
United States, x, 46, 49
University of Auckland, 111
Urewera Mural, The (McCahon), 159–60
Urewera National Park, 56, 160

Vanua'aku Party, 31–32, 71–72, 142
Vanuatu: administrative regions, 33; cargo
cults, 31, 79, 198–201, 202; Chiefs Act,
32–33; Constitution, 28, 32, 51, 52,
225*n*7–8, 245*n*5; cooperatives, 199–201,
211, 246*n*7; court system, 30–31; credit
unions, 33, 175, 176–77, 191, 198, 199,
201, 204, 210, 246*n*7; criminal justice
system, 56; economic development
and exports, 33–34, 142, 241*n*16;
foreign aid, 33; government, 1, 30–33,
35; and *Happy Planet Index,* 204–05,
246*n*9; history, 28–33; independence,
1, 30, 32, 33, 141–42; influence of
Christianity in, 30, 34, 53, 71, 80, 142,
226*n*11, 232*n*14, 234*n*22–23; and
intangible cultural heritage, 17, 202,
210; Land Dive ceremony, ix, 66, 87,
217*n*1, 230*n*10; land rights, 142, 143,
192–95, 210, 245*n*4; languages, 33;
legal system, 32–33, 51–53, 54, 55–56,
63–64, 225*n*7–8, 226*n*9; map of, *29*;
National Charter for Self-Reliance, 127;
population, 1, 33, 47, 224*n*3; tourism, 6,
34, 77, 141, 142, 230*n*9, 233*n*20; trade,
30, 31; Traditional Money Banks in

Vanuatu Project, 175–76; World Trade
Organization membership, xi, 56–57, 62,
208, 209, 228*n*1; Year of the Traditional
Economy, 175–76. *See also* Copyright
Act (Vanuatu); copyright in Vanuatu;
indigenous/indigeneity; kastom; Pig
Bank Project; sand drawing; sorcery;
Vanuatu Kaljoral Senta (VKS)
Vanuatu Copyright and Related Rights Act. *See*
Copyright Act (Vanuatu)
Vanuatu Credit Union League (VCUL), 176–
77, 191, 198
Vanuatu Cultural Centre. *See* Vanuatu Kaljoral
Senta (VKS)
Vanuatu Indigenous People's (VIP) Forum, 48,
195–96
Vanuatu Kaljoral Senta (VKS): anthropological
research, 127–28, 245*n*1; colonial
origins, 150; and cultural property
issues, 150; economic development
efforts, 34–35; exhibition space, 75,
126–27; First National Arts Festival,
125; history, 123–29; as indigenous
museum, 128–29, 138, 150; Juvenile
Justice Project, 126; and kastom, 34–35,
125, 127, 139, 142–44; museological
model for, 128–29; National Cultural
Research Policy, 127–28, 239*n*5, 245*n*1;
National Library, 124, 126; National
Photo, Film and Sound Archive, 125,
126; Oral Traditions Project, 125, 126;
photo, *124*; as provincializing entity, 127,
138, 150, 210; role in Pig Bank Project,
127, 176; Sand Drawing Project, 127;
social and political activism, 128, 129;
Traditional Marine Tenure Project, 126;

and UNESCO, 17; Vanuatu Cultural and Historical Sites Survey, 126; Women's Culture Project, 126, 143; Year of the Traditional Economy, 175–76; Young People's Project, 126

Vanuatu National Cultural Council, 17

Vanuatu National Museum. *See* Vanuatu Kaljoral Senta (VKS)

Verdery, Katherine, 193

Vuhunanwelenvanua, Chief, 195

Wagner, Roy, 141

WAI 262. *See* Waitangi Tribunal

Waikaremoana, Lake, 159

Waitai, Rana, 158

Waitangi Tribunal: on biculturalism, 41; establishment of, 40; as interpreter of Treaty of Waitangi, 40–42, 53–55, 102; and *kaitiakitanga* claims (guardianship), 113, 114, 115–17; and Māori claims to foreshore and seabed, 14–15, 42, 55, 110; and Māori claims to indigenous flora and fauna (WAI 262), 2, 15, 55, 110, 111, 113–17, 209; and *taonga,* 146, 148; and *tino rangatiratanga* claims (sovereignty), 35, 38, 42, 55, 110, 113–15; WAI 262 summary, 238n25

Walters, Gordon, 94

Webb, Peter, 159, 165–66

Wedde, Ian, 160

Weiner, Annette B., 27

Wengrow, David, 95

West Papua, 48

whakapapa: as Māori cosmology/genealogy, 49, 53, 130, 134, 136, 240n13; in museum displays, 134, 136, 138; and *taonga,* 146, 158, 160, 163, 244n24; for toi iho trademark applications, 106, 107, 110; translation and definition, 240n13

whakatauki (proverbs and sayings), 53

Whanganui Māori, 165–67

Whanganui Regional Museum, 165

Whiting, Cliff, 107, 133

Wihongi, Mrs. Del, 113

Williams, John, 30, 146

Williams, Paul, 169

Williams, William, 155

Wilson, Matthew McIntyre, 95

Windsor, Edward, Duke of, 167

Woodward, Keith, 124

Woog, Dr., 157

World Intellectual Property Organization (WIPO), 11–12, 13, 87, 220n8–9

World Trade Organization (WTO): New Zealand membership, 57, 208; Vanuatu membership, xi, 56–57, 62, 208, 209, 228n1. *See also* Trade Related Aspects of Intellectual Property Rights (TRIPS)

Wurwurnaim, 71

Young Māori Party, 39